BEHIND THE LENS

BEHIND THE LENS

THE WORLD HOCKEY ASSOCIATION 50 YEARS LATER

THE PHOTOGRAPHY OF STEVE BABINEAU

WRITTEN BY

BRIAN CODAGNONE

FOREWORD BY

HOWARD BALDWIN

Published by ECW Press
665 Gerrard Street East
Toronto, Ontario, Canada M4M 1Y2
416-694-3348 / info@ecwpress.com

Editor for the Press: Michael Holmes
Cover design: Jessica Albert
Cover images: Steve Babineau

ON THE COVER:
Bobby Hull — Winnipeg Jets (top left)
Gordie Howe — Houston Aeros (middle left)
Wayne Gretzky — Edmonton Oilers (bottom left)
André Lacroix — New Jersey Knights (top right)
Ted Green — New England Whalers (second from top, right)
Mike Walton — Minnesota Fighting Saints (middle right)
Ralph Backstrom — Chicago Cougars (second from bottom, right)
Gerry Cheevers — Cleveland Crusaders (bottom right)

LIBRARY AND ARCHIVES CANADA CATALOGUING
IN PUBLICATION

Title: Behind the lens : the World Hockey Association 50 years later / the photography of Steve Babineau ; written by Brian Codagnone ; foreword by Howard Baldwin.

Names: Babineau, Steve, photographer. | Codagnone, Brian, author. | Baldwin, Howard, 1942- writer of foreword.

Identifiers: Canadiana (print) 20220275408 | Canadiana (ebook) 20220275416

ISBN 978-1-77041-700-7 (softcover)
ISBN 978-1-77852-053-2 (ePub)
ISBN 978-1-77852-054-9 (PDF)
ISBN 978-1-77852-055-6 (Kindle)

Subjects: LCSH: World Hockey Association—Pictorial works. | LCSH: Hockey—Pictorial works.
Classification: LCC GV847.23 .B33 2022 | DDC 796.356022/2—dc23

PRINTED AND BOUND IN CANADA

PRINTING: FRIESENS 5 4 3 2 1

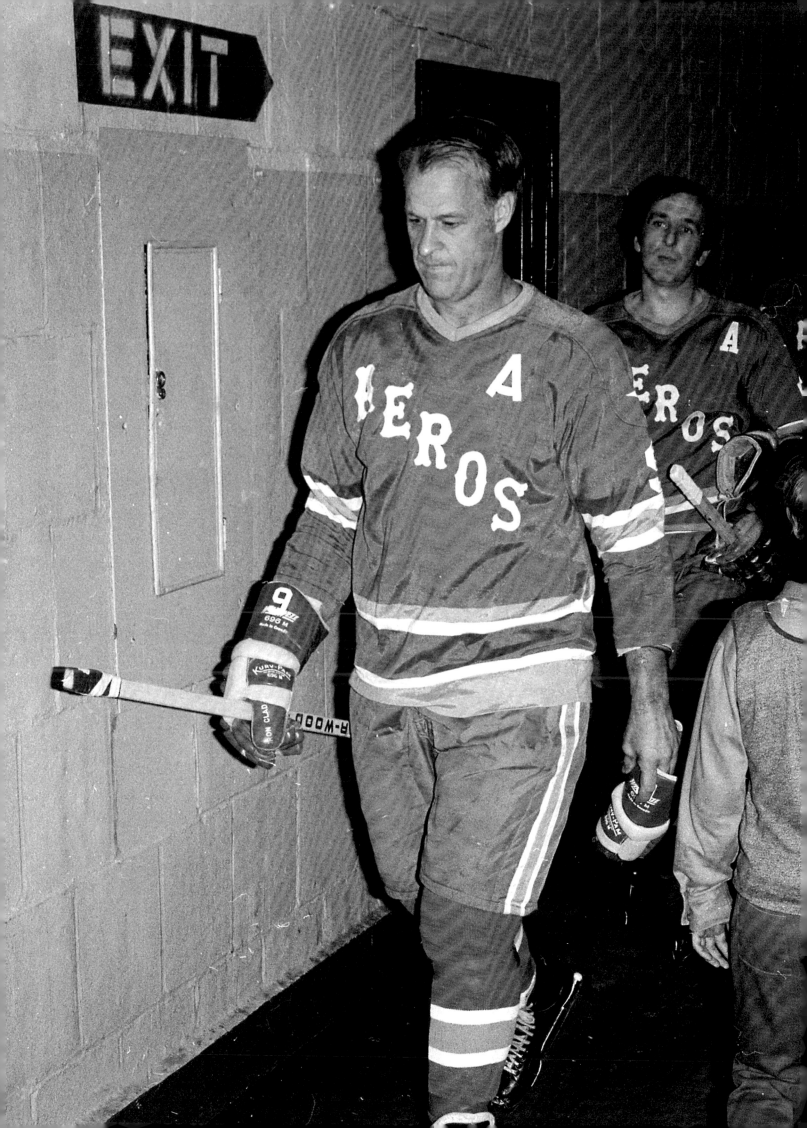

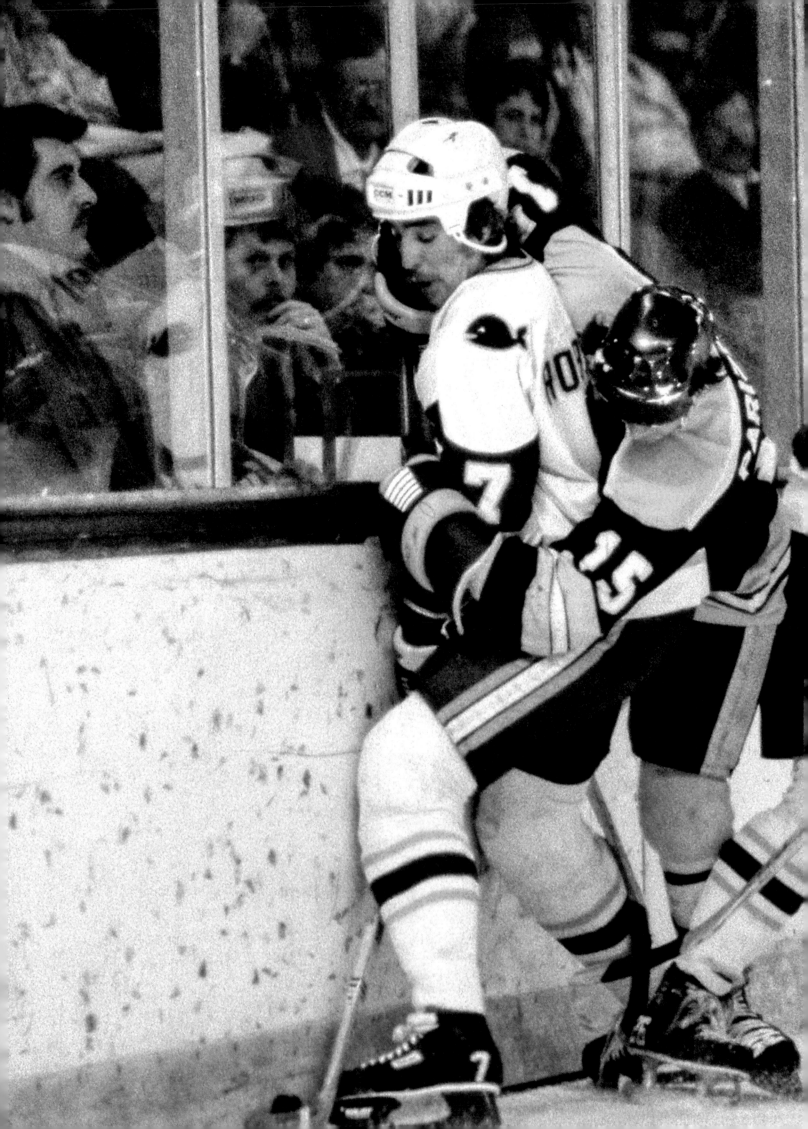

To my family.
—BC

To my wife, Anita (a Canadian), who has for 50 years
given me the lease on life to photograph THE Game.
—SB

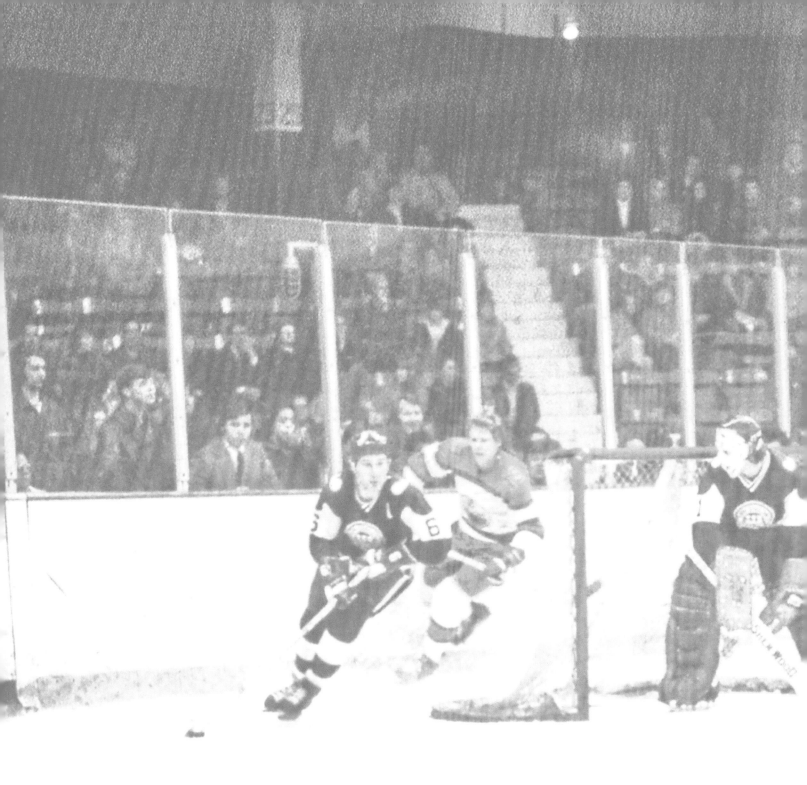

CONTENTS

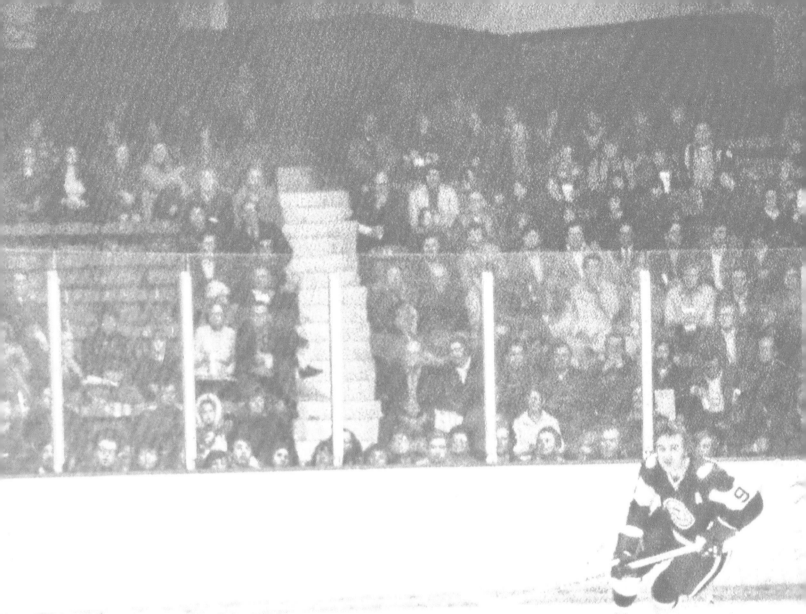

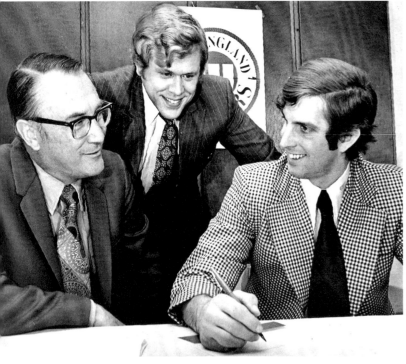

From left to right: Howard Baldwin, Jack Kelly and Larry Pleau

Howard Baldwin

Howard Baldwin

FOREWORD

IN NOVEMBER 1971 John Coburn and I were awarded the 12th franchise of the newly formed WHA. The WHA was created by two Southern California businessmen, Gary Davidson and Dennis Murphy, who had never even seen a hockey game. These same two men created the American Basketball Association.

We were 29 years old when we were granted the franchise for Boston. We had a formidable challenge in that the Boston Bruins were at the peak of their popularity. They had just won a Stanley Cup and had the most exciting and dynamic player in the league, Bobby Orr. As one newspaper headline proclaimed—a day after we were awarded the franchise—we had two chances: "slim and none."

And thus the New England Whalers were born—and my journey from the city of Boston to the city of Hartford, and then into the NHL, began.

At the same time another journey began, that of brilliant sports photographer Steve Babineau. Steve always enjoyed taking pictures. When he saw the arrival of a new team in a new league he immediately bought a seven-game ticket package, reached out to the *Hockey News* and sold them on the idea of having a photographer who was willing to take pictures of Whalers action and send them in.

As the Whalers began their journey so did Steve. And what a journey it's been for him (as well as yours truly).

The Whalers moved from Boston to Hartford within two years. For the WHA years based in Hartford, the team spent as much time playing in Springfield. Initially the Civic Center wasn't

complete, and then in 1977, incredibly, its roof collapsed. Few remember, but when the Whalers first played in the NHL it was at the Springfield Civic Center.

I always remember the look on the great Guy Lafleur's face when he first set foot on the ice in Springfield. The seating capacity was 7,500. He looked around the building and said, "Not quite a building the Montreal Canadiens are used to playing in . . ."

Steve was always there: for both openings of the Hartford buildings, at the merger announcement and for many other games and events. At the same time Steve was following the Whalers he developed a relationship with the Boston Bruins and soon became their go-to photographer.

Steve is as much a part of hockey media history, particularly in New England, as anyone I can think of. The beautiful eye he has for capturing the great moments he's witnessed is marvelously expressed in his body of work.

Enjoy this great book. I sure did.

—HOWARD BALDWIN

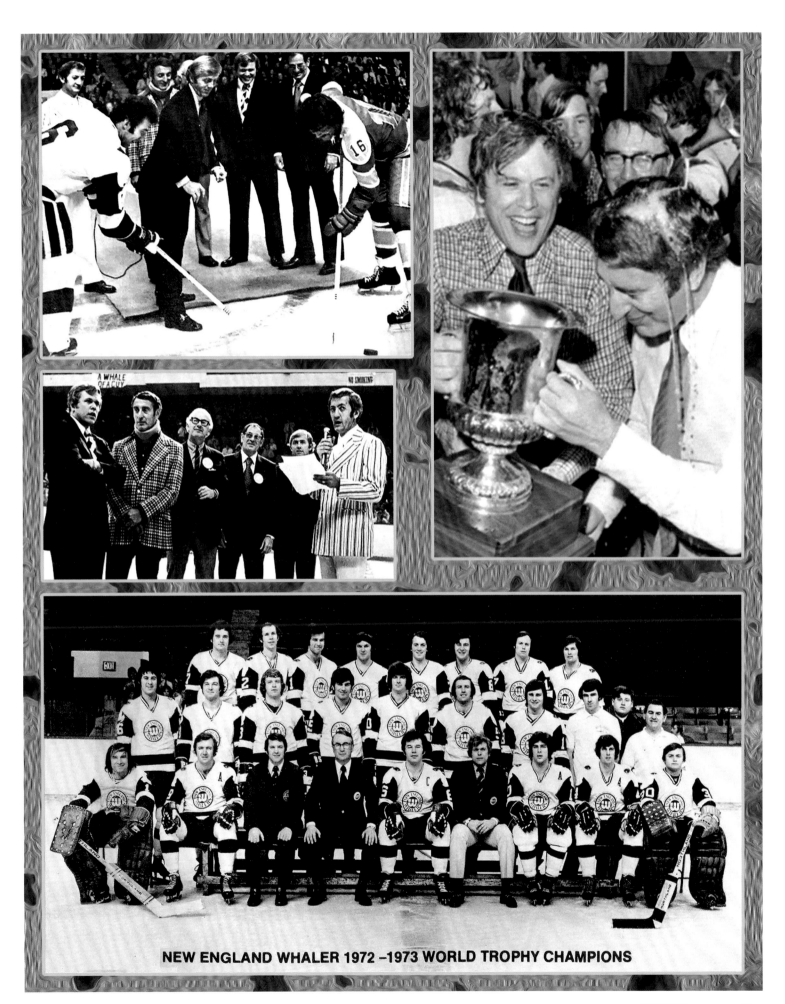

NEW ENGLAND WHALER 1972 –1973 WORLD TROPHY CHAMPIONS

PREFACE

IT'S DIFFICULT FOR me to say how long I've known Steve. It seems like he's always been around wherever hockey is played in New England. In the 20-plus years I've been at TD Garden (and its various names), as well as 30-plus years with the Sports Museum, his work and presence have been a constant.

I remember his son and daughter, Brian and Jamie, when they worked for us at the museum; now they've gone on to be successful in their own right. So much time has passed.

Like Steve, I grew up in the Boston area watching and playing hockey in the golden age of Bobby Orr and the Big Bad Bruins. I remember going to Whalers and Braves games when tickets for the Bruins were nearly impossible to get. It was good, entertaining hockey; I didn't know then that Steve was photographing the games on his way to bigger and better things.

He later said, "Buying obstructed view seats to see the Bruins with Orr, Sanderson, Esposito and Cheevers, along with buying season tickets to the AHL Boston Braves 1971–74 and adding the New England Whalers of the World Hockey Association, in my glory, I brought a camera along for the ride."

And it's been a glorious ride indeed.

—BRIAN CODAGNONE

*Don Herriman,
Mike Hydman and
Bernie Parent*

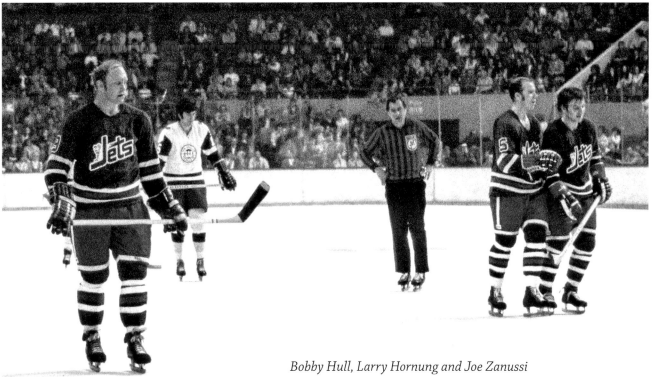

Bobby Hull, Larry Hornung and Joe Zanussi

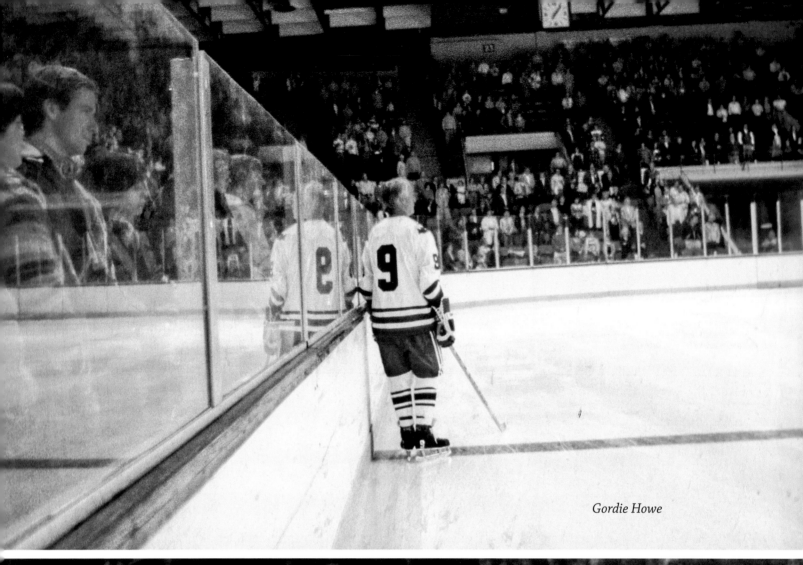

Gordie Howe

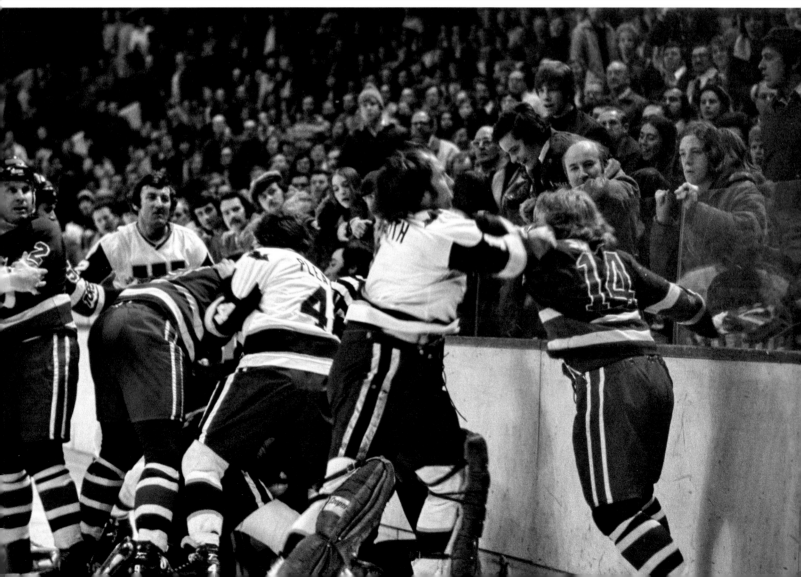

CHAPTER 1

"THE LEAGUE"—THE WORLD HOCKEY ASSOCIATION

FOR DECADES, the National Hockey League had no competition. In football and basketball, new leagues were willed into existence; both ended up merging with the senior leagues. Baseball hadn't seen serious competition since the short-lived Federal League in pre–World War I. By the 1970s, however, a change was coming that would reshape the world of professional hockey forever.

In 1971 articles of incorporation were filed to create what would become the World Hockey Association. Gary Davidson and Dennis Murphy met in Los Angeles with writer Walt Marlow and began mapping out a league that could seriously compete with the NHL. It wouldn't be an easy task. To compete, the new league would have to infringe on the NHL's territory and players.

The league founders saw an opportunity, not only in major league cities where the NHL had a monopoly, but in underserved markets in Canada and the United States. The market was ripe for a competing league, but it took planning and, most of all, money. There was no shortage of potential owners who saw not only profits but the prestige of owning a major league franchise.

Howard Baldwin, an executive with the Philadelphia Flyers, didn't need to be swayed. He bought into the league and acquired the rights to a franchise in New England. Baldwin would later become the league's president. Wayne Belisle led the Minnesota entry while Paul Deneau claimed a franchise for Dayton, Ohio.

Would Florida be a viable market? The West Coast? Why not? The important thing was that they were bringing major league hockey to places that had a fan base but, in the pre-cable days, no access to the pro game.

The initial league entrance premium for each franchise was set at $25,000, and by November 1971, Murphy and Davidson had announced that the league would begin play in 1972 with 12

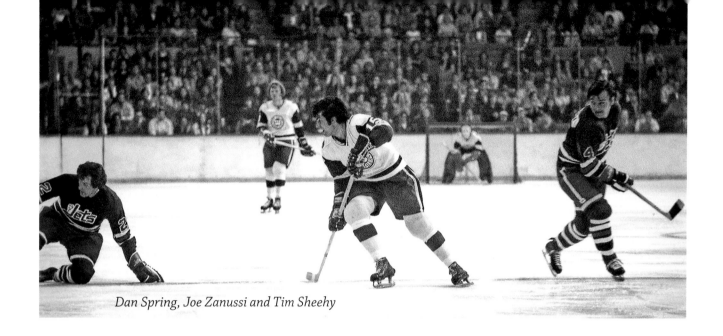
Dan Spring, Joe Zanussi and Tim Sheehy

teams: Calgary, Chicago, Dayton, Edmonton, Los Angeles, Miami, New England, New York, Ottawa, Saint Paul, San Francisco and Winnipeg. Most of these new franchise owners had neither the experience nor the finances to operate a major league hockey team—but the league was ready to go ahead anyway.

Once the teams were created (although Miami never played a game in the Sunshine State; Dayton and San Francisco also relocated before a single puck was dropped), it was time to fill out the rosters. To do this the league made several innovations. While the WHA opened the door to college players, underage juniors and, eventually, the untapped market of elite European players, the biggest draw for NHL talent would be better pay and the abolishment of the reserve clause.

The NHL began to take the upstart league seriously when several players under contract jumped to the WHA in search of both better pay and the freedom to play where they wished. As the only game in town, the NHL had determined who would play at the big-league level and how much they would be paid for their services. Even when the NHL doubled in size in 1967, and then added two more franchises (Buffalo and Vancouver, both established markets for hockey) in 1970, little had changed, as there was no incentive for the league to improve conditions. Players were bound to their respective teams for life, until they were released, traded or retired and, except for a handful of superstars, had no leverage as to pay or mobility. For example Red Kelly of the Red Wings was traded to the Rangers but refused to go, threatening to retire first. At last another deal was struck that sent him to Toronto. But such examples were few and far between.

After more than 60 players jumped to the new league, the NHL began to take notice. At first they tried legal means, suing to hold players to their respective teams and contracts. They managed to (temporarily) stop stars such as goaltenders Bernie Parent and Gerry Cheevers, defensemen J.C. Tremblay and Ted Green and forward John McKenzie among other established NHL players who rejected contracts from their current NHL teams. Instead, they opted for the bigger payday of the new league.

The NHL continued to press the issue in court, but in 1972 Judge A. Leon Higginbotham Jr. of the U.S. district court in Philadelphia made an injunction against the NHL, preventing it from

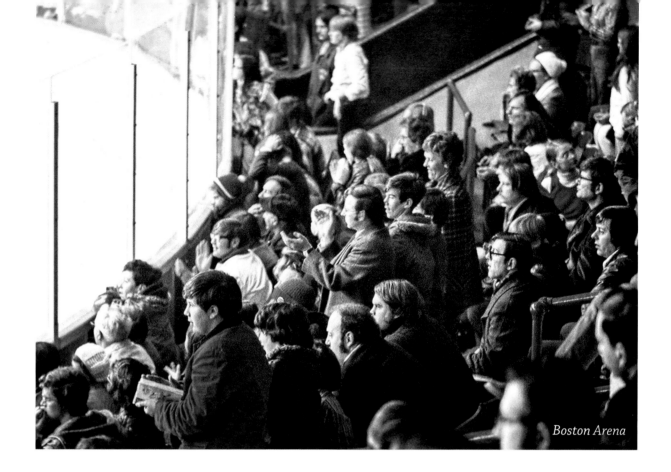
Boston Arena

enforcing the reserve clause and freeing all players who had restraining orders against them. The NHL's monopoly on major league professional hockey talent was over.

Once it was determined that players could sign with the new league, the WHA needed some big names to draw in the fans. Bobby Hull, who was mired in stalled contract talks with the Chicago Black Hawks, said half-jokingly that he would switch leagues for a million dollars. To everyone's surprise, the WHA pooled their assets and made him an offer that he couldn't refuse: a $1 million signing bonus and a 10-year, $2.7 million contract with the Winnipeg Jets—the largest contract in hockey history at the time. Overnight, the WHA had credibility.

It didn't always work out in their favor, however. The Philadelphia Blazers (formerly the Miami Screaming Eagles) made history when they signed Bruins star Derek Sanderson to a five-year, $2.65 million contract that made him the highest-paid professional athlete in the world. Even though they spread out the money over 10 years, it soon became obvious that there was no way they could make good on it. They eventually bought out the contract, and Sanderson returned to Boston after a mere eight games.

Another innovation was selling the naming rights to the league championship trophy, much in the way teams in almost every sport do with their playing venues. The Avco Financial Services Corporation put up $500,000 for the rights, although the trophy itself wasn't ready by the time the New England Whalers won the first Avco Cup in 1973, forcing them to drink from their divisional championship trophy instead. It would be the Whalers' last championship. Quebec would win it once, Houston twice and Winnipeg three times.

Although for the most part games were well-attended, the league was plagued with financial problems. Many franchises would relocate, some more than once, even in mid-season.

The merger with the NHL—perhaps to quell competition, or perhaps the NHL smelled blood in the water—began in 1977. In the end, it was more absorption than merger, as four teams (the Whalers, Jets, Nordiques and Oilers) joined the big league in 1979.

The last WHA game took place on May 20, 1979, when the Winnipeg Jets captured the league championship and the final Avco Cup by defeating the Edmonton Oilers four games to two.

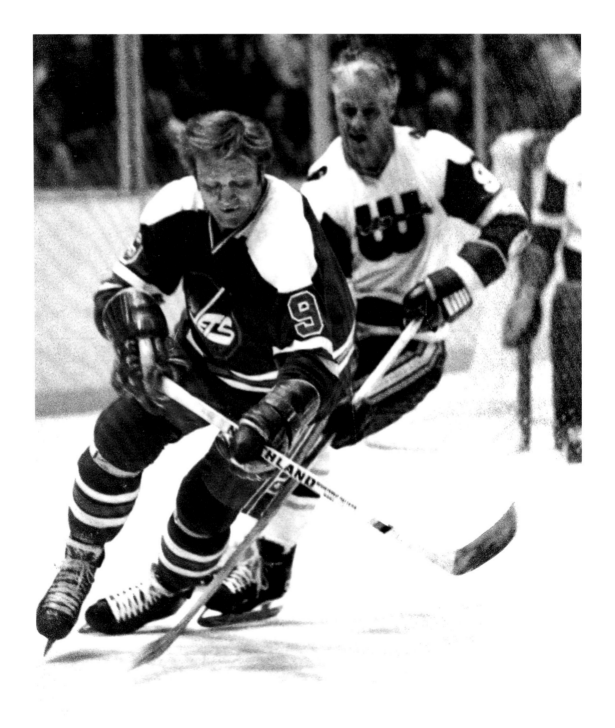

Bobby Hull and Gordie Howe

CHAPTER 2
IN THE BEGINNING

I FIRST BECAME a fan of the game when Bobby Orr came to town with the Oshawa Generals to play an exhibition game at the Garden against the Niagara Falls Flyers on December 5, 1964. At age 12, watching him dominate the game with his skating skills and puck control was amazing. Orr fighting Derek Sanderson at center ice was cool too . . .

As an athlete, my number one sport was baseball. I grew up playing the game and had some skills. I also played lot of street hockey but didn't start skating until the eighth grade. I played high school hockey at Rindge Technical School in Cambridge, MA, where we set the GBI league record of most consecutive varsity losses (44), the streak beginning when I was a freshman and ending my first game as a senior. A knee injury playing hockey and the subsequent surgery cost me my baseball career. However, the link to the game of hockey became stronger for me as we played at the old Boston Arena, home of the Boston Bruins from 1924 until 1928, when Boston Garden opened. The Bruins sometimes practiced at Harvard University's Watson Rink, where the Rindge hockey team would also practice. Skating in Boston Arena, the building where Eddie Shore, Milt Schmidt and Dit Clapper played, and later practicing at the Watson rink, where Bobby Orr, Phil Esposito, Gerry Cheevers and other Bruins players practiced in the morning, ignited my lifetime passion for the game of hockey.

I started going to Bruins games in 1964, when I was 12, with my next-door neighbor. Later when I was in high school and had a primitive camera, I would buy obstructed view seats and capture images to hang on my bedroom wall. In 1971, the Boston Braves, the Bruins AHL farm team, began to play in the Garden, so I bought season tickets to see Terry O'Reilly, Larry Robinson, Dave Schultz and other up-and-coming players. The following year, 1972, the

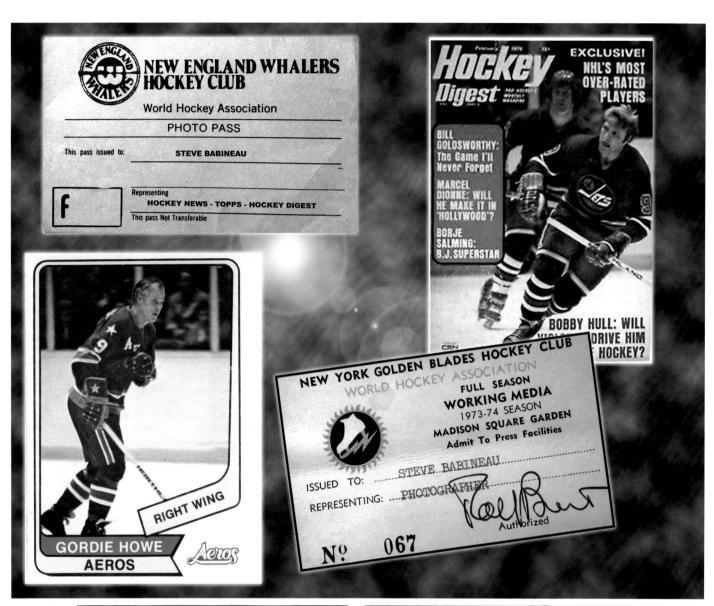

Steve Babineau, 1970s

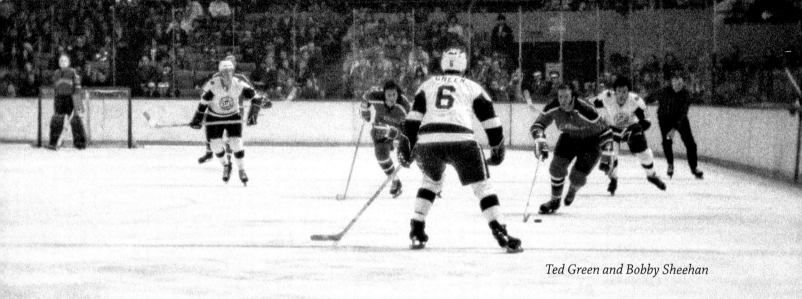

Ted Green and Bobby Sheehan

World Hockey Association was formed and the New England Whalers began playing in the old Boston Garden. So now I had three options. I bought the first seven games to see the Whalers in the WHA, watching former NHL players Ted Green, Bobby Hull, John McKenzie, J.C. Tremblay and others from behind the lens.

"KID, WE DON'T HAVE ANY"

Bryan Campbell and Mike Hyndman

I became an avid reader of the *Hockey News* out of Montreal, as my next-door neighbor would give me paper the after reading it. I noticed that three weeks into the season there were four pages of editorial about the WHA, but no photographs of the players. I asked my mother if I could make a long-distance phone call to the *Hockey News*. When I think back, if Mom had said no, would I be writing this? Anyway, I spoke with editor Charlie Halpin and asked why there were no pictures of the WHA. His response was, "Kid, we don't have any." And then he asked me if I had some. I said yes.

I set up a dark room in the bathroom and printed and shipped some 5"x 7" black-and-white prints. Two or three weeks later, my neighbor gave me his copy of the *Hockey News* and said, "You might want to keep this one." I had two photos in the issue, of Bobby Sheehan and Tim Sheehy, with credit. It was the start of a lifelong journey.

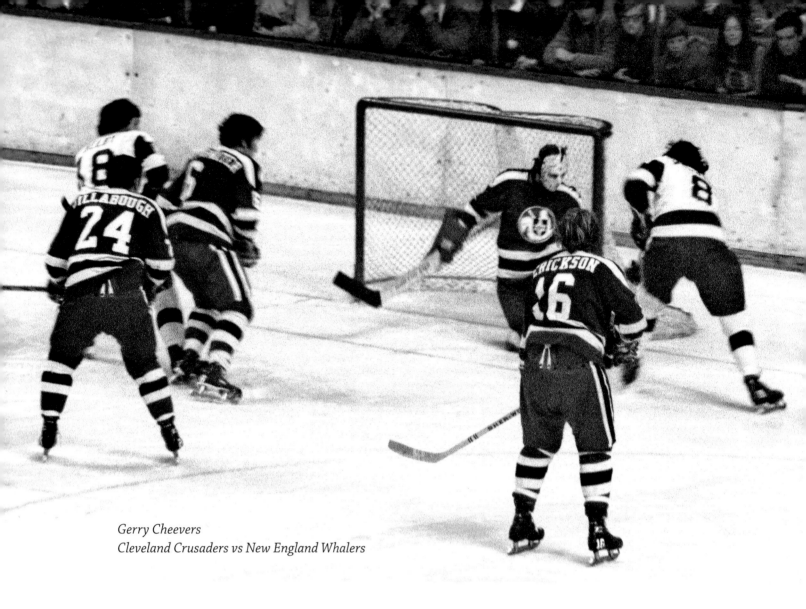

Gerry Cheevers
Cleveland Crusaders vs New England Whalers

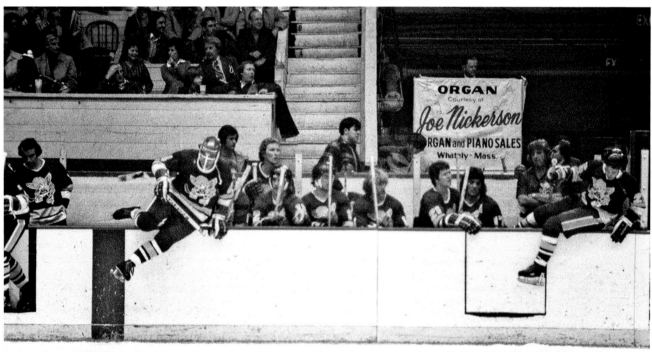

Minnesota Fighting Saints

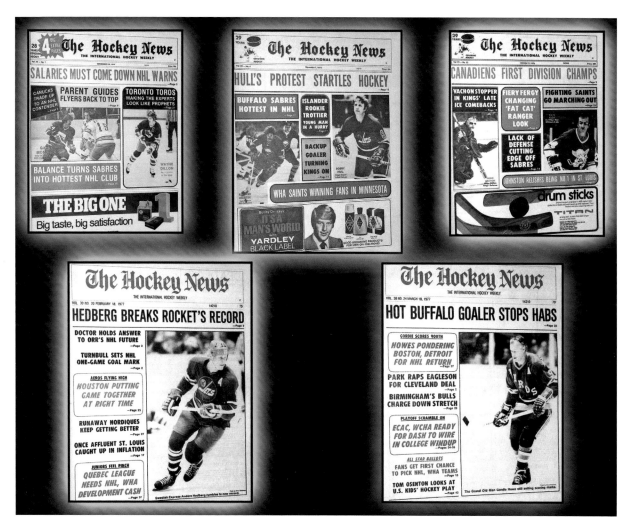

Steve Babineau's early Hockey News *covers and Topps Hockey cards*

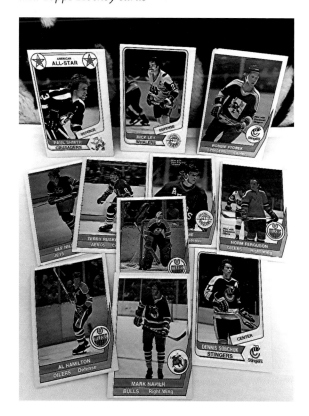

Mr. Halpin called me back and said, "Kid, I'm getting you a season credential to shoot the WHA. That league needs all the publicity they can get . . ." And that's how my career as a professional sports photographer began. The next season I found myself shooting the NHL, also for the *Hockey News*. I continued to photograph the WHA for the life of the league; from 1972 until 1979, I was traveling from the old Boston Garden, to Boston Arena, the Hartford Civic Center and Springfield, MA, and 2022 marks my 50th year photographing the game.

—STEVE BABINEAU

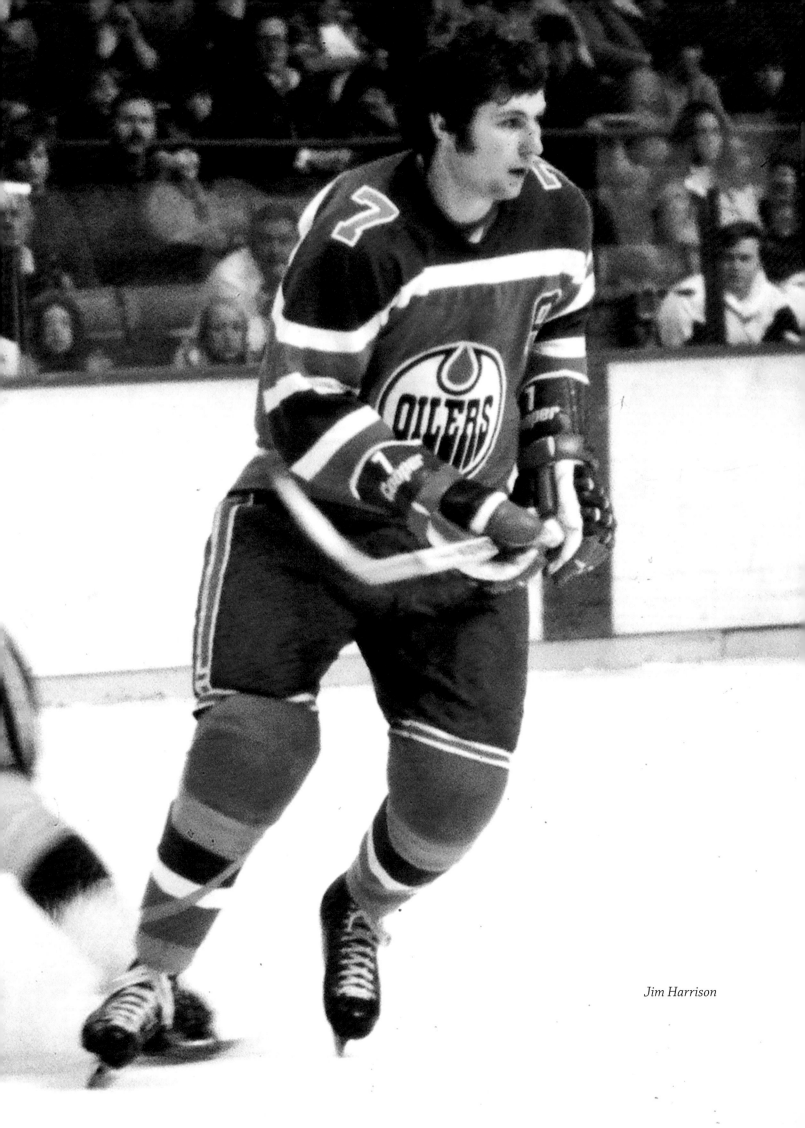

Jim Harrison

CHAPTER 3
FRANCHISES

ALBERTA ('72 – '73) / EDMONTON OILERS ('73 – '79)

Most teams are named to define the city they play in (Houston Aeros, Cleveland Crusaders, Chicago Cougars), some are more regional (New England Whalers, Minnesota Fighting Saints). As a charter member of the WHA, the Edmonton Oilers were originally meant to be a provincial rival of the Calgary Broncos. The Broncos, however, never played a single game, having been relocated to Cleveland following the death of team owner Bob Brownridge. The team was renamed the Alberta Oilers, with the intention of the team splitting games between Edmonton and Calgary. This proved impractical and diluted the fan base rather than increasing it, so the team reverted to the name Edmonton Oilers when it went back to calling that city home.

The man behind the team, William "Wild Bill" Hunter, long-time owner of junior team the

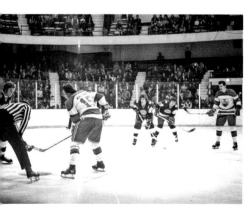
Dennis Kassian and Bernie Blanchette

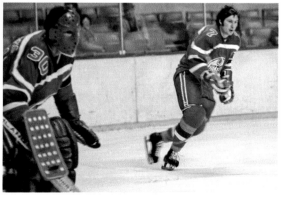
Jack Norris and Jim Harrison

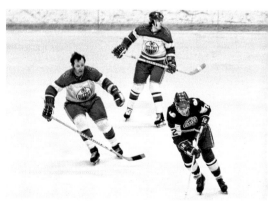
Brian Carlin

Edmonton Oil Kings, was looking to bring big-league hockey to Western Canada. Though very successful, the Oil Kings played in the small and aging Edmonton Gardens, which held only 5,200 spectators. A new arena, The Northlands Coliseum, with its 17,000-plus seating capacity, was under construction and due to open in 1974.

With the financial backing of two local businessmen, Zane Feldman and Dr. Charles Allard, Hunter's new team would have a much stronger financial footing than most of the other proposed WHA organizations. Because of this, the Oilers were able to sign established players such as defensemen Al Hamilton, Ken Baird and Bob Wall, and veteran forwards Jim Harrison and Val Fonteyne.

That season Harrison led the team in scoring with 86 points, which included a 10-point game. Fonteyne added 39. Also in that inaugural season, captain Al Hamilton established himself as a natural leader as well as a proficient scorer. Hamilton would go on to play all seven WHA seasons in Edmonton, where he was their all-time leader in points and games played.

Alberta boasted five 20-goal scorers that first season, including and Ed Joyal with 22, Ron Walters with 28 and Rusty Patenaude, who netted 29. Rusty would go on to score 20 or more goals in all five of his seasons with the Oilers.

They were weak in goal, however, having journeymen Jack Norris and Ken Brown between the pipes. They would finish a disappointing fifth place in the Western Division.

The following season Brian Shaw, a former coach of the junior Oil Kings, was named the new head coach. Remarkably, they finished with the exact same record as their first season, 38-37-3. They made the playoffs for the first time, but they were defeated in the first round by the Minnesota Fighting Saints.

Hunter continued to improve his team, with many young and old (and many overachieving) players. Left wing Ron Climie, acquired from Ottawa, led the team in scoring with 38 goals.

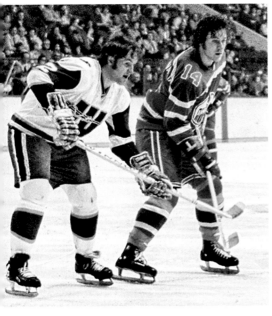 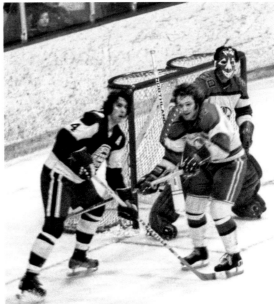 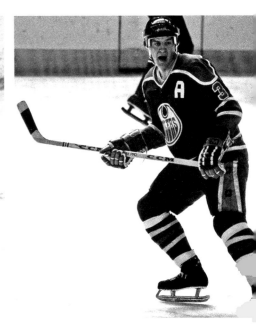

Blair MacDonald and Rick Ley *Rusty Patenaude, Jack Norris and Larry Pleau* *Al Hamilton*

Nineteen-year-old right winger Blair MacDonald scored 21 times in his rookie season. He would go on to play seven years with the club (in both the WHA and NHL) and would have four consecutive 30-goal seasons, including 46 in the Oilers' first season after the NHL merger.

In the 1974–75 season, despite playing to healthy crowds in the new Northlands Coliseum, the Oilers struggled, posting a 36-38-4 record. They finished last in the new Canadian Division and missed the playoffs. Brian Shaw led the team to an acceptable 30-26-3 record but was replaced late in the season by Bill Hunter himself. Wild Bill didn't have much success behind the bench, coaching them out of playoff contention by going 6-12-1 the rest of the way.

In the 1975–76 season, 20-year NHL veteran (and later Hall of Famer) left winger Norm Ullman led the team in scoring. Besides Ullman, right winger Rusty Patenaude had a breakout 42-goal year. A series of poor trades followed. Blair MacDonald, a 21-year-old in his third season, was sold to Indianapolis. Fortunately, he returned to the Oilers two years later. Mike Rogers, in just his second season with the Oilers, was traded by Hunter to New England for the aging Wayne "Swoop" Carleton. Rogers had 300 goals left in his career. Carleton had only five and was out of the league the following season.

Scoring was one thing; another key to success was improving the team defensively. Shoring up their goaltending, the Oilers lured six-time Stanley Cup winner Jacques Plante out of retirement, if only for 31 games in the 1974–75 season. The following year they acquired veteran netminder Dave Dryden from the Chicago Cougars (where he had been a part owner). Best known as Ken Dryden's brother, he'd go on to play his final five seasons in Edmonton in both the WHA and NHL.

By summer 1976, the team was struggling financially. Hunter sold the team to Dr. Charles Allard, who quickly resold it to Nelson Skalbania. In late 1976, Peter Pocklington joined Skalbania as a partner. Under Pocklington's leadership, in the final year of the WHA the team would acquire Wayne Gretzky from the Indianapolis Racers.

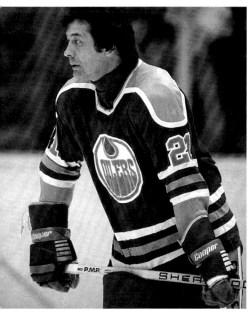

Bryan Campbell

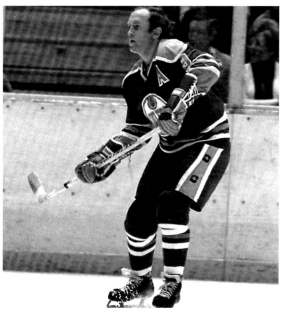

Norm Ferguson

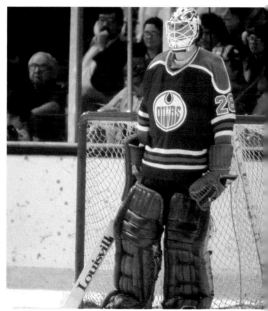

Dave Dryden

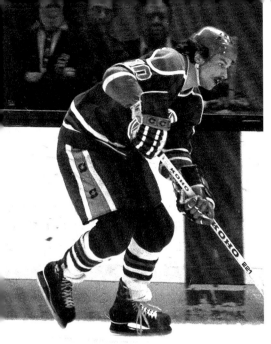

Dennis Sobchuck

Bill Flett

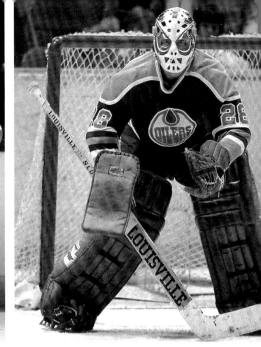

Dave Dryden

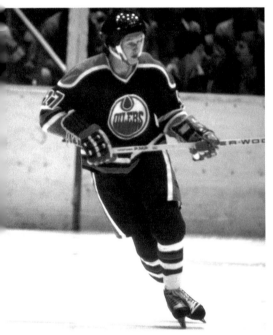

Gary MacGregor

Paul Shmyr and Warren Miller

Brett Callighen

Dave Semenko

Ron Chipperfield

Glen Sather

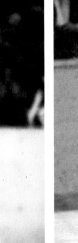

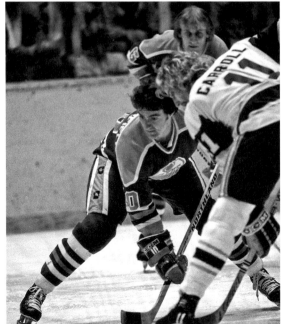

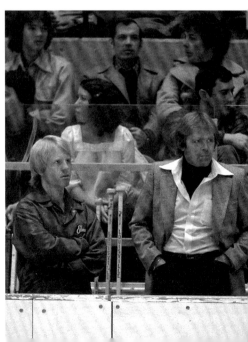

Another key acquisition was the signing of NHL veteran Glen Sather. Sather, who scored a respectable 53 points, was named player-coach of the Oilers with 18 games remaining in the 1976–77 season. After that season he retired as a player to become the full-time head coach. His influence would be far-reaching in Oilers history, especially after the NHL-WHA merger.

In their final WHA season, 1978–79, the Oilers averaged over 11,200 fans per game, the best in the league, and finished first with 98 points (48-30-2).

Despite the ups and downs of the WHA era, the Oilers had proven themselves to the city of Edmonton and the province of Alberta, and their loyal fans would be rewarded. Their team became one of four to survive the NHL-WHA merger and reemerged as a new and very successful entry into the National Hockey League.

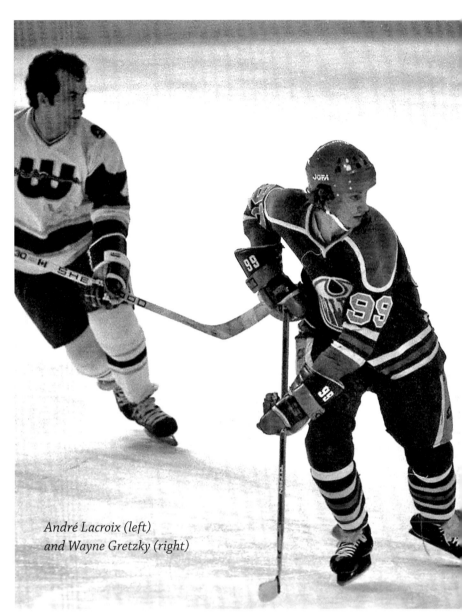

André Lacroix (left)
and Wayne Gretzky (right)

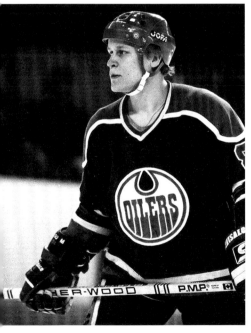

Risto Siltanen

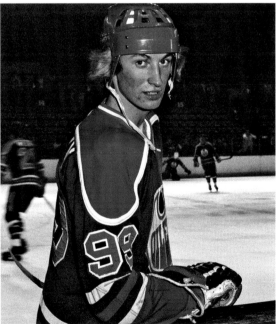

Wayne Gretzky

Wayne Gretzky

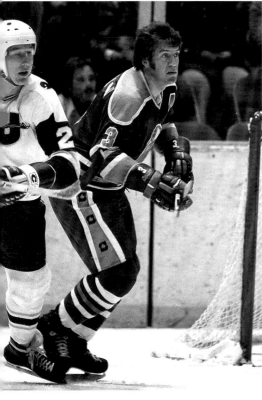

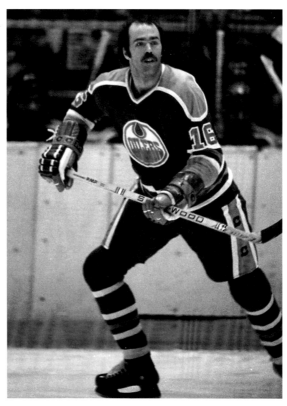

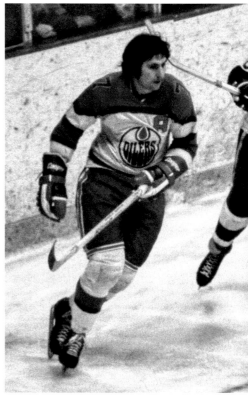

Al Hamilton: 455 games, 53 goals, 258 assists and 311 points.

Pierre Guite: 72 games, 13 goals, 22 assists and 35 points.

Jim Harrison: 113 games, 63 goals, 92 assists and 155 points.

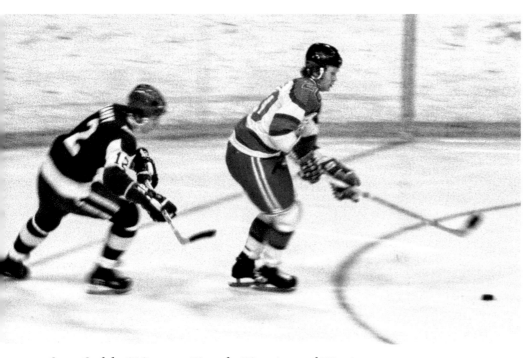

Steve Carlyle: 218 games, 11 goals, 59 assists and 70 points.

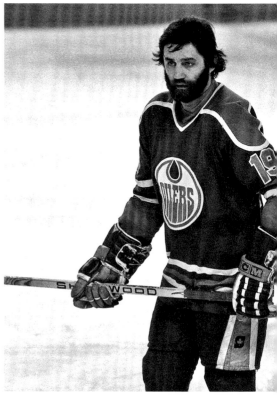

Bill Flett: 195 games, 103 goals, 84 assists and 187 points.

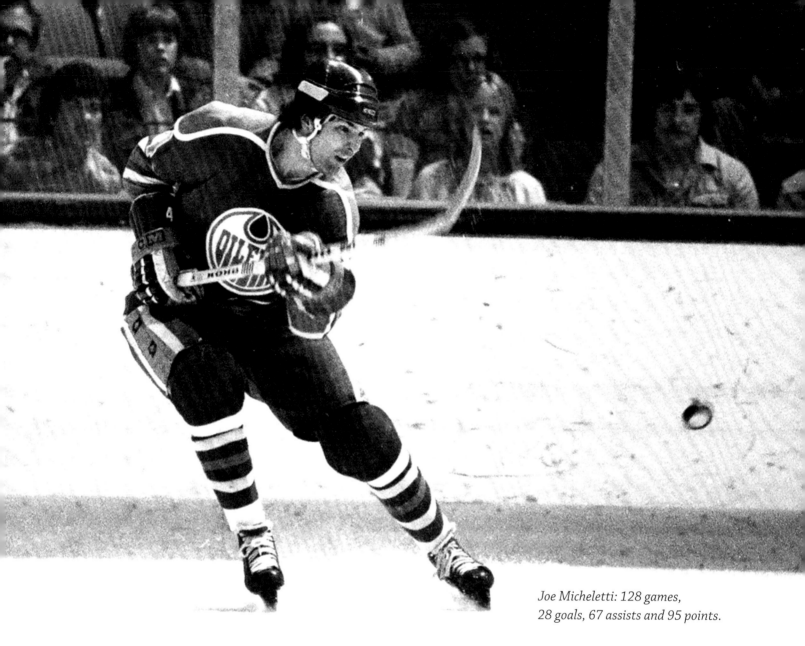

Joe Micheletti: 128 games,
28 goals, 67 assists and 95 points.

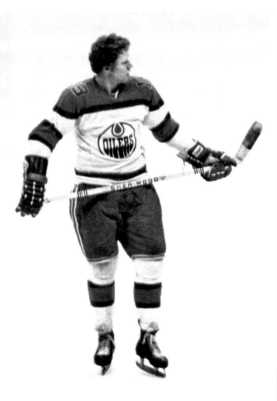

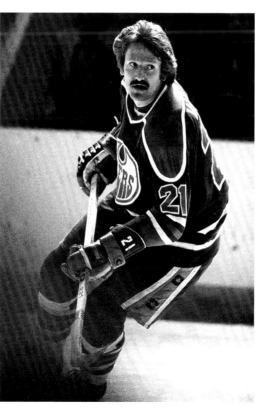

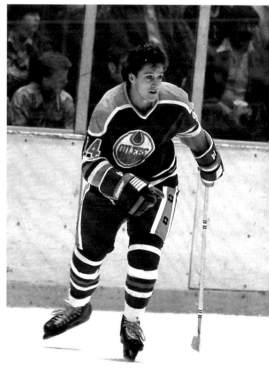

Ken Baird: 276 games, 77 goals,
92 assists and 169 points.

Stan Weir: 68 games, 31 goals,
30 assists and 61 points.

Blair MacDonald: 339 games, 118 goals,
124 assists and 242 points.

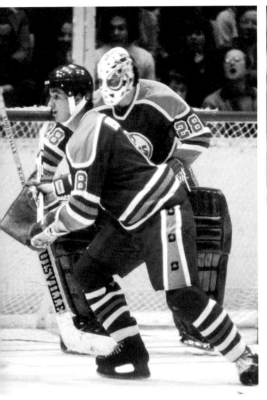

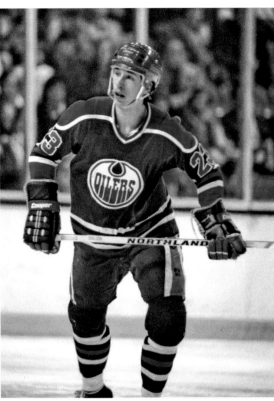

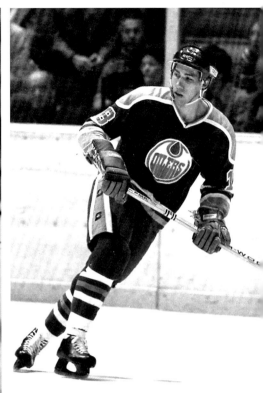

Ron Busnick: 88 games, 4 goals, 20 assists and 24 points.

Steve Carlson: 73 games, 18 goals, 22 assists and 40 points.

Brett Callighen: 180 games, 60 goals, 85 assists and 145 points.

Paul Shmyr: 160 games, 17 goals, 79 assists and 96 points.

John Hughes: 41 games, 2 goals, 15 assists and 17 points.

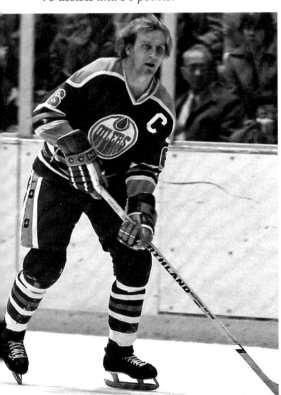

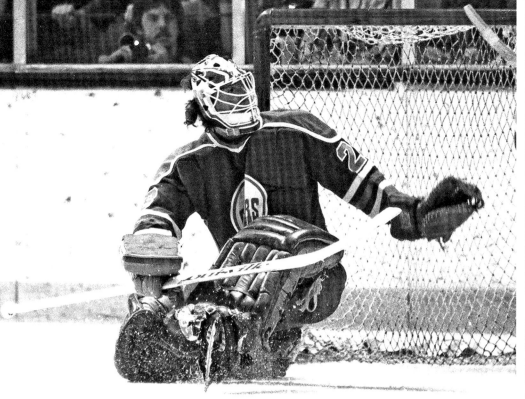

Dave Dryden: 197 games, 94 wins and 87 losses.

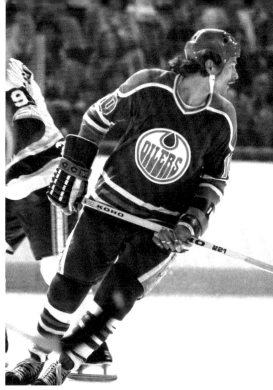

Dennis Sobchuck: 87 games, 32 goals, 40 assists and 72 points.

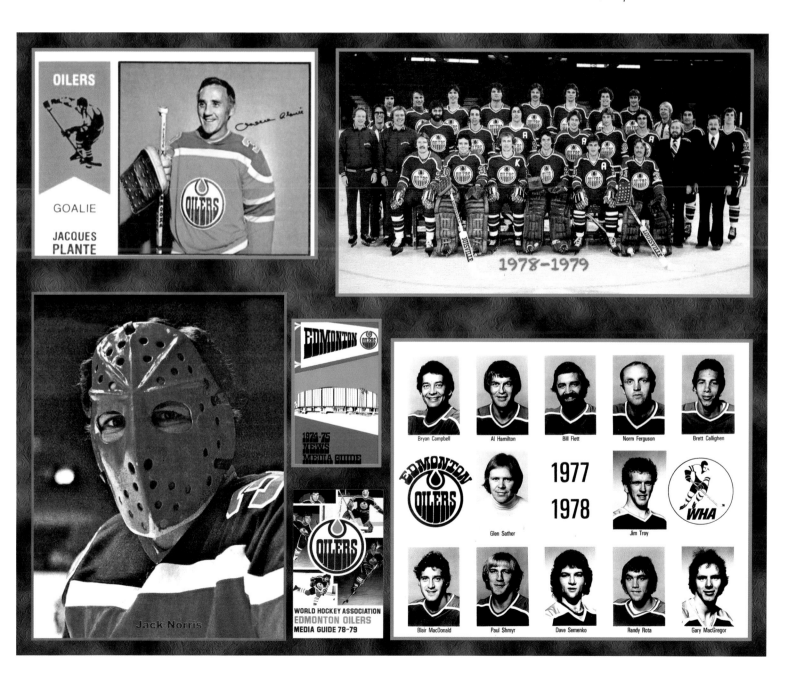

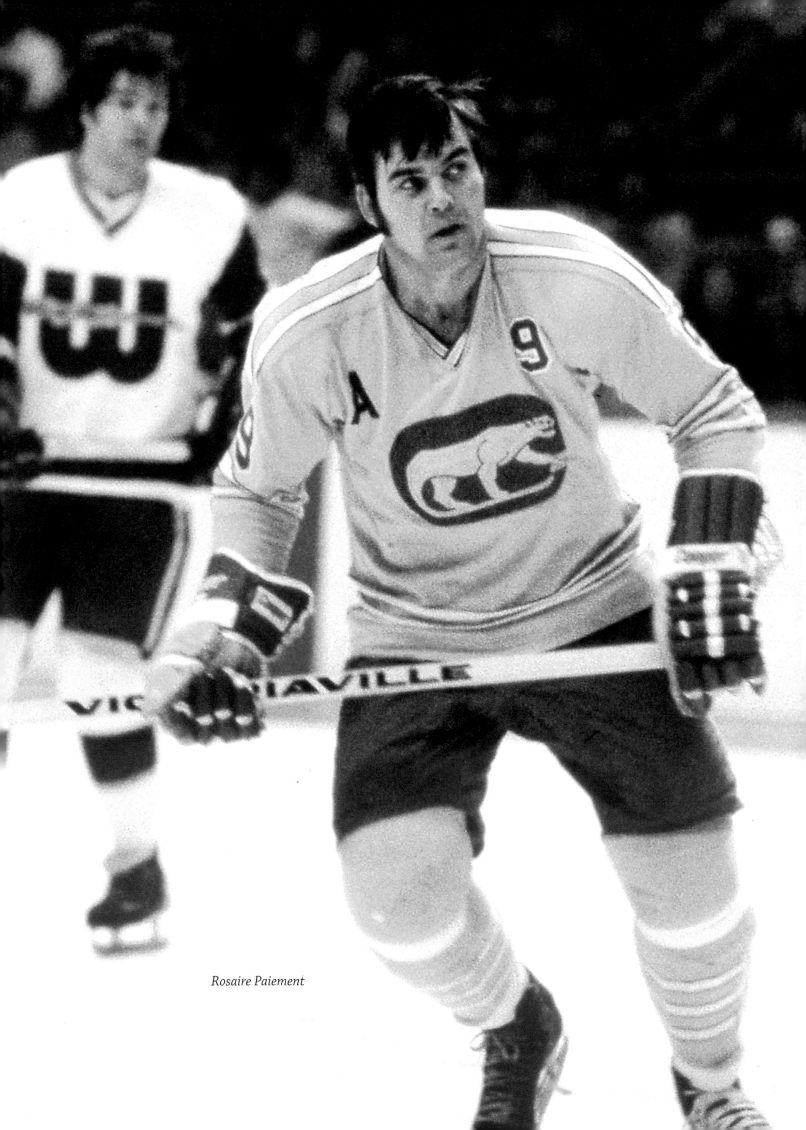

Rosaire Paiement

CHICAGO COUGARS ('72–'75)

In general, one could divide the new WHA franchises into two categories: teams in established NHL cities (New York, Boston, Philadelphia, Chicago) designed to compete in a ready-made hockey market and teams in potential markets that were ripe for major league hockey (Cincinnati, Quebec, Winnipeg, Ottawa).

Chicago businessmen Jordon and Walter Kaiser saw an opportunity in Chicago for a team to rival the NHL Black Hawks. The Original Six powerhouse hadn't won a Stanley Cup since 1961; fans would have to wait until 2010 for another one, long after the Cougars and the WHA were a distant memory, but they remained loyal to their team.

Like many WHA team owners, while the Kaisers were successful in business they had little or no experience in running a hockey team and the expenses involved.

Although a charter WHA franchise, the Cougars were beset by problems right from the start. In 1972 they took to the ice in their distinctive green and gold uniforms at the International Amphitheatre, a small Chicago venue with a seating capacity of about 9,000. Due to their inability to sign any big-name players, or even many of major league caliber, they finished with a dismal 26 wins to earn a last-place spot in the Western Division and last overall in the league standings. They would never play before a home team crowd of 5,000 spectators.

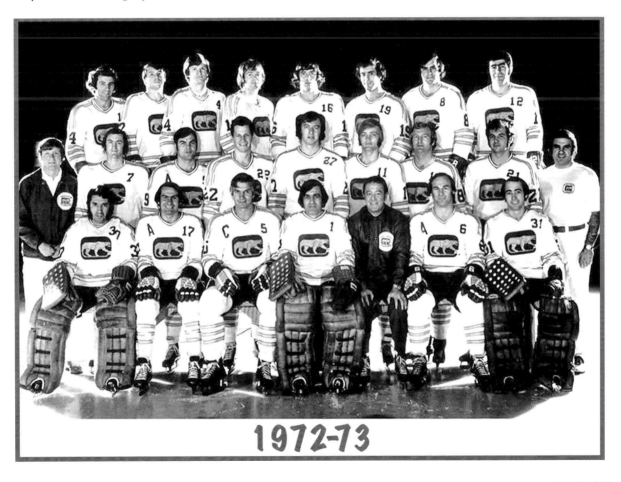

1972-73

One major problem was their home rink. The Cougars planned to play in the new Rosemont Horizon arena, but it didn't open until 1980, five years after the team folded. Barely able to afford talent, the Cougars were unable to secure the funding needed for a major league venue. Instead they continued to play most of their home games in the International Amphitheatre, with some played at the Randhurst Ice Arena, an even smaller rink.

One ambitious plan was to raid the Black Hawks for talent, but they were able to sign only a handful of mostly minor-leaguers. The following season they began recruiting in earnest, eventually signing familiar names such as former Montreal stalwart Ralph Backstrom, popular Black Hawks veterans Pat Stapleton and Eric Nesterenko, as well as up-and-comer Darryl Maggs and veteran Rosaire Paiement.

The well-traveled Backstrom brought maturity and experience to the team. Already a 15-year NHL veteran with six Stanley Cups and a Calder Trophy under his belt, Backstrom had been traded to the Black Hawks after stints in Montreal and Los Angeles but jumped to the new league in the Cougars' second season, 1973–74.

Also arriving that year was Black Hawks fan favorite Pat "Whitey" Stapleton. Stapleton had played 10 years in the NHL, eight as a Black Hawk. He was soon joined by Eric Nesterenko, a hard-hitting veteran of Chicago's 1961 Stanley Cup championship team.

Darryl Maggs was a promising junior player who was drafted by the Black Hawks. After a year in the minors with the Dallas Black Hawks, Maggs made the parent club in 1971–72. The next season he was traded to the California Golden Seals, a far less desirable team, so in 1973 Maggs jumped to the Cougars. He would go on to play five years in the league with four different teams, never returning to the NHL.

Darryl Maggs and Ralph Backstrom

Ralph Backstrom

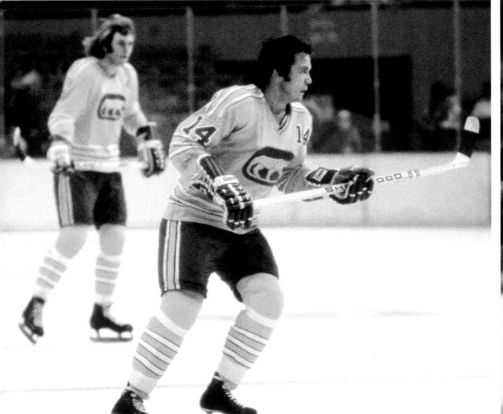

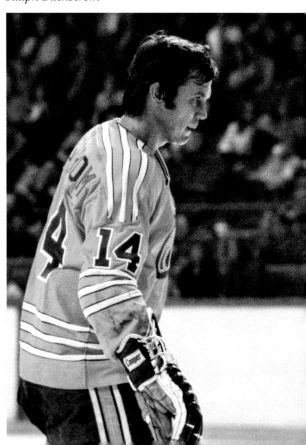

Pat Stapleton

Darryl Maggs

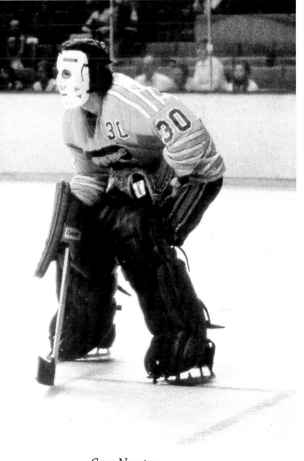

Cam Newton

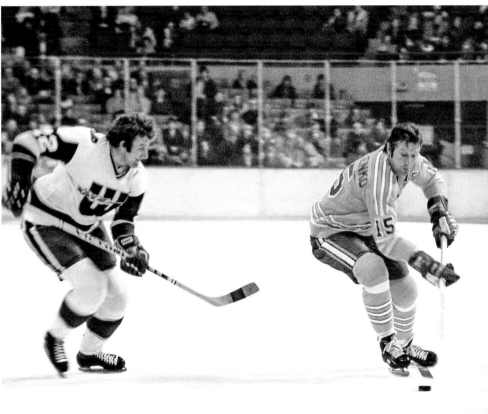

Eric Nesterenko

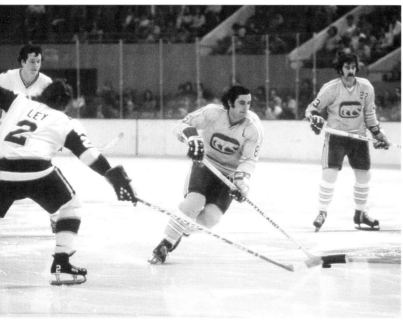

Rod Zaine and Peter Mara

Reg Fleming

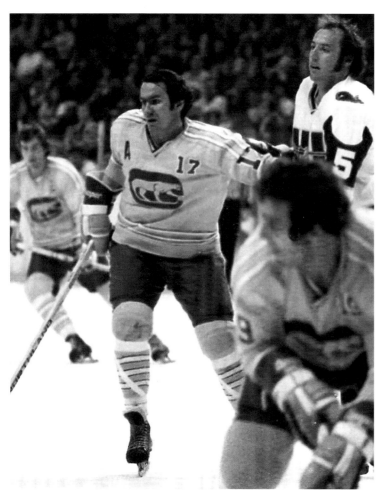

Bob Sicinski

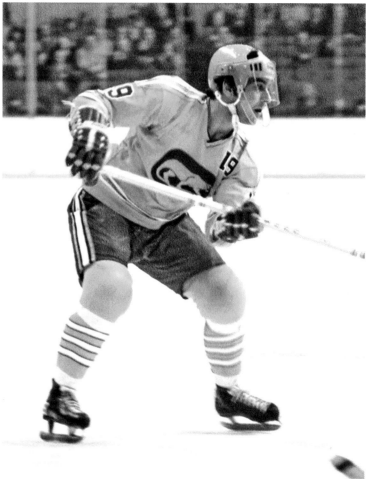

Jan Popiel

Rosaire Paiement enjoyed success in Philadelphia with the Flyers, but after being chosen by Vancouver in the 1970 expansion draft, signed with the Cougars after two seasons. Paiement had 33 goals, 69 points and 135 penalty minutes in his first WHA campaign. Overall, he would put up 216 points in his time with the Cougars, racking up 319 penalty minutes along the way.

Despite a fourth place finish in 1973–74 the Cougars went to the playoffs, even defeating New England and Toronto to go to the final against the Houston Aeros, who swept the series in four games.

By their last season, 1974–75, things were looking better, on paper anyway. But the Cougars played to dwindling crowds, often fewer than 4,000 fans. After losing money because of poor attendance and increasing costs, in December the Kaiser brothers, in an unprecedented move, sold the team to a consortium that included Ralph Backstrom, Dave Dryden (who had been signed in that last season to shore up the team's weak link, goaltending) and Pat Stapleton. It would become the first professional franchise to be owned by the players.

Even so, the end was nigh. At the close of the 1974–75 season the team ceased operations. Many of the players' contracts were transferred to the new Denver Spurs—so many that some saw the Spurs as a continuation of the Cougars, not an expansion team. It was the end of what seemed to be a promising WHA franchise competing in a major NHL market.

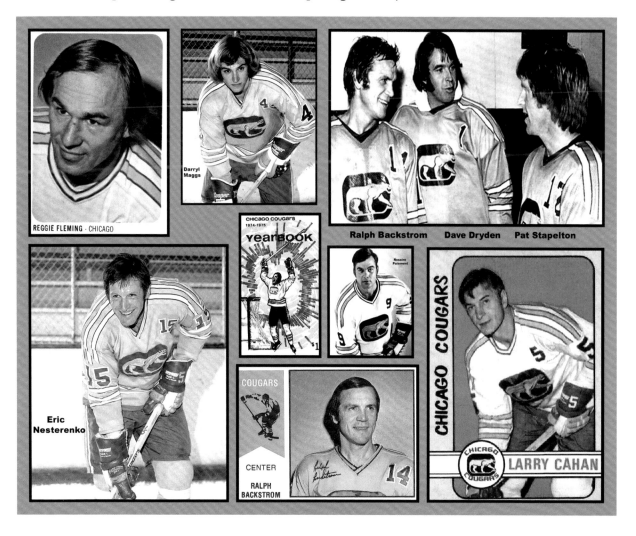

REGGIE FLEMING · CHICAGO

Darryl Maggs

Ralph Backstrom Dave Dryden Pat Stapelton

CHICAGO COUGARS 1974-1975 yearbook $1

Rosaire Paiement

Eric Nesterenko

COUGARS CENTER RALPH BACKSTROM

CHICAGO COUGARS LARRY CAHAN

Rod Zaine: 220 games, 9 goals, 25 assists and 44 points.

Darryl Maggs: 150 games, 14 goals, 49 assists and 63 points.

Jan Popiel: 199 games, 71 goals, 73 assists and 144 points.

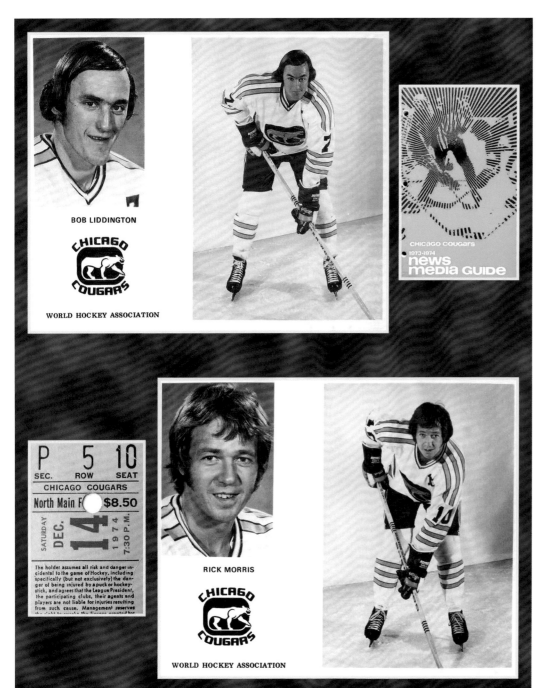

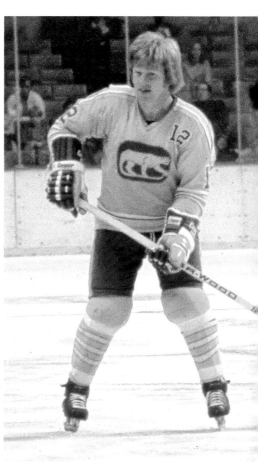

Pat Stapleton: 146 games, 10 goals, 82 assists and 92 points.

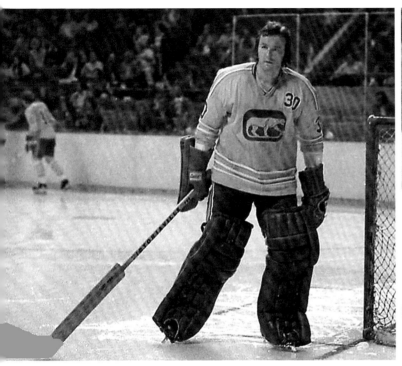

Cam Newton: 77 games, 37 wins and 38 losses.

Rosaire Paiement: 234 games, 89 goals, 127 assists and 216 points.

Reg Fleming: 119 games, 25 goals, 57 assists and 82 points.

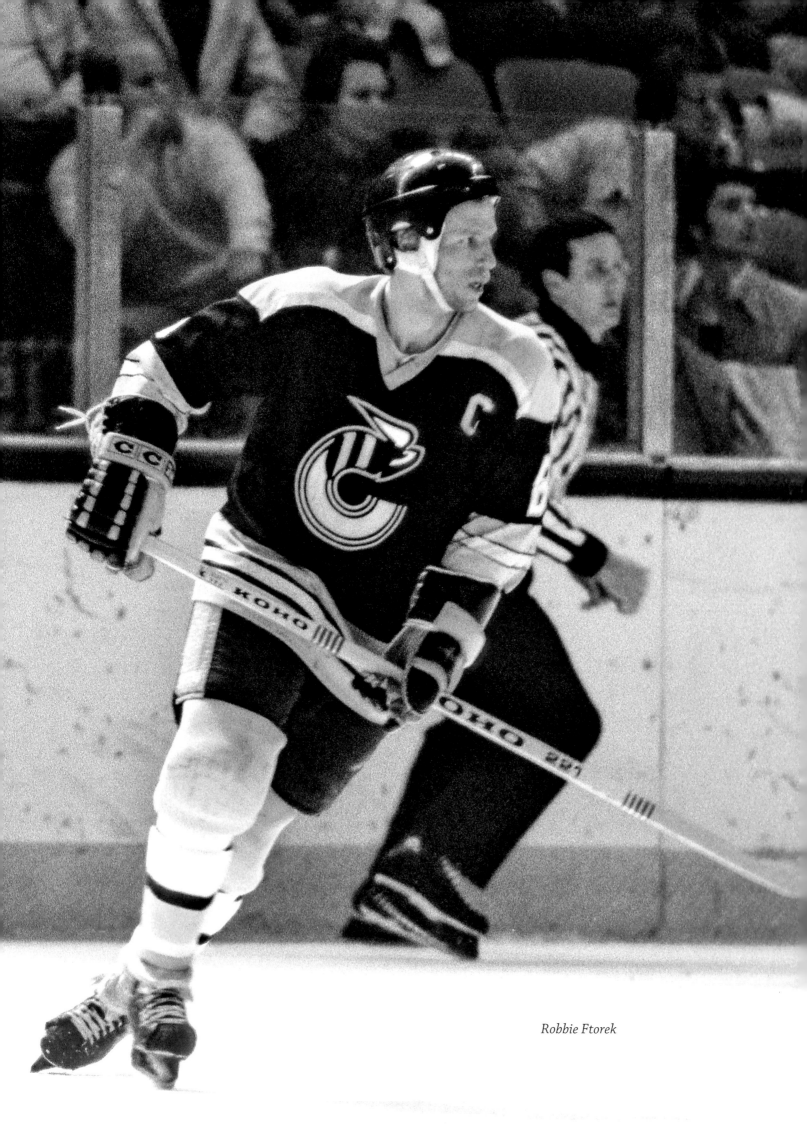

Robbie Ftorek

CINCINNATI STINGERS ('75–'79)

1975 saw the advent of major league hockey in the Queen City. The expansion team, called the Stingers, played in the new Riverfront Coliseum from 1975 to 1979, making them one of the few WHA franchises to play in a 15,000-seat-or-larger arena.

They came into the WHA in a roundabout way. Owners Bill DeWitt Jr. and Brian Heekin originally petitioned the NHL for a franchise for Cincinnati, which they saw as having major league potential, with franchises in baseball, football and, until 1972, basketball. When that failed, they accepted the first expansion franchise awarded by the fledgling WHA in May 1973. They would not play until 1975, as DeWitt and Heekin worked arduously to build Riverfront Coliseum. The arena finally opened in September 1975 with the Stingers as its primary tenant.

While popular with the fans, as they had no NHL franchise to compete with, in their first season the team finished last in the Eastern Division, winning 35, losing 44 and tying 1. In all the team's history (1975–79) they failed to attain a winning record, usually finishing near the bottom of the league standings. This was in spite of having such fledgling talent as future Hall of Famers (and then teenagers) Mike Gartner and Mark Messier as well as established players like goaltender Mike Liut and forwards Robbie Ftorek, Dave Forbes and Rick Dudley. They would make the playoffs twice in their four-year history, being eliminated before the final both times.

The most famous of these players, Messier, began his career with the Indianapolis Racers. The cash-strapped Racers had traded Wayne Gretzky to Edmonton in November 1978, so in an effort to fill the hole left in their roster, signed Messier. His debut was less than impressive; he failed to put up any points in the five games he played there. He signed with the Stingers as a free agent after the Indianapolis team folded but would go on to an impressive career in the NHL, playing on four Stanley Cup championship teams with Edmonton.

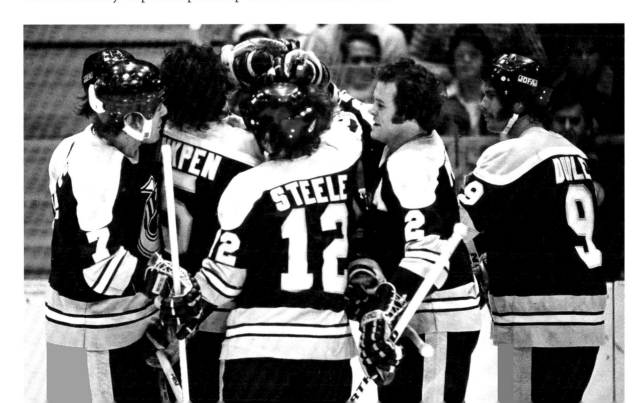

Rick Dudley

Jamie Hislop

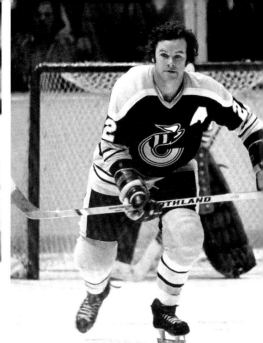

Ron Plumb

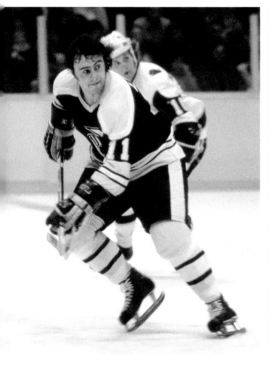

Jacques Locas

Dennis Sobchuk

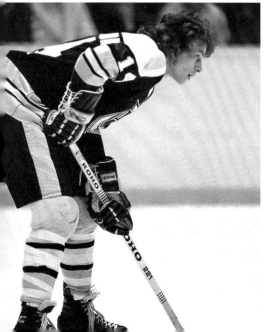

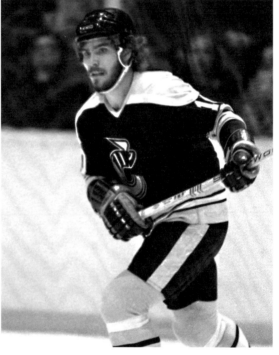

John Hughes

Peter Marsh

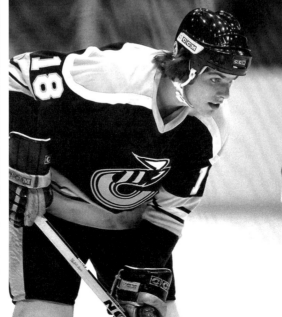

Rich LeDuc

Blaine Stoughton

The Stingers scored a major coup when they signed WHA MVP Robbie Ftorek after the Phoenix Roadrunners disbanded in 1977. Ftorek was never really given a chance in the NHL, so after two seasons with Detroit he moved to the WHA's Phoenix Roadrunners in 1974. He quickly became the Roadrunners' biggest star and cemented his legacy as one of the most accomplished American players of the 1970s. Ftorek played parts of three seasons in Phoenix, and when the Roadrunners franchise folded, he signed with the Stingers. He played there until the WHA ceased operation after the 1978–79 season, then returned to the NHL to play for the Quebec Nordiques and New York Rangers.

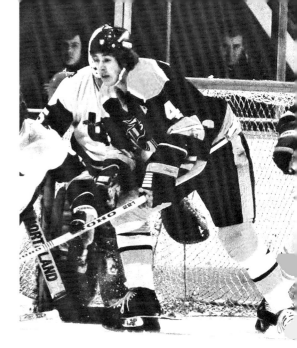

Barry Melrose

Rick Dudley was another bright spot. Beginning in 1972, he played three seasons with the Buffalo Sabres before switching leagues in 1975. He played four seasons with the Stingers. On February 4, 1979, he was "traded" back to the Sabres, on the condition that they pay the remainder of his contract.

Like many well-traveled players, Blaine Stoughton found some measure of success in the WHA. He played for 12 teams in his major league career, including two seasons with Cincinnati.

Ron Plumb would also play the bulk of his eight-year career in the WHA (seven seasons). His total of 549 career games in the league is second only to the 551 games played by André Lacroix.

In 1978 the team had the dubious honor of setting attendance records three months apart: the smallest crowd (4,408 in a January 5–3 win against the Aeros) and the largest crowd (13,951 in a March 2–0 win over Edmonton).

Still, they lasted until the NHL-WHA merger, no mean feat given the transient nature and financial situations of many WHA franchises. Six WHA teams (the Nordiques, Whalers, Jets, Bulls, Stingers and Oilers) remained. The Stingers, along with the Bulls, were paid to disband and were not part of the merger.

Dave Inkpen *Mike Gartner* *Paul Hoganson*

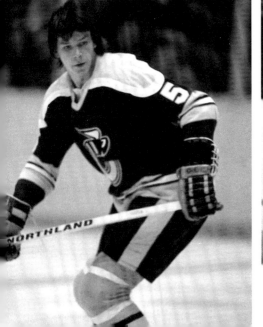
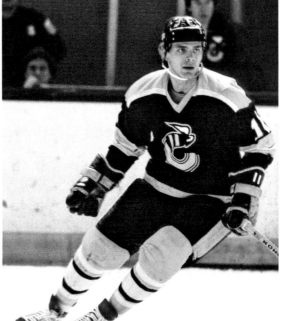
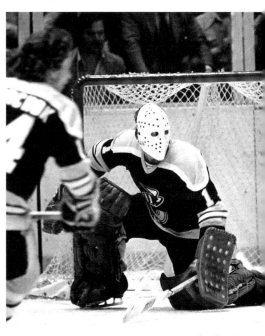

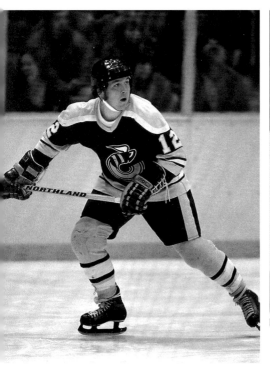

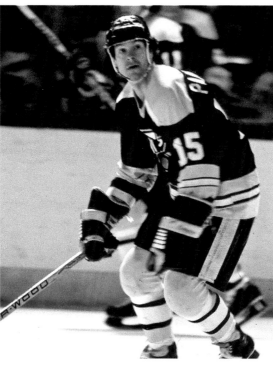

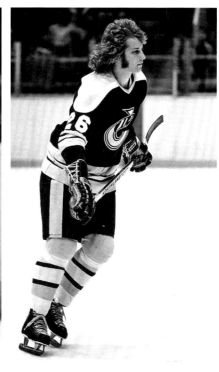

Dave Debol: 78 games, 21 goals, 37 assists and 58 points.

Michel Parizeau: 30 games, 3 goals, 9 assists and 12 points.

Greg Carroll: 103 games, 21 goals, 52 assists and 73 points.

Dennis Sobchuk: 183 games, 81 goals, 101 assists and 182 points.

Rich LeDuc: 135 games, 79 goals, 86 assists and 165 points.

Dave Inkpin: 128 games, 7 goals, 38 assists and 45 points.

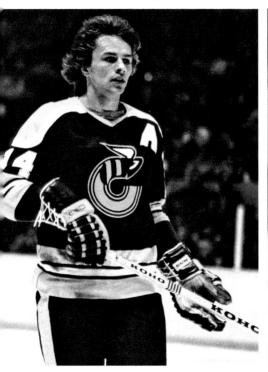

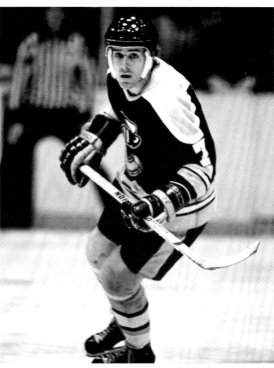

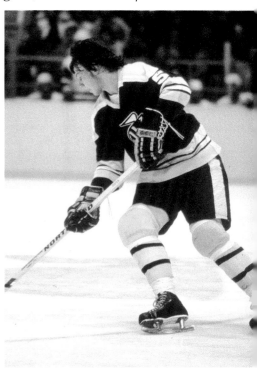

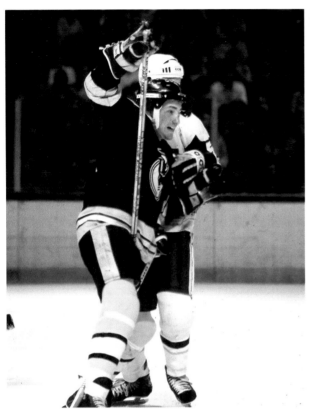

Reg Thomas: 98 games,
36 goals, 41 assists
and 77 points.

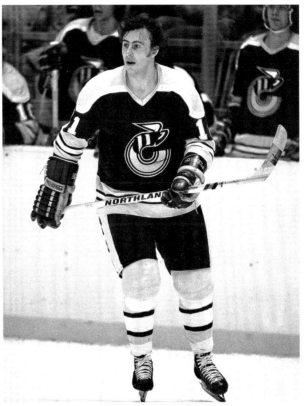

Jacques Locas: 142 games,
45 goals, 61 assists and
106 points.

Rick Dudley: 270 games, 131 goals,
146 assists and 277 points.

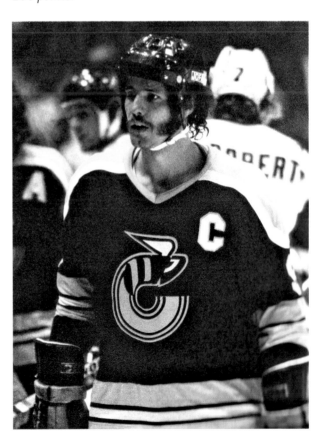

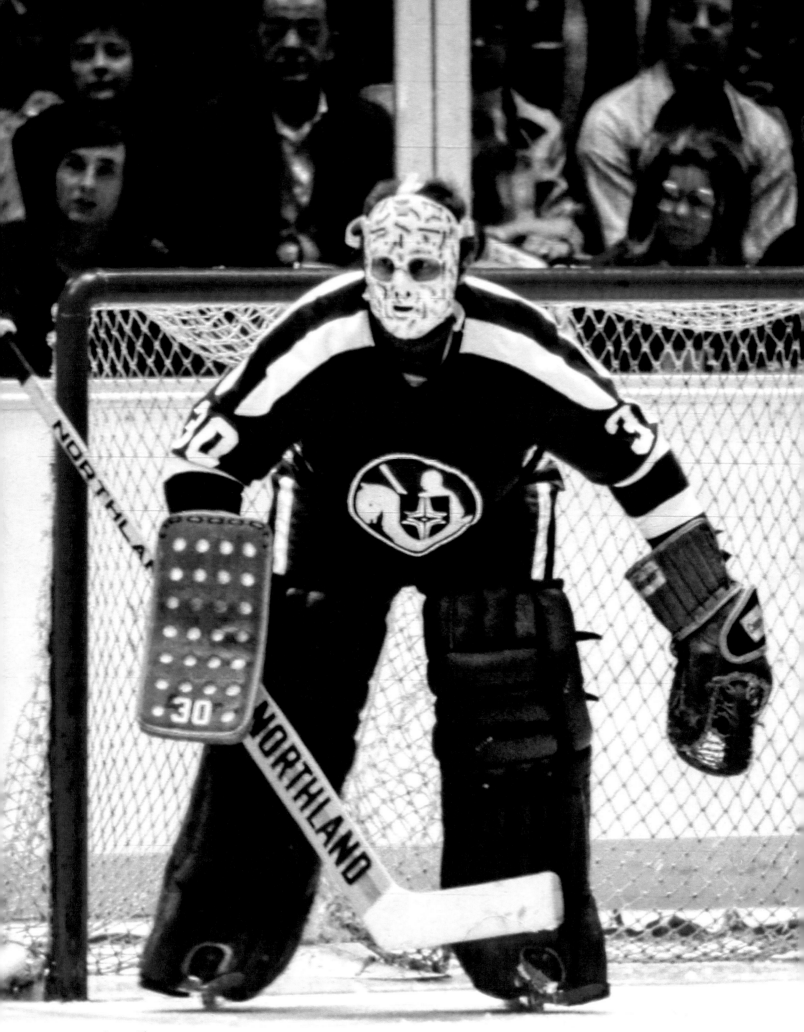

Gerry Cheevers

CLEVELAND CRUSADERS ('72–'76) / MINNESOTA FIGHTING SAINTS ('76–'77)

The Crusaders were originally the Calgary Broncos, but never played a game out west. Seen as a potential provincial rival for the Edmonton Oilers, the Broncos chose Barry Gibbs, Jim Harrison, Dale Hoganson and Jack Norris in the first WHA draft (1971). But when team owner Bob Brownridge took ill and died, Nick Mileti stepped in and set his sights on Cleveland, bringing many Broncos players with him.

Mileti was something of a legend in Cleveland sporting circles as the owner of (or having controlling interest in) the Cavaliers of the NBA, the Cleveland Indians baseball club, the Cleveland Barons of the AHL, and the Richfield Coliseum. The team became the Crusaders and began play in 1972, first in the old Cleveland Arena and later in the new and much-improved Richfield Coliseum.

Cleveland had a long history of winning hockey with the AHL Barons. Between 1937 and 1973 they won 10 division titles and nine Calder Cups as league champions. Crusaders owner Nick Mileti had such confidence in the new team that he moved the AHL Barons to Florida.

Barons mainstay Bill Needham was named coach. With a mix of young players and old hands such as Al McDonough, Gerry Pinder, Jim Harrison, Paul Shmyr, Rich LeDuc and Skip Krake, Needham led the club to the playoffs in his two-year tenure behind the bench. Attendance was good, but they still needed a marquee name. That came in Gerry Cheevers.

cleveland crusaders
1972-1973

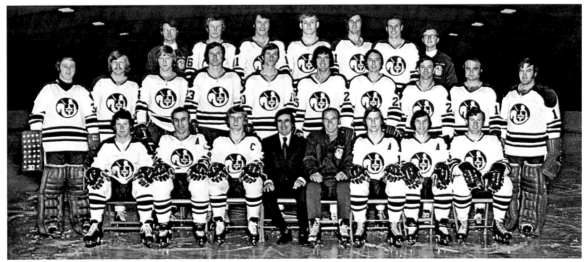

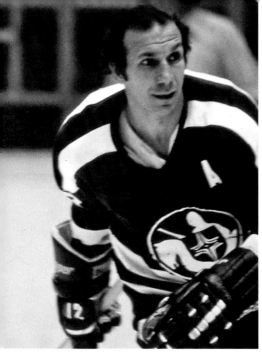

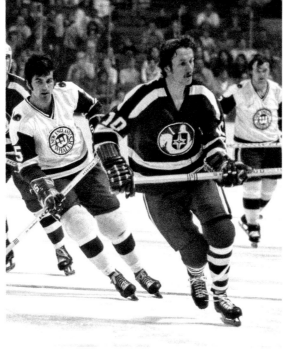

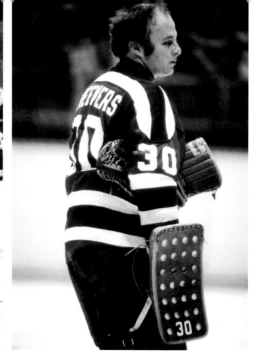

Gary Jarrett

Ron Buchanan

Gerry Cheevers

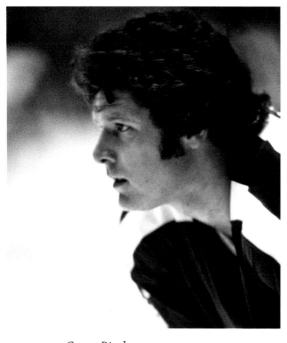

Gerry Pinder

Cheevers was coming off two Stanley Cup championships in Boston and was considered one of the best in the game. He signed a then unheard of seven-year contract that paid $200,000 per season to become a Crusader.

Al McDonough was a journeyman right winger who played 237 games in the NHL and 200 games in the WHA. He joined the Crusaders for the 1974–75 season after playing for the Los Angeles Kings, Pittsburgh Penguins and Atlanta Flames. Having better success in the WHA, McDonough scored 64 points in 1974–75. He spent two more seasons with the franchise, including after its move to become the Minnesota Fighting Saints. After three seasons in the WHA he returned briefly to the NHL with Detroit in 1977 and retired in 1978.

Paul Shmyr and Kevin Ahearn

Jim Harrison

Jim Wiste

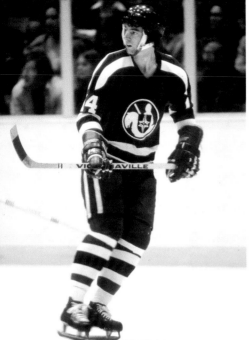

Al McDonough

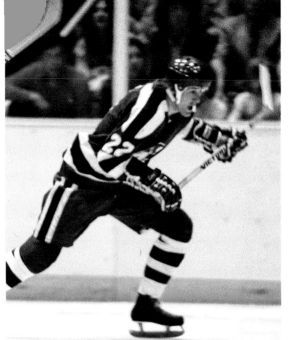

Rich LeDuc

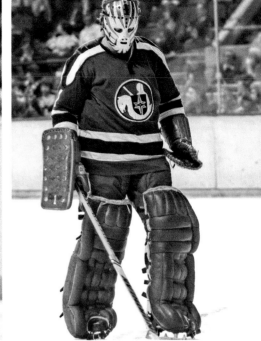

Bob Whidden

Paul Shmyr was one of the top defensive stars in the short history of the WHA, noted for his hard-nosed play, having jumped from the NHL's California Golden Seals to the upstart Crusaders. He spent four seasons with Cleveland, garnering the league's top defenseman trophy in 1976. He subsequently played for the WHA's San Diego Mariners, where he enjoyed his best offensive campaign, and played two years for the Edmonton Oilers, captaining the club to a regular-season league championship in the WHA's final season.

Having represented Canada at the 1968 Winter Olympics and the 1969 World Championships, Gerry Pinder was drafted by the Black Hawks, where he played two seasons before being traded to the California Golden

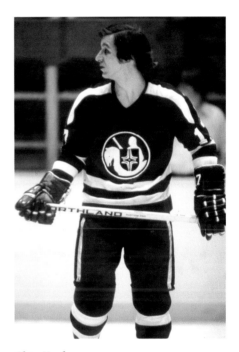

Skip Krake

Ralph Hopiavouri

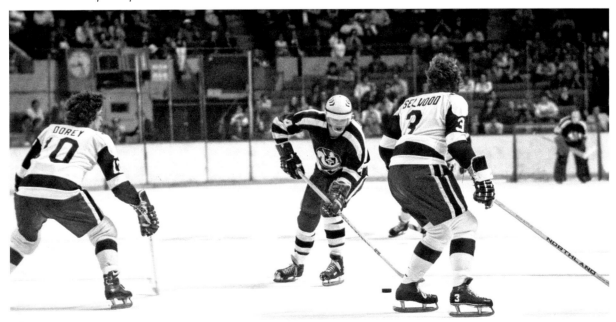

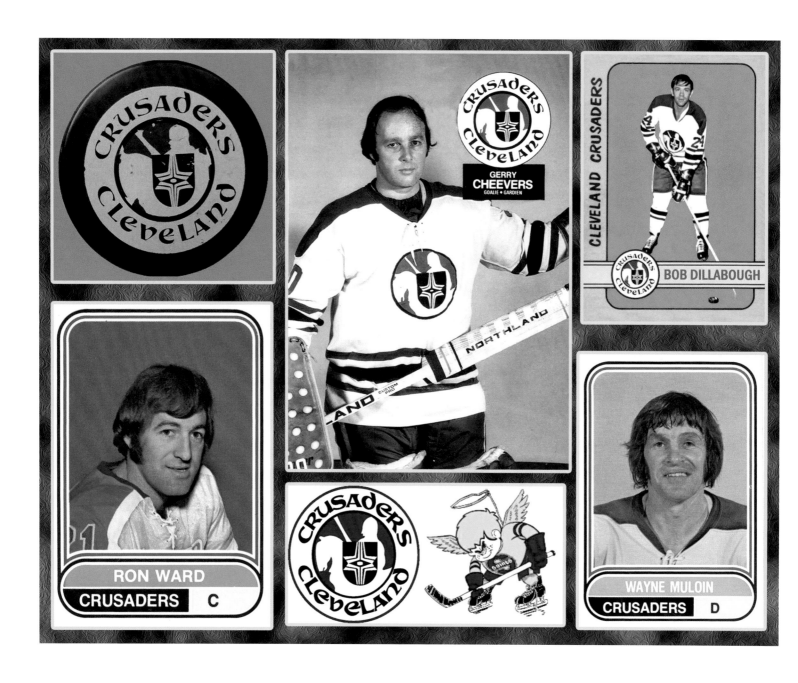

Seals. While he put up good numbers on the West Coast, he decided to jump to the WHA, joining the Crusaders in 1972. He would stay with Cleveland for four seasons before being traded to the San Diego Mariners in fall 1976. His time there was brief, as the team folded at the end of that season. He then signed as a free agent with Edmonton in June 1977, where he played only five games before retiring.

After two uneventful seasons in Boston, Richie LeDuc signed with Cleveland in 1974, where he put up good numbers over the next two years: 71 goals and 53 assists for 124 points. He would later play for Cincinnati, Indianapolis and Quebec before a brief return to the NHL after the Nordiques were part of the league mergers in 1979.

Originally a member of the Bruins organization, Skip Krake bounced between the majors and

the minors with Boston, Los Angeles and Buffalo before trying his luck with the WHA in 1972. He played three seasons in Cleveland before being traded to Edmonton in 1975. He would spend one season there, 1975–76, his last in the major leagues.

Although he didn't become a regular player until his third season in the NHL, Gary Jarrett had seven years of NHL experience under his belt when he joined the Crusaders in 1972. He would play the last four years of his career with Cleveland.

Ron Buchanan's junior hockey career was with the Oshawa Generals, skating for teams that included Bobby Orr and Wayne Cashman. He had a cup of coffee in the NHL with Boston and St. Louis (five games with no points scored) before moving to the WHA. He played four years with Cleveland, Indianapolis and Edmonton before retiring in 1976.

While the Crusaders never won a championship, they made the playoffs every year and attendance was good. But when the NHL moved the struggling California Golden Seals to Cleveland

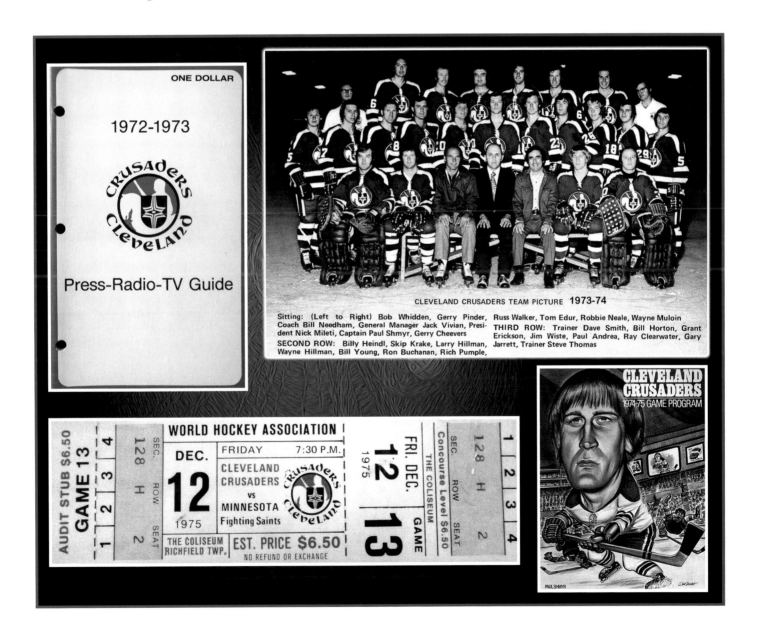

CLEVELAND CRUSADERS TEAM PICTURE **1973-74**

Sitting: (Left to Right) Bob Whidden, Gerry Pinder, Coach Bill Needham, General Manager Jack Vivian, President Nick Mileti, Captain Paul Shmyr, Gerry Cheevers
SECOND ROW: Billy Heindl, Skip Krake, Larry Hillman, Wayne Hillman, Bill Young, Ron Buchanan, Rich Pumple, Russ Walker, Tom Edur, Robbie Neale, Wayne Muloin
THIRD ROW: Trainer Dave Smith, Bill Horton, Grant Erickson, Jim Wiste, Paul Andrea, Ray Clearwater, Gary Jarrett, Trainer Steve Thomas

FRONT ROW (left to right) — Mike Curran, President Bob Brown, Dave Keon, Ron Ward, Bill Butters, Ray Adduono, Louie Levasseur. SECOND ROW — General Manager / Coach Glen Sonmor, Gord Gallant, Butch Deadmarsh, Jack Carlson, Ray McKay, Al McDonough, John A. Stewart, Jerry Zrymiak, Assistant Coach Jack McCartan. BACK ROW — Trainer Glenn Gostick, John McKenzie, Al Arbour, Dan Gruen, Pat Westrum, Mike Antonovich, Equipment Assistant Greg Scott, Equipment Manager Buddy Kessel.

1976-1977

19 W 18 L 5 T

(playing, ironically, as the Barons), Mileti saw the writing on the wall and moved the team to Minnesota as the second (or "New") Fighting Saints. It was a very different roster, as Gerry Cheevers retuned to Boston after a salary dispute. Gerry Pinder and Paul Shmyr were traded to San Diego. And the team folded soon after. Jim Harrison also returned to the NHL. Al McDonough went to Minnesota with the team.

The addition of such players as Dave Keon, John McKenzie and Jack and Steve Carlson didn't help sustain the franchise. They folded in 1977, having played a mere 42 games.

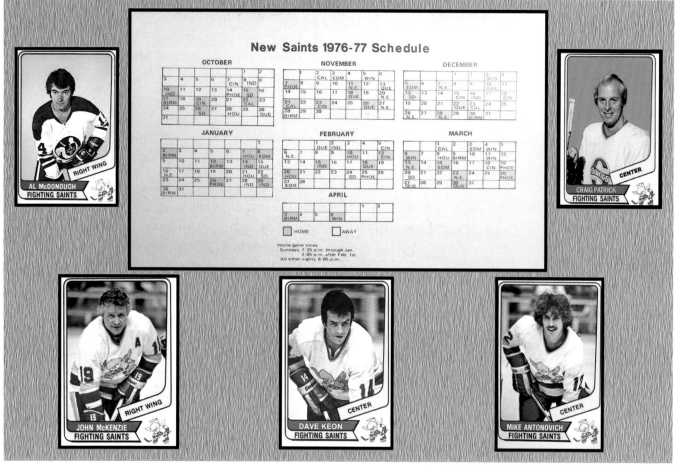

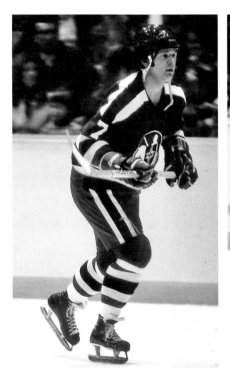
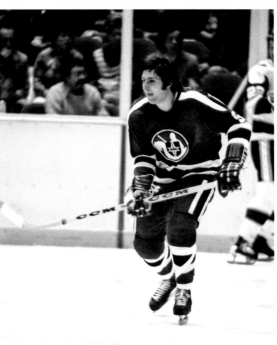
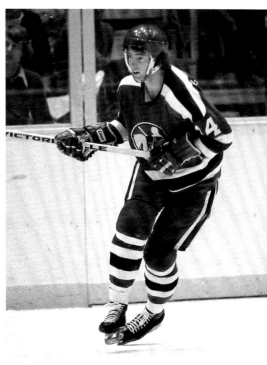

Gerry Pinder: 304 games, 87 goals, 127 assists and 214 points.

Jim Harrison: 119 games, 54 goals, 60 assists and 114 points.

Al McDonough: 200 games, 66 goals, 73 assists and 139 points.

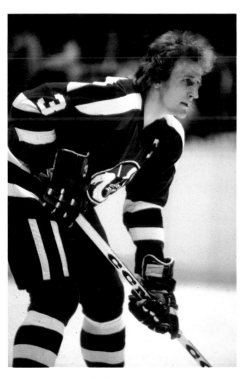
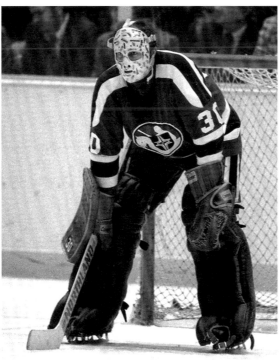
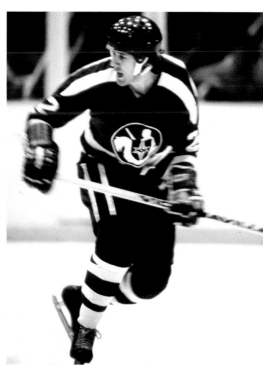

Paul Shmyr: 270 games, 31 goals, 132 assists and 163 points.

Gerry Cheevers: 191 games, 99 wins and 78 losses.

Rich LeDuc: 157 games, 71 goals, 53 assists and 124 points.

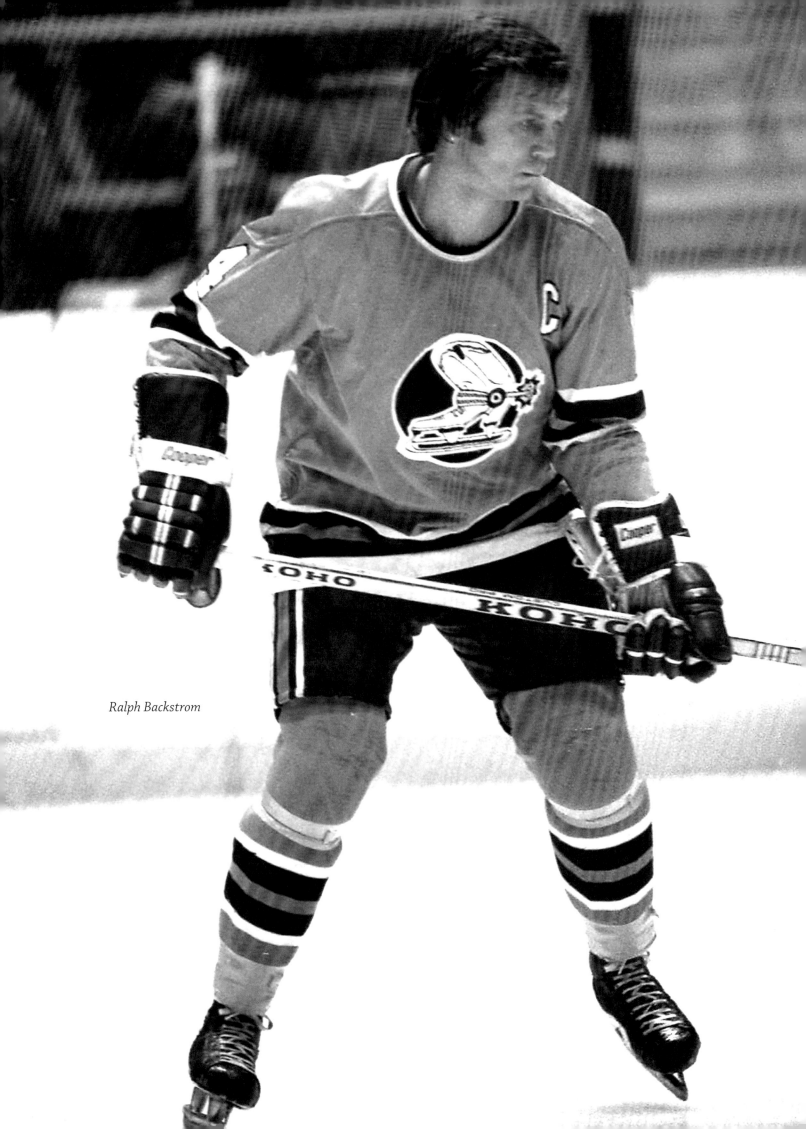

Ralph Backstrom

DENVER SPURS ('75–76) / OTTAWA CIVICS ('76)

It began with the hopes of an NHL franchise. It ended with the shortest tenured team in WHA history.

Ivan Mullenix, owner of the CHL Denver Spurs, was looking to break into big league hockey. In 1975 he sought, and got, a "conditional" franchise for the upcoming NHL expansion. It wasn't his first experience with the NHL—the previous year he had tried to buy the failing California Golden Seals and move them to Denver. But the expansion never happened, and the Seals eventually moved to Cleveland. Instead, Mullenix looked to the WHA for a franchise.

In 1975 the new WHA Denver Spurs were born. Fourteen of the players came from a dispersal draft from the late Chicago Cougars, although some of the original Spurs players, such as Don Borgeson, remained. They were hardly the cream of the crop, with the exception of Ralph Backstrom, Darryl Maggs and Gary MacGregor. Other ex-Cougars included Peter Mara, Frank Rochon, Bryon Baltimore, Mark Lomenda, Rick Morris, Keith Kokkola and Bob Liddington. Goalies Bob Johnson and Cam Newton (another ex-Cougar) would both have losing records that season.

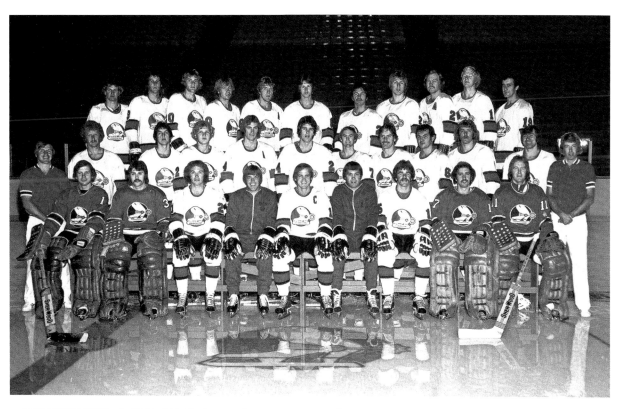

TEAM PICTURE LINEUP - Front left to right: John Clayton (assistant trainer), Bob Johnson (goal), Chris Grigg (goal), Brian Lavender (center/left wing), Jean Guy Talbot (coach and general manager), Ralph Backstrom (team captain, C), Bob McCord (assistant coach), Frank Rochon (left wing), Nick Sanza (goal), Cam Newton (goal), and Toby Wilson (trainer).

Middle row, left to right: Brian Gibbons (left defense), Ron Delorme (right wing), Greg Miazga (center), Darryl Maggs (right defense), Keith Kokkola (left defense), Bob Liddington (left wing), Mark Lomenda (right wing), Larry Maverty (right defense), Bryon Baltimore (left defense), Denis Delauriers (left defense).

Back row - left to right: Ken Gassoff (center), Barry Legge (left defense), Mal Zinger (right wing), Rich Morris (left wing), Jean|Paul LeBlanc (center), Gary McGregor (center), Peter Mara (center), Ed Pizunski (right wing), Larry Bignell (left defense), Gary Bredin (right wing), Jan Popiel (left wing).

Ralph Backstrom

Jean-Guy Talbot

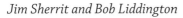

Jim Sherrit and Bob Liddington

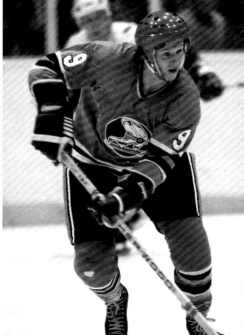

Gary MacGregor

Most of the team was made up of journeymen like John Arbour who, having been traded to the Spurs from the Saints earlier in the year, found himself back in Minnesota for the seven final games of the season after the team folded; Glasgow-born Jim Sherrit; minor league legend Bill "Goldie" Goldthorpe; Larry Bignell, in his only WHA season; Brian Lavender, also in his one WHA season; J.P. LeBlanc; and Gary Bredin.

The coach was NHL veteran Jean-Guy Talbot—and he would turn out to be the only coach

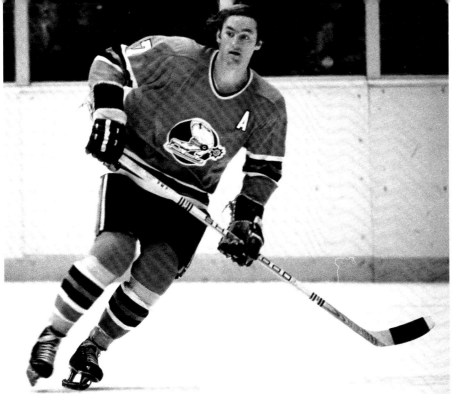

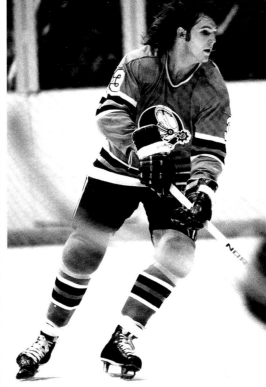

Bob Liddington

Barry Legge

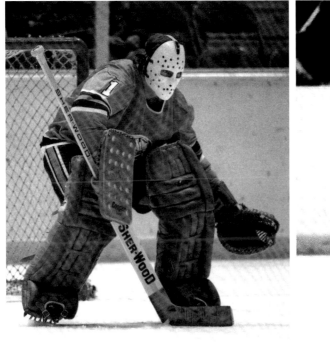

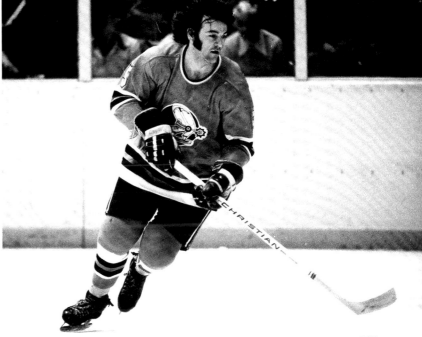

Bob Johnson

John Arbour

the team would ever have. The seven-time Cup winner as a player in Montreal had previously coached the St. Louis Blues.

Still, it was "big league hockey," something the residents of Denver had long hoped for. Apparently not in the WHA, however. Opening night saw a mere 5,000 fans show up at McNichols Sports Arena (a venue that held nearly 16,000) to watch the Spurs fall to the Racers 7–1. It wouldn't get much better. The team was only drawing an average of 3,000 to 3,500, the

Darryl Maggs

Frank Rochon

lowest in the league. By December they were last in the Western Division and last overall in the league, with a woeful 29 points.

Many thought that the poor support from the fans was because they felt slighted by the NHL. They saw the WHA as unstable and the Spurs as not the major league team they deserved.

This feeling was exacerbated by rumors that the NHL expansion team Kansas City Scouts would be relocating to Denver. In their two-year existence they hadn't fared much better than the Spurs, but the NHL thought that a team could succeed there nonetheless. Becoming the Colorado Rockies, the team played six seasons in the same McNichols Arena. With a losing record every year, eventually they would move again. They attracted interest in Ottawa, but instead moved to New Jersey as the Devils.

December 30, 1975, would be the last time the Spurs played in Denver. Plagued with debt (the city filed a tax lien on December 31), poor attendance and a losing team, Mullenix reached out to a group of Ottawa businessmen known as the Founders Club. One condition for their help was that the Spurs would have to move to Ottawa immediately.

So immediately, in fact, that it even caught the players by surprise. They learned on a road trip in Cincinnati on January 1 that they were no longer the Denver Spurs, but the Ottawa Civics. The new team didn't even have time to create a logo, so they played as the Ottawa Civics still wearing their Spurs uniforms, boot crest and all.

They didn't have to wear them very long. After losing to the Stingers 2–1, then the Aeros 4–2, they managed a 5–2 win against the Fighting Saints. They returned "home" to the Ottawa Civic Center. Their

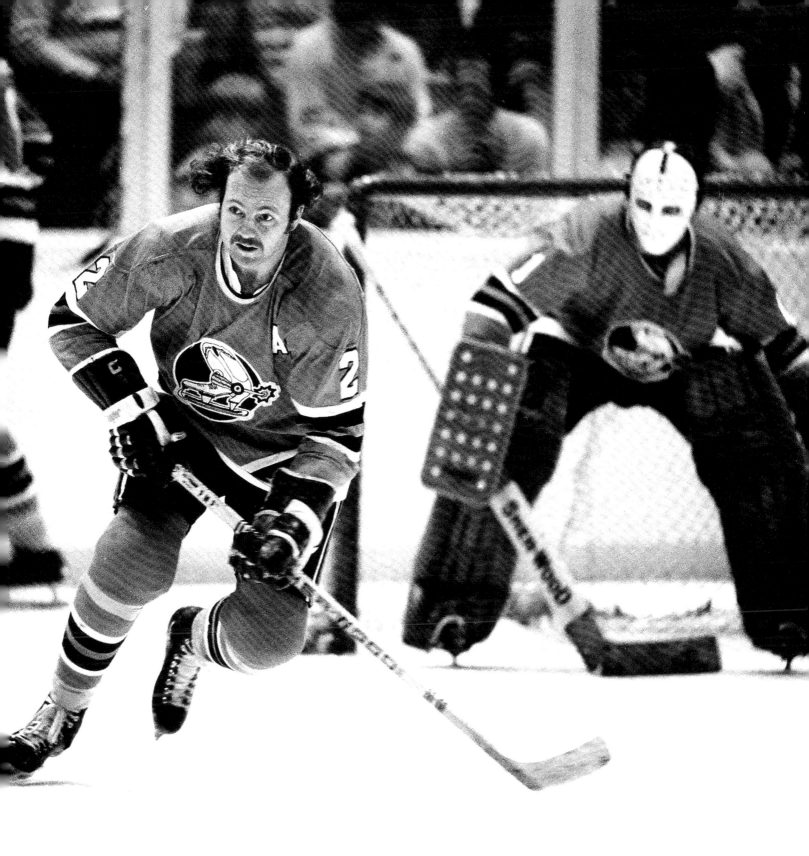

Larry Bignell and Bob Johnson

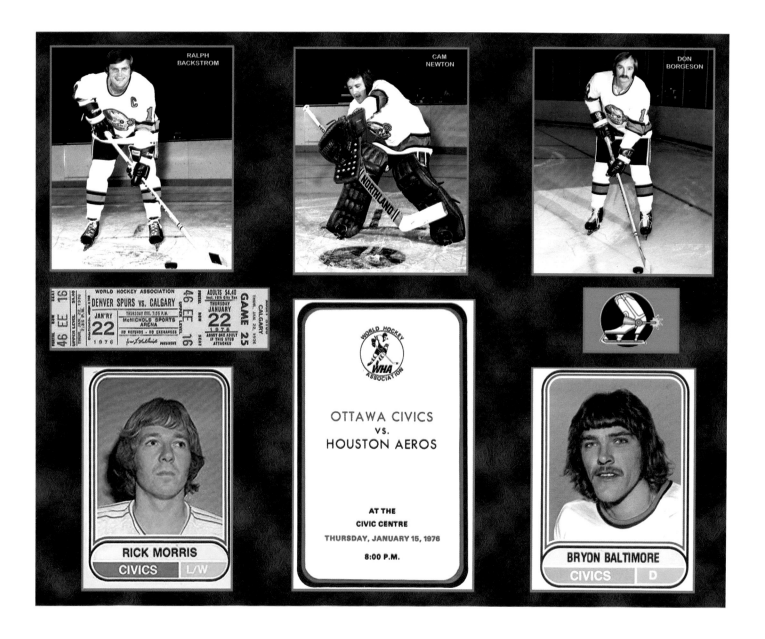

RALPH BACKSTROM

CAM NEWTON

DON BORGESON

RICK MORRIS
CIVICS L/W

OTTAWA CIVICS
VS.
HOUSTON AEROS

AT THE
CIVIC CENTRE
THURSDAY, JANUARY 15, 1976
8:00 P.M.

BRYON BALTIMORE
CIVICS D

debut in Ottawa was a 3–2 loss before a mostly curious crowd of 8,467 fans. While attendance improved, their next three games were losses.

Mullenix's deal with the Founders had never been completed, and he was unwilling to have a team in Ottawa, especially since he had hoped for civic support for the Civics. With Mullenix still saddled with debt from Denver and Ottawa mayor Lorry Greenberg making it clear that there would be no municipal assistance, negotiations ceased, as did the team. They officially folded on January 17, 1976.

Having played a mere 41 games, the Spurs/Civics have the dubious honor of being the shortest-lived franchise in WHA history.

Ralph Backstrom: 41 games, 21 goals, 29 assists and 50 points.

Gary MacGregor: 38 games, 16 goals, 14 assists and 30 points.

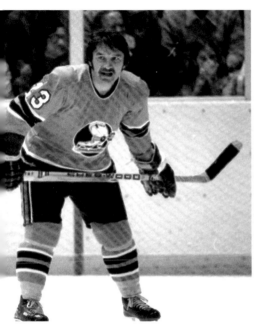

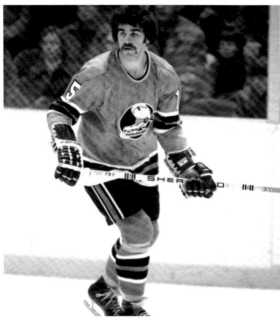

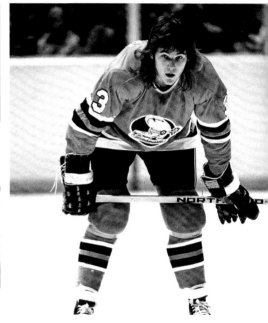

Pete Mara: 40 games, 3 goals, 7 assists and 10 points.

Frank Rochon: 41 games, 11 goals, 10 assists and 21 points.

Barry Legge: 40 games, 6 goals, 8 assists and 14 points.

John Arbour: 34 games, 2 goals, 13 assists and 15 points.

Ron Delorme: 22 games, 1 goal, 3 assists and 4 points.

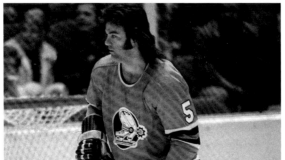

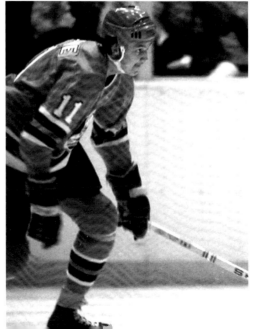

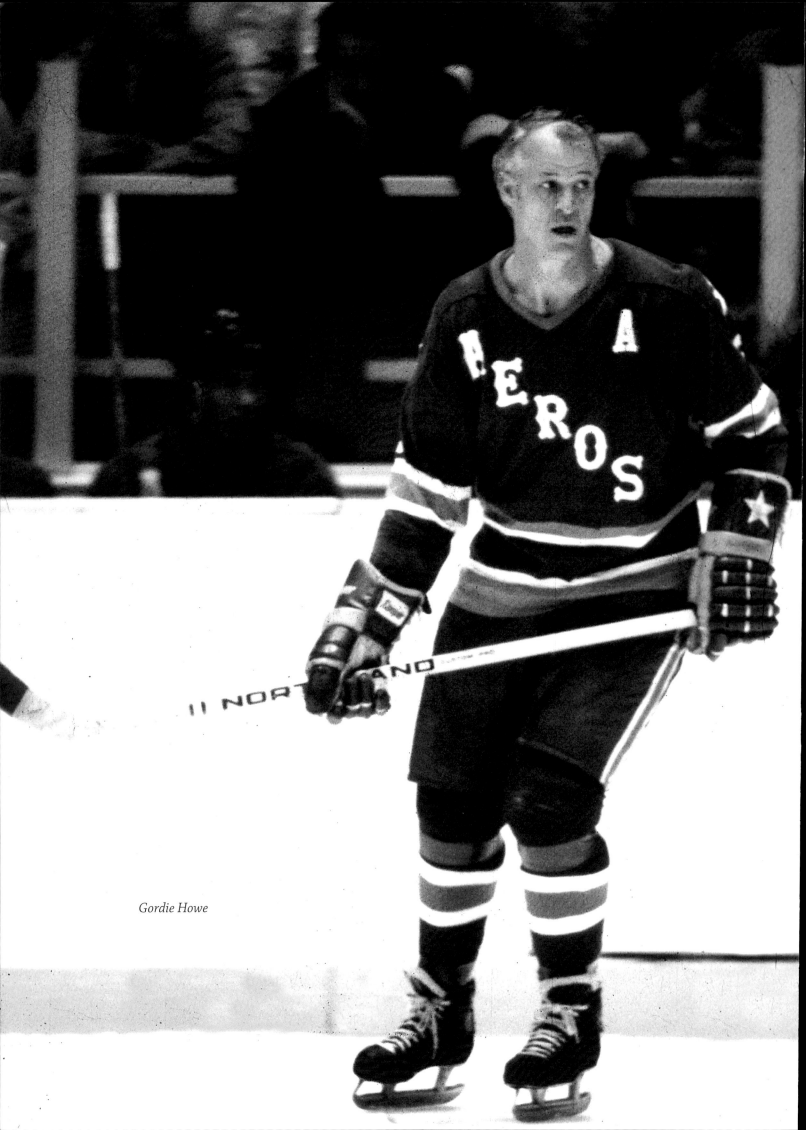

Gordie Howe

HOUSTON AEROS ('72–'78)

"WHA BRINGS BIG LEAGUE HOCKEY TO DAYTON": it was a headline that wasn't destined to be realized. Franchise owner Paul Deneau wanted to put his new team, the Aeros, in Dayton, OH, but was met with lukewarm reception from potential fans. Not only that, but there wasn't a suitable arena in which the team could play. Dayton's Hara Arena held only 5,000 and wasn't considered a major league–capacity venue.

Before the first puck was dropped the team was relocated to Houston and named the Aeros (for the city's connections to the aerospace industry). Now they had a home, but did they have fans?

They began play in the antiquated Sam Houston Coliseum, an arena they would call home until 1975, when they moved to the bigger facility known as the Summit. The new arena held nearly 15,000, on par with most NHL buildings. They played there until the team folded in 1978.

Veteran coach Bill Dineen was chosen to helm the team—and he would be the only coach the team would have in its six years of existence. A career minor-leaguer who had brief stints with Detroit and Chicago in the NHL, he found his calling behind the bench. After the Aeros folded, he coached the New England Whalers and was twice named the AHL coach of the year, along the way winning two Calder Cups as AHL champions.

Notable players that first season included veteran center Gord Labossiere, the leading scorer with 96 points; defenseman Paul Popiel, who would play all six of the Aeros' seasons; WHA old hand Frank Hughes; and wing Ted Taylor, who would score a career-high 76 points. The defense was also bolstered by the addition of Larry Hale and Gord Kannegiesser.

With a respectable 39-35-4 record, the team finished second in WHA West Division. They were later swept by the Winnipeg Jets in the semifinal playoffs.

The next season would see a major turning point for the team: it came with the addition of Mark, Marty *and* Gordie Howe.

The elder Howe had retired after an astonishing 25-year NHL career, all with the Detroit Red Wings. Unsatisfied with retirement, Gordie signed with Houston to play with his two sons, the

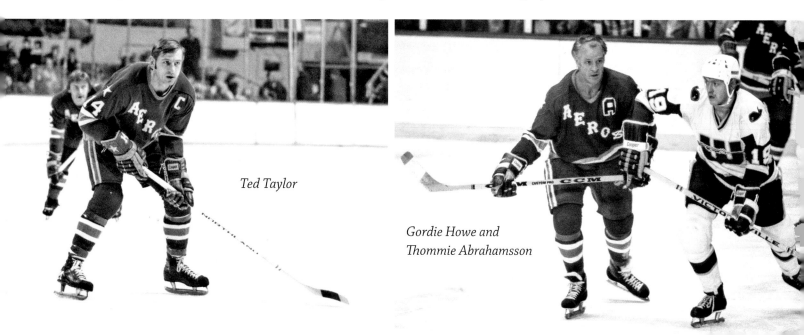

Ted Taylor

Gordie Howe and
Thommie Abrahamsson

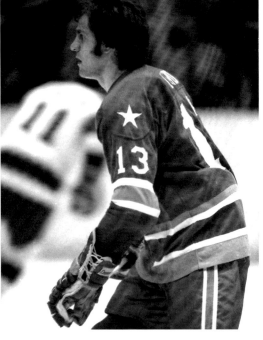

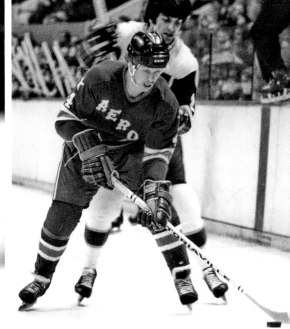

Marty Howe *Larry Lund* *Mark Howe and Tim Sheehy*

first father-son(s) combination in professional hockey. At 45, Howe proved he hadn't lost a step, scoring 31 goals and 69 assists. He won the Gary L. Davidson Award as the league MVP in 1974, a trophy that would be renamed in his honor the following year. The Howes would be a key part of two consecutive Avco Cup championships (1974 and 1975) in their four years with the team.

Terry Ruskowski and John Tonelli both got their start with the Aeros and were later joined by André Lacroix, who would play for several WHA and NHL teams over his long hockey career. Rich Preston played four years in Aeros blue, netting 105 goals and 120 assists; Larry Lund would play all six years of his major league career in Houston, racking up 426 points.

Another advantage the team had was strong goaltending. A weak spot for many other WHA teams, the Aeros boasted the services of Wayne Rutledge, who spent the final six years of his nine-year career with Houston. Ron Grahame would play four years in Houston before moving on to the NHL in 1977. Don McLeod did his share between the pipes in his two years in Houston (1972–73, 1973–74), as did Ernie Wakely in his one season, 1977–78.

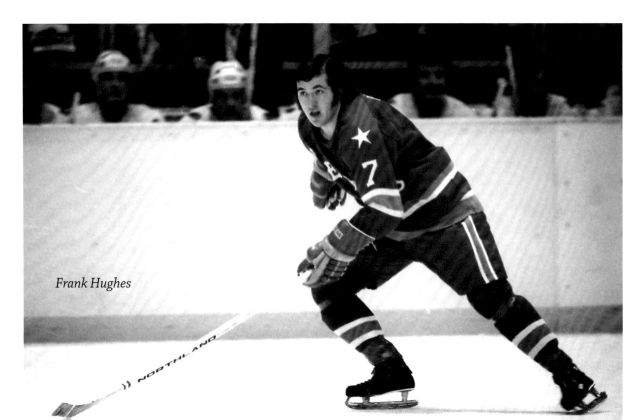

Frank Hughes

Larry Hale

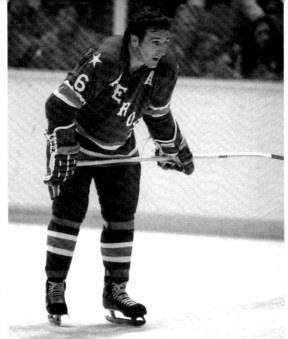

Paul Popiel

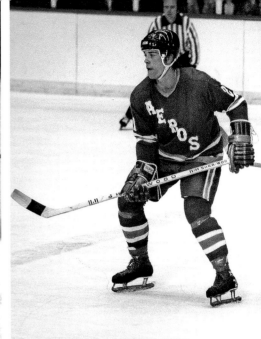

Rich Preston

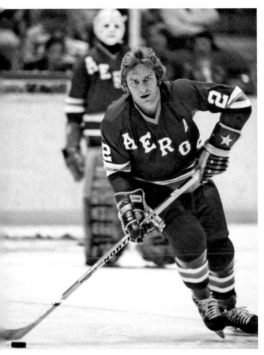

John Schella

Terry Ruskowski

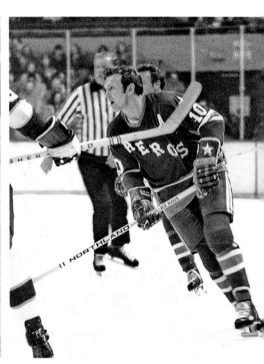

Gord Labossiere

Don Laraway

Wayne Rutledge

Ron Grahame

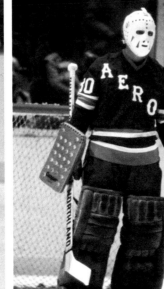

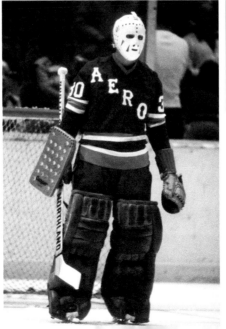

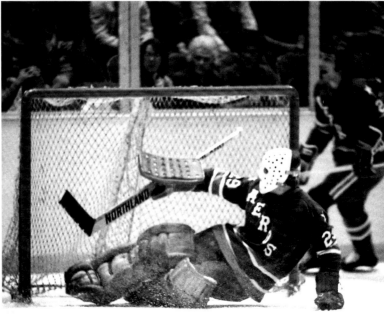

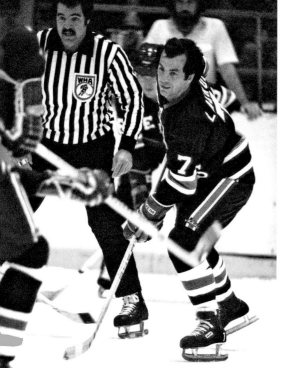

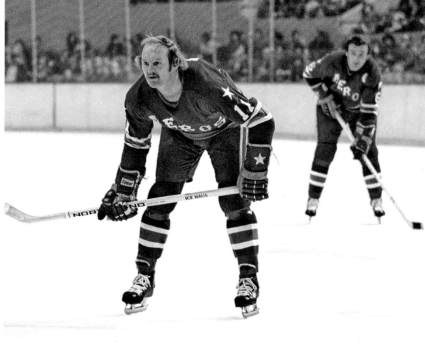

André Lacroix　　　　　　　　*Murray Hall and Paul Popiel*

Along with Winnipeg, Houston was one of the strongest teams in the league. They won four consecutive Western Division titles, from 1973–74 to 1976–77. With their two Avco Cup championships, they were second only to the Jets, who won three.

Despite their success on the ice, the Aeros too were plagued with financial troubles. In 1977 the three Howes went as free agents to the New England Whalers, a team that would survive the WHA and merger with the NHL. After the merger, Howe made his return to the NHL with the now Hartford Whalers, playing one season at age 51, the oldest man to ever play in the league.

Summit chairman and Houston businessman Kenneth Schnitzer, who was now a part owner, wanted the Aeros to be part of the NHL. Many felt that they would be an ideal addition, as they were a still a strong team (even without the Howes) with a solid fan base. It never came to pass, however, due to resistance of many NHL team owners. With no chance of joining the NHL and the prospect of the WHA ceasing to exist as a league, Schnitzer reluctantly folded the Aeros on July 9, 1978.

Gord Kannegiesser　　　　　　　　*John Gray*　　　　　　　　*Cam Connor*

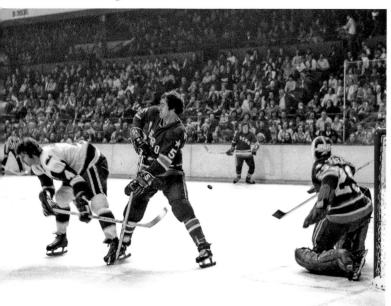

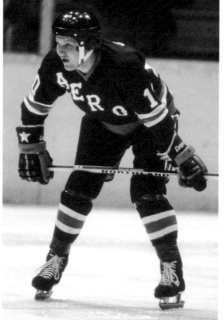

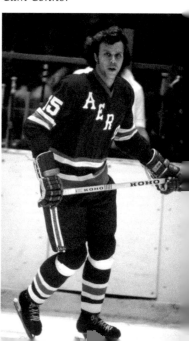

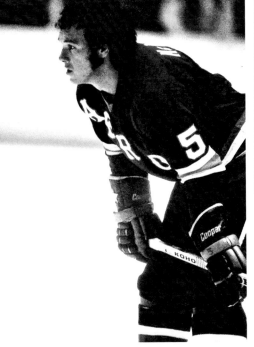

Al McLeod

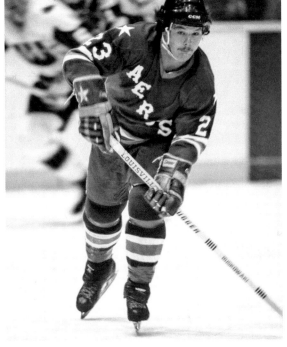

Jim Sherrit

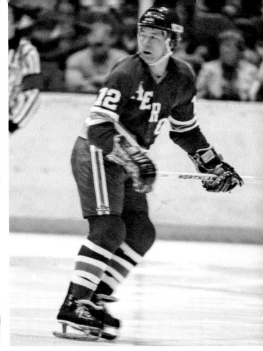

Morris Lukowich

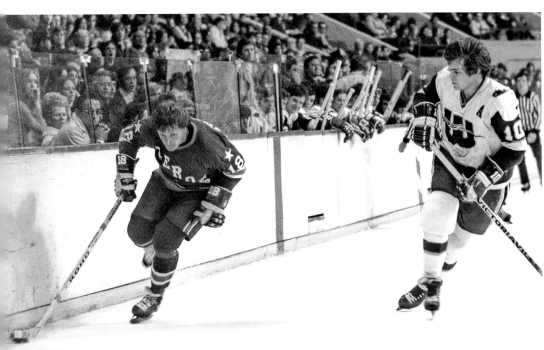

Jack Stanfield

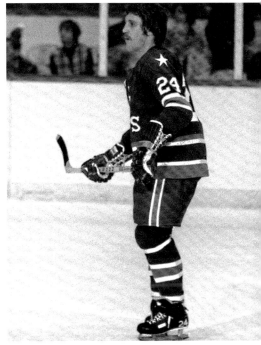

Glen Irwin

Mark Howe, Larry Lund and Bill Prentice

Ron Hansis and George Lyle

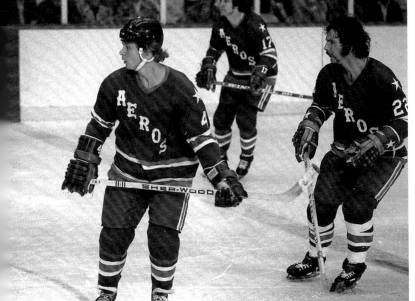

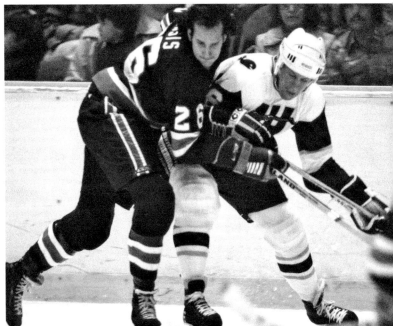

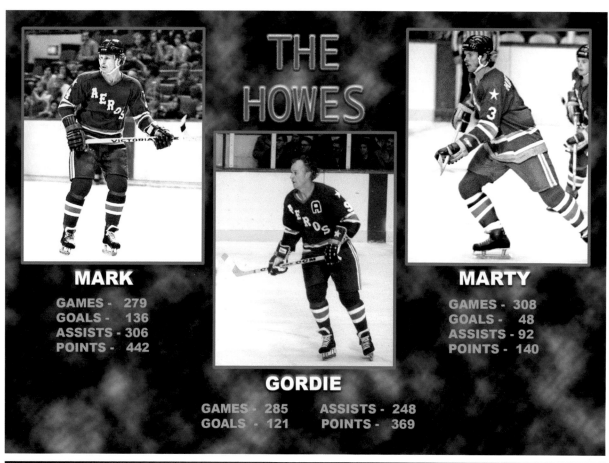

THE HOWES

MARK

GAMES - 279
GOALS - 136
ASSISTS - 306
POINTS - 442

GORDIE

GAMES - 285 ASSISTS - 248
GOALS - 121 POINTS - 369

MARTY

GAMES - 308
GOALS - 48
ASSISTS - 92
POINTS - 140

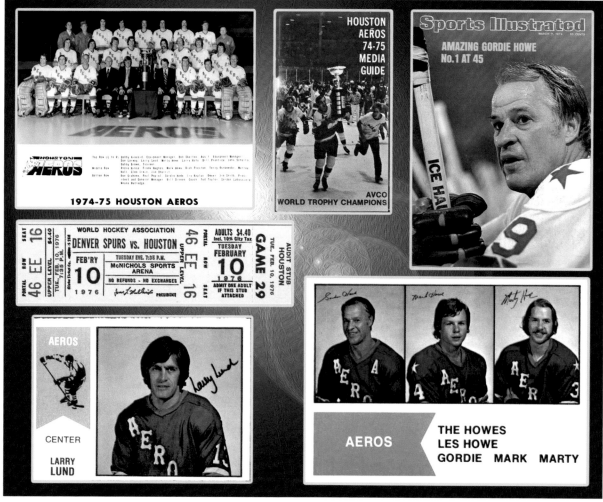

1974-75 HOUSTON AEROS

HOUSTON AEROS 74-75 MEDIA GUIDE

AVCO WORLD TROPHY CHAMPIONS

AMAZING GORDIE HOWE No.1 AT 45

AEROS

CENTER

LARRY LUND

THE HOWES
LES HOWE
GORDIE MARK MARTY

AEROS

Frank Hughes: 343 games, 149 goals, 151 assists and 300 points.

Murray Hall: 312 games, 96 goals, 125 assists and 221 points.

Paul Popiel: 468 games, 62 goals, 265 assists and 327 points.

Morris Lukowich: 142 games, 67 goals, 53 assists and 120 points.

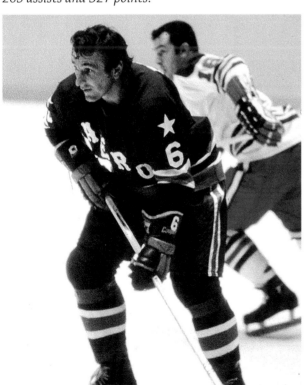

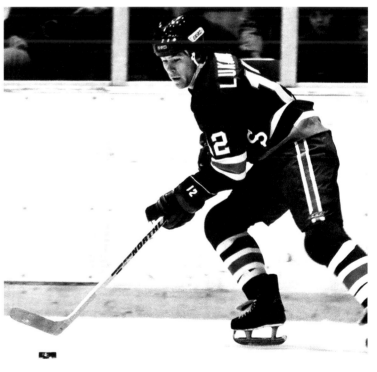

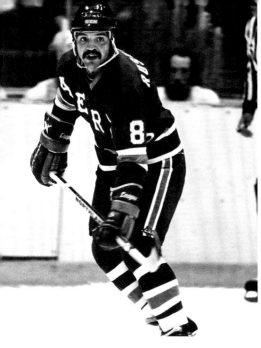
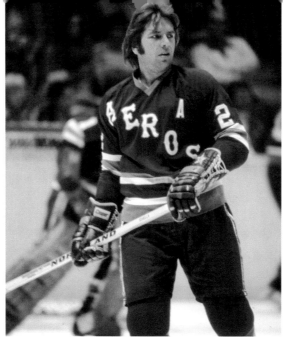
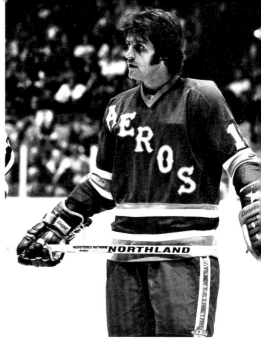

Terry Ruskowski: 294 games, 63 goals, 188 assists and 251 points.

John Schella: 385 games, 39 goals, 143 assists and 182 points.

Larry Lund: 459 games, 149 goals, 277 assists and 426 points.

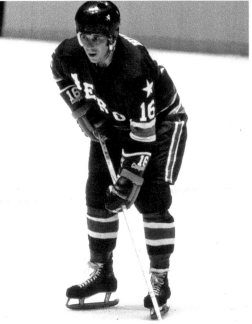
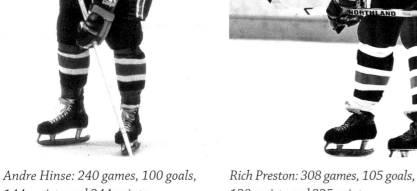
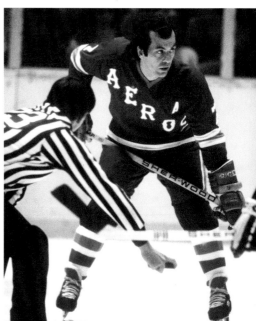

Andre Hinse: 240 games, 100 goals, 144 assists and 244 points.

Rich Preston: 308 games, 105 goals, 120 assists and 225 points.

André Lacroix: 78 games, 36 goals, 77 assists and 113 points.

Ted Taylor: 420 games, 123 goals, 164 assists and 287 points.

Wayne Rutledge: 175 games, 93 wins and 72 losses.

Dwayne Pentland: 29 games, 1 goal, 2 assists and 3 points.

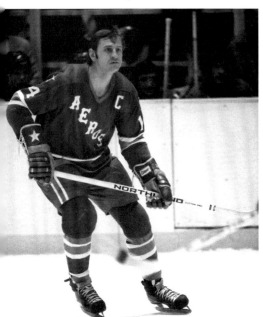

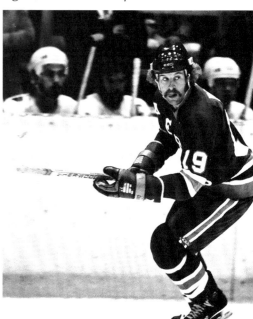

Gary Williamson: 9 games, 2 goals, 6 assists and 8 points.

Scott Campbell: 75 games, 8 goals, 29 assists and 37 points.

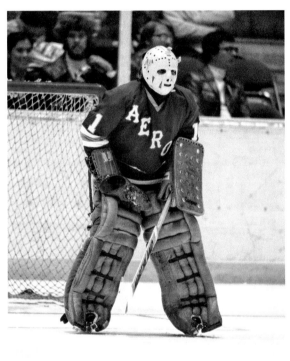

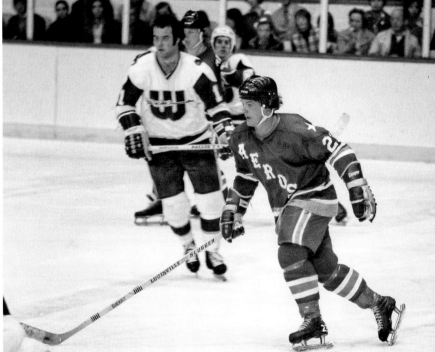

Lynn Zimmerman: 20 games, 10 wins and 9 losses.

Jim Sherrit: 153 games, 52 goals, 53 assists and 105 points.

Ron Grahame: 143 games, 102 wins and 37 losses.

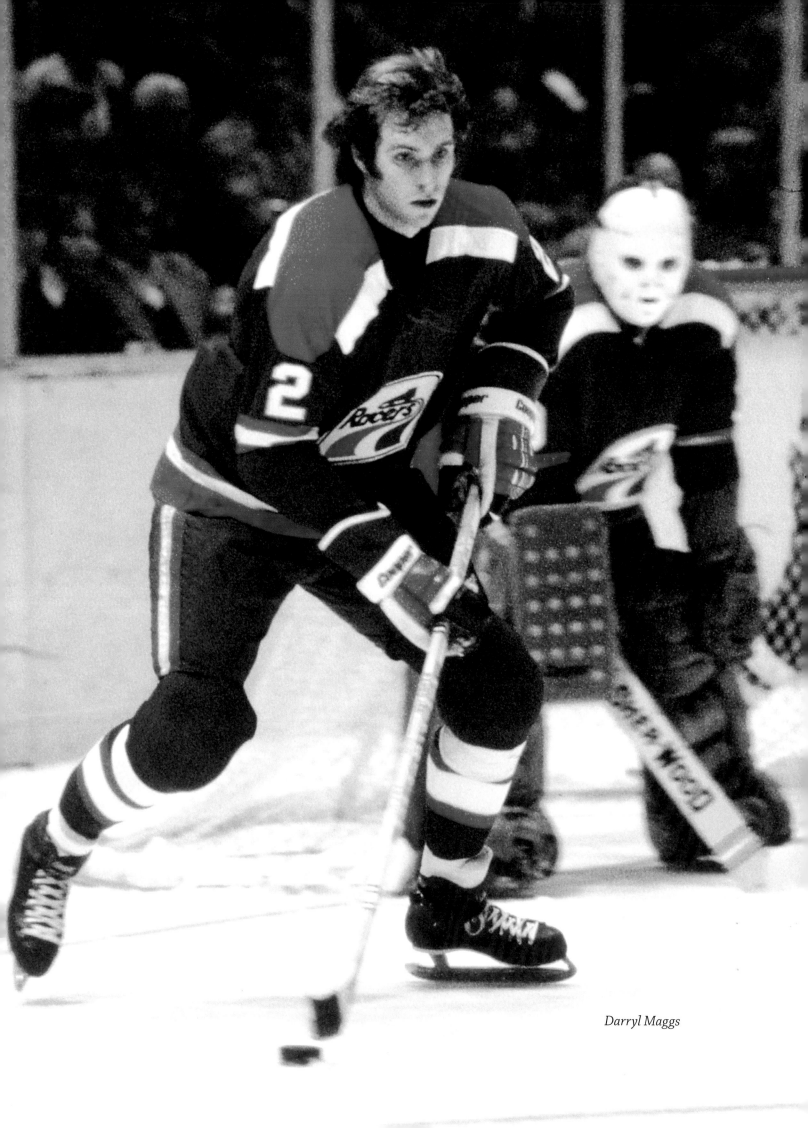

Darryl Maggs

INDIANAPOLIS RACERS ('74 – '78)

Full of what could optimistically be called confidence, in 1974 the league expanded, awarding franchises to Phoenix and Indianapolis. In the Racers the WHA saw an opportunity to bring major league hockey to a city that would later see the ABA Pacers join the senior league in 1976 and lure the NFL Colts from Baltimore in 1984.

The team was originally owned by the consortium Indiana Pro Sports, Inc., headed by John Weissert. Over its lifetime, ownership would change several times; Paul Deneau soon took over from the original owners, followed by Harold Ducote and finally, and most famously, Nelson Skalbania.

The Racers hosted their home games at the short-lived (1974–99) Market Street Arena for four full years from 1974 until the team folded in 1978. (They played only 25 games in the last season of the WHA, 1978–79.) The arena held nearly 16,000 fans for hockey games, and Racers games were well attended. The hockey fans of Indianapolis embraced their new team; in fact, they led the league in attendance in the 1976–77 season.

The first team boasted many veterans; of the top 10 scorers only one was 20 years old. They were strong in net too, with goaltenders Michel Dion and Andy Brown, the last NHL maskless goalie.

Later players included Ken Block, who played seven of his eight career years in the WHA; Bryon Baltimore, another WHA veteran; Chicago mainstays (both NHL and WHA) Pat Stapleton and Darryl Maggs; journeyman defenseman Barry Wilkins; right wing Rene LeClerc; and scoring defenseman Kevin Morrison, who once netted 81 points with the San Diego Mariners. Veterans Claude St. Sauveur, Rosaire Paiement and Bobby Sheehan would also wear Racer red, white and blue for a time.

Bryon Baltimore *Ken Block* *Rene LeClerc*

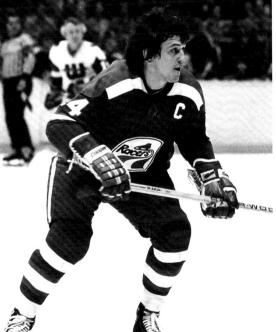
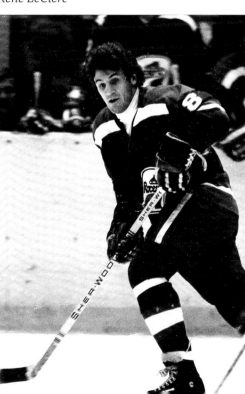

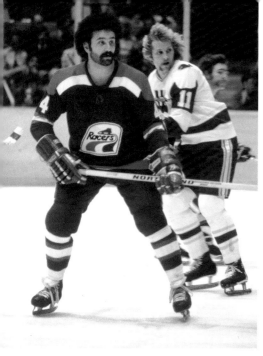

Kevin Morrison

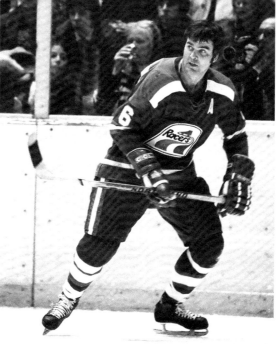

Rosaire Paiement

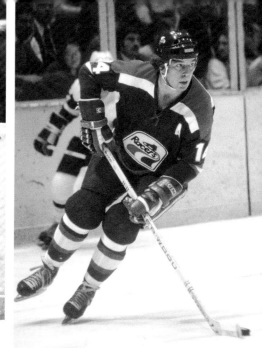

Barry Wilkins

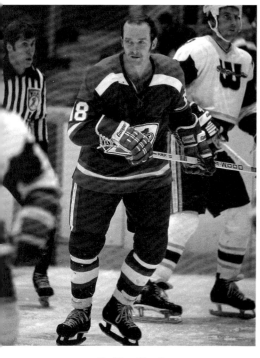

Bobby Sheehan

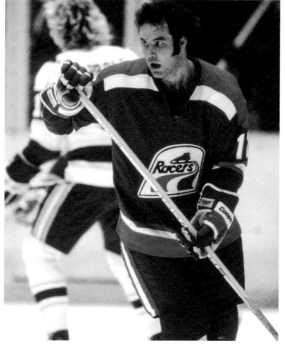

John French

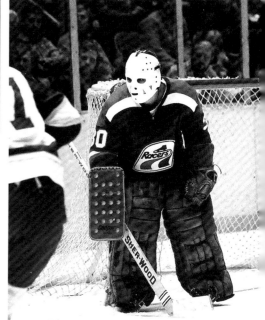

Gary Inness

Don Burgess

Claude St. Sauveur

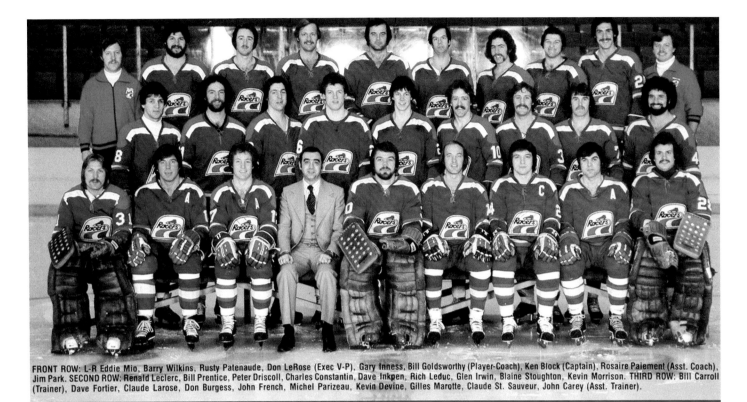

FRONT ROW: L-R Eddie Mio, Barry Wilkins, Rusty Patenaude, Don LeRose (Exec V-P), Gary Inness, Bill Goldsworthy (Player-Coach), Ken Block (Captain), Rosaire Paiement (Asst. Coach), Jim Park. SECOND ROW: Renald Leclerc, Bill Prentice, Peter Driscoll, Charles Constantin, Dave Inkpen, Rich Leduc, Glen Irwin, Blaine Stoughton, Kevin Morrison. THIRD ROW: Bill Carroll (Trainer), Dave Fortier, Claude Larose, Don Burgess, John French, Michel Parizeau, Kevin Devine, Gilles Marotte, Claude St. Sauveur, John Carey (Asst. Trainer).

INDIANAPOLIS RACERS 1977-78

A major coup came in spring 1976, when they signed future NHL Hall of Famer Dave Keon, who became a free agent when the Minnesota Fighting Saints folded. His time in Indianapolis was brief, however. He signed with the new Fighting Saints (formerly the Cleveland Crusaders) after only 12 games.

Businessman and frequent franchise owner Nelson Skalbania bought the club from Harold Ducote in 1977, helping it to avoid folding . . . for a time, anyway. Skalbania tried to revitalize the club in 1978 by boldly signing 17-year-old Sault Ste. Marie Greyhounds star Wayne Gretzky to a personal services contract rather than a standard team contract. Gretzky would later sign a similar contract with Oilers owner (and one-time Skalbania business partner) Peter Pocklington.

Gretzky made his professional debut as a Racer, but played only eight games in Indy before a cash-strapped Skalbania traded him (along with Eddie Mio and Peter Driscoll) to the Edmonton Oilers for a reported $800,000. It would be Gretzky's only year playing in the WHA, but the beginning of a long and successful career in the NHL.

Eighteen-year-old Mark Messier would also make his brief WHA debut on a tryout contract with the Racers, playing five games in 1978–79 before the team folded. He went to Cincinnati that year before moving on to Edmonton in 1979, by then in the NHL.

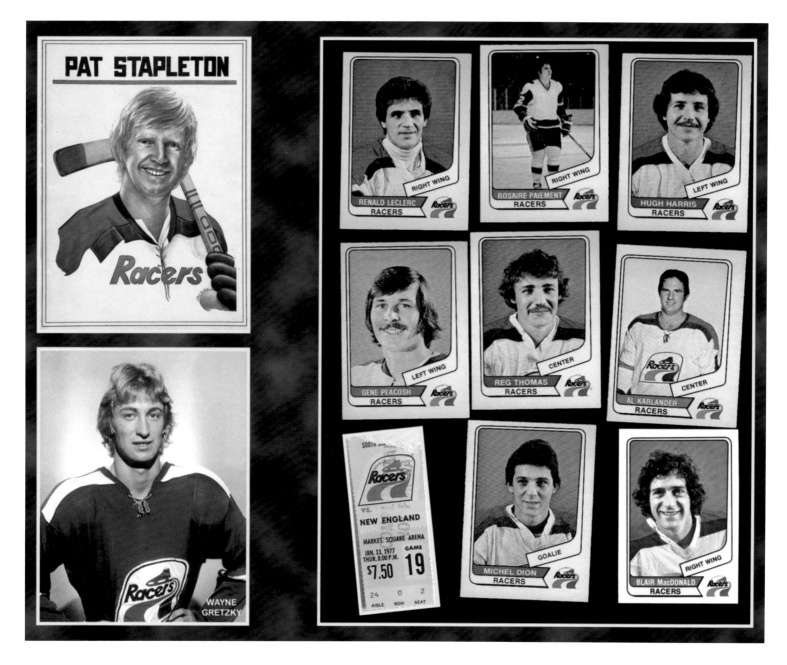

It had always been Skalbania's hope to move the franchise to Canada to have a better chance of joining the NHL. The merger included all of the WHA's Canadian teams (the Edmonton Oilers, Quebec Nordiques and Winnipeg Jets) and one American team, the New England Whalers. Renamed the Hartford Whalers, they were no longer Boston based and thus not seen to be in direct competition with the Bruins. Neither league wanted to upset the sometimes delicate negotiations, so Skalbania's plan to move the team north of the border was never to be.

Despite frequent changes in ownership and the usual financial ups and downs, the Racers enjoyed support from the fans and still had good attendance numbers. Indianapolis, however, was not thought to be a major league city.

Darryl Maggs: 168 games, 27 goals, 86 assists and 113 points.

Dave Fortier: 54 games, 1 goal, 15 assists and 16 points.

Kevin Devine: 76 games, 19 goals, 23 assists and 42 points.

Don Burgess: 82 games, 12 goals, 13 assists and 25 points.

Kevin Morrison: 80 games, 17 goals, 42 assists and 59 points.

Rosaire Paiement: 128 games, 24 goals, 49 assists and 73 points.

Bryon Baltimore: 79 games, 2 goals, 23 assists and 25 points.

Brad Rhiness: 12 games, 3 goals, 3 assists and 6 points.

Frank Spring: 13 games, 2 goals, 4 assists and 6 points.

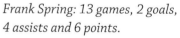
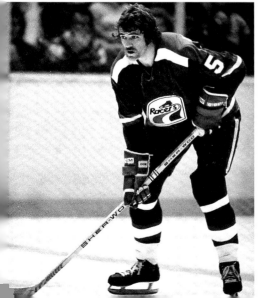
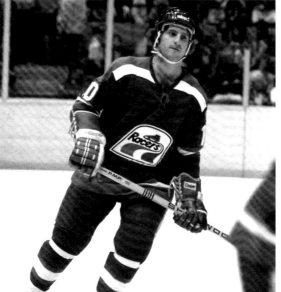
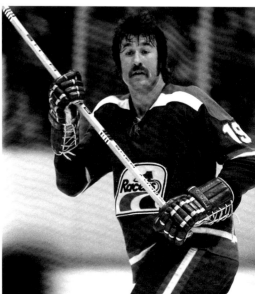

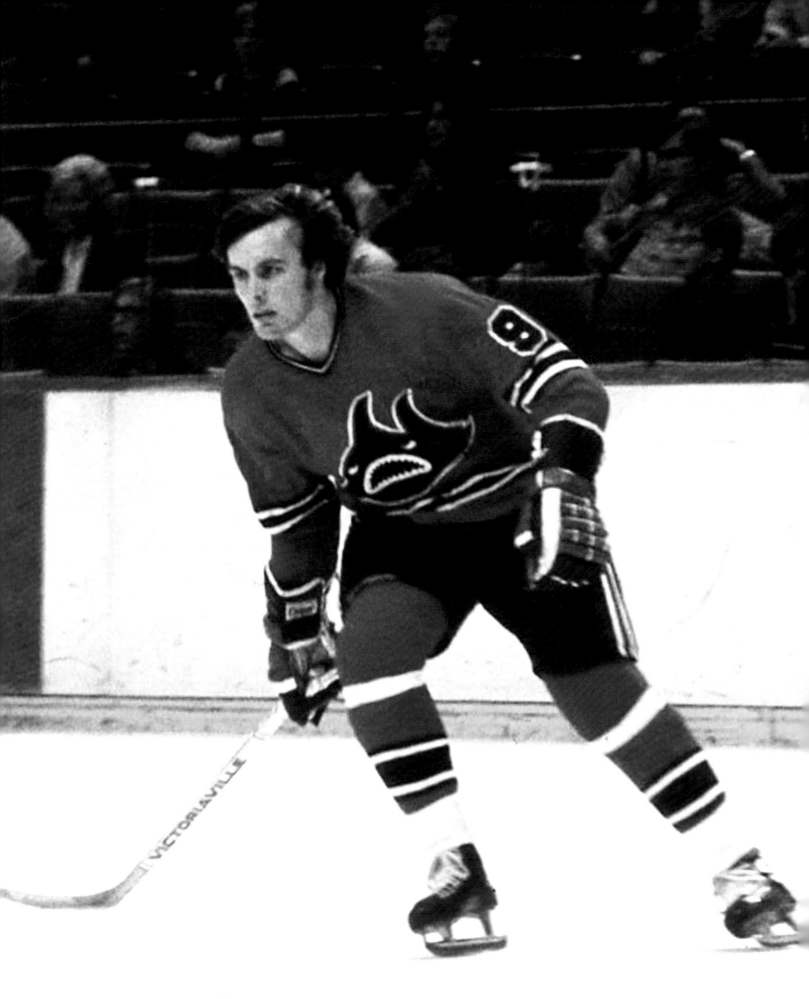

Marc Tardif

LOS ANGELES SHARKS ('72–'74) / MICHIGAN STAGS ('74–'75) / BALTIMORE BLADES ('75)

One of the Original Twelve WHA franchises, the team was owned by WHA co-owner Dennis Murphy. The visionary entrepreneur had many irons in the fire when it came to new leagues; in addition to the WHA he co-founded the American Basketball Association, World Team Tennis and Roller Hockey International. The hope of the new league was to put teams on the West Coast to challenge the NHL franchises in Oakland and Los Angeles; the Sharks (originally to be called the Aces) located in Los Angeles and the Seahawks in San Francisco. But the Seals were struggling to stay viable in the Bay Area and would eventually relocate to Cleveland. Reading the market, the WHA transferred the San Francisco franchise to Quebec before the players suited up for a single game. They felt that Los Angeles, the bigger market, could handle two teams, even if the Kings were an established NHL club and played in the much bigger Forum.

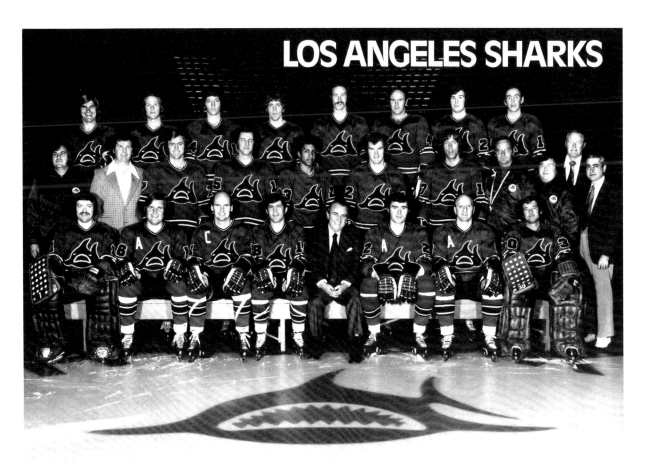

FIRST ROW: Russ Gillow, Carl Heiskala, Ted McCaskill, Gary Veneruzzo, Dennis Murphy, Jim Watson, Gerry Odrowski, George Gardner
SECOND ROW: Larry Oldes, Gary Morrell, Bart Crashley, Joe Szura, Alton White, Tom Gilmore, Mike Hyndman, Terry Slater, Norman Fong, Hank Ives, John Kanel.
THIRD ROW: Tom Serviss, Fred Speck, Peter Slater, J. P. LeBlanc, Jim Niekamp, Ralph MacSweyn, Bernie MacNeil, Steve Sutherland

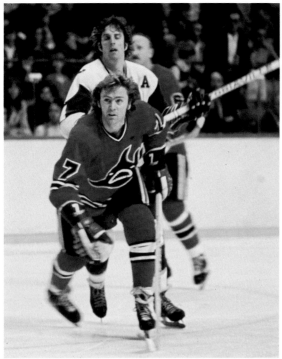

Bart Crashley

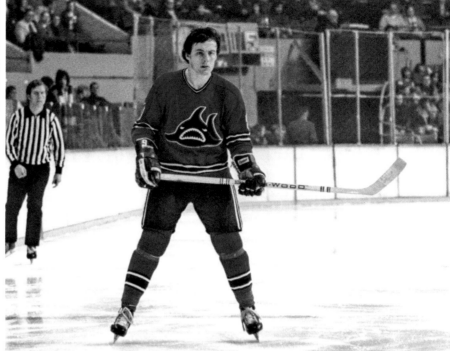

Marc Tardif

The Sharks were moderately successful with a decent fan base. They played most of their games at the Los Angeles Memorial Sports Arena, which held a respectable 14,546 hockey fans, but they sometimes hit the ice at the Long Beach Sports Arena, a smaller venue with a max of 12,500.

Not having a marquee player, the Sharks allowed several journeymen and career minor-leaguers a chance to shine. Gary Veneruzzo was the first season's leading scorer with 73 points. J.P. LeBlanc had 69, Bart Crashley and Joe Szura tied with 45. Jim Niekamp had a career-high 29

Bill Reed

Jacques Locas

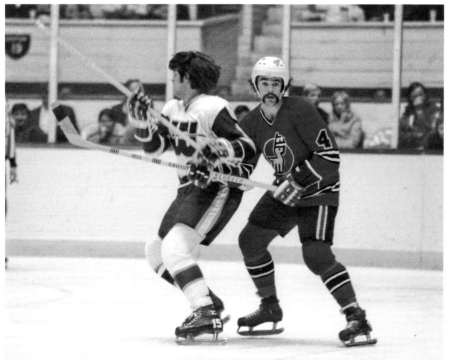

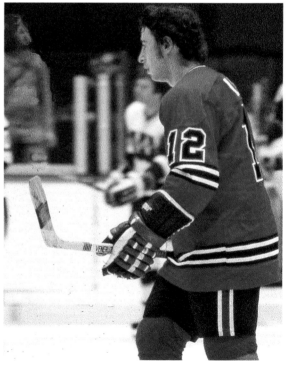

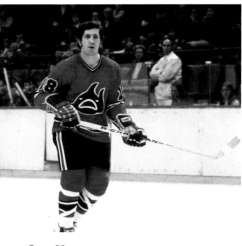

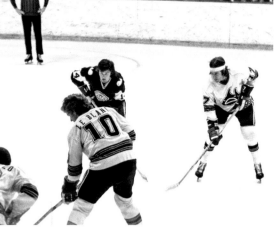

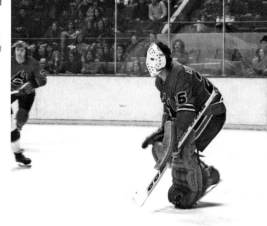

Gary Veneruzzo *J.P. LeBlanc, Mike Hyndman and Kevin Ahearn* *Paul Hoganson*

points in his only season with the Sharks, and six-year NHL veteran Gerry Odrowski would score 73 points in his two seasons in Los Angeles.

Goalie George Gardner enjoyed a five-year NHL career with Detroit and Vancouver before jumping to the new league. Thirty-two-year-old rookie Russ Gillow shared the netminding duties, and together they combined for 36 wins and 35 losses.

In the Sharks' second season they were bolstered by 70-point-scorer Marc Tardif, who had already won two Cups with Montreal. Brian McDonald came over from Houston and contributed 52. Veneruzzo scored 68 points, LeBlanc 66. Rookie Reg Thomas put up 35.

While the Sharks were playing well, the Kings were beginning to emerge as the more successful team and were thus attracting more fans. At the end of the season it was announced that the team would relocate to Michigan and be renamed the Stags.

Jim Niekamp *Gerry Odrowski* *Marc Tardif*

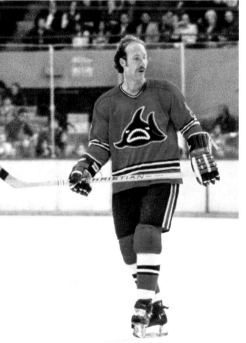

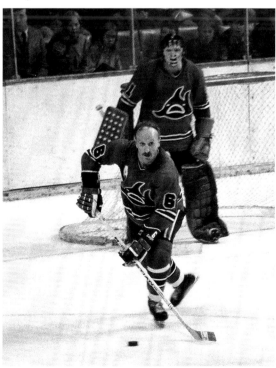

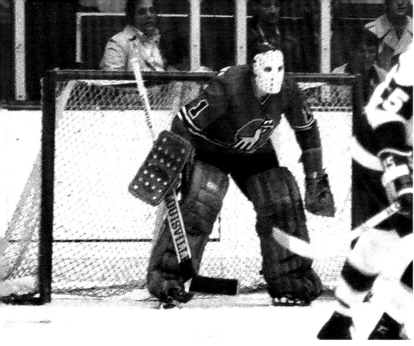

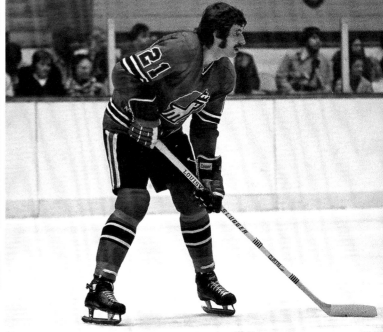

Gerry Dejardins *John Mizuk*

The team was purchased by Detroit businessmen Charles Nolton and Peter Shagena. They thought that the Stags in Cobo Arena would be able to compete with the Red Wings for Motor City fans and that they would develop a rivalry with the Toronto Toros. Even though the Red Wings had been struggling of late, they underestimated the fans' fierce loyalty to the team.

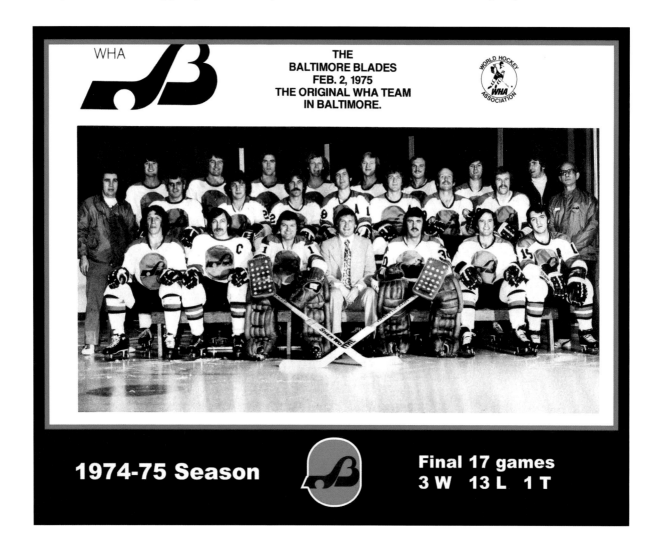

The Stags lasted until January, when they were once again on the move. With what could mildly be called "encouragement" by the league (they didn't want the bad press of losing another team), they relocated to Baltimore. They called the modest Baltimore Arena home and wore hand-me-down uniforms from the AHL Baltimore Clippers, with a large Blades crest covering the original Clippers logo.

The team roster was pretty much intact. Gary Veneruzzo was the leading scorer for the team with 60 points, by far highest on the club. (J.P. LeBlanc came in second with 49.) Goalie Gerry Desjardins was lured away from his NHL career to play for the Stags/Blades, only to return after 41 games.

The team managed only three wins in their 17 games in Baltimore, and there was talk of another move, this time to Seattle, but nothing ever came of it. They officially folded in May 1975.

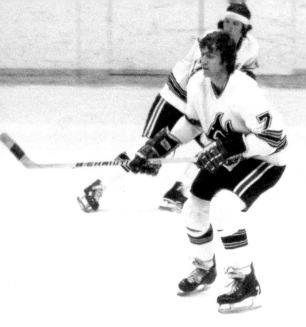
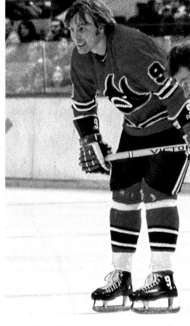

Bart Crashley: 148 games, 22 goals, 53 assists and 75 points.

Marc Tardif: 98 games, 52 goals, 35 assists and 87 points.

Randy Legge: 78 games, 1 goal, 14 assists and 15 points.

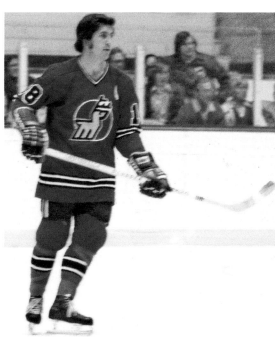
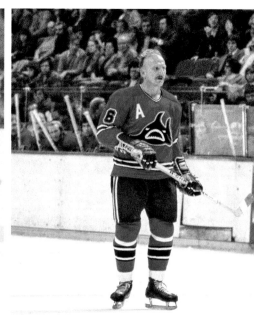

Jacques Locas: 12 games, 1 goal, 4 assists and 5 points.

Gary Veneruzzo: 233 games, 115 goals, 86 assists and 201 points.

Gerry Odrowski: 155 games, 10 goals, 63 assists and 73 points.

Paul Curtis: 76 games, 4 goals, 15 assists and 19 points.

Reg Thomas: 127 games, 22 goals, 34 assists and 56 points.

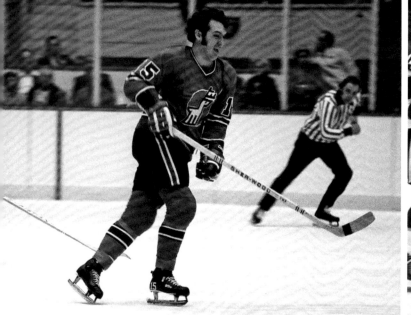
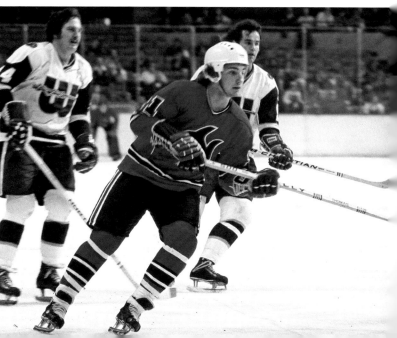

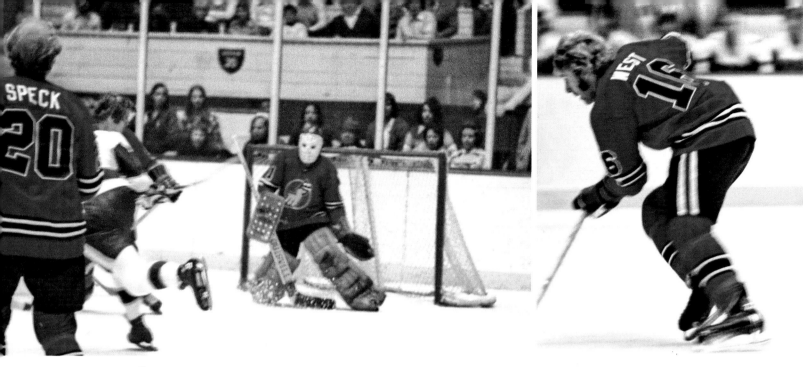

Russ Gillow: 56 games, 21 wins and 26 losses.

Steve West: 50 games, 15 goals, 18 assists and 33 points.

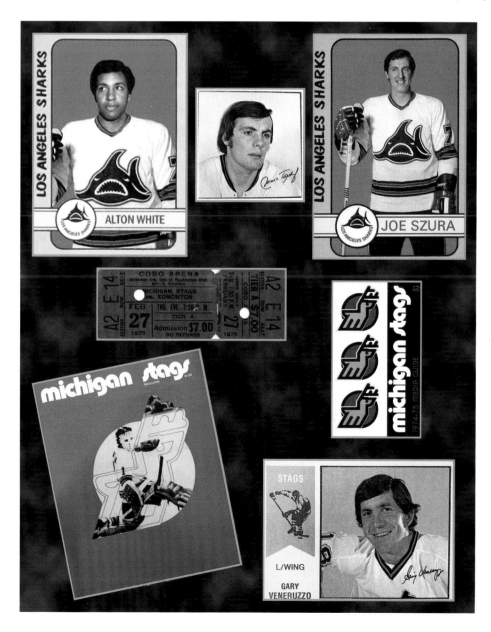

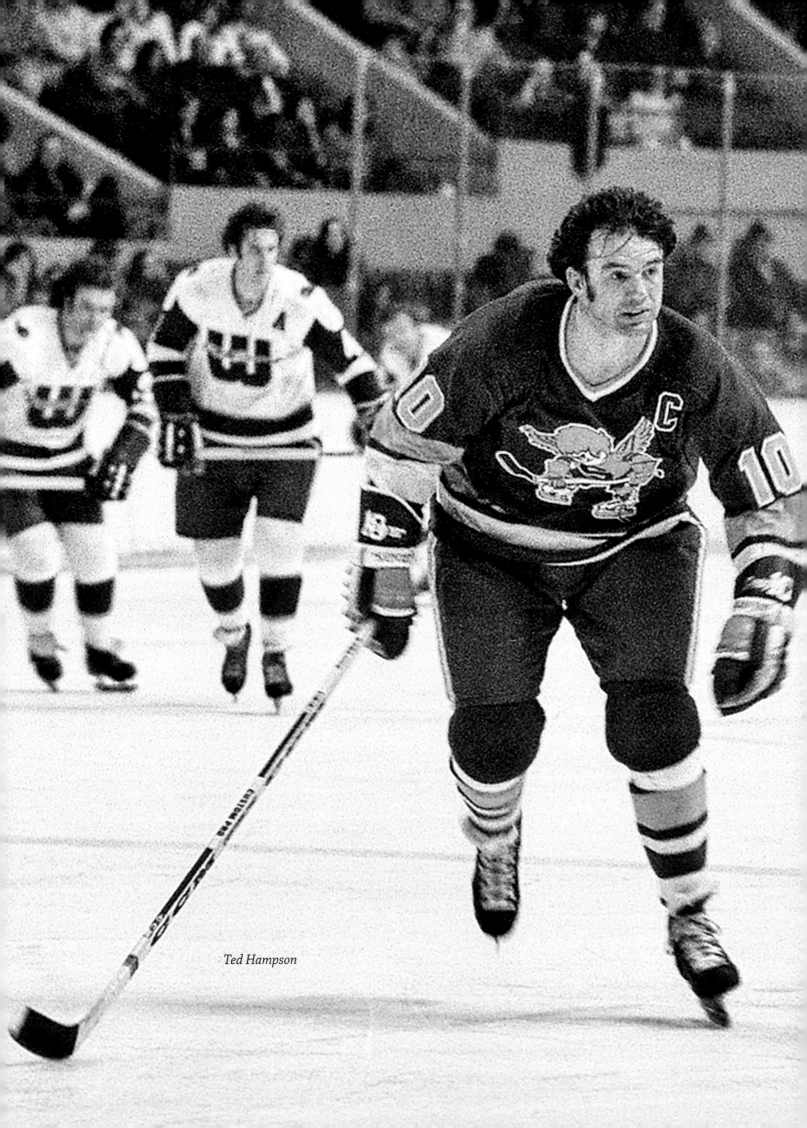
Ted Hampson

MINNESOTA FIGHTING SAINTS ('72 – '76)

The Saints may not have been the best team in the WHA, but they were certainly the most colorful.

In 1971 a franchise, one of the Original Twelve, was granted to a group of nine Minnesota businessmen led by Wayne Belisle. Most were silent partners; Belisle would be the president of the club.

Like the Whalers, the Saints wanted to stock the team with as many local players as possible. In fact, in their first season 10 of their 24 players were Americans—rare in professional hockey at the time. Some turned out to be one-season wonders, but many contributed to the success and popularity of the team, including Mike Antonovich, who would play seven of his twelve pro years in the WHA, defenseman John Arbour and 1960 Olympic gold medal winning goalie Jack McCartan. Many NHL veterans helped strengthen the team, notably Mike Walton, Wayne Connelly and Ted Hampson.

The first coach and GM was Glen Sonmor, an NHL veteran who most recently had been a coach with the Minnesota Golden Gophers college team. It was the Gophers that proved a serious rival to the Saints, as unlike in most other WHA cities, the college game was a major draw. Sonmor would soon step down as coach to focus on his duties as general manager. He was replaced by Harry Neale, who remained the team's coach until the original team folded.

Wayne Connelly

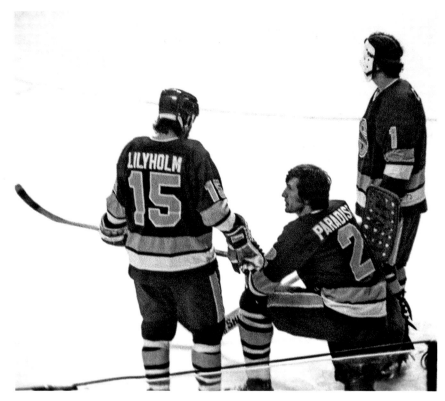

Len Lilyholm, Dick Paradise and Mike Curran

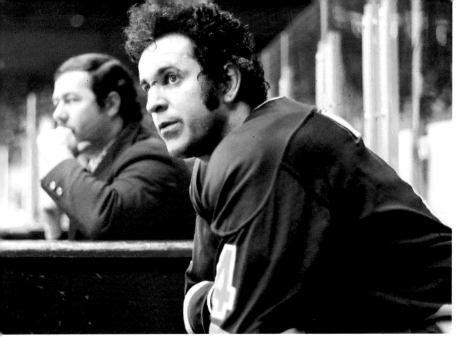
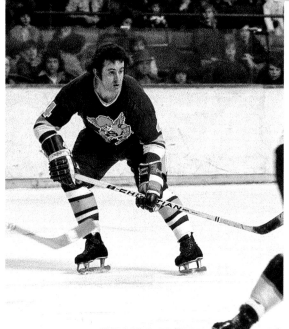

Mike Walton

Rick Smith

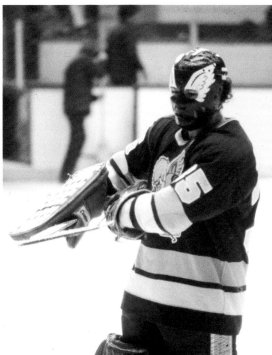

John Garrett

John McKenzie

The Saints always had winning teams even if they never won a championship. They played their first season in the 5,000-seat Roy Wilkins Auditorium before moving into the more spacious St. Paul Civic Center. Holding 16,000 fans for hockey, the Civic Center was known for its clear acrylic dasher boards. Because of the unusual dimensions of the building, the clear boards provided better spectator sight lines, but they could be disconcerting for players not used to them.

They were also known for their rough style of play. In fact, their minor league affiliate Johnstown Jets inspired the Charlestown Chiefs in the cult classic movie *Slap Shot*. The Carlson brothers, Jack, Jeff and Steve, were the model for the Hanson brothers, with Jeff and Steve playing the roles. Jack was unable to fill out the trio in the film as he was called up by the Oilers

for the playoffs. In his place, Dave Hanson, no stranger to dropping the gloves himself, took the role of Jack Hanson.

Another Saints alumnus, Bill "Goldie" Goldthorpe was the inspiration for *Slap Shot*'s Ogie Ogilthorpe, right down the plush afro and nasty attitude. A "have fists, will travel" journeyman, Goldthorpe played for ten minor league and four WHA teams. His total of 132 penalty minutes in just 194 professional games is not likely to be matched.

While the real Saints played a physical game, it wasn't all goon hockey. They always had a winning club, later adding NHL veterans such as Rick Smith, Dave Keon, John Garrett and John McKenzie. Paul Holmgren played his first season with Minnesota before beginning his long NHL career.

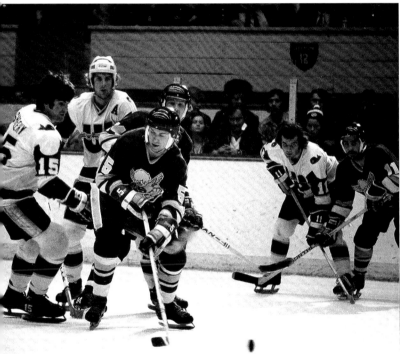

Don Tannahill, Gary Gambucci and Murray Heatley

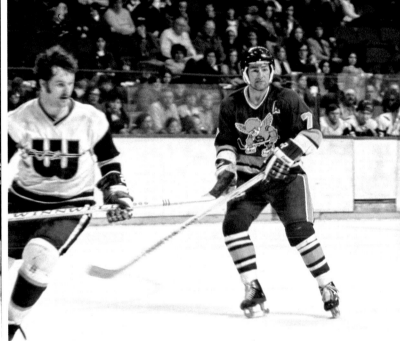

Wayne Connelly

John Arbour

Danny O'Shea

Dave Keon

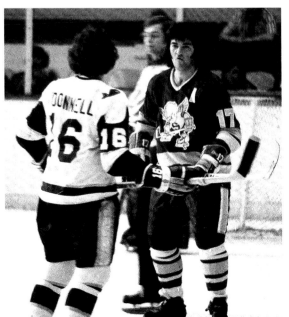

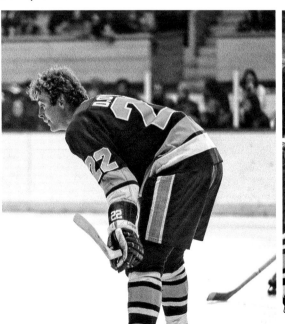

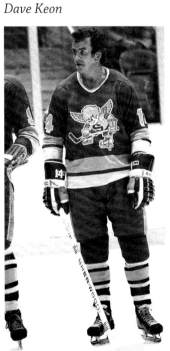

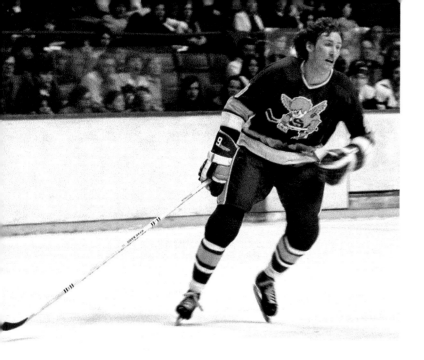

George Morrison

But, like many WHA teams before them, money (or the lack thereof) was an obstacle. Team President Wayne Belisle tried to keep the team afloat until sufficient funds could be raised, even getting the players to agree to play despite not being paid. Another plan had the players becoming partners, as had been tried in Chicago with the Cougars, but nothing came of it. Original investor Jock Irvine was reported to be negotiating to sell the franchise, eyeing Miami as a likely destination.

The biggest obstacle for potential buyers was that no investors wanted to assume the team's debts or payroll. Some investors expressed interest, but in the end the owners and potential buyers couldn't come to an accord. So, despite the on-ice success of the team,

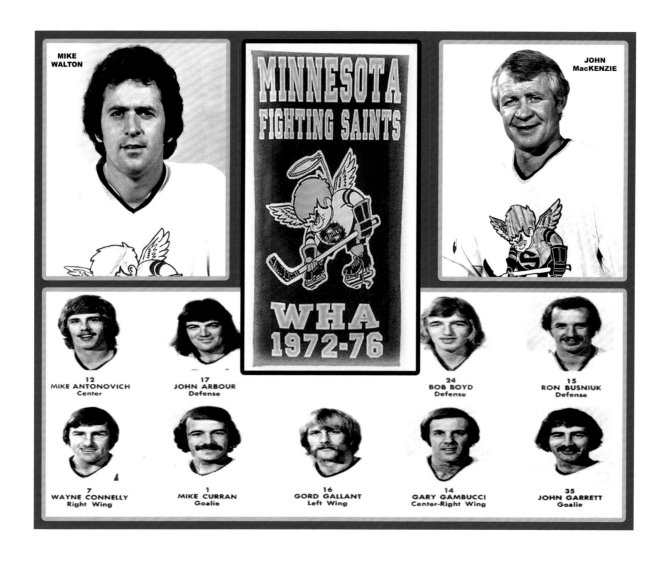

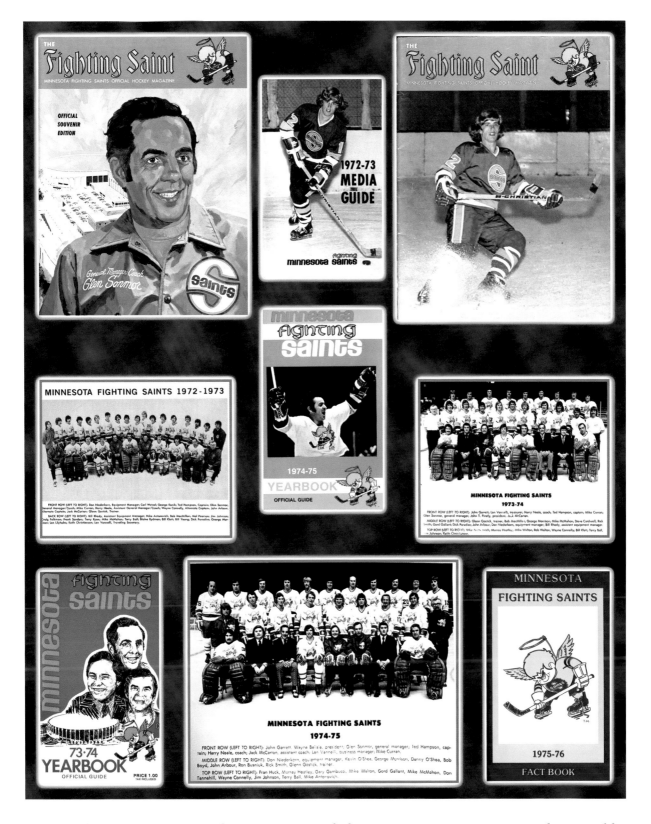

keeping the team running, and more importantly keeping it in Minnesota, proved impossible. It was announced that the team would fold, and the Fighting Saints played their last game on February 25, 1976.

It wasn't the end, however. When the NHL moved the struggling Golden Seals to Cleveland (where they would play as the Barons), Crusaders owner Nick Mileti decided to move the team to Minnesota, now dubbed the "New" Fighting Saints. It didn't work out; the new team folded after only 42 more games.

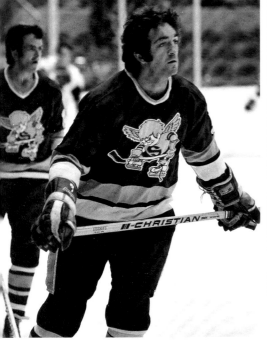

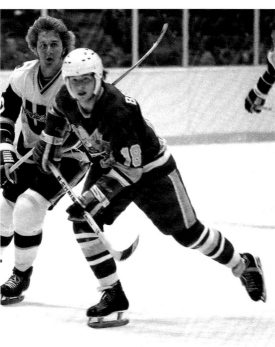

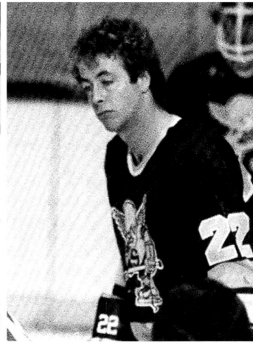

Rick Smith: 200 games, 20 goals, 89 assists and 109 points.

Bruce Boudreau: 30 games, 3 goals, 6 assists and 9 points.

Danny O'Shea: 76 games, 16 goals, 25 assists and 41 points.

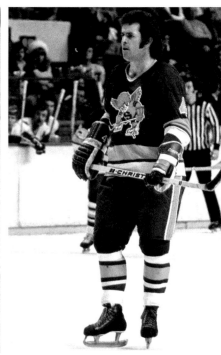

Wayne Connelly: 291 games, 144 goals, 140 assists and 284 points.

Mike Antonovich: 309 games, 117 goals, 116 assists and 233 points.

Mike Walton: 211 games, 136 goals, 145 assists and 281 points.

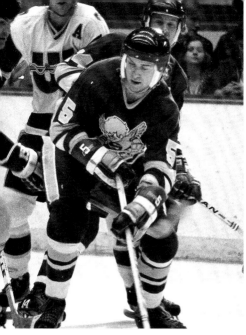
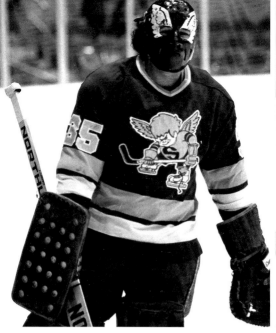

Don Tannahill: 72 games, 23 goals, 30 assists and 53 points.

John Garrett: 150 games, 77 wins and 63 losses.

Mike McMahon: 200 games, 27 goals, 89 assists and 116 points.

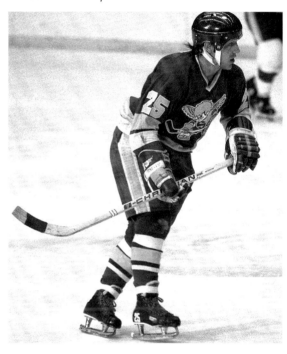
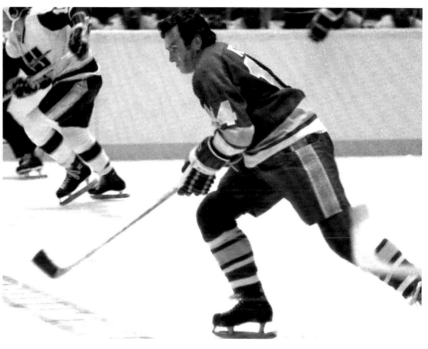

Fran Huck: 137 games, 39 goals, 77 wins and 116 losses.

Dave Keon: 99 games, 39 goals, 76 assists and 115 points.

Gord Gallant: 175 games, 23 goals, 34 ssists and 57 points.

Ted Hampson: 291 games, 56 goals, 134 assists and 190 points.

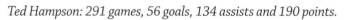
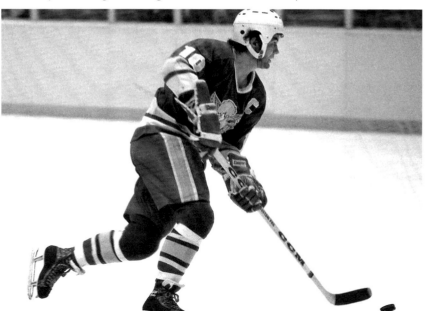
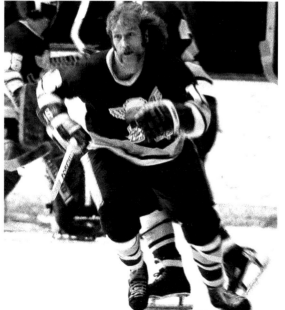

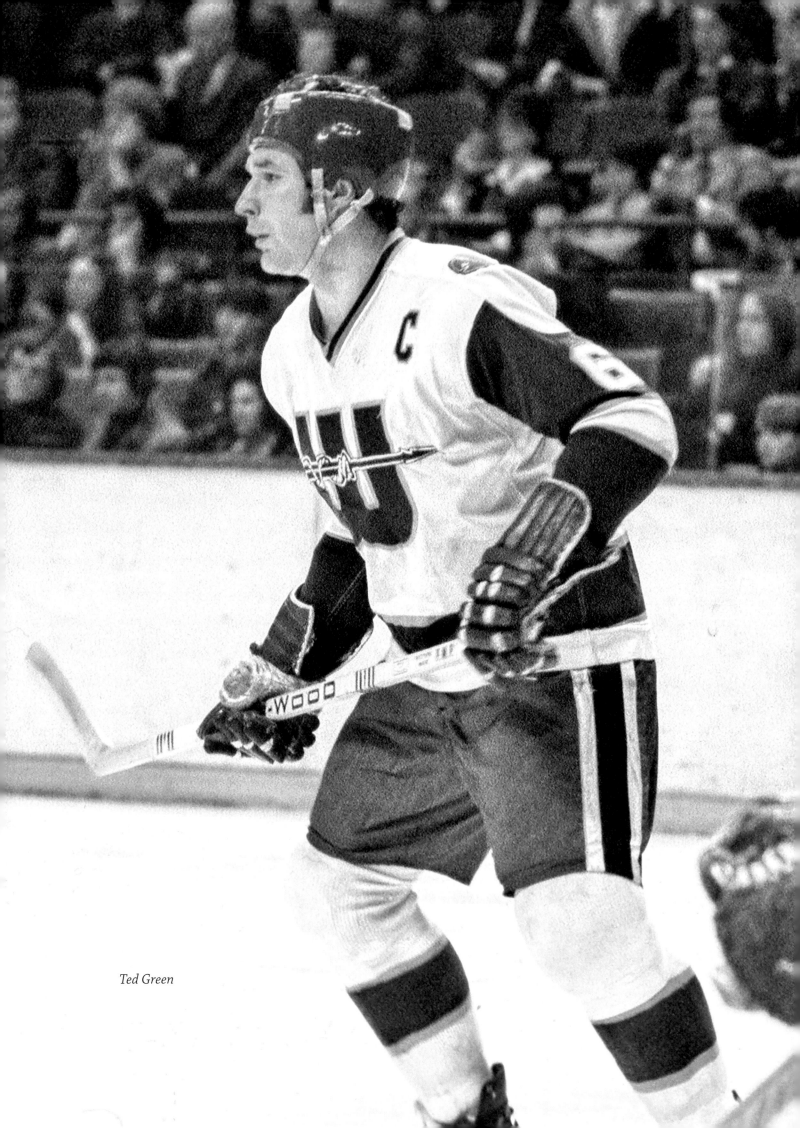

Ted Green

NEW ENGLAND WHALERS ('72–'79)

In the early 1970s, the Boston area was hockey mad. The "Big, Bad Bruins" ruled the day, with their AHL farm club the Braves not far behind. The Whalers weren't the only team to call an established NHL city home; the Philadelphia Blazers, New York Raiders, Chicago Cougars and Los Angeles Sharks shared that claim, though none of them would last.

Businessman and entrepreneur Howard Baldwin felt that the area could support a new team. It wouldn't be easy, but it could be done. The New England Whalers were established as a charter member of the WHA when a franchise was awarded to a group consisting of Baldwin, John Coburn, Godfrey Wood and William Barnes. They would play primarily in Boston Garden and the Boston Arena.

Seeking immediate credibility and to appeal to Boston fans, they signed local talent such as Bruins star Ted Green (the team's first captain), colorful journeymen such as Tommy "The Bomber" Williams, who had established himself as a rare American in the NHL, Tom Webster, Terry Caffery and goaltender Al Smith. They also went against conventional thinking and signed American Olympic and college players such as Larry Pleau, Kevin Ahearn, John Cunniff and Paul Hurley. Also filling out the roster were underused but talented NHL players Jim Dorey, Tim Sheehy and Rick Ley. Not surprisingly, the first coach was Jack Kelley, who had found success as a college coach at hockey powerhouse Boston University.

The most famous player to sign with the Whalers was Ted Green. "Terrible Ted" (as he was known due to his aggressive, often violent style of play) had suffered a near-fatal injury from a stick fight in a 1969 exhibition game against the St. Louis Blues. A blow to the head crushed his skull and left him paralyzed on his left side. He missed the entire 1969–70 season then returned to play two more years with the Bruins before jumping to the Whalers, where he was named the captain. The Whalers shared the Garden ice with the Bruins and AHL Braves, although many games were played in the antiquated Boston Arena. That first season he would help the Whalers win the first WHA championship on Boston Garden ice, defeating Winnipeg four games to one. It would be the Whalers' only championship.

After three seasons with New England, Green was traded to the Winnipeg Jets, by now the powerhouse of the league. After four seasons with the Jets he retired as a player but continued on as a coach, most notably with the Edmonton Oilers.

Al Smith was backed up in net by Bruce Landon, who would spend his entire five-year career with New England. Later additions would include Swedish twins Christer Abrahamsson in net and Thommie Abrahamsson on defense—the WHA was ahead of the NHL in signing European players. John "Pie" McKenzie joined the team after stints with Philadelphia, Vancouver, Cincinnati and both versions of the Fighting Saints. The immensely popular spark plug (he stood only

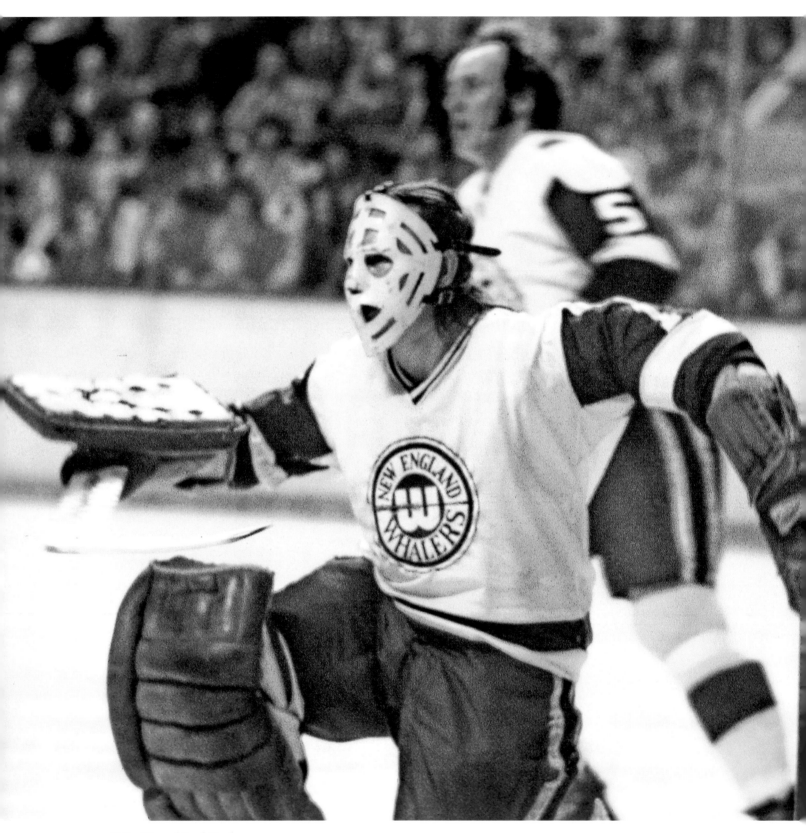

Al Smith and Paul Hurley

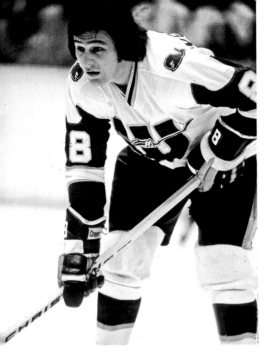

Tom Webster

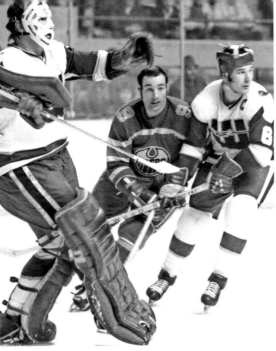

Al Smith and Ted Green

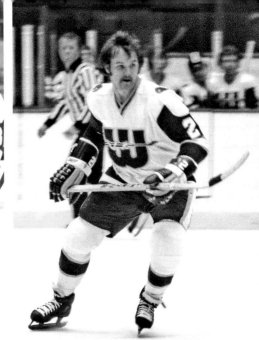

Rick Ley

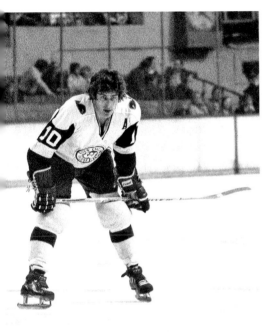

Jim Dorey

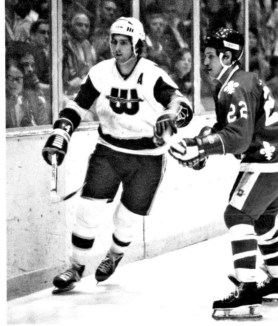

Larry Pleau and Francois Lacombe

Dave Keon

Thommie Abrahamsson

Christer Abrahamsson

Tim Sheehy

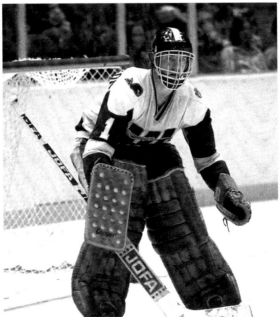

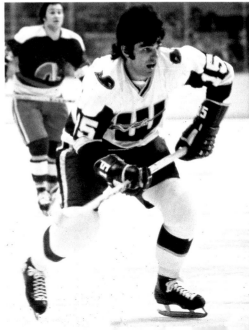

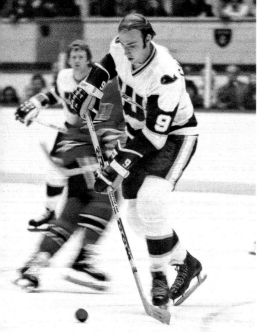

Wayne Carleton

Ralph Backstrom

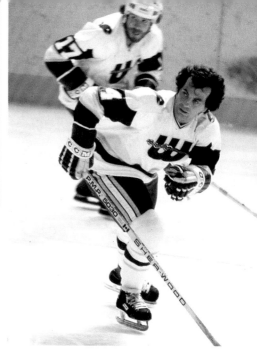

André Lacroix and Mike Rogers

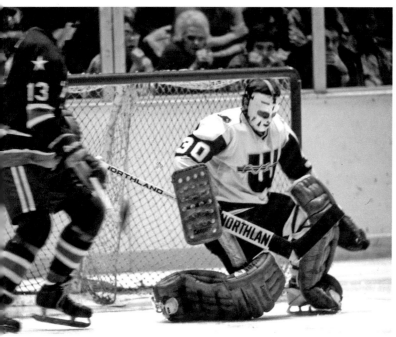

Bruce Landon

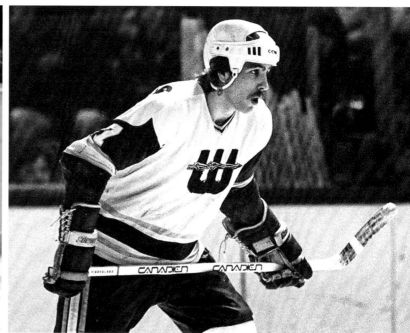

Gordie Roberts

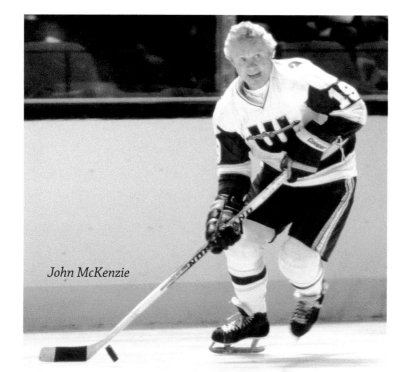

John McKenzie

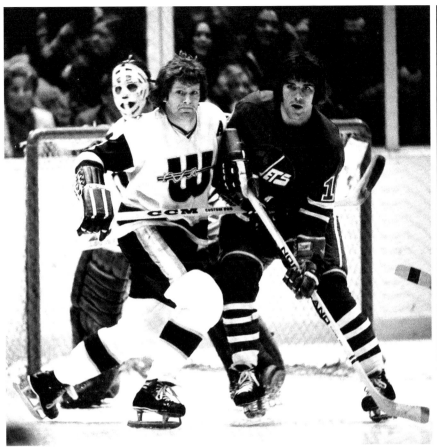

Brad Selwood

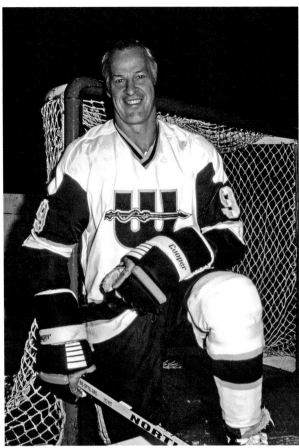

Gordie Howe

5'9") ended his 19-year playing career after three season with the Whalers. Steve Carlson is best remembered as one of the Hanson brothers in *Slap Shot*. He and brother Jack both played for the Whalers—Steve for two years, Jack for three. Originally a Maple Leaf, Brad Selwood played 431 games in the WHA, all with the Whalers. Rick Ley suited up for all seven seasons of the Whalers'

Brad Selwood, Rick Ley, Doug Roberts, Paul Hurley, Gary Swain and Nick Fotiu

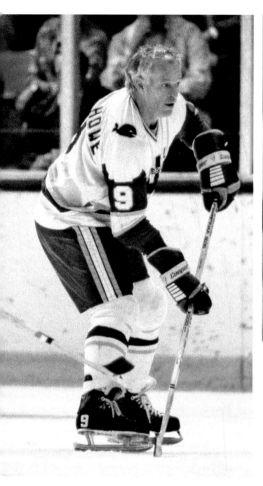

Gordie Howe

Mark Howe

Marty Howe

existence, from 1972 to 1979. He played his last two seasons with Hartford, then in the NHL. At only 17, Gordie Roberts was one of the WHA's underage junior signings. He played four seasons with New England before embarking on a long NHL career.

A major coup for the team was the signing of Gordie, Mark and Marty Howe. After winning two Avco Cups in Houston, the Howes came to New England as free agents. Mark would play two WHA seasons there, becoming a Hartford Whaler after the league merger. Marty would also play two seasons with New England, followed by a long career in Hartford.

Even though they played in the shadow of the Bruins, the Whalers were popular with Boston fans. They were a winning team too, taking the first WHA championship. Despite the team's successes, however, they were number three in the pecking order behind the Bruins and even the minor league Braves when it came to playing dates—fourth if you count the Celtics.

Ownership decided to move the team to Hartford, Connecticut. Their thinking was that Hartford would be a good fit, as hockey was popular and they didn't have a team to call their own. They were right. Hartford embraced the new team; their first game on January 11, 1975, at the Hartford Civic Center was a sellout.

The fan base continued to grow and even followed the team to Springfield after the roof of the Civic Center collapsed in 1978 due to heavy snow. The team would return to Hartford in 1980 as the Hartford Whalers of the NHL.

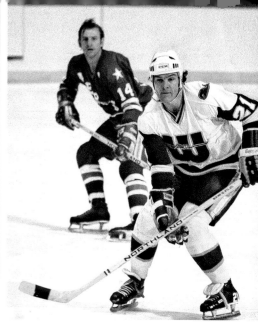

Doug Roberts: 140 games, 7 goals, 31 assists and 38 points.

Bill Butters: 73 games, 2 goals, 21 assists and 23 points.

Mike Byers: 190 games, 51 goals, 54 assists and 105 points.

Dave Hynes: 22 games, 5 goals, 4 assists and 9 points.

John Danby: 150 games, 16 goals, 25 assists and 41 points.

Guy Smith: 38 games, 4 goals, 8 assists and 12 points.

Al Karlander: 125 games, 27 goals, 55 assists and 82 points.

Rosaire Paiement: 93 games, 33 goals, 45 assists and 78 points.

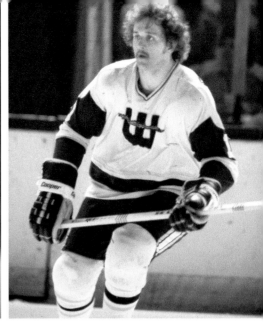

Tommy Williams: 139 games, 31 goals, 58 assists and 89 points.

Gordie Roberts: 393 games, 42 goals, 144 assists and 186 points.

Alan Hangsleben: 334 games, 36 goals, 73 assists and 109 points.

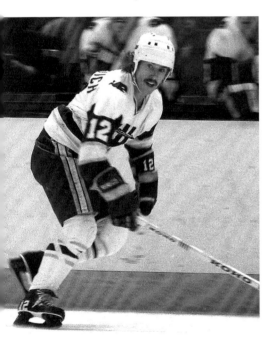

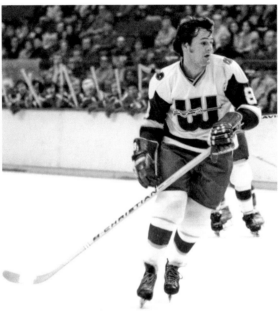

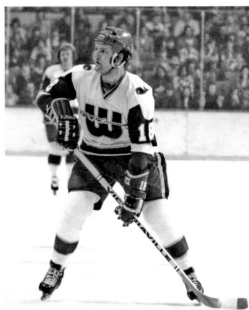

Mike Antonovich: 170 games, 64 goals, 71 assists and 135 points.

Tom Webster: 352 games, 220 goals, 205 assists and 425 points.

Bob Charlebois: 110 games, 8 goals, 10 assists and 18 points.

Terry Caffery: 143 games, 54 goals, 98 assists and 152 points.

Dick Sarrazin: 35 games, 4 goals, 7 assists and 11 points.

Paul Hurley: 215 games, 9 goals, 66 assists and 75 points.

John Garrett: 41 games, 20 wins and 17 losses.

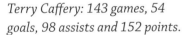

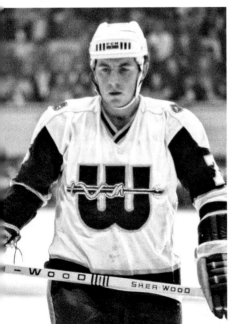

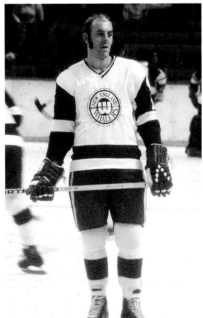

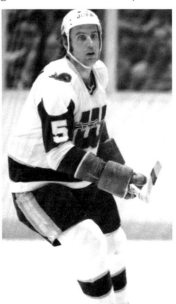

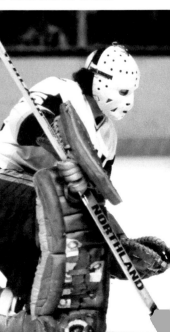

Mike Rogers: 274 games, 98 goals, 159 assits and 257 points.

Jack Carlson: 136 games, 18 goals, 32 assists and 50 points.

Steve Carlson: 69 games, 10 goals, 16 assists and 26 points.

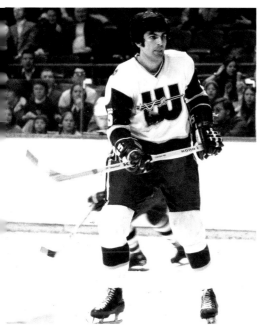

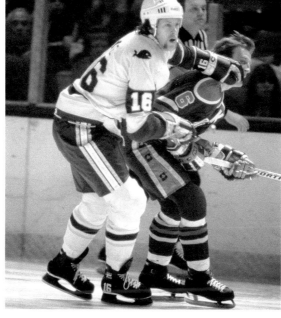

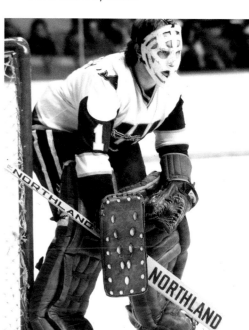

Tim Sheehy: 232 games, 91 goals, 91 assists and 182 points.

George Lyle: 202 games, 86 goals, 75 assists and 161 points.

Al Smith: 260 games, 141 wins and 98 losses.

Fred O'Donnell: 155 games, 32 goals, 26 assists and 58 points.

Thommie Abrahamsson: 203 games, 28 goals, 67 assists and 95 points.

Larry Pleau: 468 games, 157 goals, 215 assists and 372 points.

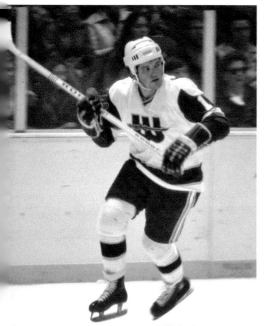

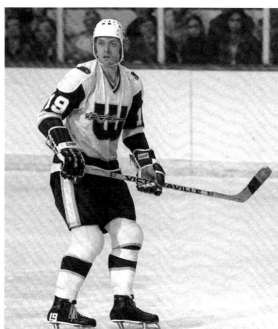

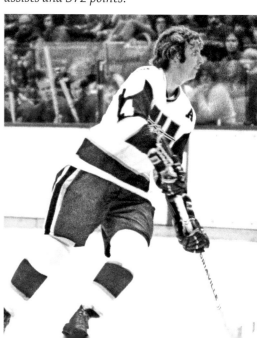

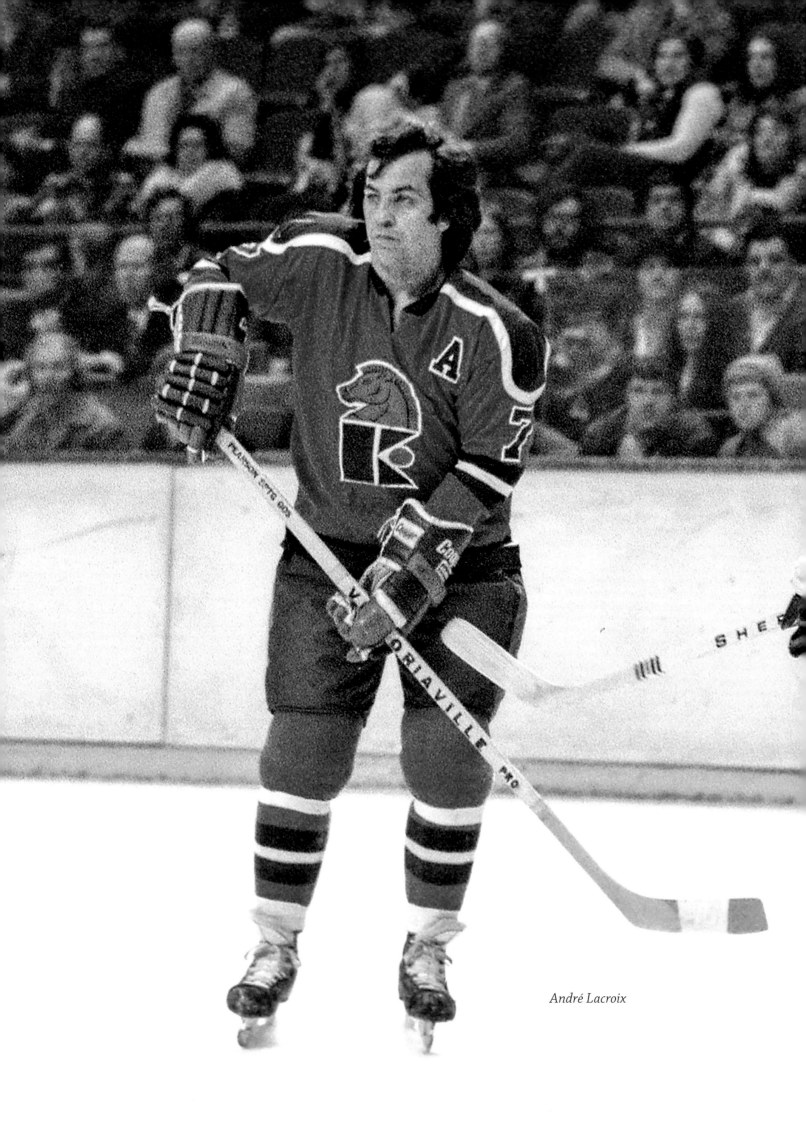

André Lacroix

NEW YORK RAIDERS ('72–'73) / GOLDEN BLADES ('73) / JERSEY KNIGHTS ('73–'74) / SAN DIEGO MARINERS ('74–'77)

The Raider were vagabonds, even by WHA standards. A charter member of the league, the Big Apple–based team was intended to be the flagship franchise, helping to give the league legitimacy and rival the NHL's Rangers. It didn't work out that way.

In addition to the Rangers, they had to compete with the expansion Islanders, who entered the NHL in 1972–73, the same year the WHA started playing. The Raiders, in fact, had initially planned to base the team in Long Island at the Nassau Veterans Memorial Coliseum, a new arena that could seat over 16,000 for hockey. The owners, Nassau County, wanted nothing to do with the fledgling league, and instead convinced the NHL to approve an expansion team to play there.

The team hired Rangers legend Camille Henry as their coach, once again hoping to appeal to New York fans. They also signed able veteran centers Ron Ward and Bobby Sheehan, wingers Wayne Rivers and Norm Ferguson and defenseman Ken Block. But player personnel wasn't the problem.

Brian Bradley Bob Winograd Jamie Kennedy Jarad Krupicka
Ian Wilkie Peter Donnelly Gary Kurt

Alton White

Ron Ward

Ron Ward and Wayne Rivers

Claude Chartre

With Long Island off the table, the team played in Madison Square Garden, the home of the rival Rangers. The situation proved untenable: high costs and low attendance dogged the Raiders, and the owners defaulted mid-season, causing the league to take over. It was a major embarrassment for the WHA, who worked hard to establish themselves as a second major league, not an oddity.

Ralph Brent, a New York real estate mogul, bought the team and, unfortunately, changed the name to the Golden Blades. Brent ordered new purple and gold uniforms that included, yes,

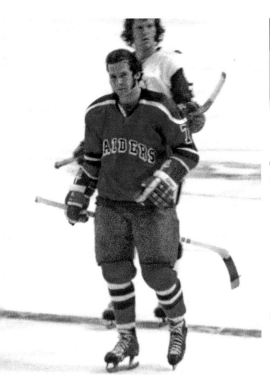

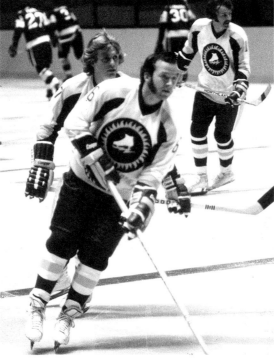

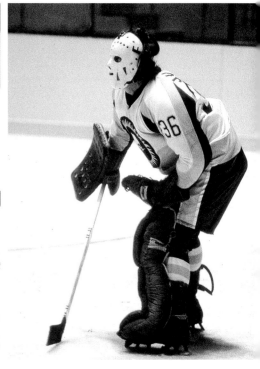

Bobby Sheehan

Joe Junkin

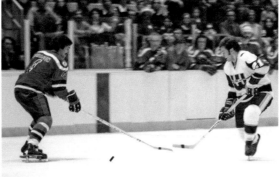
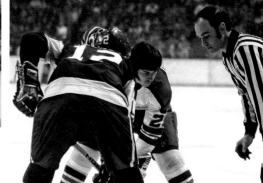

Harry Howell and Norm Ferguson Kevin Morrison and Mike Byers Gene Peacosh

golden skate blades (and white skates at first) and hoped the team would be worth the investment. It wasn't. The team was still playing in Madison Square Garden in the long shadow of the Rangers.

They were able to sign André Lacroix, who scored 111 points. The team also acquired another Rangers legend in Harry Howell, who was named player-coach and ordered the team's white skates painted black.

They drew poorly at MSG, even more poorly than the Raiders did. Most nights they would play to crowds of 500 in an arena that held 18,000 for hockey. Unable to make the team profitable, or even viable, Brent gave up. Once again, the failing team was under league control. In November 1973 they moved again, marking the team's third name and second home in less than two full seasons. Hoping to fill the gap left by the departed Philadelphia Blazers, the now Jersey Knights took up residence in the antiquated Cherry Hill Arena, which held roughly 4,000 fans and had outdated and in some cases nonexistent facilities. It immediately became clear that a new home had to be found.

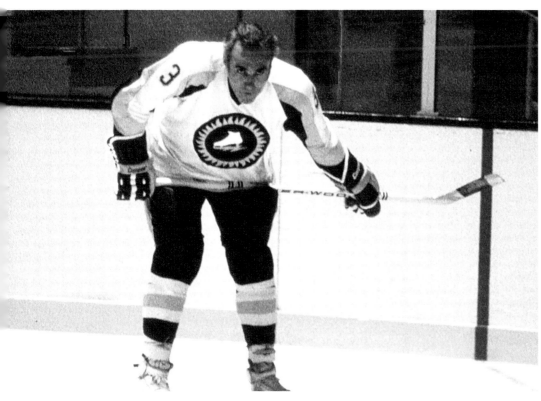
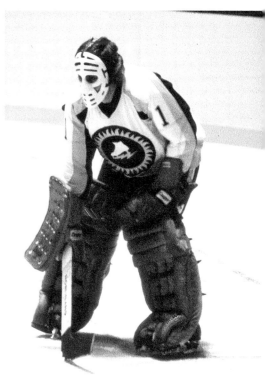

Harry Howell Jim McLeod

Norm Ferguson *Brian Perry* *André Lacroix*

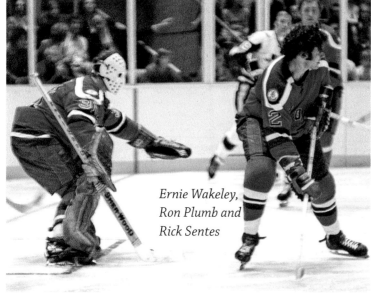

Ernie Wakeley, Ron Plumb and Rick Sentes

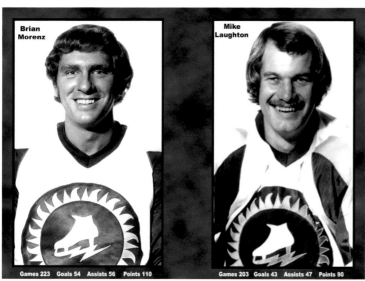

In 1974 the team was purchased by Joe Schwartz, a Baltimore-based businessman. Many thought that the team would be moving to that city, but instead it was relocated to San Diego as the San Diego Mariners. With the team reverting to the original Raiders colors of blue and orange, they hoped to find new life on the West Coast. And for a while they did, mostly due to Harry Howell, still serving as player-coach, André Lacroix, Wayne Rivers, Kevin Morrison, captain Norm Ferguson and goalie Ernie Wakely. But attendance was still poor, drawing only around 5,000 fans per game at the San Diego Sports Arena, less than half of the building's capacity.

They lasted four years in San Diego. Ray Kroc, the McDonald's magnate who also owned the San Diego Padres, bought the team with the hopes of relocating it, most likely to Melbourne, FL. When that failed due to a lack of a suitable arena, Krok sold the team to Bill Putnam, who changed the

name to the Florida Breakers but couldn't get a foothold in the Sunshine State, unable to work up a fanbase. Then Jerry Saperstein, son of Globetrotters founder Abe Saperstein, wanted to buy the team, also with plans to relocate to Florida. This also fell through, and the Mariners folded in fall 1977, just before the season started.

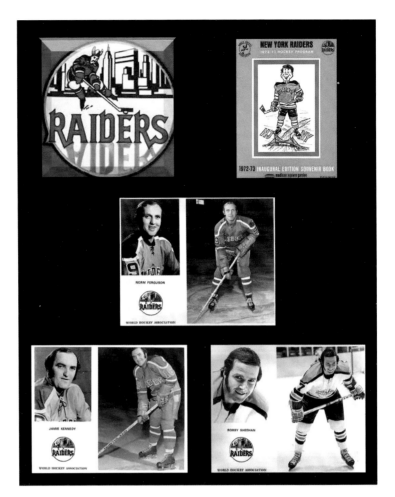

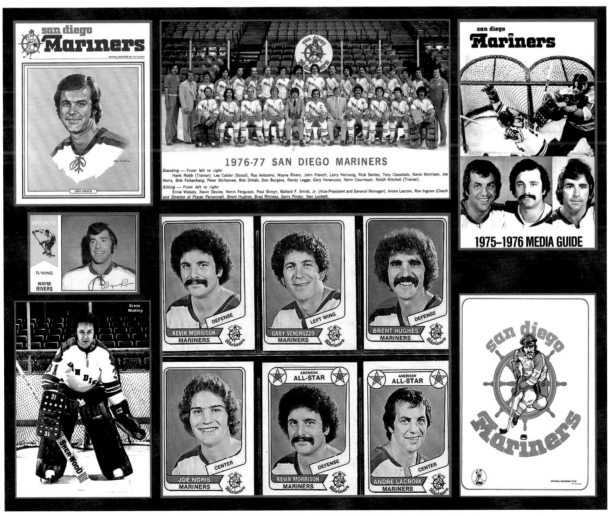

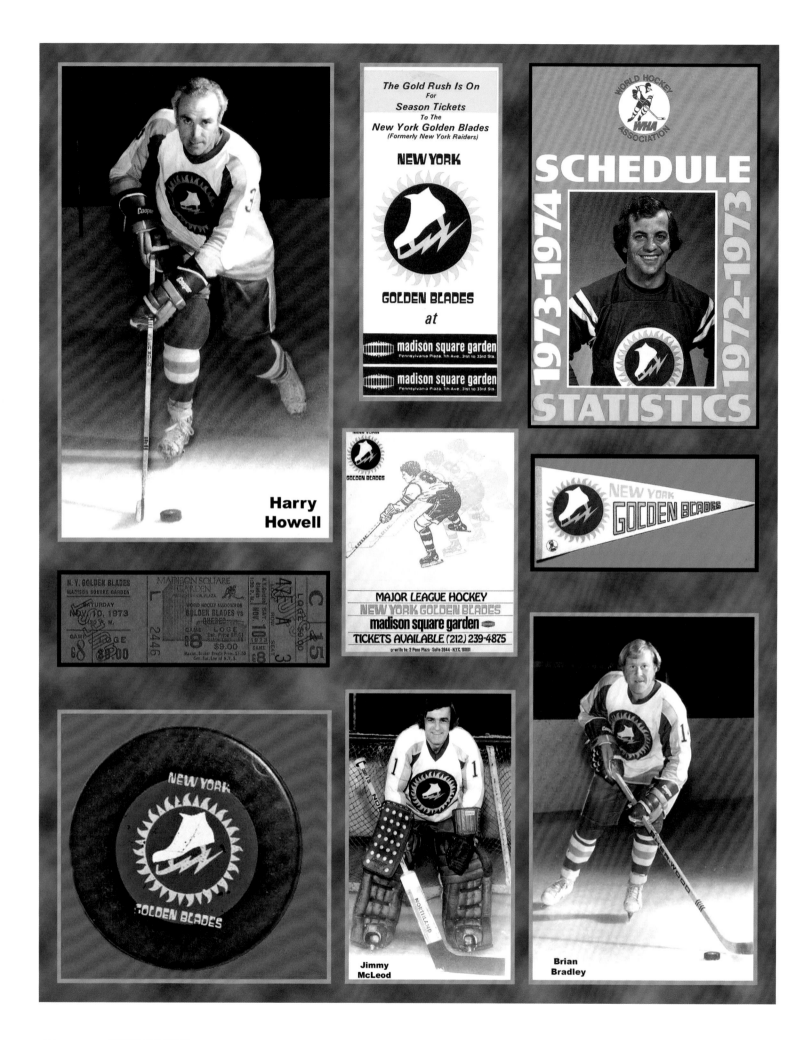

The Gold Rush Is On
For
Season Tickets
To The
New York Golden Blades
(Formerly New York Raiders)

NEW YORK

GOLDEN BLADES

at

madison square garden
Pennsylvania Plaza, 7th Ave., 31st to 33rd Sts.

madison square garden
Pennsylvania Plaza, 7th Ave., 31st to 33rd Sts.

1973-1974 SCHEDULE STATISTICS 1972-1973

Harry Howell

MAJOR LEAGUE HOCKEY
NEW YORK GOLDEN BLADES
madison square garden
TICKETS AVAILABLE (212) 239-4875
or write to: 2 Penn Plaza, Suite 2044 - N.Y.C. 10001

NEW YORK GOLDEN BLADES

NEW YORK
GOLDEN BLADES

Jimmy McLeod

Brian Bradley

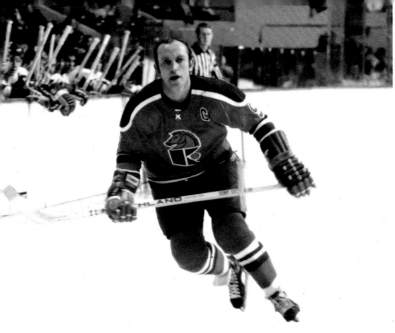
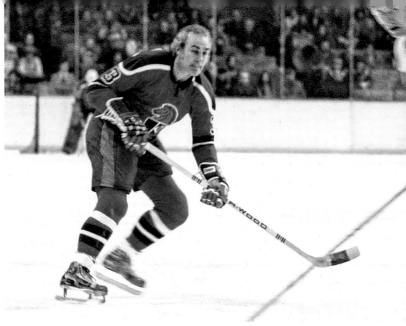

Norm Ferguson: 365 games, 148 goals, 163 assists and 311 points.

Harry Howell: 139 games, 7 goals, 33 assists and 40 points.

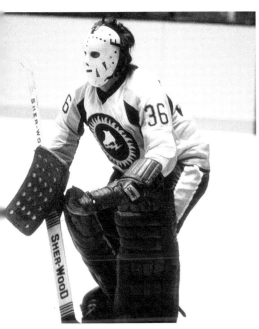

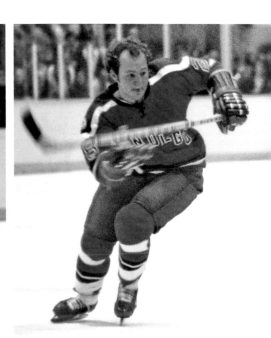

Joe Junkin: 69 games, 27 wins and 32 losses.

André Lacroix: 317 games, 133 goals, 340 assists and 473 points.

Jim Hargreaves: 84 games, 9 goals, 20 assists and 29 points.

Ernie Wakeley: 146 games, 77 wins and 57 losses.

Bob Faulkenberg: 221 games, 5 goals, 37 assists and 42 points.

Jim McLeod: 10 games, 3 wins and 7 losses.

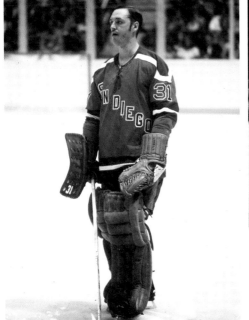

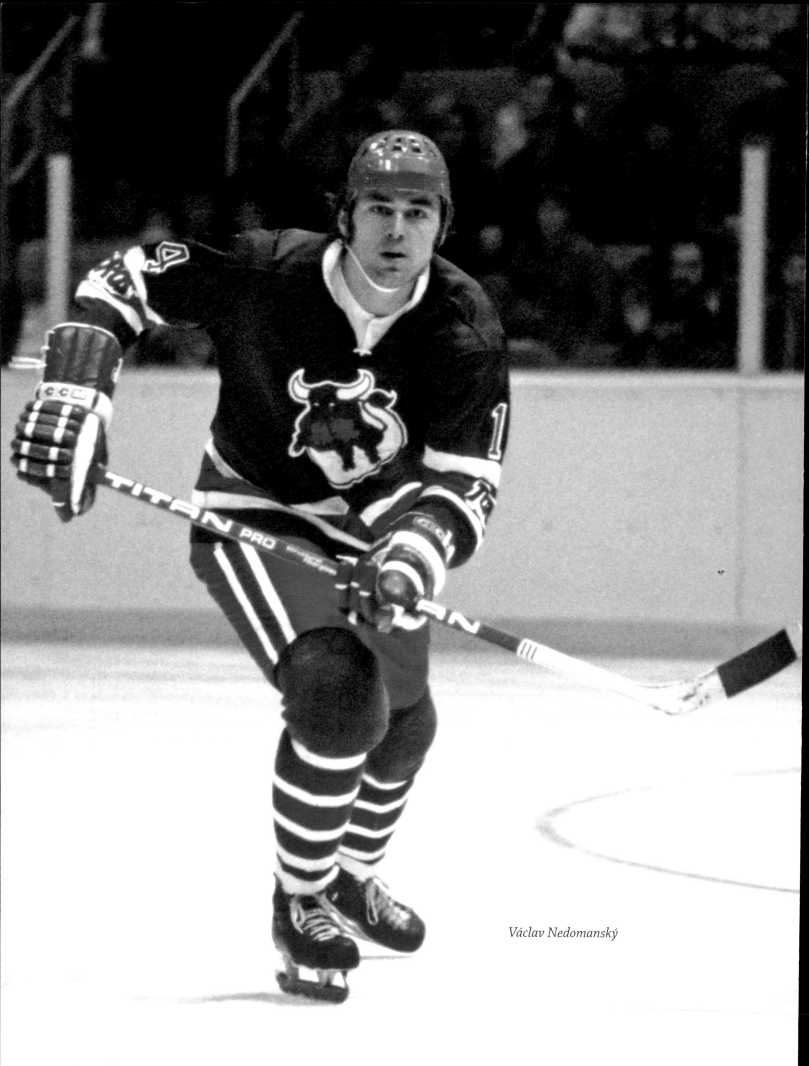

Václav Nedomanský

OTTAWA NATIONALS ('72 – '73) / TORONTO TOROS ('73 – '76) / BIRMINGHAM BULLS ('76 – '79)

When Toronto native Doug Michel realized that he could afford a WHA franchise for only $25,000 (plus $10,000 for league expenses and a $100,000 bond) he jumped at the chance to become a charter member.

Hoping to base his team in Toronto, he discovered that it wouldn't be easy. Leery of potential competition for box-office dollars, Maple Leafs owner Harold Ballard demanded such onerous terms that an agreement to play in Maple Leafs Gardens was out of the question. After a plan to locate the team in Hamilton failed (this attempt was also fought by the Leafs) Michel set his sights on Ottawa.

An agreement was made for the team, now dubbed the Ottawa Nationals, to play in the new Civic Centre. While still expensive, and a much smaller venue, it was better than the terms offered by the Leafs. Michel agreed to pay the Civic Centre $100,000 as a guarantee, plus rent and television money.

Now they had a home, but they had to build a team. That would take money—something that was in short supply. Michel was put in touch with Buffalo businessman Nick Trbovich. Trbovich

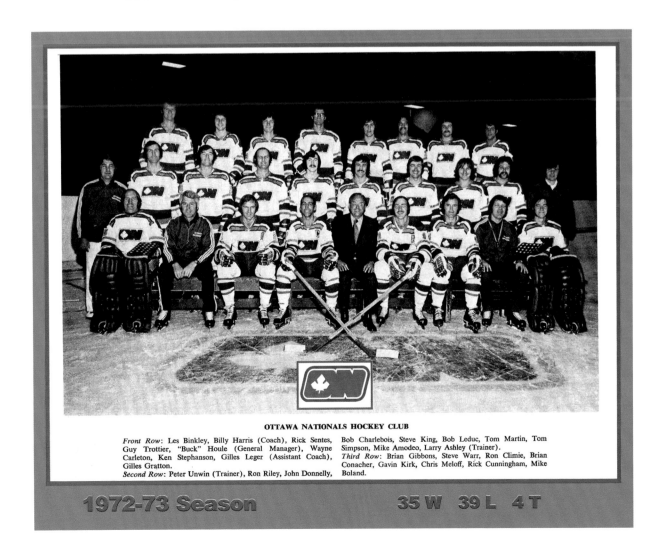

OTTAWA NATIONALS HOCKEY CLUB

Front Row: Les Binkley, Billy Harris (Coach), Rick Sentes, Guy Trottier, "Buck" Houle (General Manager), Wayne Carleton, Ken Stephanson, Gilles Leger (Assistant Coach), Gilles Gratton.
Second Row: Peter Unwin (Trainer), Ron Riley, John Donnelly, Bob Charlebois, Steve King, Bob Leduc, Tom Martin, Tom Simpson, Mike Amodeo, Larry Ashley (Trainer).
Third Row: Brian Gibbons, Steve Warr, Ron Climie, Brian Conacher, Gavin Kirk, Chris Meloff, Rick Cunningham, Mike Boland.

1972-73 Season **35 W 39 L 4 T**

Wayne Carleton

Gavin Kirk

Gilles Gratton

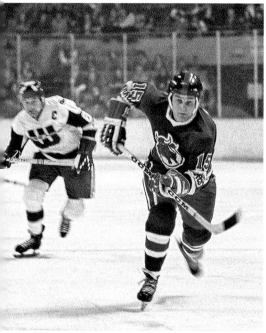

Brit Selby and Ted Green

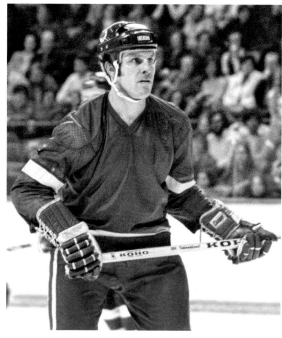

Carl Brewer

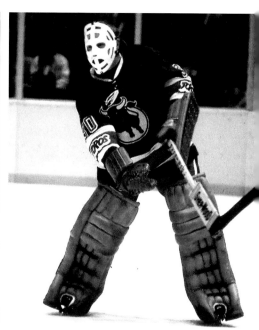

Les Binkley

Paul Henderson

Wayne Dillon

Jim Turkiewicz

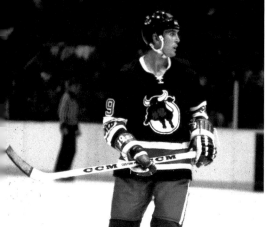

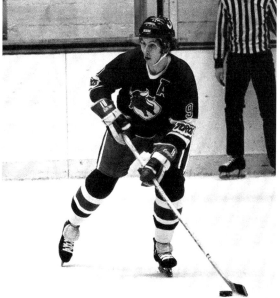

agreed to invest in the team, paying Michel $200,000 for 80 percent of the franchise, with Michel running the hockey side of things.

For a coach they hired Maple Leaf veteran Billy Harris. Players that season included Wayne "Swoop" Carleton. Carleton, a former Leaf and member of the 1970 Bruins Stanley Cup team, would lead the team in scoring with 91 points. Also signed were Gavin Kirk (28 goals, 40 assists), Bob Charlebois (24 goals, 39 assists) and Guy Trottier (26 goals, 36 assists). In net were veteran Les Binkley and the always-colorful Gilles Gratton.

While they were a decent team, even making the playoffs only to lose to the Whalers (who would go on to win the first Avco Cup), they still had trouble attracting fans. One problem was the size of the arena, even though they never played to a full house. They also lacked any big-name stars.

After that first season Michel and Trbovich sold the team to John F. Bassett for $1.8 million. Bassett, a former athlete, businessman, sports team owner, investor and broadcasting pioneer, immediately moved the team to Toronto and renamed them the Toros.

They were still unable to come to terms to play in Maple Leaf Gardens, despite having played their playoff games there the season before. Instead, they played in Varsity Arena, an even smaller venue than the Civic Centre. By 1974 they would move into Maple Leaf Gardens, where they would play for the rest of their time in Toronto.

The next move was to sign some new talent, especially former Leafs. Carl Brewer, a three-time Stanley Cup winner in Maple Leafs blue, was among the first. Following were Václav Nedomanský, Pat Hickey and Brit Selby They managed to put a decent team on the ice with a 41-33-4 record to finish second in WHA East Division.

The following season, 1974–75, proved to be even better. The jewel in the crown was Frank Mahovlich. Mahovlich, a six-time Cup winner (four with Toronto and two with Montreal) and

Frank Mahovlich

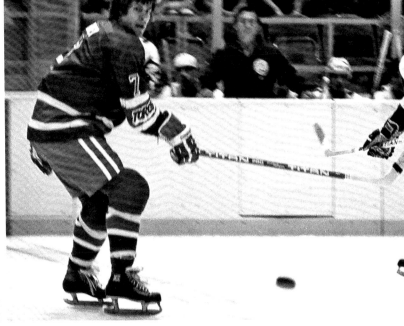

Jim Dorey

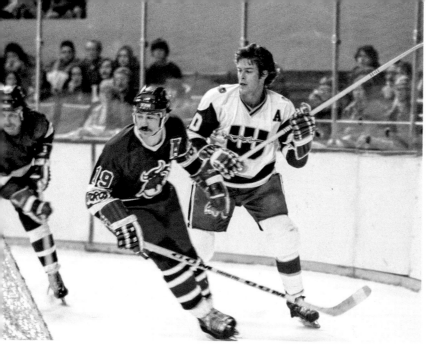

Bob LeDuc and Jim Dorey

1957 Calder Cup winner, brought a veteran presence. Unhappy with the way he was treated by the Leafs, especially by long-time coach Punch Imlach, he had been traded from Toronto to Detroit and later Montreal before returning to Toronto as a member of the Toros. Wearing his familiar No. 27, he brought 18 years of NHL experience to the new league as well as a much-needed level of legitimacy. He scored 82 points that year, second only to Wayne Dillon, who had 95.

Paul Henderson had become known as the hero of the 1972 Summit Series between NHL stars (no WHA players were included) and the powerhouse team from the Soviet Union. While not a first-rank star, Henderson became immortal with the scoring of "The Goal" in Game 8. He wasn't comfortable with the fame it brought and with the pressure of playing with the Leafs, so he accepted an "offer he couldn't refuse" from Toros owner John Bassett. Except for a brief comeback attempt in 1979–80, he would play the rest of his career in the WHA. He competed once more against the Soviets in 1974.

Václav Nedomanský is best known as the first player to defect from behind the Iron Curtain to play in North America. An Olympic star (he had won silver and bronze with his native

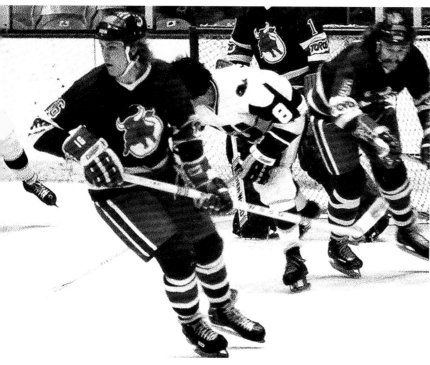

Pat Hickey

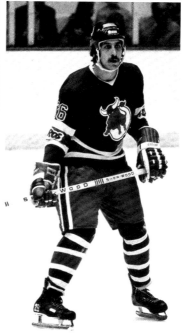

Tony Featherstone

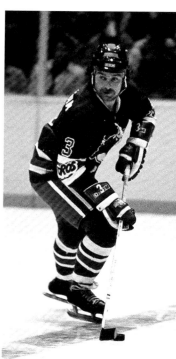

Rick Cunningham

Czechoslovakia), he thrived with the Toros, never scoring less than 81 points a season during his time in Toronto.

But, like many teams that shared ice with the NHL, they found themselves priced out of the market or subjected to poor dates and high arena rental prices. This was especially true in Toronto, where Leafs owner Harold Ballard did everything he could to make sure that no team other than the Leafs would succeed. As the NHL was doing WHA franchises no favors, nearly all moved on to smaller but more viable markets. For the Toros, it was the unlikely city of Birmingham, AL.

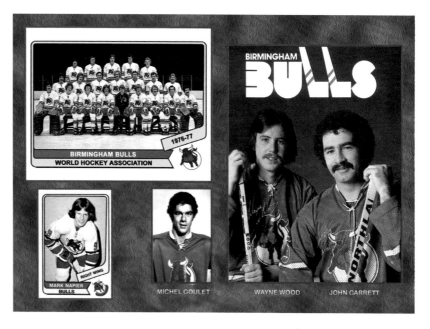

Birmingham may seem a strange home for a hockey team, but that's where the Toros, renamed the Birmingham Bulls (so they could use their old uniforms, minus the Toros sleeve patches), would call home from 1976 until the team folded in 1979.

With a losing record in their first season, 1976–77, they took a different

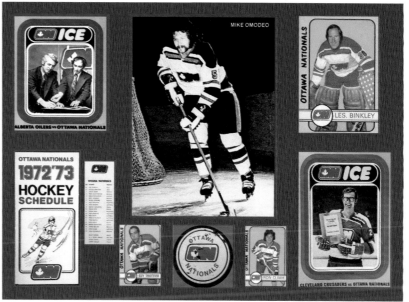

tack with the hiring of veteran player and coach Glen Sonmor. Under his leadership the Bulls were transitioned to an aggressive style of play. Despite setting penalty records, they still had a losing record. Long time minor league tough guy and coach John Brophy took the reins for the final season, but couldn't rise above a .500 win percentage, finishing 32-42-6.

They were not short of talent, with players who would go on to be NHL stars. Rick Vaive (in the first season of his 14-year career), Michel Goulet (who would later star with Quebec and Chicago in the NHL), Craig Hartsburg, Rob Ramage and Gaston Gingras, to name a few, also played for the franchise.

The Bulls weren't included in the NHL-WHA merger of 1979, mainly because Birmingham wasn't considered a major league city capable of supporting an NHL franchise.

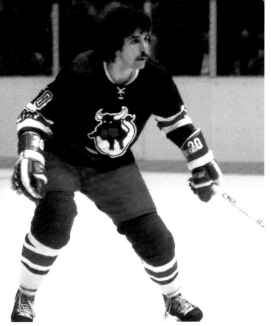

Peter Marrin: 278 games, 81 goals, 112 assists and 193 points.

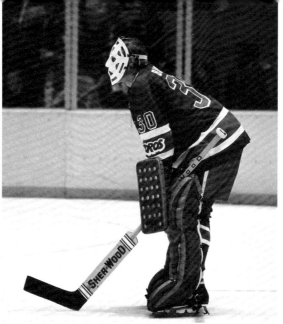

Les Binkley: 81 games, 30 wins and 36 losses.

Gavin Kirk: 325 games, 101 goals, 202 assists and 303 points.

Rick Foley: 11 games, 1 goal, 2 assists and 3 points.

Mark Napier: 237 games, 136 goals, 118 assists and 254 points.

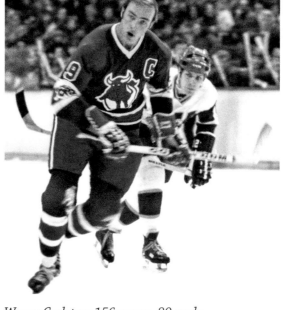

Wayne Carleton: 156 games, 80 goals, 105 assists and 185 points.

Guy Trottier: 149 games, 55 goals, 69 assists and 124 points.

Paul Henderson: 360 games, 140 goals, 143 assists and 283 points.

Jim Turkiewicz: 392 games, 24 goals, 119 assists and 143 points.

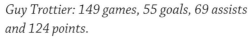

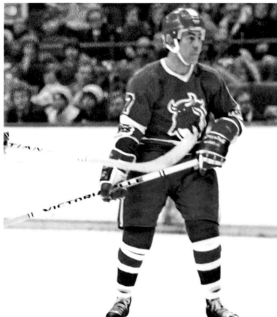

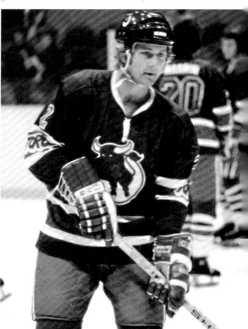

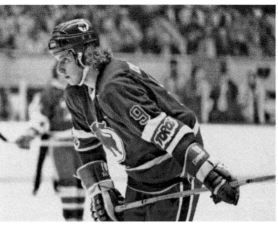

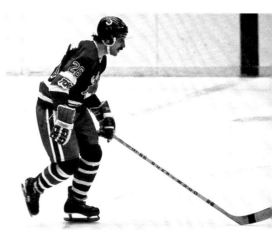

Jim Shaw: 37 games, 11 wins and 16 losses.

Wayne Dillon: 212 games, 71 goals, 128 assists and 199 points.

Tony Featherstone: 108 games, 29 goals, 45 assists and 74 points.

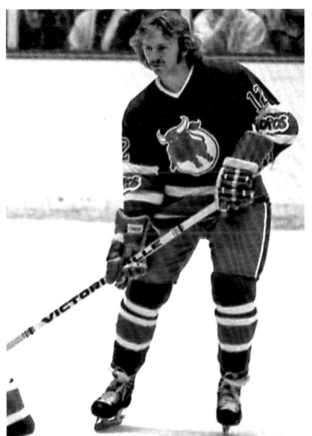

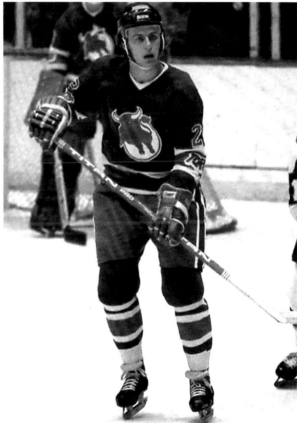

Tom Simpson: 299 games, 122 goals, 82 assists and 204 points.

George Kuzmicz: 35 games, 0 goals, 12 assists and 12 points.

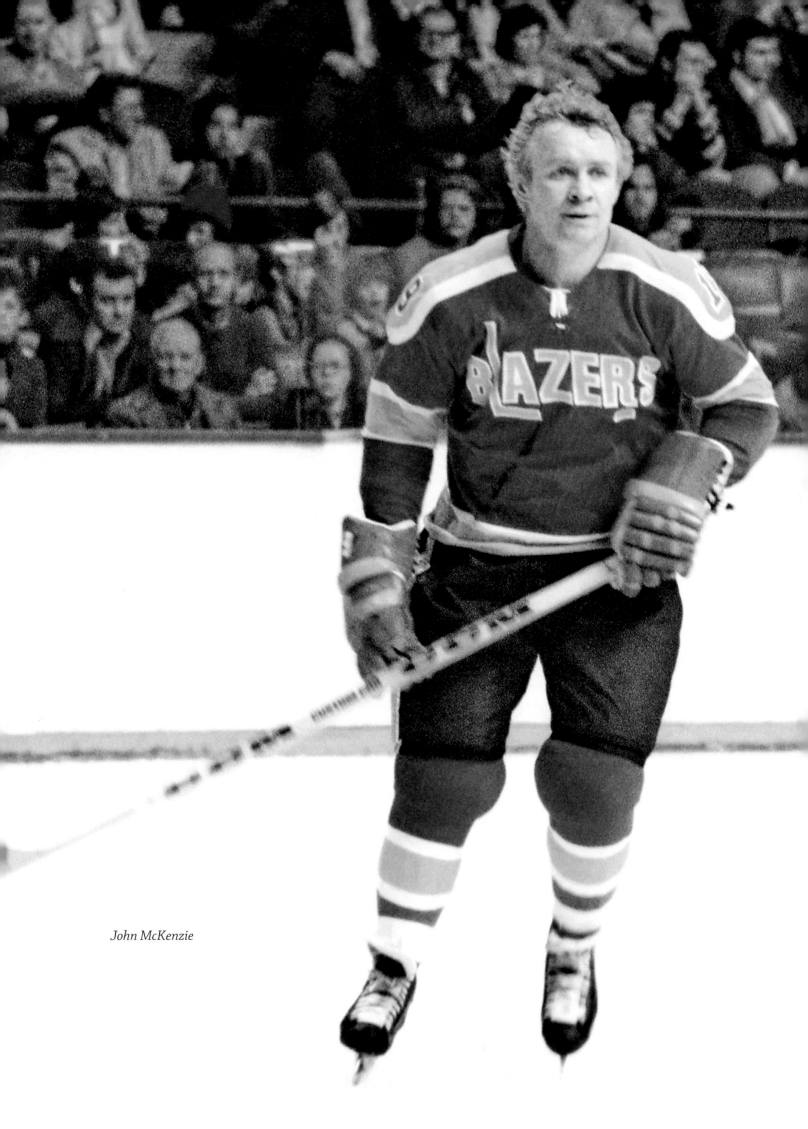

John McKenzie

PHILADELPHIA BLAZERS ('72–'73) / VANCOUVER BLAZERS ('73–'75) / CALGARY COWBOYS ('75–'77)

For the WHA, Florida and hockey didn't mix. It began in Miami with the birth of the league.

When franchises were being established, businessman Herb Martin, eager to bring big-league hockey to the Sunshine State, was granted a franchise, to be named the Miami Screaming Eagles.

They made an immediate stir by signing star goalie Bernie Parent, the first big-name NHL player to ink a deal with the fledgling league.

They had a star, they had a uniform, they even produced promotional and press material. What they lacked, in addition to money, was a suitable place to play. Martin had planned to build a new, state-of-the-art facility, but he wasn't able to put together a deal in time for the premiere of the league. The only option was to play in the inadequate and undersized Sportatorium until a new arena could be built. Seeing no viable plans or options, the league terminated Martin's franchise.

Enter Bernard Brown and James Cooper. They took over the rights to the Miami Screaming Eagles franchise (and its holdings). Brown and Cooper knew that there was no chance of the team succeeding in Florida. They relocated the franchise to Philadelphia, now to be called the Blazers, and clad the team in flashy burnt orange and yellow uniforms.

It was a move that pleased Bernie Parent, as Philadelphia had been his home even before being traded to the Maple Leafs. Brown and Cooper knew they needed more big-name players, though, and made what was up until that time the biggest deal in professional sports.

In summer 1972, they signed Bruins star and media darling Derek Sanderson's record-breaking contract: $2.65 million with a $600,000 signing bonus. Since he'd earned a fraction of that in Boston, he jumped at the chance.

Bernie Parent

Derek Sanderson

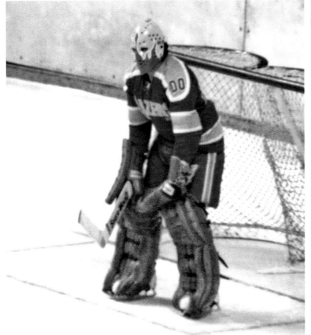

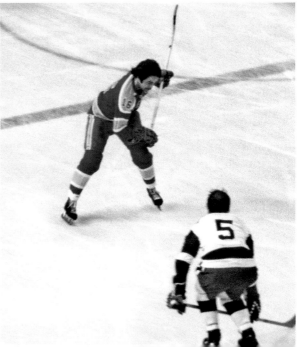

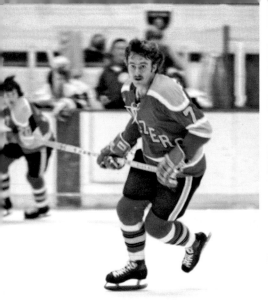
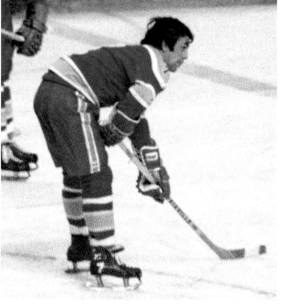
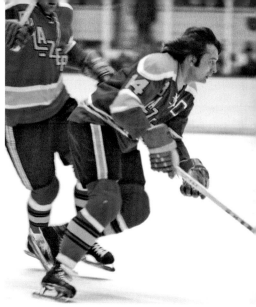

Ron Chipperfield *André Lacroix* *Bryan Campbell*

They didn't put all their eggs in one basket, though. John McKenzie, miffed at being left unprotected in the NHL expansion draft, signed on as player-coach, although he would only coach 13 games before stepping aside in favor of veteran Phil Watson. Also added to the first Blazers roster were Flyers mainstay André Lacroix, NHL veteran Danny Lawson, Ron Plumb (in the first season of a seven-year WHA career), as well as journeymen Bryan Campbell and Don Burgess, both of whom had 20-plus-goal seasons.

Absent from the top scorers was Derek Sanderson. Hampered by injuries and in poor shape, Turk scored only three goals in the eight games he played with the team. Frustrated and unable to pay the full amount anyway, the team bought out his contract for $1 million. He returned to Boston, but he was never the same player.

Another problem was one that haunted many WHA franchises (including the never-to-play Miami Screaming Eagles): finding a suitable arena to call home. Now having to compete with the Flyers for Philly hockey fans, the Blazers played not on Broad Street, but in the Philadelphia Civic Center, a 9,100-seat rink that was plagued with problems.

On opening night, what should have been a special occasion for the team and the few curious fans who turned up was instead a disaster. The ice was poor and pucks kept disappearing under the

Danny Lawson *Jim Cardiff* *Claude St. Sauveur*

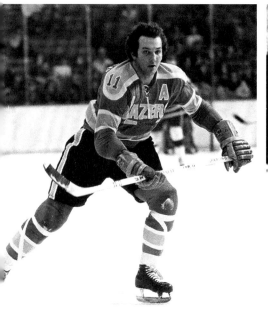
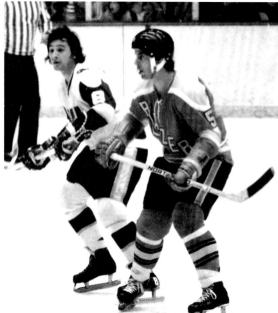
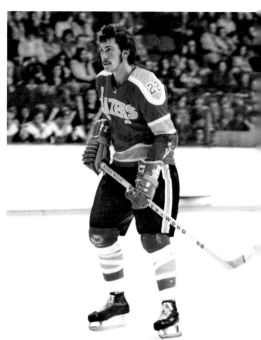

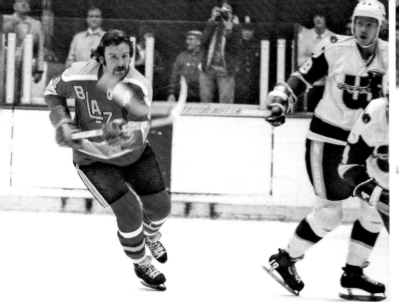

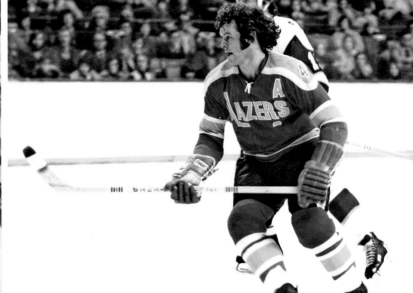

Ron Plumb

Mike Pelyk

ill-fitting boards. The Zamboni, having arrived late at the arena, drove onto the playing surface and crashed through the already inadequate ice. The referees had no choice but to cancel the contest. In an ill-conceived promotion, the club had given each patron in attendance a souvenir orange puck. When the announcement was made, pucks rained down on the ice in protest of the cancellation.

Things didn't get much better. While they finished with a record of 38-40-0 (76 points), putting them third in the East Division, they never could sway the fans of Philadelphia to abandon the ascending Flyers in favor of the upstart team. After the one season Brown and Cooper sold the team to Vancouver businessman and philanthropist Jim Pattison, who moved them to that city. They retained the Blazers name and colors, although toned things down with black, instead of orange, pants.

Like Philadelphia, Vancouver had an NHL team to compete with. The Canucks were part of the 1970 expansion along with the Buffalo Sabres. But by the time the Blazers arrived in 1973 the Canucks were yet to have a winning season. Placed in the powerful NHL East Division, they fared poorly, failing to even make the playoffs in their first four years. The fans were getting impatient for winning hockey. The Blazers may not have fit that bill, but for the hockey crazed fans, they were an alternative.

Don McLeod　　　　　*Duane Rupp*　　　　　　　　　　*Pat Price*

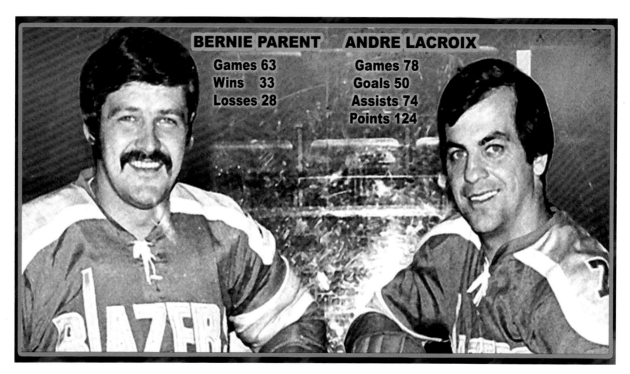

BERNIE PARENT	ANDRE LACROIX
Games 63	Games 78
Wins 33	Goals 50
Losses 28	Assists 74
	Points 124

Parent and Lacroix

At very least they were an entertaining team. Parent, Lacroix and Sanderson were long gone (in Sanderson's case much to the relief of the owners, who were free from his contract), but they still had Pie McKenzie, Bryan Campbell, Pat Price in his sole WHA season before spending 13 years with various NHL teams, Maple Leaf veteran Mike Pelyk, Claude St. Sauveur, Danny Lawson and NHL journeyman Duane Rupp. In goal they had veteran Don McLeod and rookie Wayne Wood. One of the more interesting signings was 42-year-old Andy Bathgate. Bathgate, a future Hall of Famer, had already played 17 seasons in the NHL, winning a Stanley Cup and a Hart Trophy along the way. He had retired in 1971, but returned to the ice for 11 games for the Blazers.

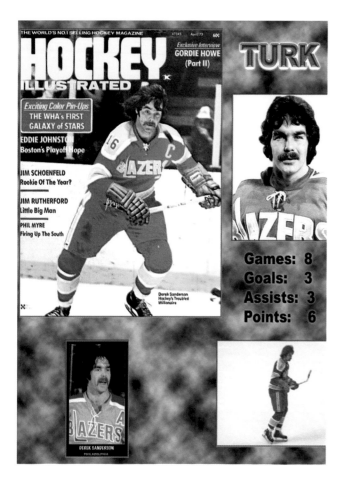

They were also sharing the Pacific Coliseum with the Canucks. The 15,000-plus-seat arena was a vast improvement over their home in Philadelphia, and attendance was good. Revitalized, they led the league in attendance, despite a less-than-stellar record of 27-50-1.

The next season saw the attendance drop to a still-respectable average of 8,014 fans per game. It was decided to move the team to Calgary, where they found new life on the Canadian prairie as the Cowboys. Gone were the Blazers' orange uniforms, replaced by a more subdued red and white. It wasn't the first attempt by

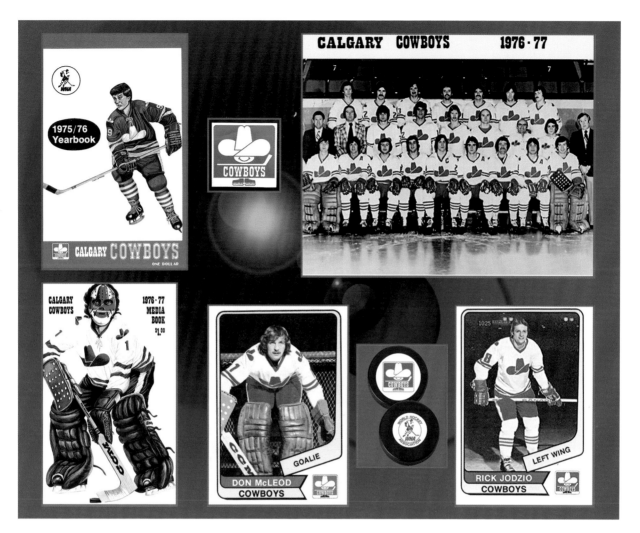

the league to locate a franchise there, playing into a natural rivalry with the Oilers. The Broncos had been awarded a franchise in the first season but never played. After the death of owner Bob Brownridge the team went to Cleveland. The Crusaders played there until 1976 when they too relocated.

The Cowboys played their games in the undersized Stampede Corral (a mere 6,500 seats) but hoped that a winning team would prompt either expansion of the arena or a new facility altogether. But the Corral would be their downfall. Owner Jim Pattison hoped the team would be part of the upcoming NHL-WHA merger, but the arena failed to meet the NHL minimum of 12,500 seats.

They suffered at the gate too. With no imminent hope for a new arena, or a viable relocation plan, Pattison had no choice but to fold the franchise before the 1977 season.

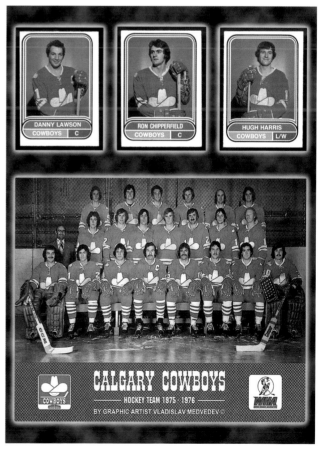

Pat Price: 69 games, 5 goals, 29 assists and 34 points.

Jimmy Jones: 81 games, 13 goals, 9 assists and 21 points.

Rob Walton: 105 games, 32 goals, 48 assists and 80 points.

Ron Plumb: 153 games, 16 goals, 73 assists and 89 points.

Don Burgess: 214 games, 61 goals, 63 assists and 124 points.

John Shmyr: 39 games, 1 goal, 5 assists and 6 points.

Don McLeod: 202 games, 88 wins and 96 losses.

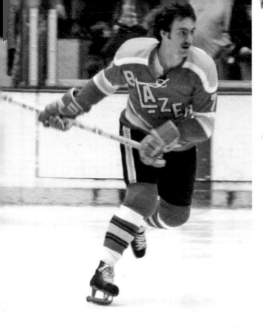
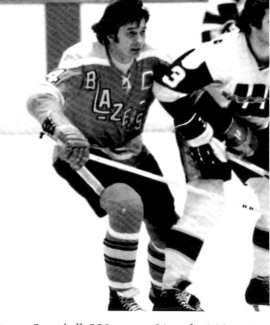
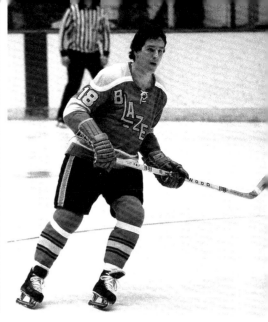

Ron Chipperfield: 236 games, 88 goals, 88 assists and 176 points.

Bryan Campbell: 229 games, 81 goals, 144 assists and 225 points.

Hugh Harris: 88 games, 28 goals, 43 assists and 71 points.

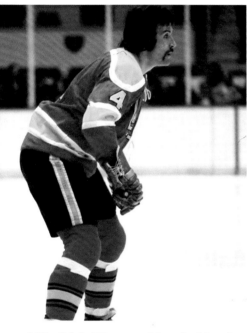
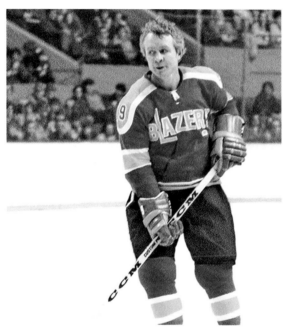
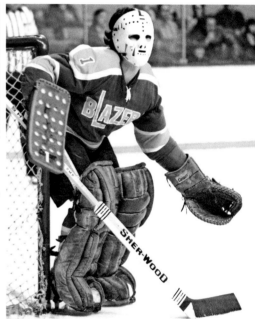

Mike Pelyk: 75 games, 14 goals, 26 assists and 40 points.

John McKenzie: 179 games, 65 goals, 125 assists and 190 points.

Pete Donnelly: 49 games, 22 wins and 24 losses.

Murray Myers: 92 games, 23 goals, 21 assists and 44 points.

Danny Lawson: 375 games, 212 goals, 197 assists and 409 points.

Claude St. Sauveur: 165 games, 63 goals, 125 assists and 190 points.

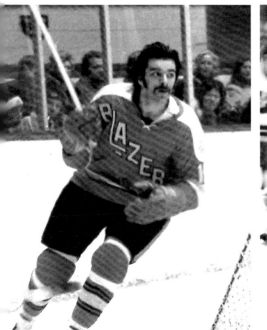
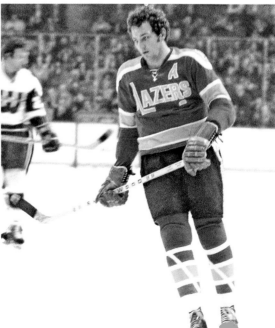

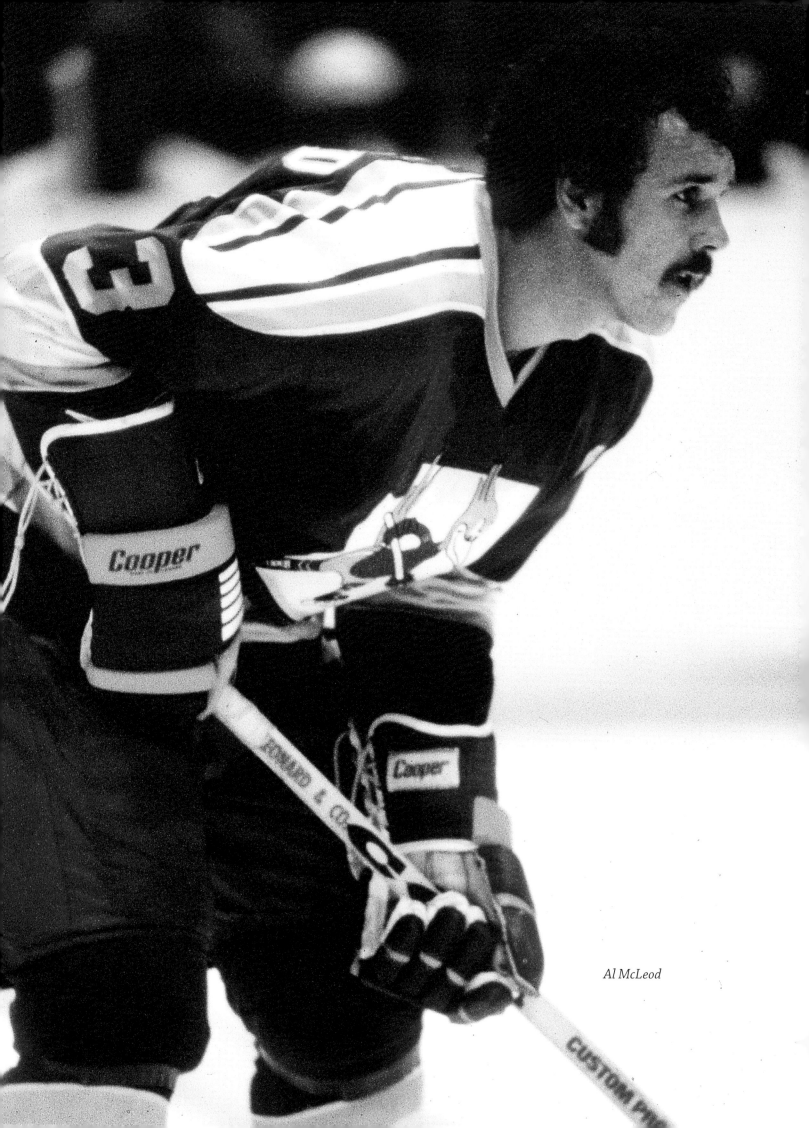

Al McLeod

PHOENIX ROADRUNNERS ('74 – '77)

The Roadrunners were one of the WHA's expansion teams, having been granted a franchise in 1973 (along with Indianapolis). Arizona businessman Ed Keller originally wanted an NHL franchise but was snubbed by the senior league. With the addition of the two teams in 1974 the WHA now boasted 14 franchises in the United States and Canada.

They began playing in 1974 in the Arizona Veterans Memorial Coliseum, dubbed "The Madhouse on McDowell," a venue that seated a respectable 13,000-plus for hockey and had been the home of the Western Hockey League's Phoenix Roadrunners. With the demise of the WHL, Keller saw an opportunity for a readymade fan base with name recognition and even signed many of the old team's players.

Local favorite Sandy Hucul signed on as coach and went on to win the 1975 Coach of the Year honors. The Roadrunners did remarkably well, finishing their initial season in fourth place in the WHA West Division with a 39-31-8 record. It was one of the league's strongest divisions, with Houston (53-25-0), San Diego (43-31-4) and Minnesota (42-33-3) ahead of Phoenix.

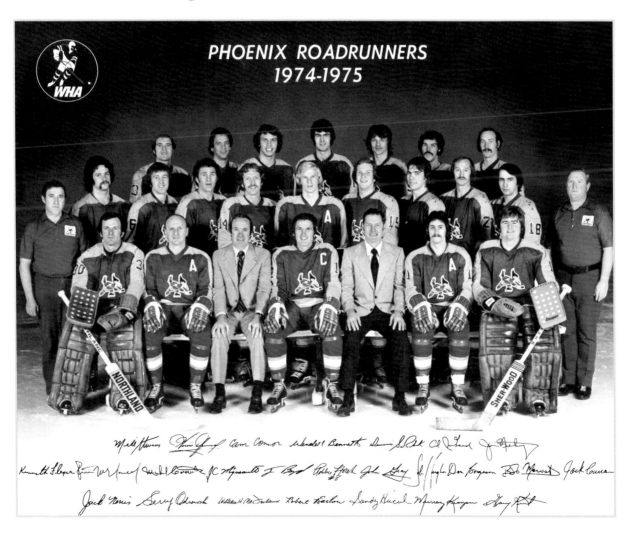

Robbie Ftorek *Ron Huston* *Garry Lariviere*

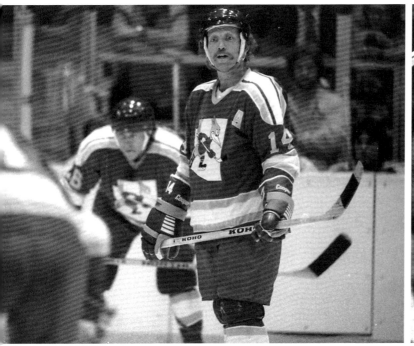

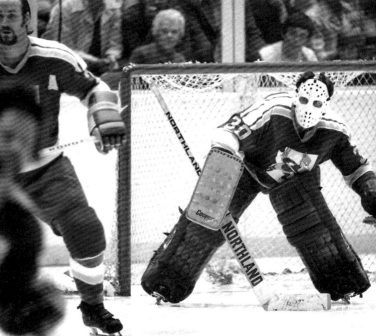

Jim Boyd *Jack Norris and Jim Niekamp*

Pekka Rautakallio *John Migneault* *John Gray*

One problem the team had was finding resources to sign major league talent. By now the NHL was taking the new league seriously and doing more to improve contracts. Players were no longer easily lured by the prospect of more money, given the financial instability of many franchises.

The brightest spot on the team was New England native Robbie Ftorek. Originally drafted by the Whalers, themselves looking to sign local players with name recognition, Ftorek instead signed as a free agent with the Detroit Red Wings. He didn't get much playing time with Detroit, who didn't see his potential, so he signed with the Roadrunners in 1974, where he played until the team's demise, then signed with Cincinnati before returning to the NHL. He would play five seasons of his 13-year career in the WHA and be remembered as one of its brightest stars.

Other notable players included goaltender Jack Norris, whose main claim to fame was being part of the trade that sent him, Gilles Marotte and Pit

Michel Cormier

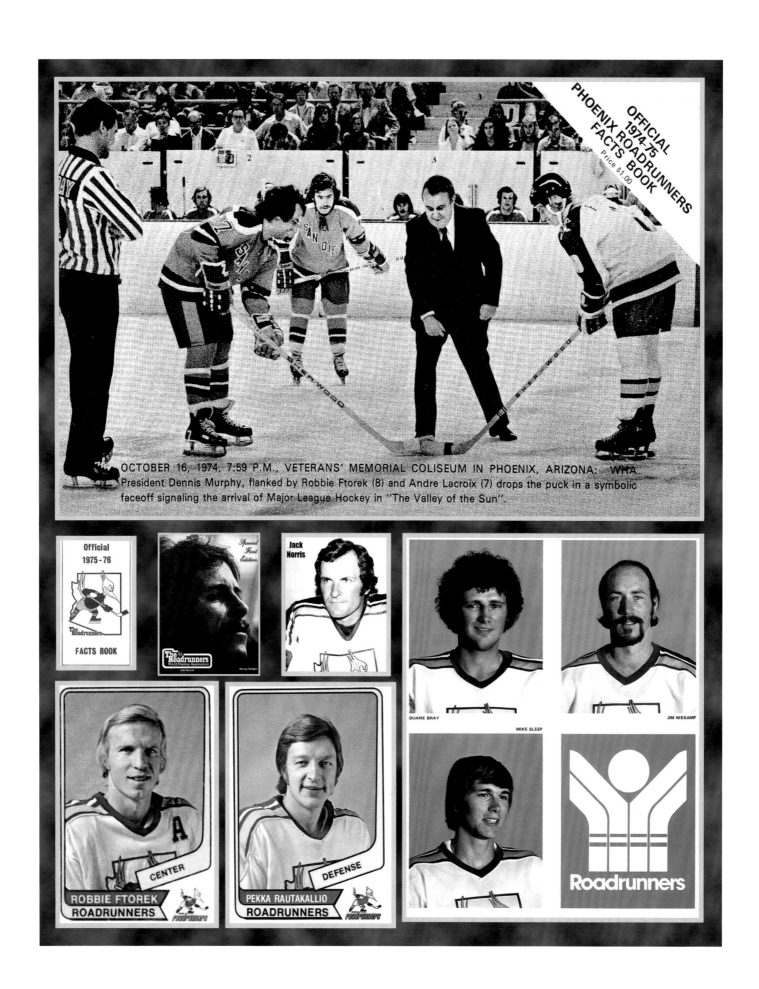

OCTOBER 16, 1974, 7:59 P.M., VETERANS' MEMORIAL COLISEUM IN PHOENIX, ARIZONA: WHA President Dennis Murphy, flanked by Robbie Ftorek (8) and Andre Lacroix (7) drops the puck in a symbolic faceoff signaling the arrival of Major League Hockey in "The Valley of the Sun".

Official 1975-76 The Roadrunners FACTS BOOK

Special First Edition The Roadrunners World Hockey Association

Jack Norris

DUANE BRAY

JIM NIEKAMP

MIKE SLEEP

ROBBIE FTOREK CENTER ROADRUNNERS

PEKKA RAUTAKALLIO DEFENSE ROADRUNNERS

Roadrunners

Martin to Chicago in exchange for Phil Esposito, Ken Hodge and Fred Stanfield, long considered the most lopsided trade in NHL history. Dennis Sobchuk scored 77 points that first season, Jim Boyd netted 26 goals for 70 points, and Don Borgeson contributed 57 points. The following season they were reinforced with Del Hall, who put up 91 points his first year and 79 in his second. Ron Huston would score 125 points in his two years with the Roadrunners.

European players helped fill the ranks. Pekka Rautakallio was signed after an impressive showing in the 1974 Summit Series exhibition. The Finnish defenseman scored an impressive 11-39-50 record while drawing a mere eight penalty minutes. On the other end of the spectrum, Cam Connor racked up 168 and 295 penalty minutes in each of his two years with the team.

While they iced respectable teams, things would go downhill after that first season with yet another Divisional realignment and the loss of many of Phoenix's better players—which was owner Ed Keller's only hope to cut costs and keep the team afloat, since it was reported that the team was losing in the neighborhood of $2 million a year. Given their financial situation, it was also impossible to come to a new agreement with Veterans Memorial Coliseum. The team folded after the 1977 season.

Serge Beaudoin　　　　*Barry Dean*　　　　　　　　　　　*Del Hall*

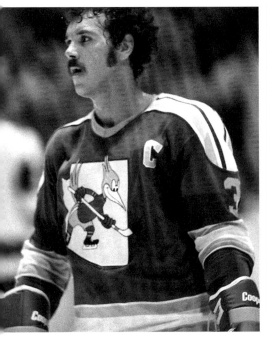

Al McLeod: 186 games, 6 goals, 38 assists and 44 points.

Pekka Rautakallio: 151 games, 15 goals, 70 assists and 85 points.

John Migneault: 115 games, 14 goals, 25 assists and 39 points.

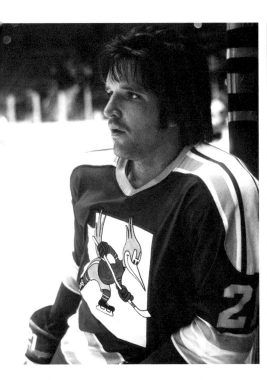

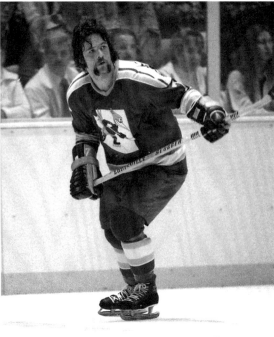

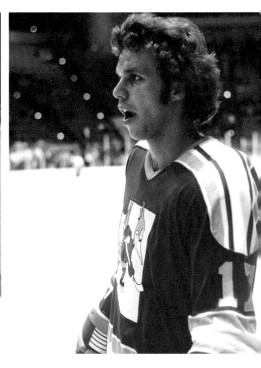

Barry Dean: 71 games, 9 goals, 25 assists and 34 points.

Peter McNamee: 65 games, 10 goals, 21 assists and 31 points.

Cam Connor: 130 games, 27 goals, 40 assists and 67 points.

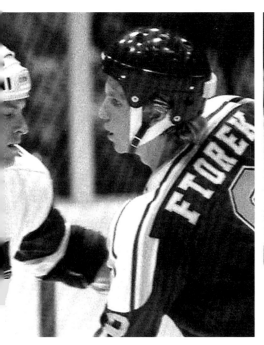

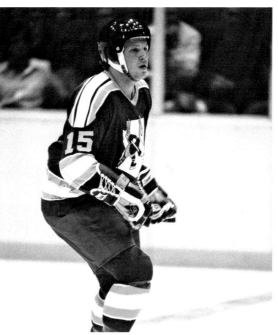

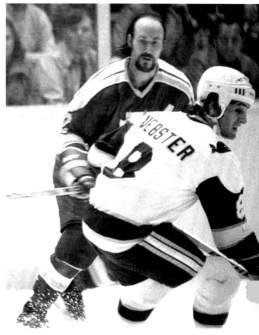

Robbie Ftorek: 213 games, 118 goals, 180 assists and 298 points.

John Gray: 182 games, 80 goals, 88 assists and 160 points.

Jim Niekamp: 229 games, 7 goals, 55 assists and 62 points.

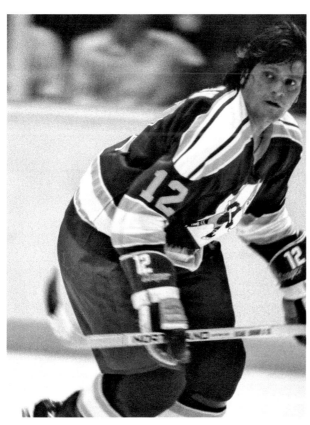

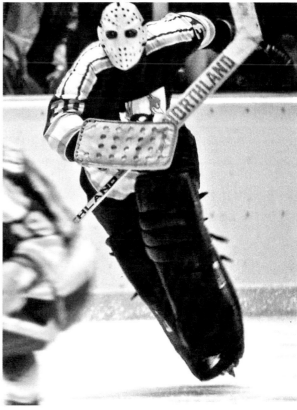

Ron Huston: 159 games, 42 goals, 83 assists and 125 points.

Jack Norris: 74 games, 35 wins and 29 losses.

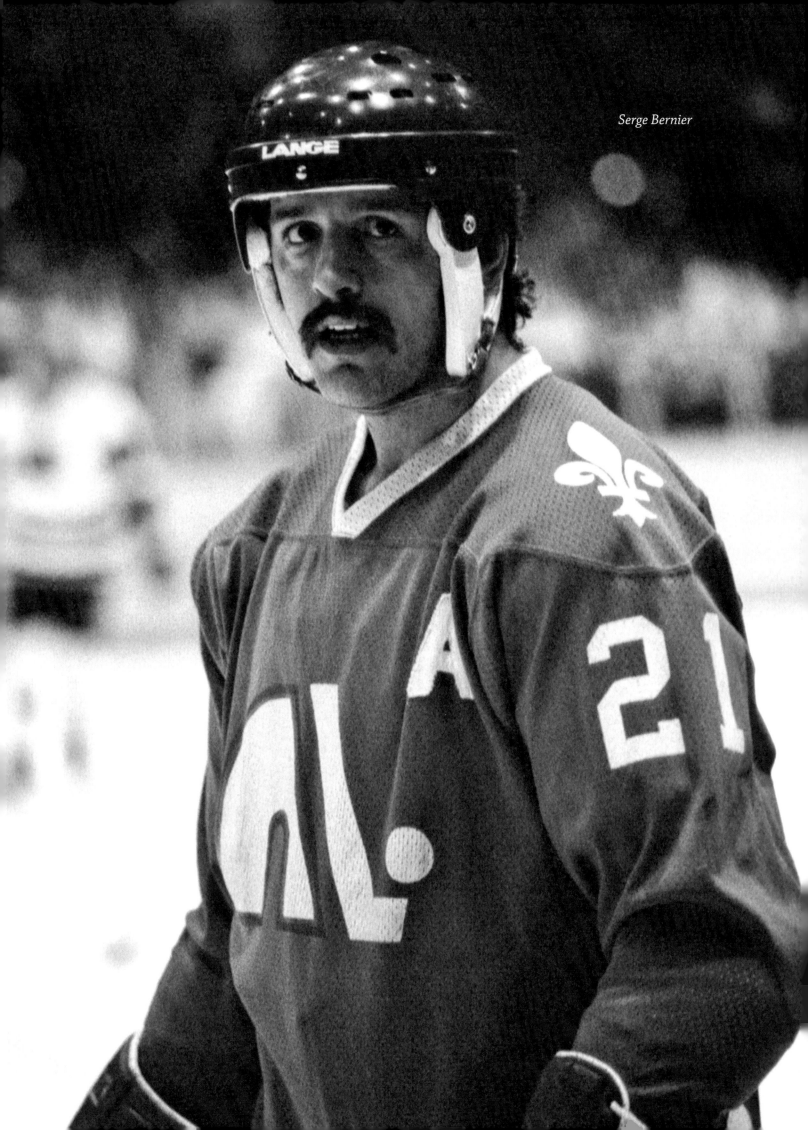

Serge Bernier

QUEBEC NORDIQUES ('72 – '79)

Despite being a smaller market, hockey and Quebec City seemed a natural fit. Other teams had played there, including the Quebec Castors (or, in English, Beavers) and Quebec Aces. Most notable—and mostly forgotten—were the Quebec Bulldogs, who played in several leagues, at several levels. They later became the Hamilton Tigers, but not before winning two Stanley Cups with the NHA, a forerunner of the NHL.

One reason for the lack of major league hockey in "La Vieille Capitale" was the Montreal Canadiens. The Canadiens cast a long shadow over the primarily French-speaking province. They weren't interested in competition, or even a close rivalry, on what they saw as their turf.

Still, the WHA came to Quebec in a roundabout way. The Nordiques were established in 1971 by WHA founder Gary Davidson as the San Francisco SeaHawks. He and fellow founder Dennis Murphy were looking for high-profile markets to build the new league's presence and credibility. In addition to getting a foothold on the West Coast, the SeaHawks would have been a natural rival for the Los Angeles franchise. The NHL had teams in Oakland and Los Angeles. The Kings had been an Original Twelve franchise when the league doubled in 1967, as had the Seals. Neither team was setting the league on fire, however. Even the name change didn't help the hapless Seals, who later relocated to Cleveland.

As was often the case, there were problems right from the start. The WHA saw no advantage to putting a team where the NHL was struggling. So, on February 11, 1972, before having played a single game, the franchise was sold to a group of Quebec-based businessmen led by Paul Racine, Jean Dacres and Jean Lesage. They moved the team to Quebec City and renamed them the Nordiques, much to the delight of the residents.

The had a franchise, now they needed a team, a coach and most importantly an image as a French-Canadian franchise, much like Montreal in their glory years. The team was originally decked out in the blue and white of the Quebec flag, with red included. Over the years the red would be all but eliminated except for trim color. The addition of fleur-de-lis symbols on the waist and shoulders marked them as a true "Quebec Team."

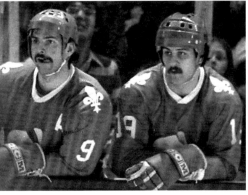
Réal Cloutier and Alain Côté

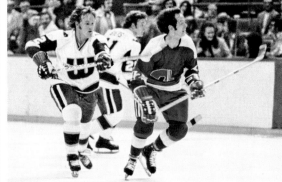
Michel Parizeau

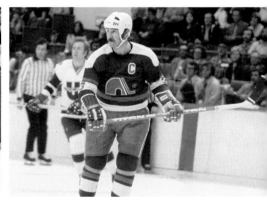
J.C. Tremblay

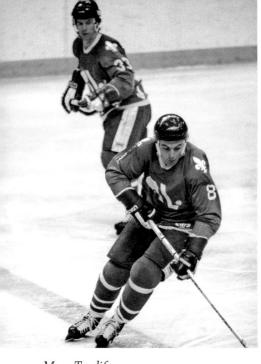
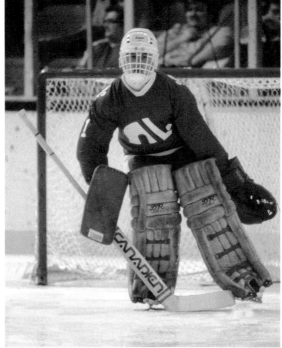
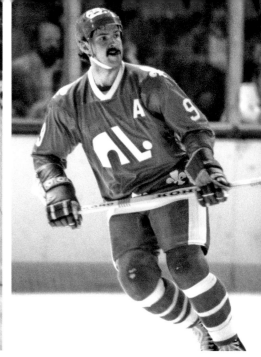

Marc Tardif

Richard Brodeur

Réal Cloutier

Francois Lacombe

Garry Lariviere

Bob Fitchner

André Boudrias

Curt Brackenbury

Norm Dubé

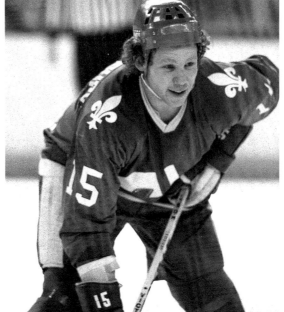
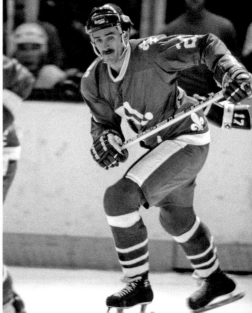

One move was to hire Canadiens legend and French Canada's hero Maurice "Rocket" Richard. While one of the greatest players in NHL history, he had never coached before. Realizing the job wasn't for him, he stepped down after a mere two games, replaced by head scout (and later general manager) Maurice Filion.

As promised, the team was stacked with primarily French-Canadian players.

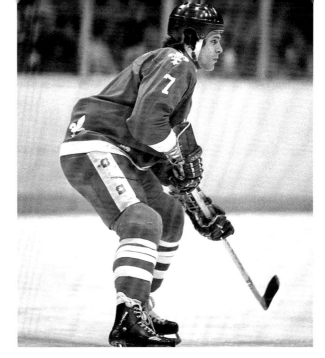

Jim Dorey

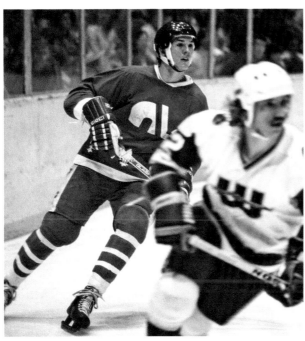

Wally Weir

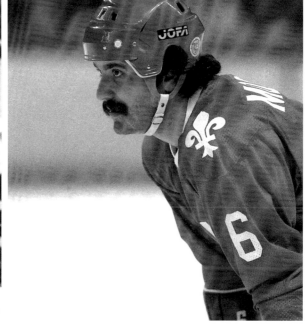

Pierre Guite

Rich LeDuc

Danny Geoffrion

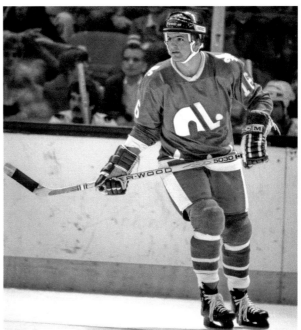

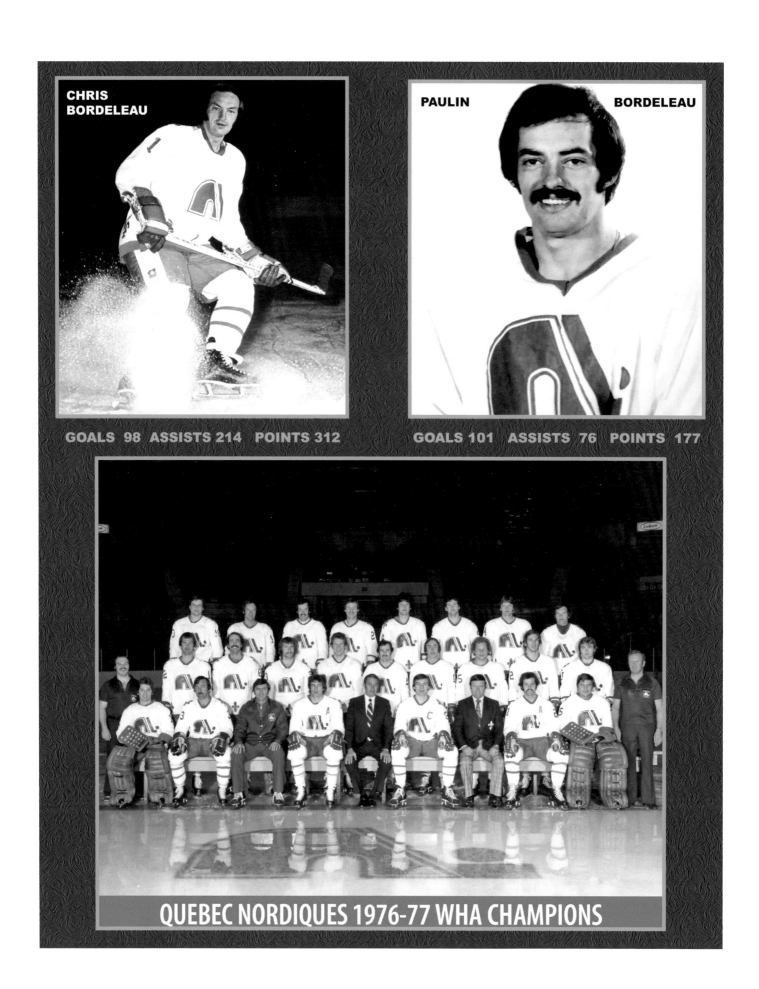

CHRIS BORDELEAU

PAULIN BORDELEAU

GOALS 98 ASSISTS 214 POINTS 312

GOALS 101 ASSISTS 76 POINTS 177

QUEBEC NORDIQUES 1976-77 WHA CHAMPIONS

In net were Serge Aubry and Richard Brodeur, other Quebecois included veteran Jean-Guy Gendron, Michel Parizeau, who found the success in the WHA that had eluded him in the NHL, and Alain "Boom Boom" Caron, so named because his hard slapshot was reminiscent of Montreal star Bernie Geoffrion. They would later be joined by center Serge Bernier; Montreal right winger Rejean Houle, who spent three seasons with Quebec before returning to the Canadiens; Montreal left winger Marc Tardif, who would play for the well-traveled Sharks, Stags and Blades before settling in with Quebec; diminutive center Christian Bordeleau; Réal Cloutier, who spent nine seasons in Quebec with both the WHA and NHL; 12-year NHL veteran André Boudrias; former Kansas City Scout Norm Dubé; former Roadrunner Garry Lariviere; Rich LeDuc, who joined them in the last WHA season but would play two more years in Quebec after the merger; and Danny Geoffrion, whose hockey lineage included his father, Bernie Geoffrion, and grandfather Howie Morenz.

Not all of the Nordiques were French-Canadian, of course. Ontario native Curt Brackenbury, who enjoyed a long career in the WHA and NHL, enforcer Bob Fitchner, defenseman Wally Weir, aging defenseman Jim Dorey, Finn Matti Hagman and former Crusader Paul Baxter were all part of the franchise.

The team's best player, however, was former Canadiens star defenseman J.C. Tremblay. Tremblay won five Stanley Cups with Montreal in 13 seasons and spent the last seven seasons of his career with Quebec. More than just a skilled and agile defenseman, he was an offensive threat too, an expert playmaker who was known for making crisp passes to rushing teammates. He would be a key contributor to the Nordiques' only Avco Cup in 1977.

When the league merger was discussed, it was insisted that all of the Canadian teams (Edmonton, Winnipeg and Quebec) be included. Because of the acrimony between the leagues (due to the WHA raiding the NHL for players, raising salaries all around and generally being a thorn in the side of the senior league for seven years), an agreement wasn't reached immediately. When it did come to pass in 1979, the Final Four also included New England, now based in Hartford, CT.

Not everyone was pleased with the compromise. In fact, five teams voted against the merger—the Canadiens, Canucks, Bruins, Maple Leafs and Kings. Most resistant was Montreal. The Canadiens had long enjoyed a virtual monopoly on fan support in the province of Quebec and saw the Nordiques as playing in an "inferior" league and thus not a real threat. They didn't want an NHL team in Quebec City, but with the eventual NHL-WHA merger, even the powerful Canadiens were forced to share la Belle Province.

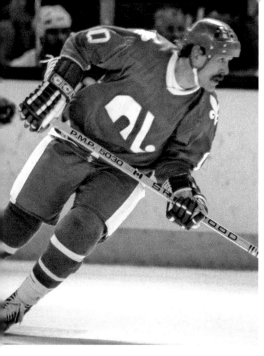

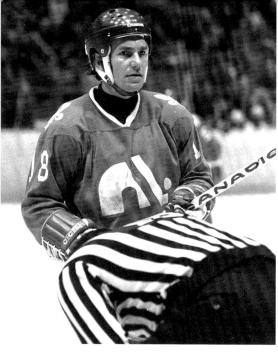

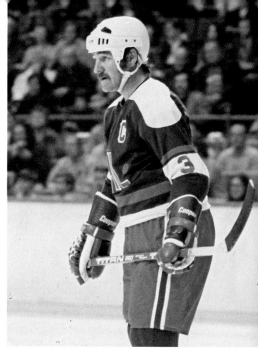

Rich LeDuc: 61 games, 30 goals, 32 assists and 62 points.

André Boudrias: 140 games, 22 goals, 48 assists and 70 points.

J.C. Tremblay: 455 games, 66 goals, 358 assists and 424 points.

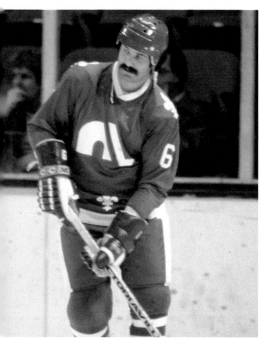

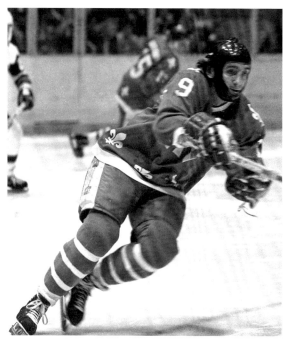

Kevin Morrison: 27 games, 2 goals, 5 assists and 7 points.

Steve Sutherland: 241 games, 65 goals, 53 assists and 118 points.

Jim Dorey: 131 games, 14 goals, 45 assists and 59 points.

Curt Brackenbury: 195 games, 37 goals, 40 assists and 77 points.

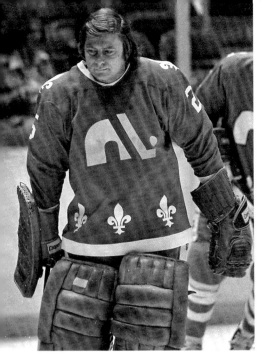

Jim Corsi: 63 games,
26 wins and 27 losses.

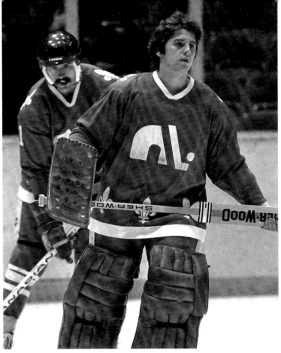

Richard Brodeur: 305 games,
165 wins and 114 losses.

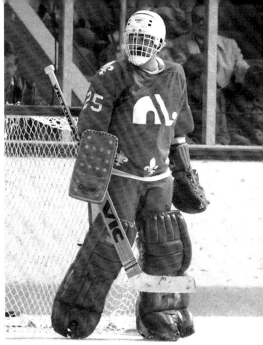

Serge Aubry: 130 games,
59 wins and 49 losses.

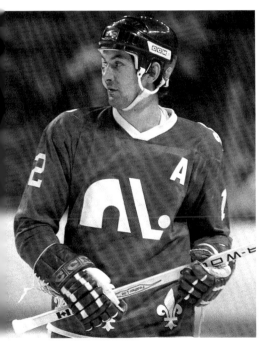

Bob Fitchner: 253 games, 41
goals, 102 assists and 143 points.

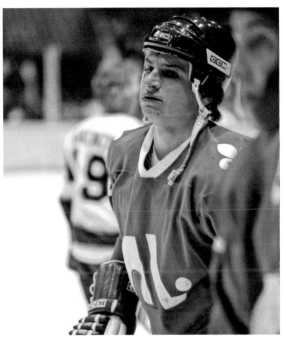

Michel Dubois: 25 games, 0 goals,
3 assists and 3 points.

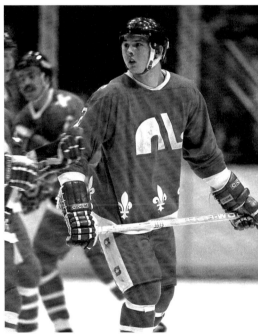

Wally Weir: 150 games, 5 goals,
24 assists and 29 points.

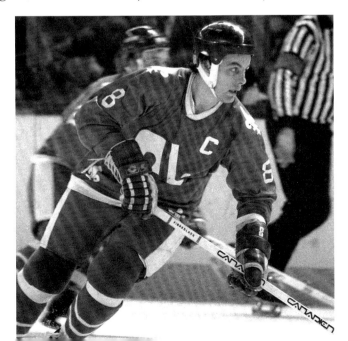

Marc Tardif: 425 games, 264 goals,
315 assists and 579 points.

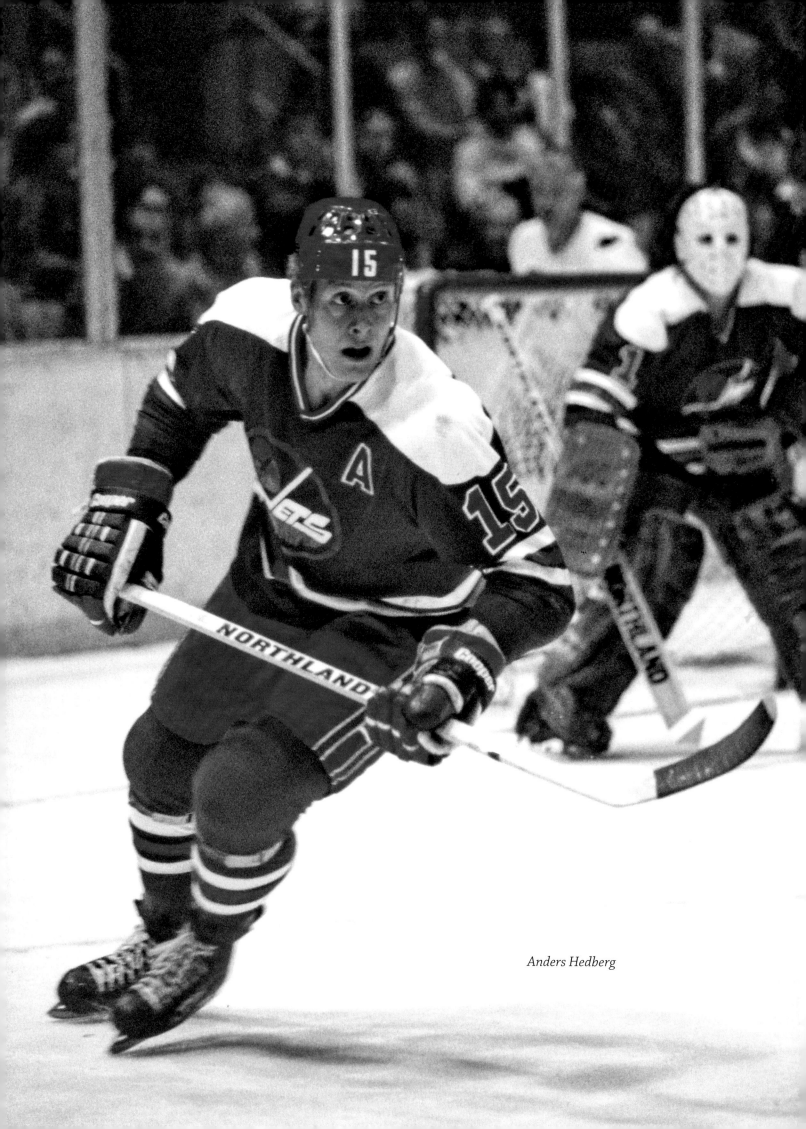

Anders Hedberg

WINNIPEG JETS ('72–'79)

The Jets were easily the most successful WHA franchise. The three-time Avco Cup champions made hockey history when they signed NHL superstar Bobby Hull as player-coach to a staggering $1.7 million 10-year contract with a $1 million signing bonus.

Hull was reportedly unhappy with both his salary and Black Hawks management. Feeling underpaid at a reported $90,000 (some sources said $100,000), he was open to offers from the new league, even though he didn't take the WHA all that seriously. Hull had joked that he would jump to the new league for a million dollars. To everyone's surprise, Jets owner Ben Hatskin offered just that, with help from the other WHA team owners. They felt it was worth it, as having a top-tier star like Hull would give the league instant legitimacy. In addition to being a much-needed star and box office draw, Hull would help the Jets to their three Avco Cup championships, in 1976, 1978 and 1979.

He wasn't the first player signed, however. That honor went to the mostly forgotten Norm Beaudin. Beaudin, a journeyman winger, played on a line with Hull and Christian Bordeleau that first season. Bordeleau, the brother of longtime Black Hawk J.P. Bordeleau, brought four years of NHL experience to the team, including a Stanley Cup with Montreal in 1969.

To add even more scoring punch, they signed 14-year NHL veteran Ab McDonald. At 36, he still netted 41 points. Defenseman Larry Hornung came over from St. Louis and would play the rest of his career in the WHA. Bill Lesuk knocked around the NHL before coming to Winnipeg, where he would play four WHA seasons and one more NHL season after the league merger.

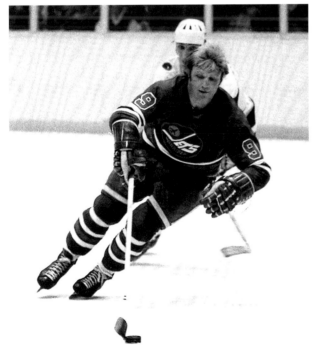

Bobby Hull

Ulf Nilsson and Anders Hedberg

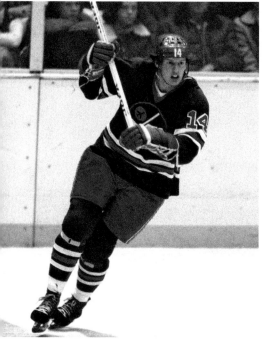

Ulf Nilsson

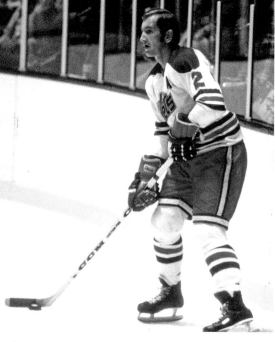

Bob Woytowich

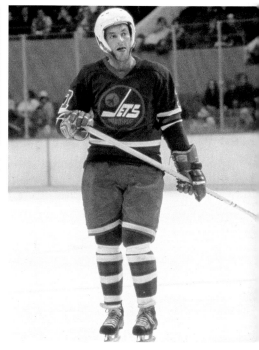

Christian Bordeleau

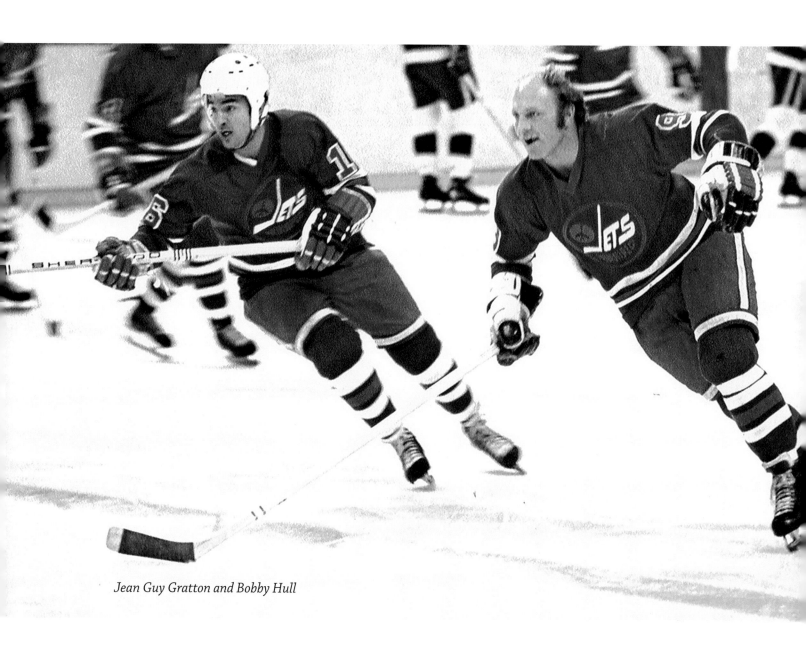

Jean Guy Gratton and Bobby Hull

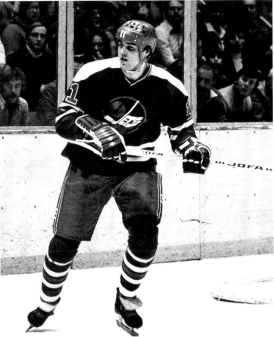

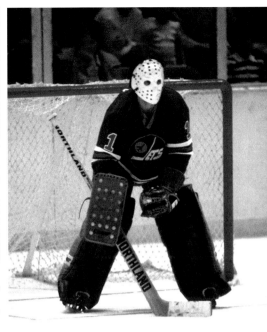

Norm Beaudin *Kent Nilsson* *Joe Daley*

Another seasoned veteran was Wally Boyer, who played the last year of his career with the Jets. Defenseman Bob Woytowich would add 34 points in his second season. Goalies Ernie Wakely and Joe Daley both had winning seasons.

In 1973–74, with Hull still doing double duty as player-coach, they added center Fran Huck, who would score a career-high 74 points. They posted a losing season, though, finishing fourth in their division. Changes were in order.

By the third season they hired long-time Black Hawks coach Rudy Pilous. Pilous, who led the Hawks to a Stanley Cup in 1961, shared the coaching duties with Hull. He later served as general manager, and in that capacity led the Jets to their Avco World Trophy championships.

That season also saw the Jets break new ground by signing Swedish forwards Anders Hedberg

Ernie Wakely *Lars-Erik Sjoberg* *Heikki Riihiranta*

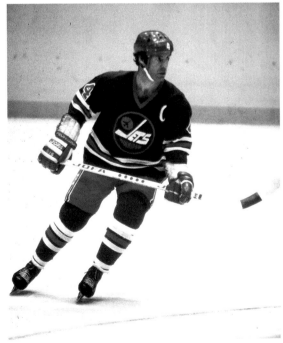

Veli-Pekka Ketola

Bill Lesuk

Thommie Bergman

and Ulf Nilsson and defensemen Lars-Erik Sjöberg and Thommie Bergman. They also grabbed goaltender Curt Larsson, who shared the net with Joe Daley after the 34-year-old Wakely stepped back. The NHL had long shied away from recruiting Europeans, as they felt they couldn't adapt to the rough-and-tumble North American game. In time they would be proven wrong.

By 1974, the former all-Canadian lineup featured five Swedes and two Finns (Heikki Riihiranta and Veli-Pekka Ketola). Hedberg and Nilsson were an immediate success, starring on a line with Hull. The trio was dubbed "The Hot Line," and they dominated WHA scoring for the next four years. During that time, they led the Jets to the championship final four times. The trio led the

Larry Hornung

Dan Labraaten

Bob Guindon

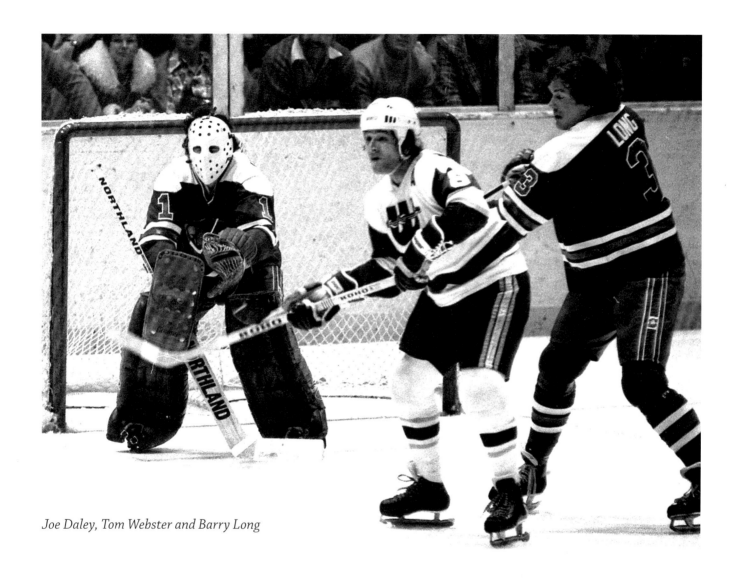

Joe Daley, Tom Webster and Barry Long

Willy Lindstrom

Peter Sullivan

Ted Green

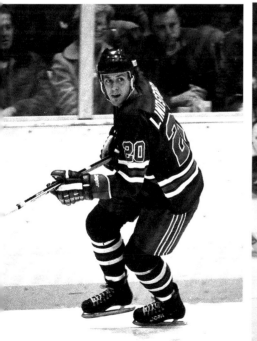

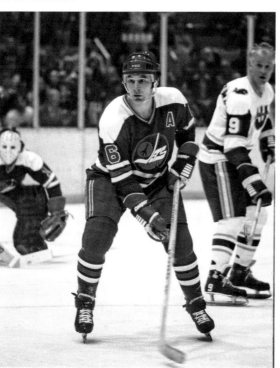

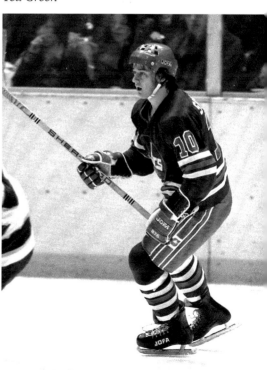

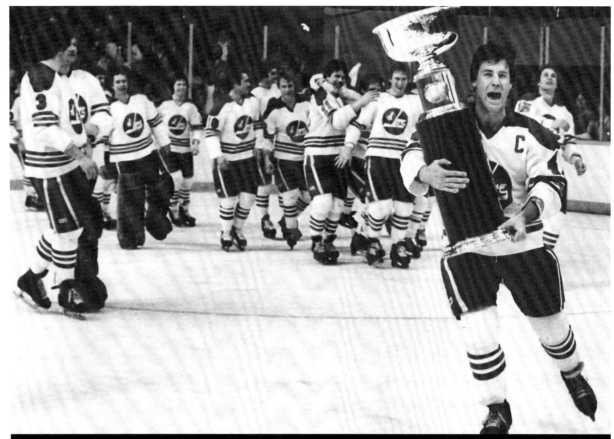

WINNIPEG JETS - 1979 WHA CHAMPIONS

team in scoring with a combined 362 points, Hull scoring 142, Nilsson 120 and Hedberg an even 100. Lars-Erik Sjöberg potted 60, with Ketola not far behind with 50.

The following season, 1975–76, with the addition of young center Peter Sullivan and hard rock defenseman Ted Green, they captured their first championship. Green, who had captained the first Avco Cup championship team with New England, would be a part of two more in Winnipeg. Bobby Kromm took over the coaching reins for the next two years before being replaced by Larry Hillman.

Another Swede, Dan Labraaten, joined the team in 1976. Daley and Larsson still shared the netminding duties, once again posting winning records. Barry Long came in a trade from Edmonton in 1976. After winning two Avco Cups with the Jets, his rights were reclaimed by the Red Wings after the merger. He would later return to Winnipeg for the final two seasons of his career.

The Jets' Avco Cup in 1979 was the last time the cup would be raised before the merger.

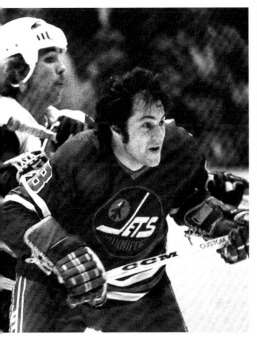

Bob Guindon: 256 games,
41 goals, 60 assists and 101 points.

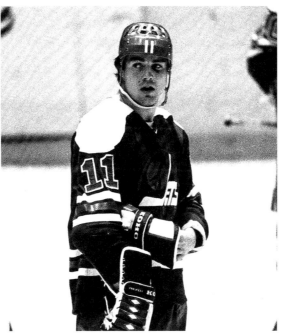

Kent Nilsson: 158 games, 81 goals, 133 assists
and 214 points.

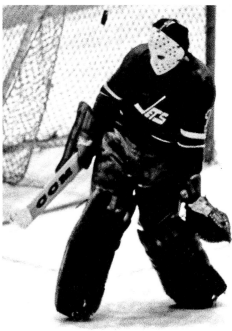

Ernie Wakely: 92 games, 44 wins
and 40 losses.

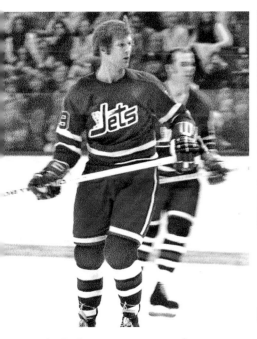

Milt Black: 189 games, 28 goals, 59 assists
and 146 points.

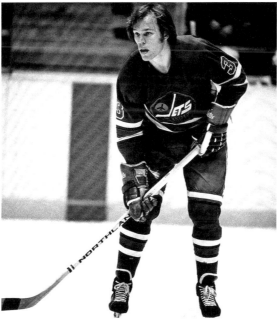

Mike Ford: 179 games, 28 goals,
79 assists and 107 points.

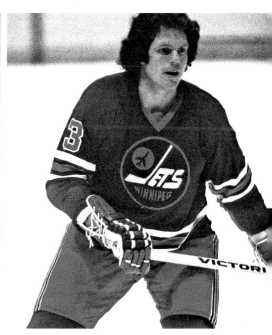

Barry Long: 228 games, 21
goals, 98 assists and 119 points.

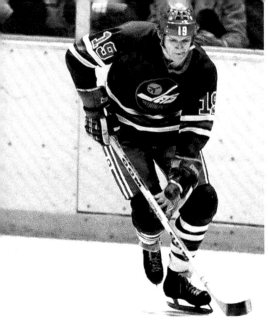

Lynn Powis: 55 games, 12 goals, 19 assists and 31 points.

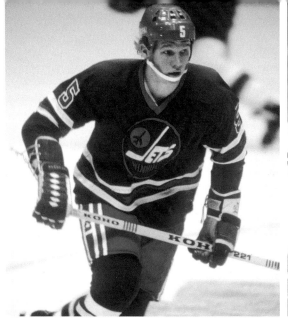

Heikki Riihiranta: 187 games, 10 goals, 38 assists and 48 points.

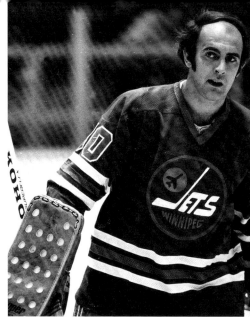

Gary Bromley: 39 games, 25 wins and 12 losses.

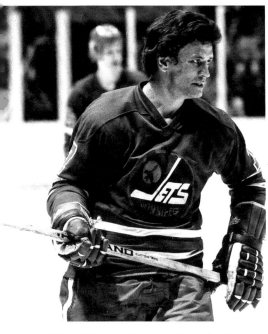

Howie Young: 42 games, 13 goals, 10 assists and 23 points.

Peter Sullivan: 313 games, 125 goals, 170 assists and 295 points.

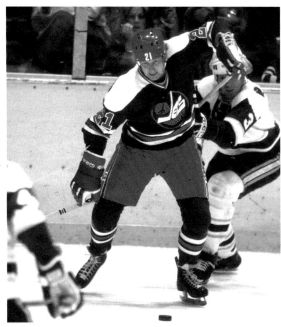

Dan Labraaten: 111 games, 42 goals, 43 assists and 85 points.

Lyle Moffat: 243 games, 49 goals, 54 assists and 103 points.

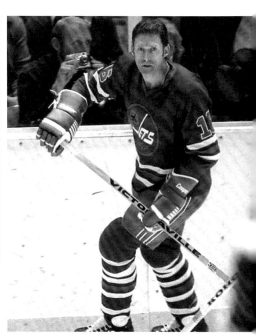

Larry Hillman: 71 games, 1 goal, 12 assists and 13 points.

Joe Zanussi: 149 games, 7 goals, 43 assists and 50 points.

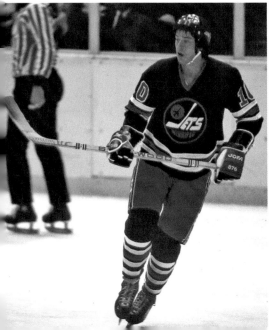

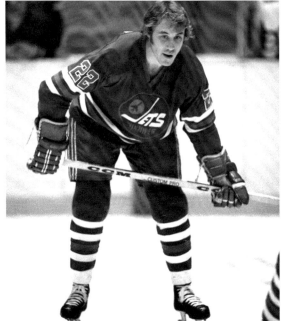

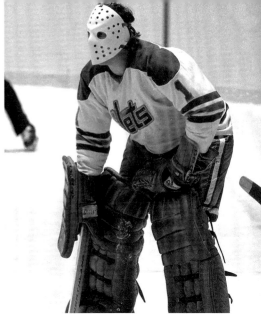

Perry Miller: 188 games, 30 goals, 56 assists and 86 points.

Lars-Erik Sjöberg: 295 games, 25 goals, 169 assists and 194 points.

Joe Daley: 308 games, 167 wins and 113 losses.

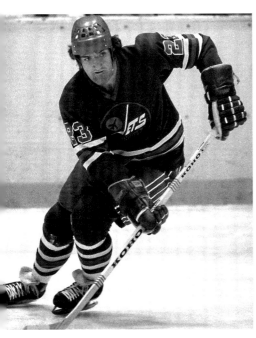
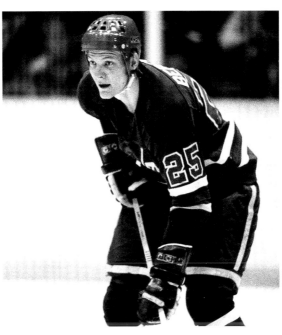
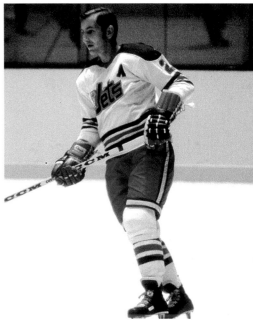

Kent Ruhnke: 72 games, 19 goals, 20 assists and 39 points.

Thommie Bergman: 237 games, 22 goals, 97 assists and 119 points.

Bob Woytowich: 158 games, 8 goals, 32 assists and 40 points.

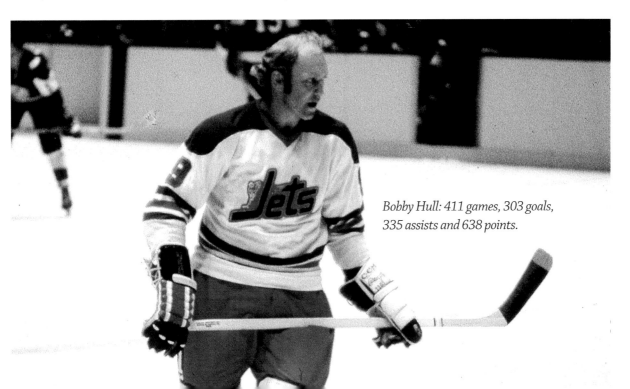

Bobby Hull: 411 games, 303 goals, 335 assists and 638 points.

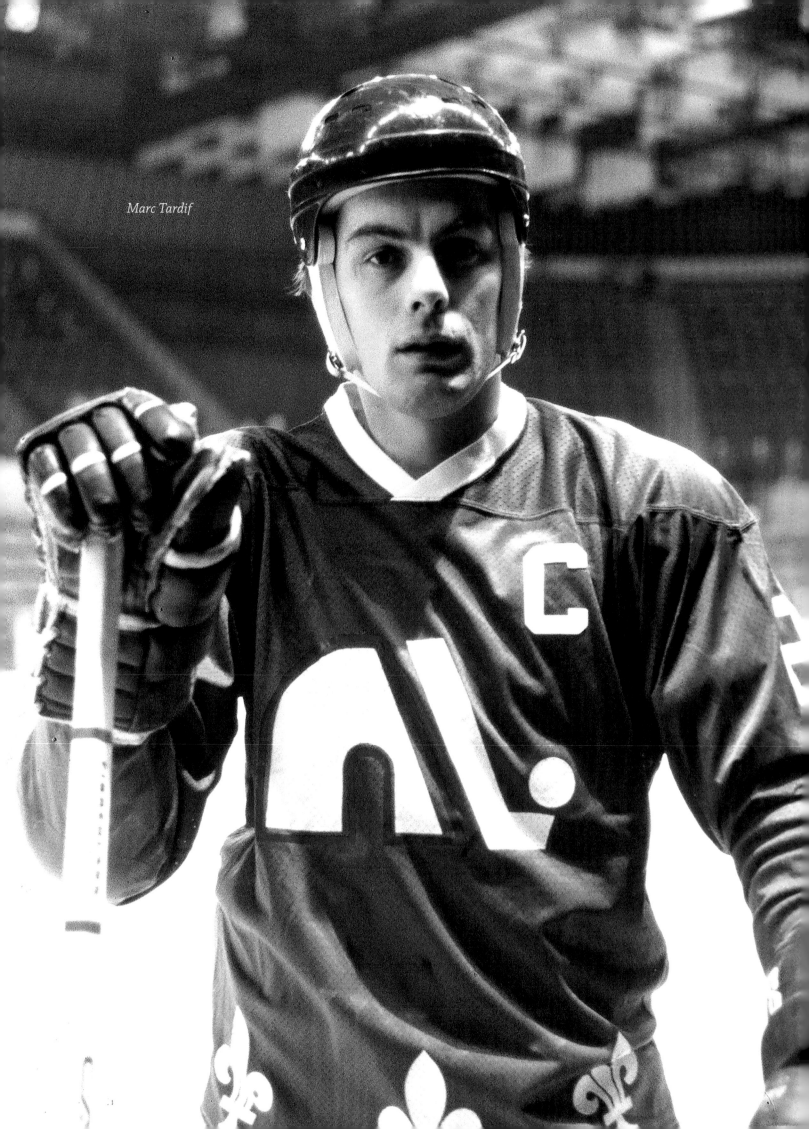

Marc Tardif

CHAPTER 4
THE LEAGUE GEMS

NORTHMEN OF QUEBEC: TARDIF, CLOUTIER, BERNIER

When the Nordiques entered the WHA, they wanted to outdo the rival Canadiens in signing French-Canadian players. Some of their early stars included J.C. Trembay, Rejean Houle, Marc Tardif, Christian Bordeleau, Richard Brodeur, Serge Bernier and Réal Cloutier.

One of their key players was Quebec-born Cloutier. After a stellar junior career with the Quebec Ramparts, he opted not to sign with an NHL team, instead choosing to play in the WHA, beginning in 1974. He made an immediate impact, drawing comparisons to Guy Lafleur. After five seasons that saw him rack up 283 goals and 283 assists, he led the league in scoring in 1977 and 1979, winning the Avco World Cup in 1977. Like many WHA players, he chose to stay with his team rather than the NHL team that drafted him. Quebec held him in such high esteem that they traded budding star Denis Savard to retain his services.

Marc Tardif wore quite a few uniforms before he went to the Nordiques. Although he had a respectable career with the Montreal Canadiens, he was drafted by the Los Angeles Sharks of the WHA. The team soon folded, sending him to the Michigan Stags, which were soon to be the Baltimore Blades (and then out of business). Bad luck for the Blades was good luck for the Nordiques. In the 1975–76 season he lit up the league, leading in goals (71), assists (77) and points (148). He was the top scorer the following season too, and ended up as the WHA's all-time goal leader with 316. His contributions helped Quebec win the 1977 Avco World Cup. His No. 8 jersey was retired by the team.

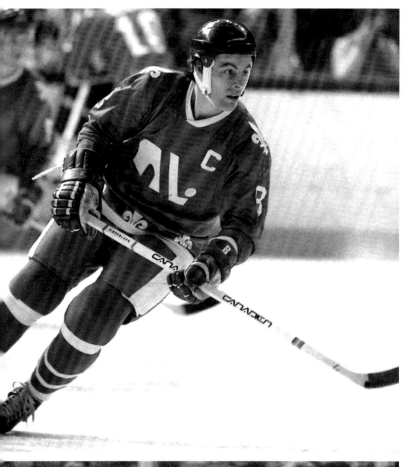

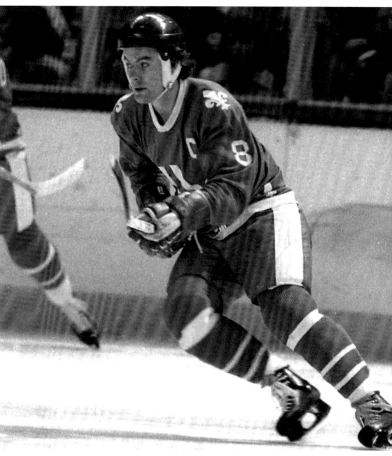

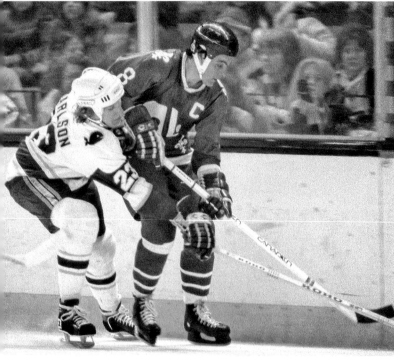

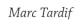
Marc Tardif

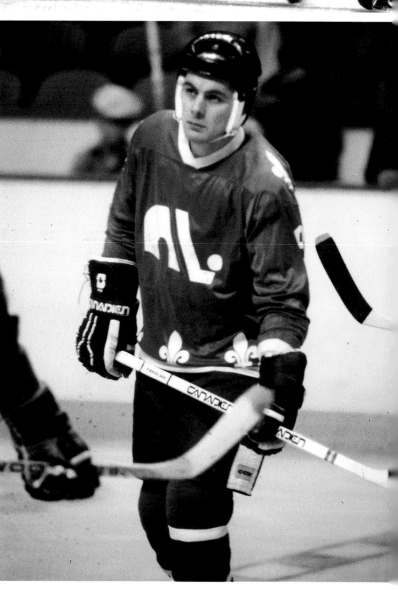

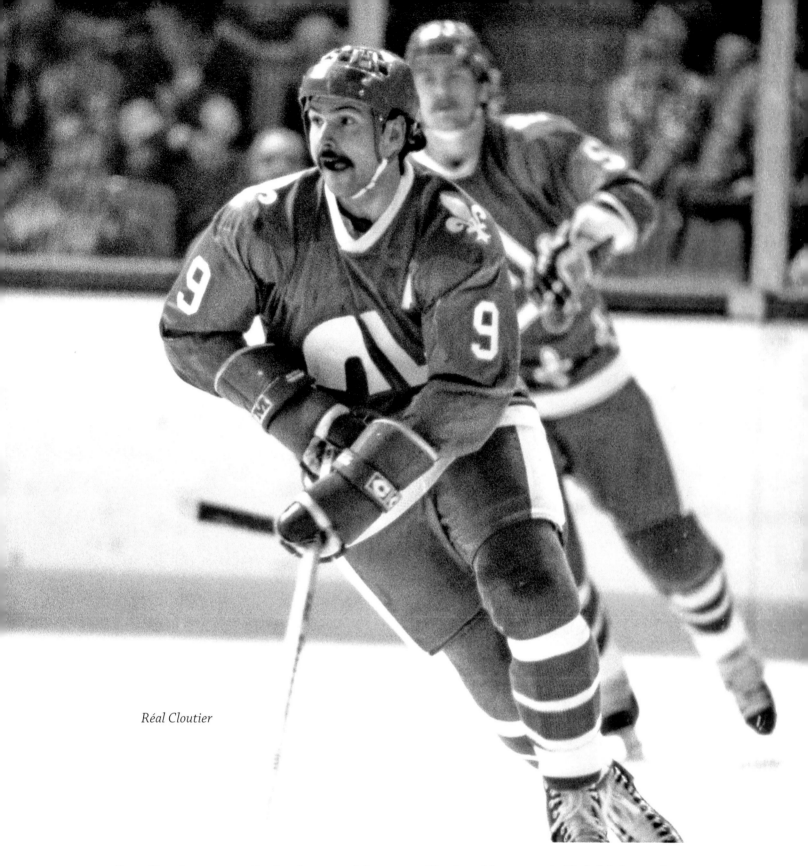

Réal Cloutier

Serge Bernier came to Quebec in a roundabout way. He played four years in Philadelphia and two in Los Angeles before joining the Nordiques. He had originally been drafted by the Ottawa Nationals, but like many WHA clubs they folded due to financial trouble after only one season. He was right at home in Quebec and would play six seasons in the WHA, all with the Nordiques. A member of the 1977 Championship team, he was a steady scorer, his best being 54 in 1974–75. His career 230 WHA goals were the third most for the league, behind only teammates Cloutier and Tardif.

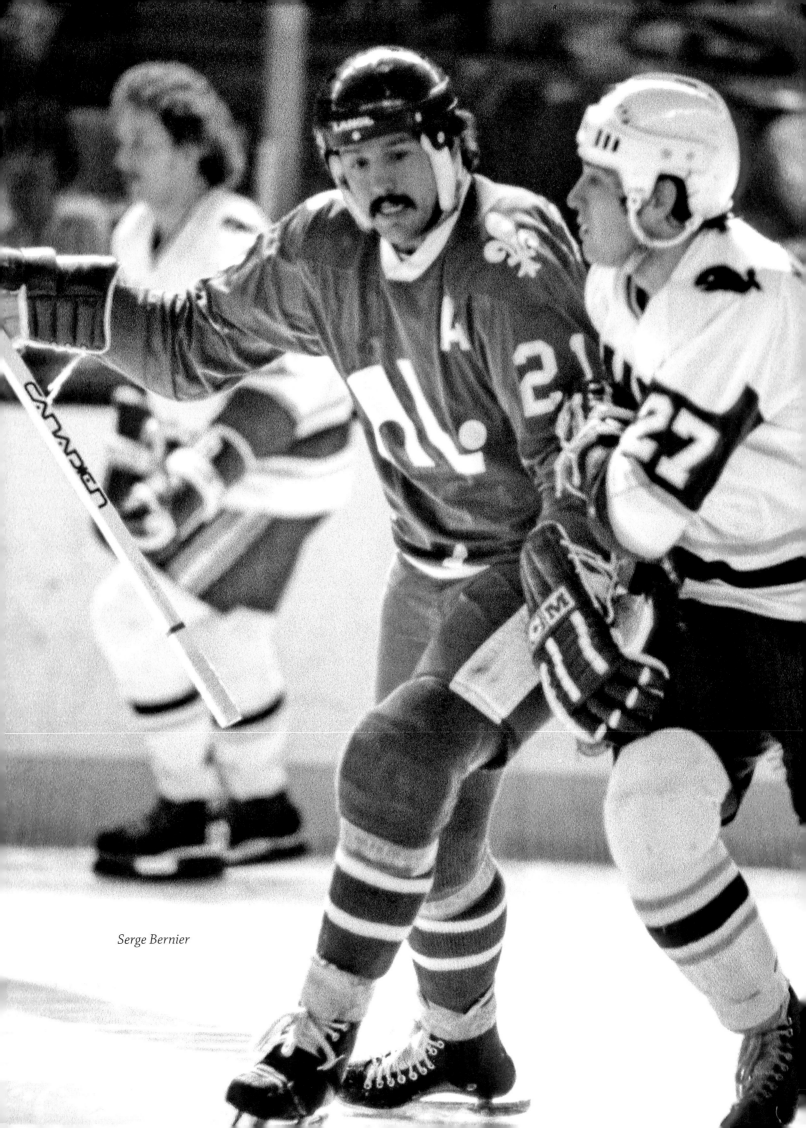

Serge Bernier

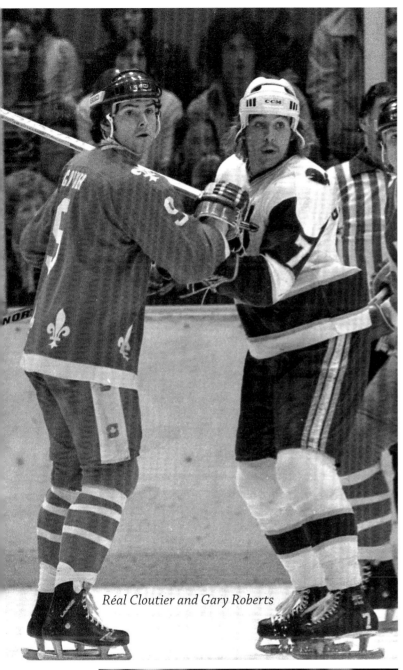

Réal Cloutier and Gary Roberts

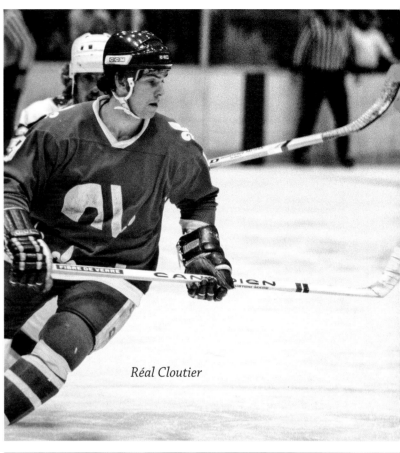

Réal Cloutier

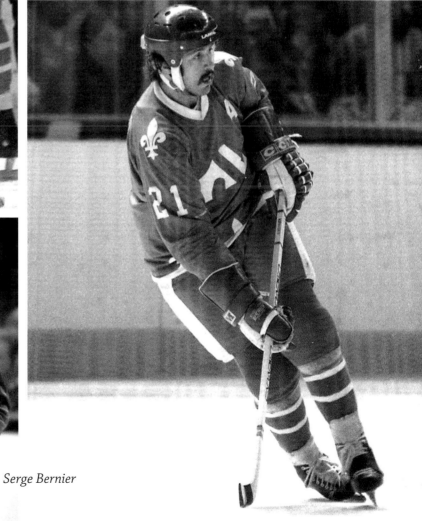

Serge Bernier

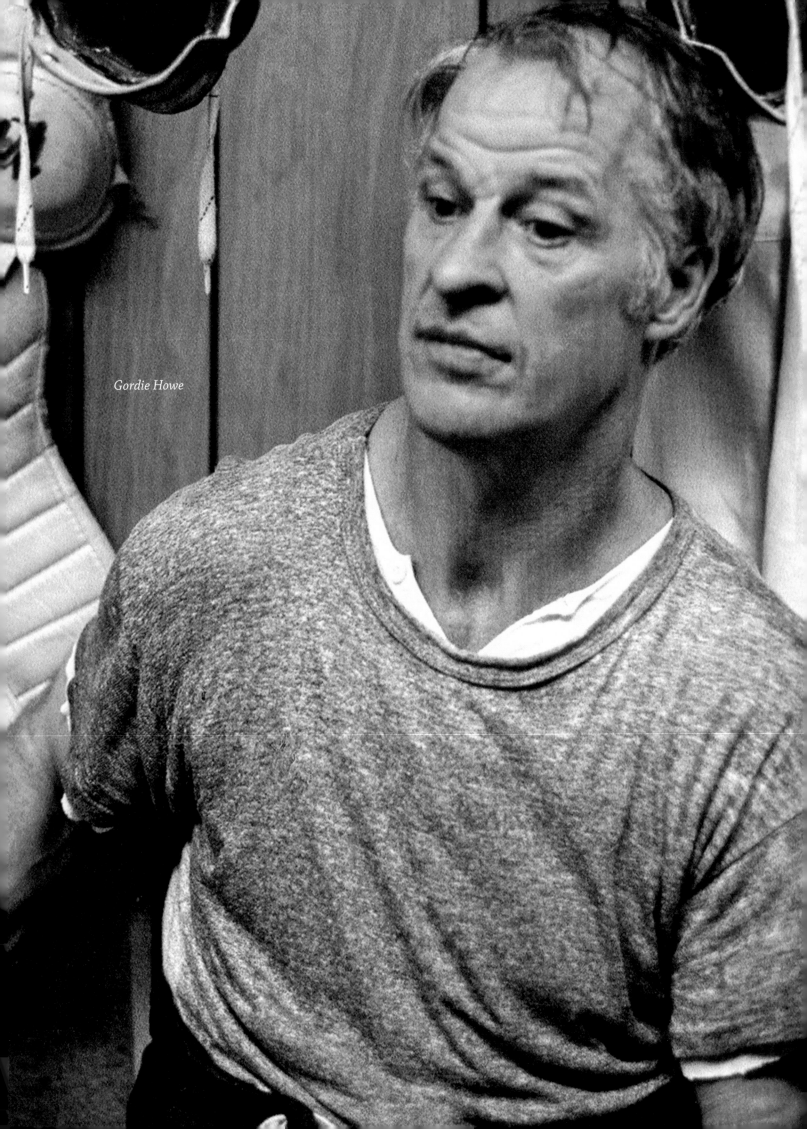

Gordie Howe

THE "FIRST FAMILY" GORDIE, MARK AND MARTY

If the signing of Bobby Hull (and other NHL stars) gave the new league the legitimacy they craved, the crown jewel was the signing of "Mr. Hockey."

Howe had retired in 1971, at the age of 42, after a stellar 25-year career, during which he earned nearly every accolade a player could achieve. His No. 9 was retired in 1972, and he was inducted into the Hockey Hall of Fame that same year (the three-year waiting period having been waived). Although he had retired due to chronic wrist pain, retirement didn't suit him. He had been given a front office job with the Red Wings but had precious little to do. Then opportunity knocked. At an age when most retired athletes are content to play golf and make public appearances, in 1973 he had the opportunity to play in the new World Hockey Association alongside his sons Mark and Marty.

The Howe boys had signed with Houston following the 1973 WHA draft, Mark having been chosen in the first round, Marty in the 12th. The signing of underage players was a move that didn't sit well with the NHL, which had a policy of not drafting junior eligible players. Gordie felt it was his sons' decision to make. As a plus, now a free agent, Gordie asked if the Aeros were interested in having him on the roster. They jumped at the chance to sign one of the all-time greats, despite his age and recent absence from the game.

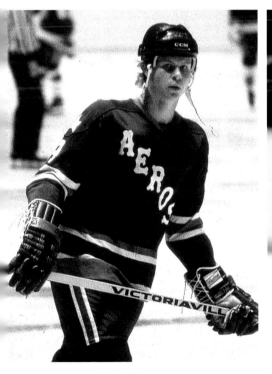

Mark Howe

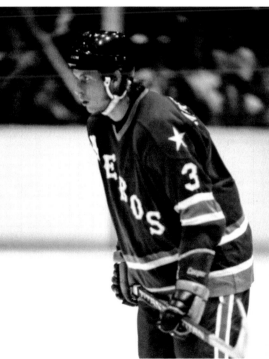

Marty Howe

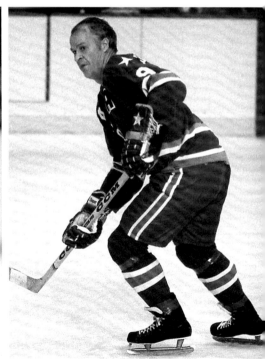

Gordie Howe

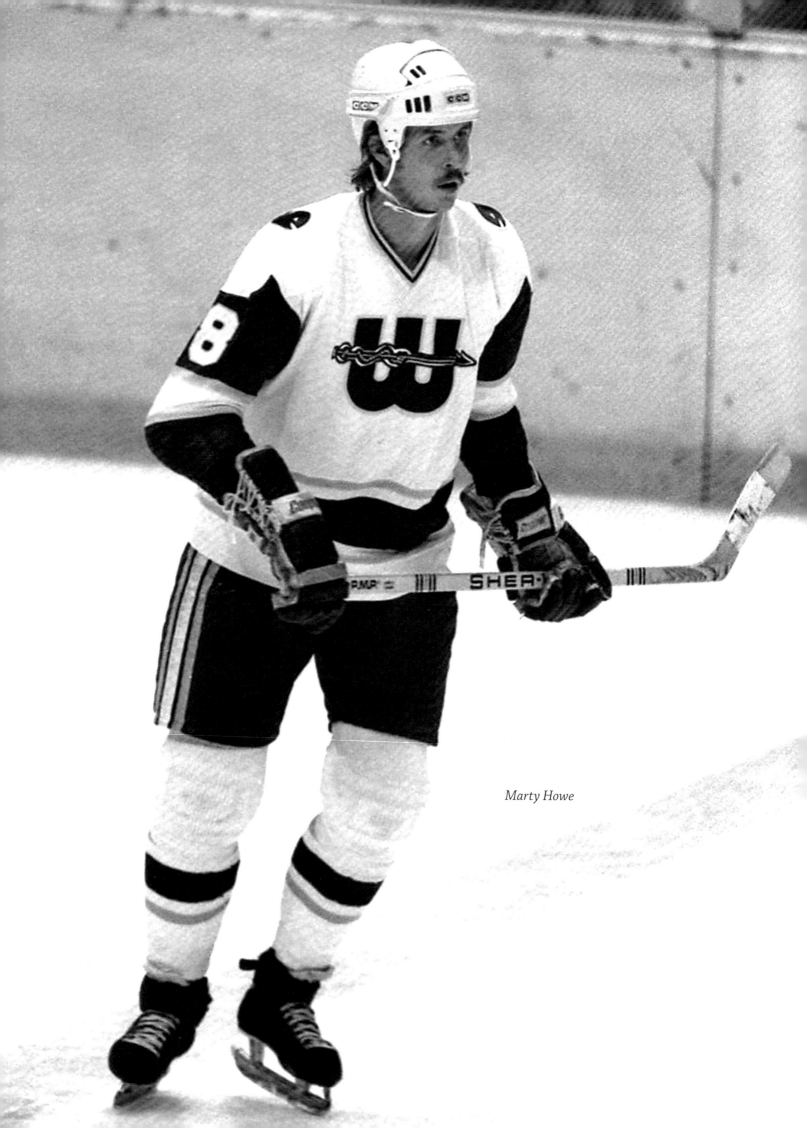

Marty Howe

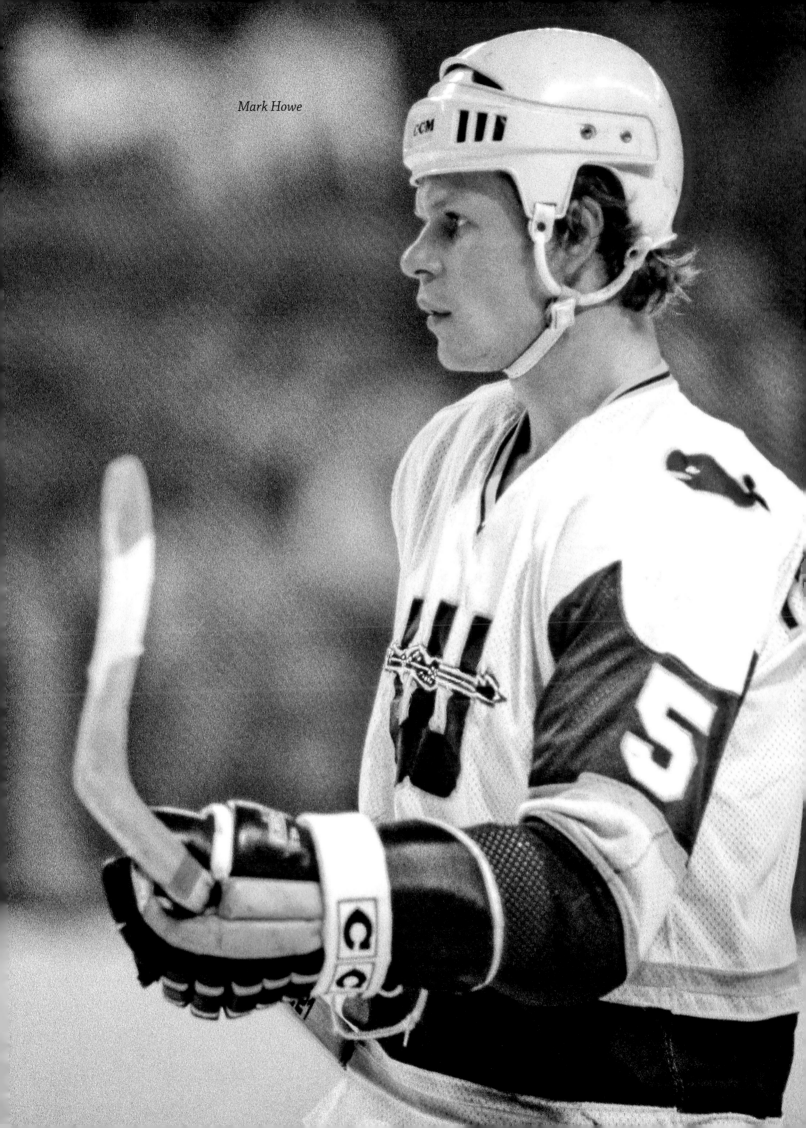

Mark Howe

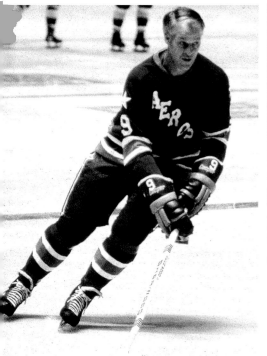

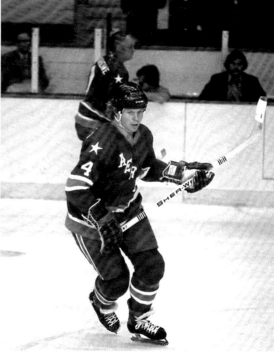

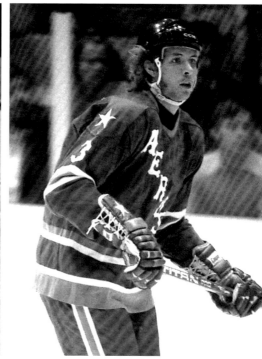

Gordie Howe

Mark Howe and Gordie Howe

Marty Howe

The Howes

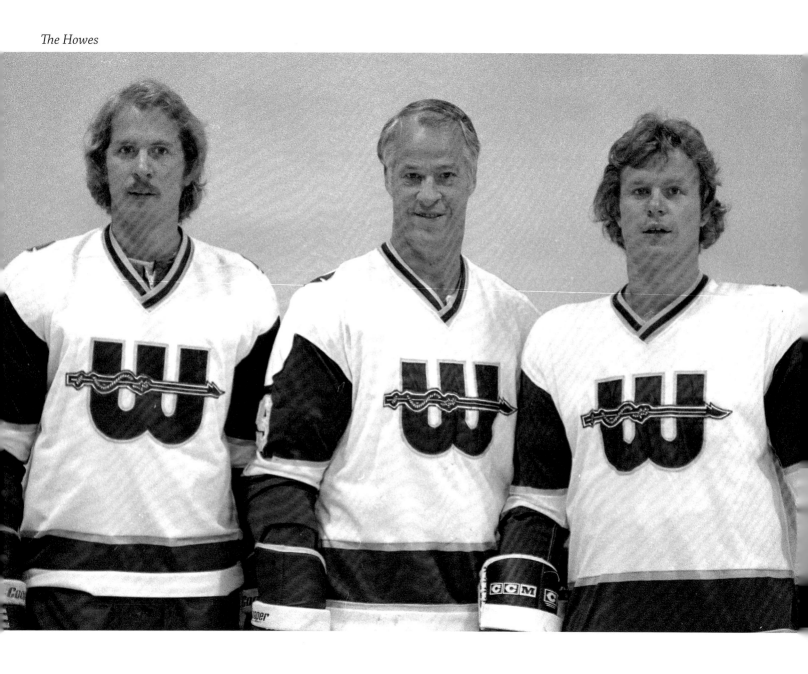

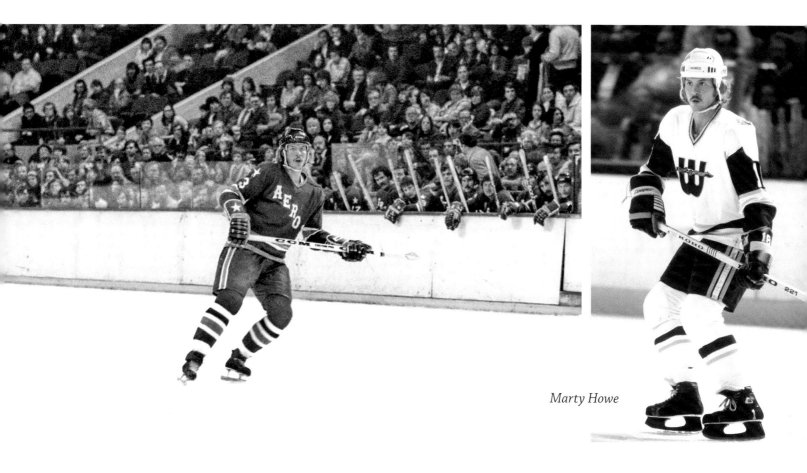

Marty Howe

It was far from a gimmick. Howe, having had surgery on his wrist, came back with a vengeance. At the age of 45, he would be a team leader. In four years with the Aeros, he scored an impressive 121 goals and 248 assists, winning two Avco World Cups along the way.

He hadn't mellowed with age or missed a step in the corners. His elbows were just as feared in the WHA as they were in the NHL. Son Mark said, "He's the nastiest player on ice I've ever seen. But he might be the most gentlemanly person I've met in my entire life."

These qualities may seem contradictory, but Howe was the very essence of this philosophy, excelling in both categories. It was said that even in old-timers' games later in his life opponents who failed to show the proper respect lived to regret it.

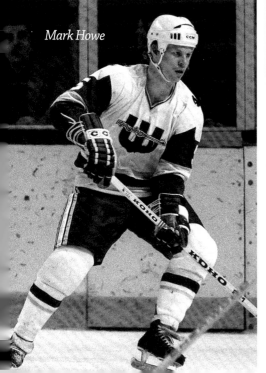

Mark Howe

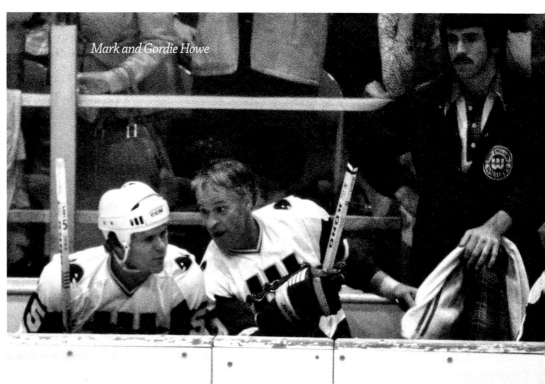

Mark and Gordie Howe

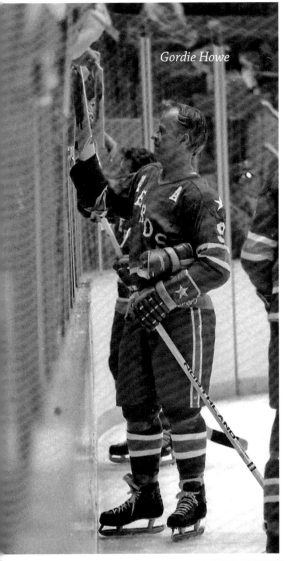

Gordie Howe

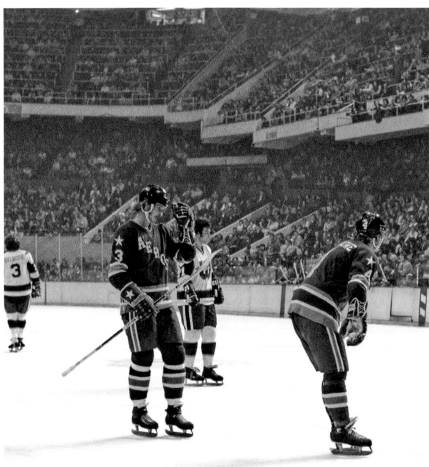

Marty and Mark Howe

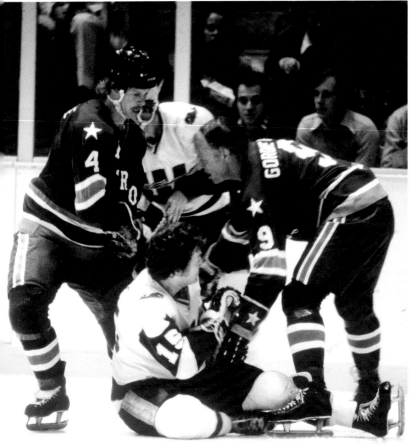

Mark and Gordie Howe

Howe and his sons would play four years in Houston. In June 1977 all three Howes signed as free agents with the New England Whalers.

Once again Gordie, Mark and Marty were a major drawing card. At age 50 Gordie led the team in scoring, and while they won no championships, they became very popular with Hartford fans. They played together for two seasons (1977–78 and 1978–79) as New England Whalers. By then there were serious merger talks between the NHL and WHA, with four WHA teams joining the senior

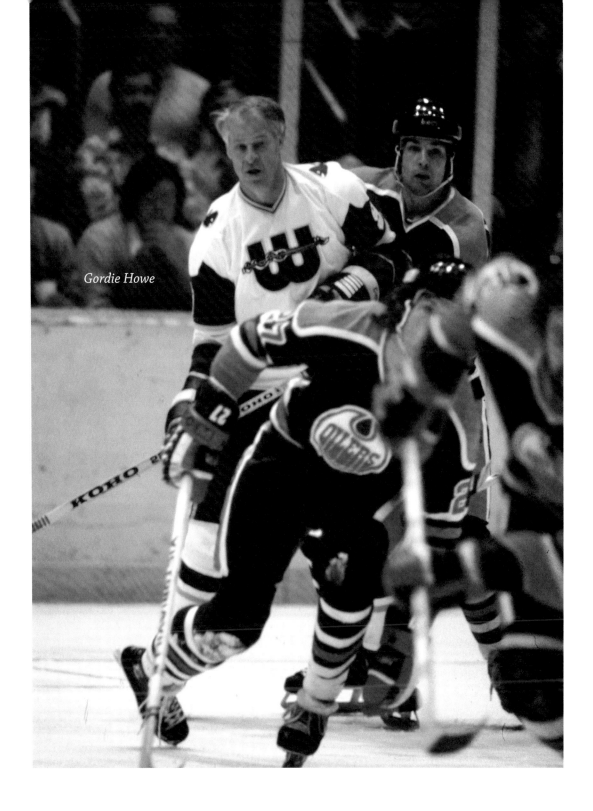

Gordie Howe

league. The Howes (among others) could remain with their WHA teams rather than the teams that held their NHL rights.

Marty Howe would play five seasons with the Whalers in the NHL, interrupted by a year with the Bruins in 1982–83. Mark Howe had three more Whalers campaigns before moving on to Philadelphia and a long Hall of Fame career that would eventually lead back to Detroit, his father's team of 25 years. Gordie Howe spent one more season with the now Hartford Whalers after the merger, and on April 11, 1980, became the oldest player to play in an NHL game at 52. It's a record unlikely to ever be broken.

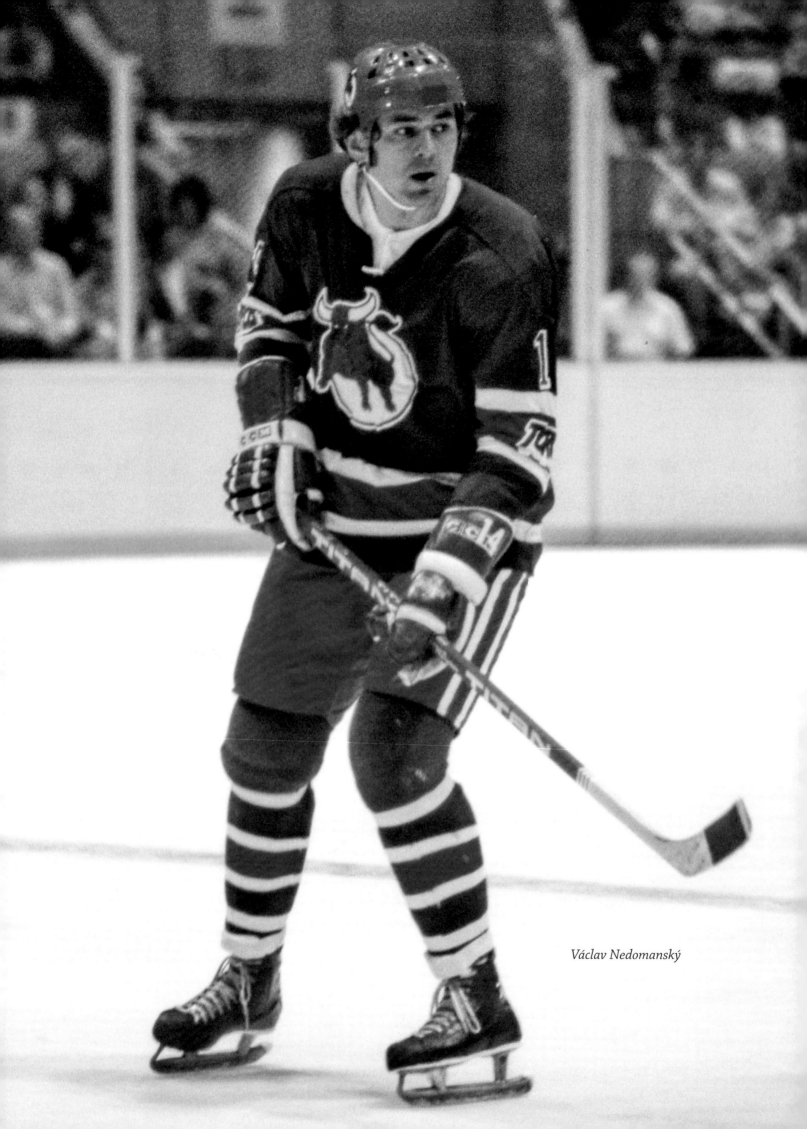

Václav Nedomanský

EL TOROS: NEDOMANSKÝ, MAHOVLICH, HENDERSON

Despite the usual financial woes that often dogged WHA teams, the Toros managed to sign three stars who would play a major role in their success on the ice.

One of the more intriguing stories was that of Václav Nedomanský, best known as the first player to defect from behind the Iron Curtain to play in North America. Already a seasoned veteran of 12 seasons in the elite Czechoslovak First Ice Hockey League, he was also an Olympic star, having won silver in 1968 and bronze in 1972. Chafing under the communist regime, he, along with his wife and son, defected to Canada via Switzerland in 1974. Defection was a dangerous undertaking back then, leaving him as a "non-person" in the eyes of his home government, all but erased from history. He would not see his homeland again until after the fall of Communism.

He thrived with the Toros, never scoring less than 81 points a season during his time in Toronto. He played four seasons in the WHA with the Toros (later the Birmingham Bulls) before joining the Detroit Red Wings in 1977 in a rare interleague trade. The rugged center would be a star there too, playing six seasons with the Red Wings, Blues and Rangers and proving that European players could compete with their North American counterparts at the highest levels. He was inducted into the Hockey Hall of Fame in 2019, having already been welcomed into the International Ice Hockey Federation Hall of Fame (1997), Slovak Hockey Hall of Fame (2002) and Czech Ice Hockey Hall of Fame (2008).

Frank Mahovlich

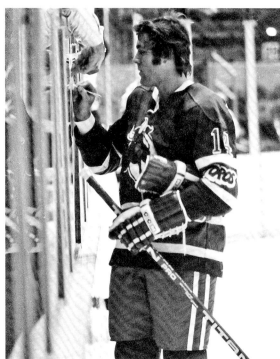

Václav Nedomanský

Paul Henderson

The biggest of the Toros stars was Frank Mahovlich, a Hall of Famer and six-time Stanley Cup winner as well as recipient of the 1958 Calder Cup. A veteran presence at age 37, he had been traded from the Leafs to Detroit and later to Montreal, where he won his final two Stanley Cups. A sensitive but supremely talented man, he was free from the pressures of playing for the Leafs, where overbearing management drove him to a nervous breakdown. He regained his touch in Detroit and Montreal before returning to Toronto as a member of the Toros in the 1974–75 season. Wearing his familiar No. 27, he brought 18 years of NHL experience to the new league as well as a much-needed legitimacy. He scored 171 points in his time with the Toros. The Big M retired in 1978 at age 40 after four years in the WHA. He was not only one of the best players in the history of the game, he was a true elder statesman and gentleman.

Paul Henderson was already an NHL veteran with the Red Wings and Maple Leafs (he was part of the trade that sent fellow future Toro Frank Mahovlich to Detroit) before becoming known as the hero of the 1972 Summit Series. While not a first-rank star, Henderson scored the series-winning goal in Game 8 and was immortalized in a famous photo of the moment, showing Yvan Cournoyer hugging him in celebration. In fact, the image was so famous that it later appeared on a Canadian postage stamp.

Not comfortable with the fame "The Goal" brought and not happy playing with the Leafs, Henderson accepted an "offer he couldn't refuse" deal from Toros owner John Bassett. Except for a brief comeback attempt in 1979–80, he played the rest of his career in the WHA. He put up respectable numbers with his new team, scoring 283 points over five seasons.

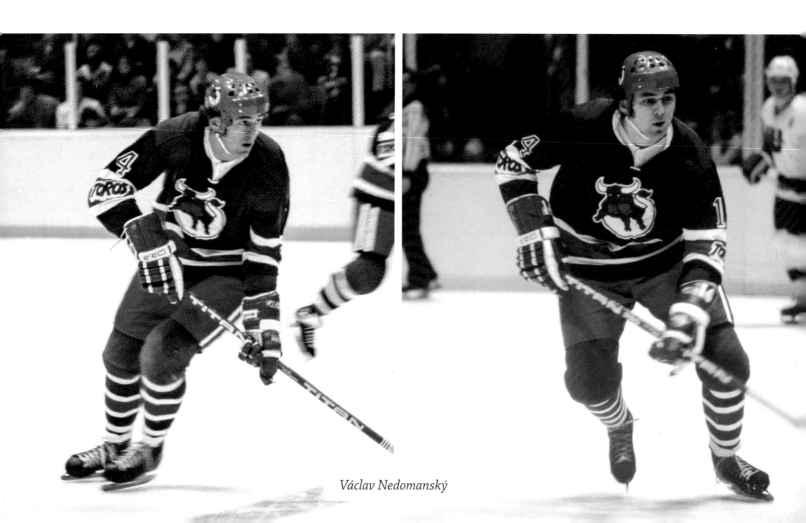

Václav Nedomanský

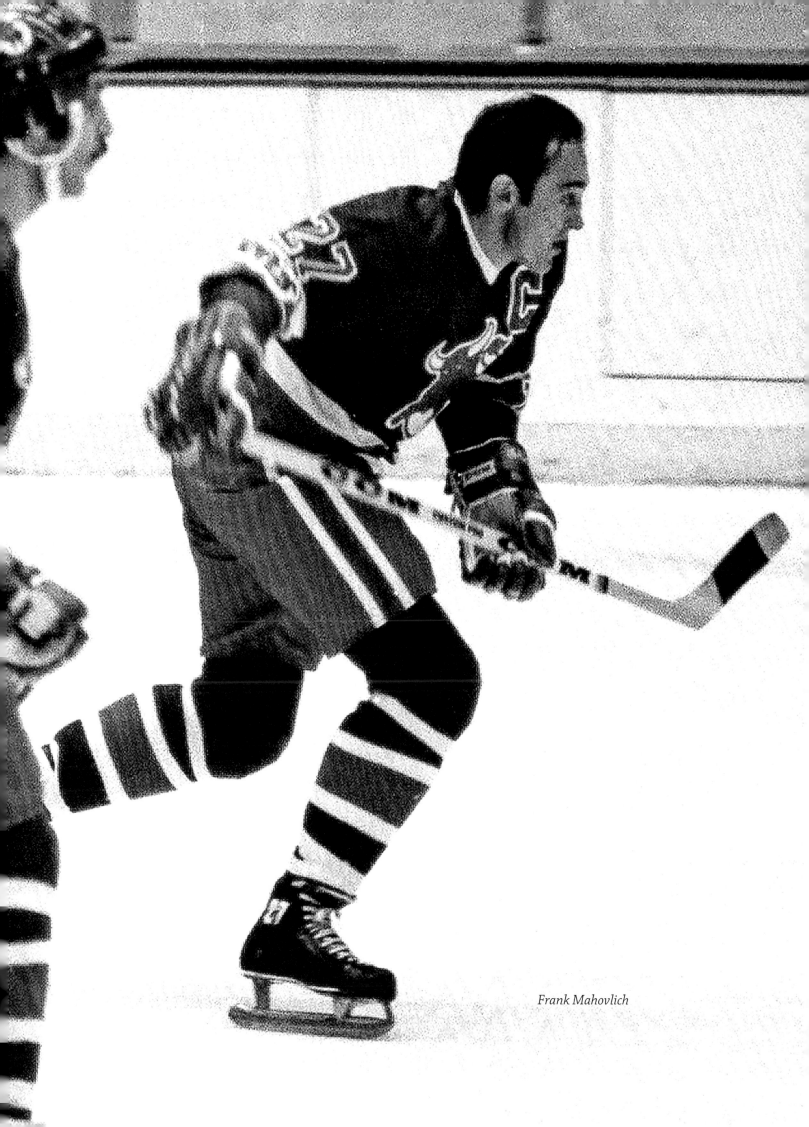

Frank Mahovlich

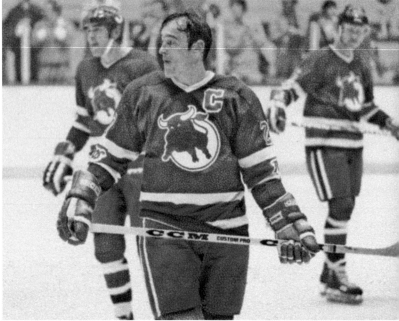

Frank Mahovlich

Paul Henderson

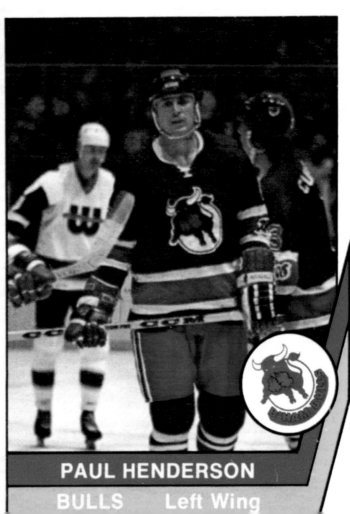

PAUL HENDERSON
BULLS Left Wing

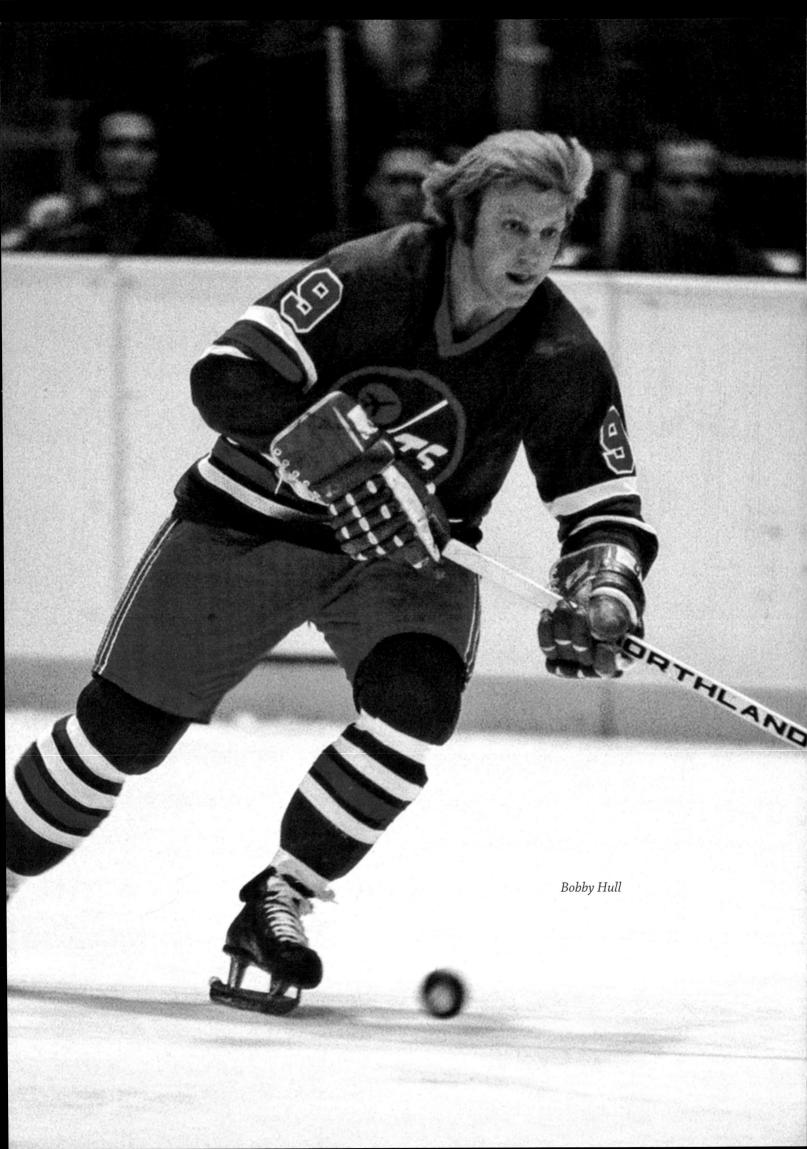

Bobby Hull

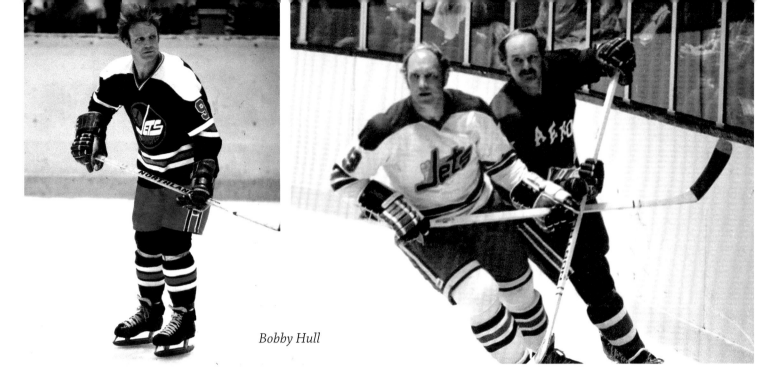

Bobby Hull

THE GOLDEN JET AND THE SWEDES: HULL, HEDBERG, NILSSON

When Bobby Hull joined the WHA, he proved he was worth his fat paycheck immediately. In addition to his blistering slapshot and scoring touch, he led the Jets to championships in 1976 and 1978. He played only a handful of games in 1979, when the Jets won the last Avco World Cup.

In 1974, the Jets went against the traditional mindset by signing Swedish star Anders Hedberg, who suggested they also sign fellow Swede Ulf Nilsson. Hedberg and Nilsson were already stars in their native country and well respected in European hockey circles. Playing alongside Bobby Hull, the trio known as "The Hot Line" dominated. Hedberg never scored less than 50 goals in his four WHA seasons, with Nilsson not far behind. They were both key contributors the Winnipeg's Avco Cup wins in 1976 and 1978. Eventually, the NHL realized the value and skill level of European players. In 1978 the Rangers signed Ulf Nilsson and Anders Hedberg away from the WHA. Hedberg would go on to play seven NHL seasons, all with the Rangers. Nilsson would play four.

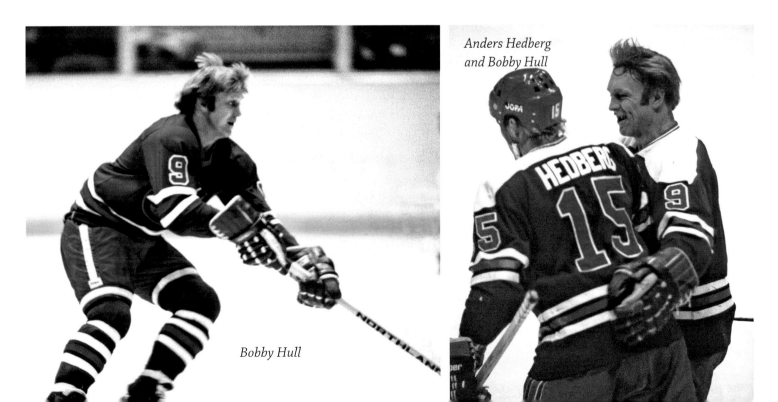

Anders Hedberg and Bobby Hull

Bobby Hull

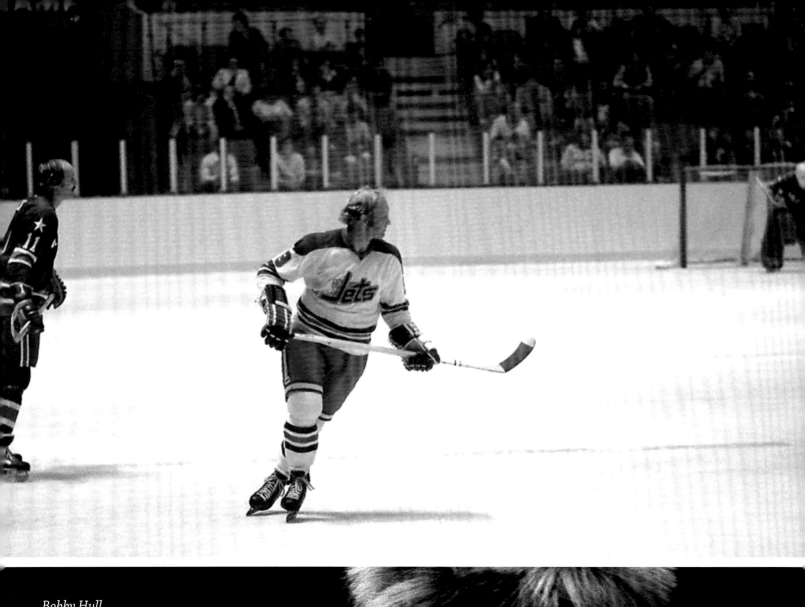

Bobby Hull

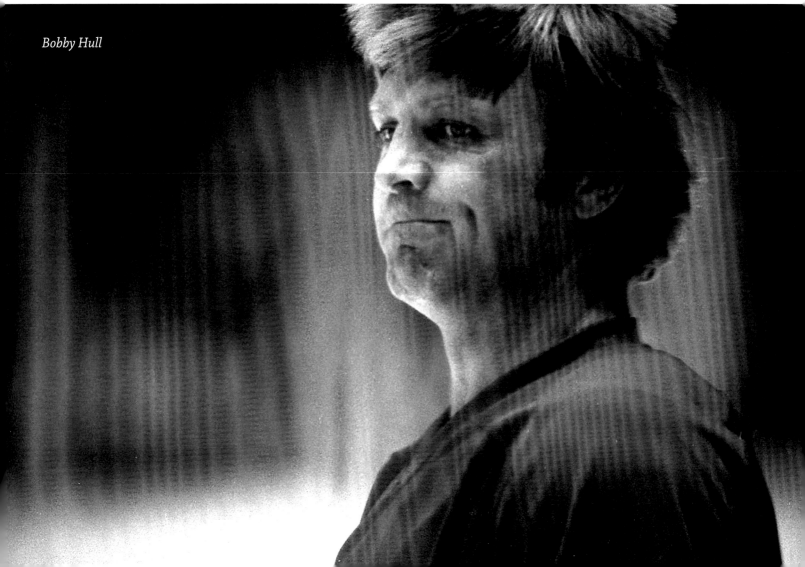

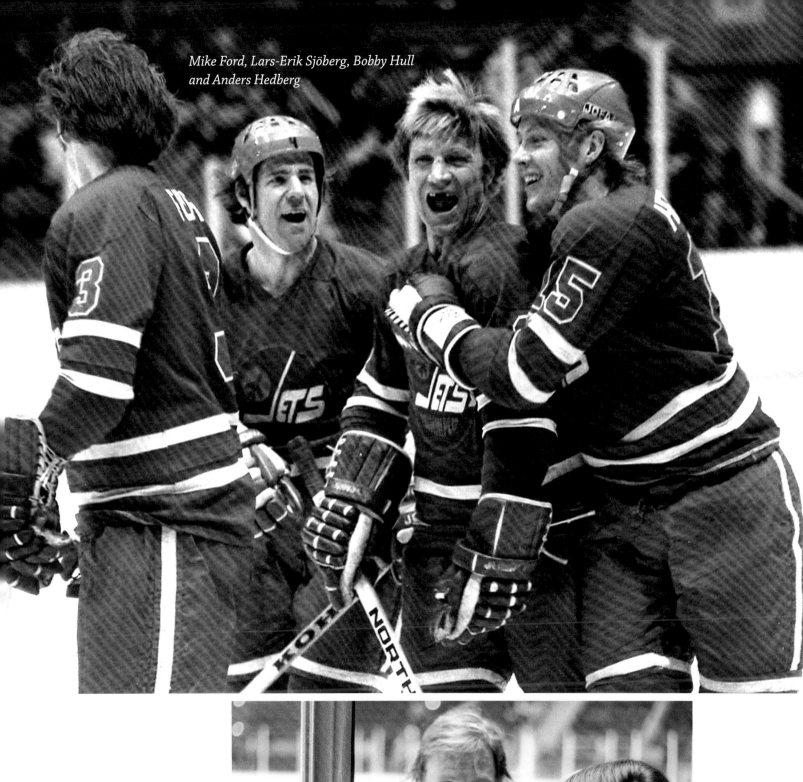

Mike Ford, Lars-Erik Sjöberg, Bobby Hull and Anders Hedberg

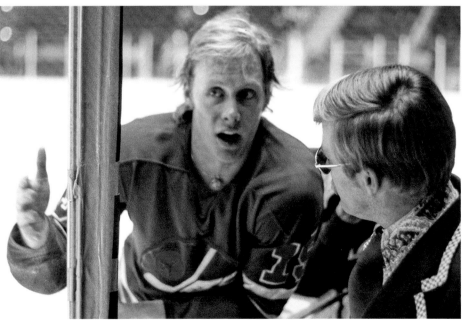

Anders Hedberg

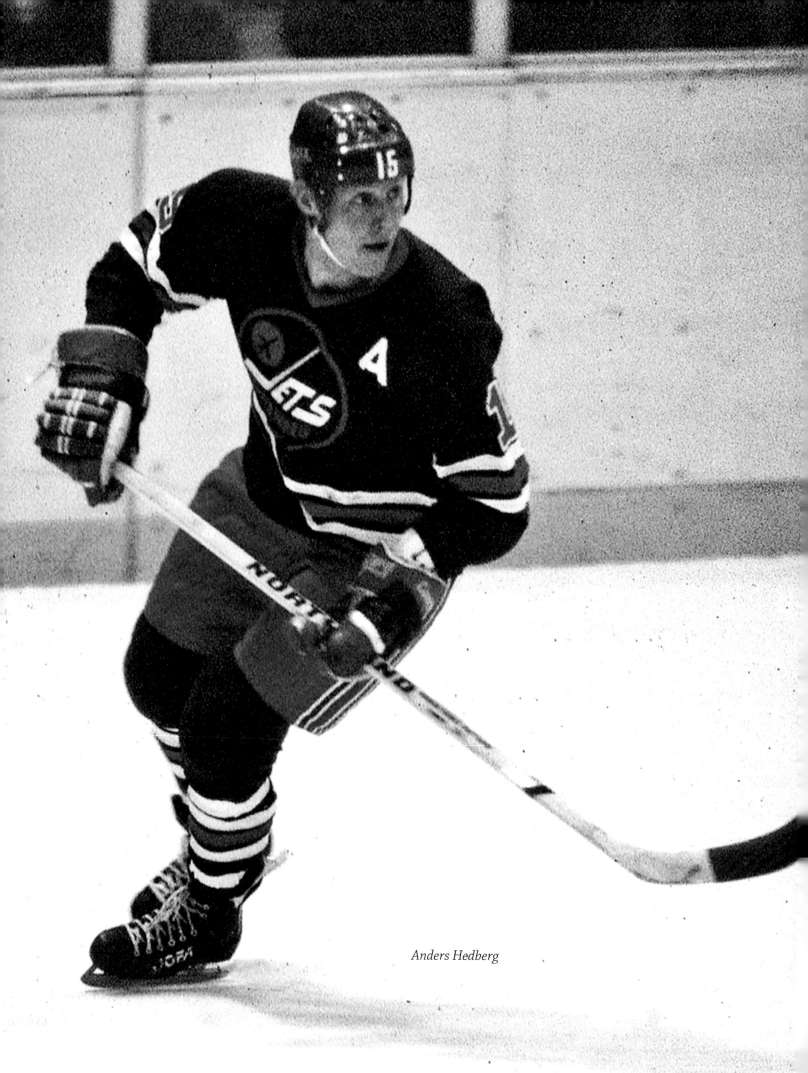

Anders Hedberg

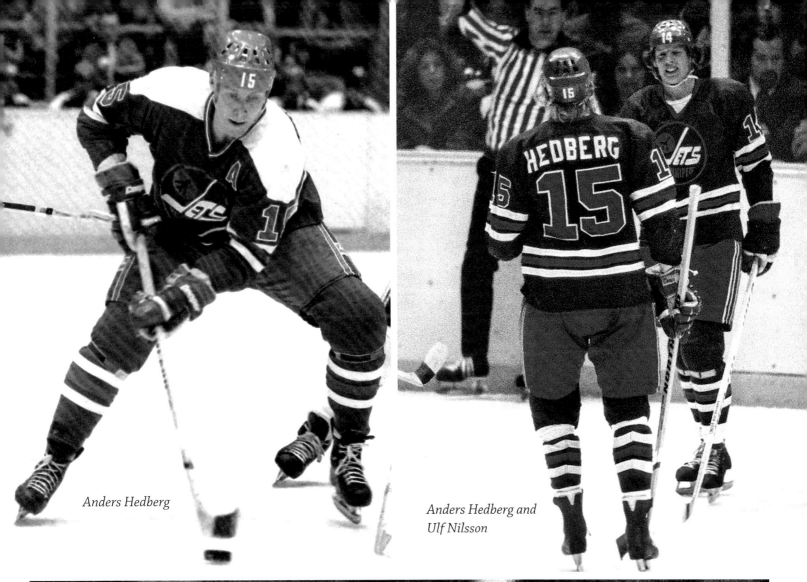

Anders Hedberg

Anders Hedberg and
Ulf Nilsson

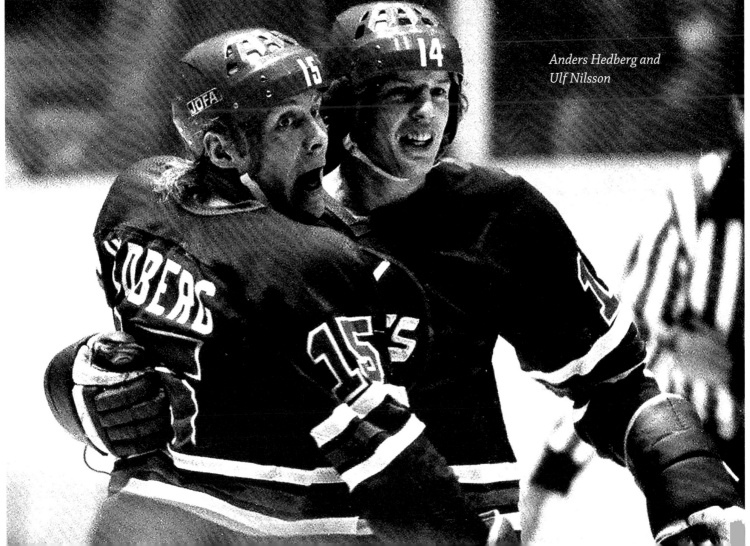

Anders Hedberg and
Ulf Nilsson

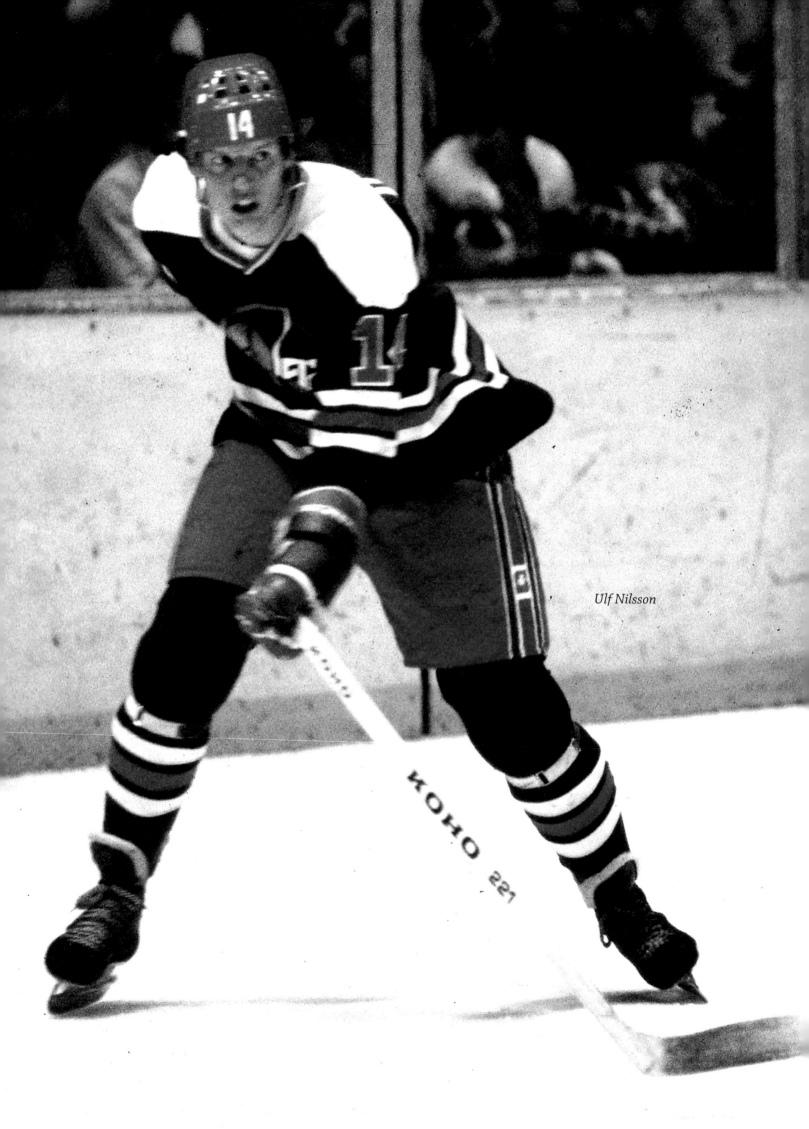

Ulf Nilsson

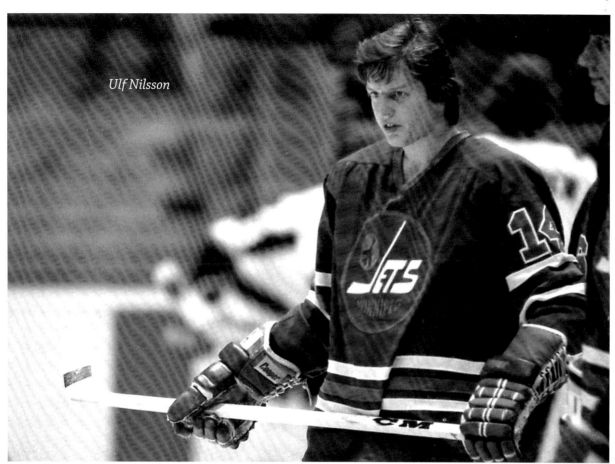

Ulf Nilsson

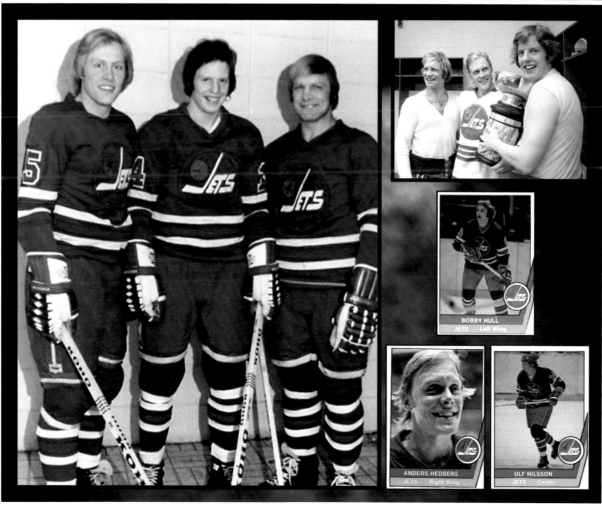

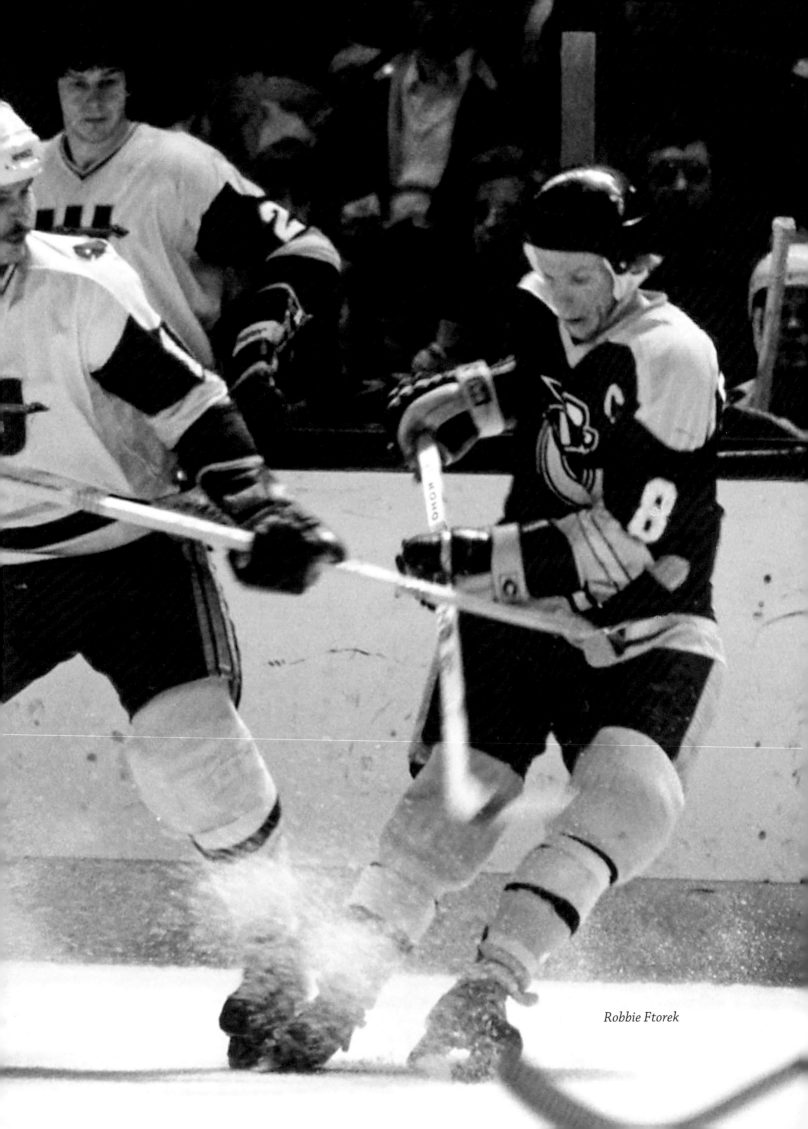

Robbie Ftorek

"LOCAL LADS" FTOREK, SHEEHAN, PLEAU AND HURLEY

A true hometown hero, Needham, MA, native Robbie Ftorek broke state scoring records at Needham High, including his own from previous years. In his senior year, 1969–70, he tore through the high school record books, scoring 118 points (54 goals, 64 assists).

He spent a season with the Junior A Halifax Atlantics before turning his attention to international hockey. He found success there too, winning a silver medal with the 1972 U.S. Olympic team, which included Kevin Ahern, Mark Howe, Henry Boucha and Tim Sheehy.

Coming off a silver medal he was drafted by the New England Whalers but opted instead to go the free agent route, signing with the Red Wings in August of that year. Detroit management thought him too small (although at 5'10" he was far from small), so he saw little playing time in Detroit. Learning that his WHA rights had been traded from New England to Phoenix, he decided to give the new league a try.

He began to play for the Roadrunners in 1974 and quickly made his mark as the team's dominant player. In his three years with the team he scored 298 points. Now a major star in the WHA, he won the league MVP award in 1977, the first American player to do so.

Unfortunately, Ftorek was one of the few bright lights in the Sun Belt city. When the Roadrunners folded after the 1977 season Ftorek signed as a free agent with Cincinnati. He became one of the WHA's leading stars and leading scorers, with 98 goals and 127 assists for 225 points in two seasons with the Stingers. After the league merger in 1979, which didn't include Cincinnati, he moved on to Quebec, now in the NHL.

After three seasons with the Nordiques he was traded to the Rangers, where he would end his major league career in 1985. He is a member of the United States Hockey Hall of Fame, the WHA Hall of Fame and the AHL Hall of Fame.

Known for his mutton chop sideburns, Bobby Sheehan had been around. In his 12-year professional career he played for six NHL teams and four in the WHA. Originally drafted by the powerhouse Montreal

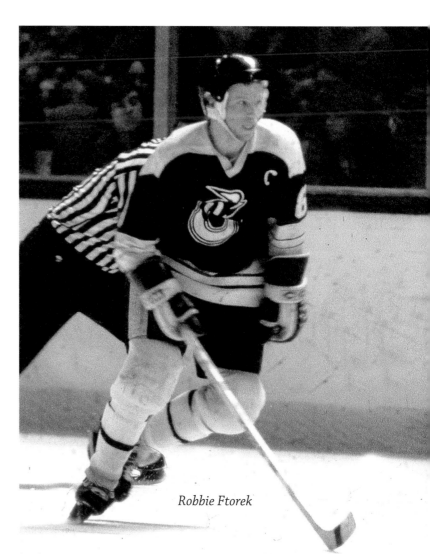

Robbie Ftorek

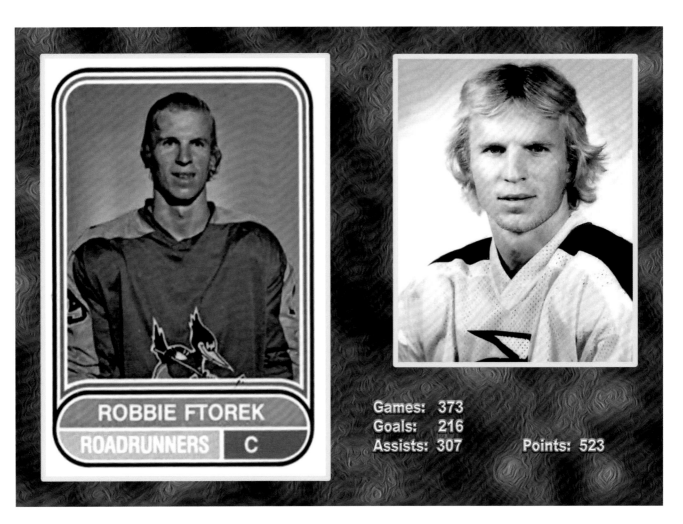

ROBBIE FTOREK

ROADRUNNERS | C

Games: 373
Goals: 216
Assists: 307 Points: 523

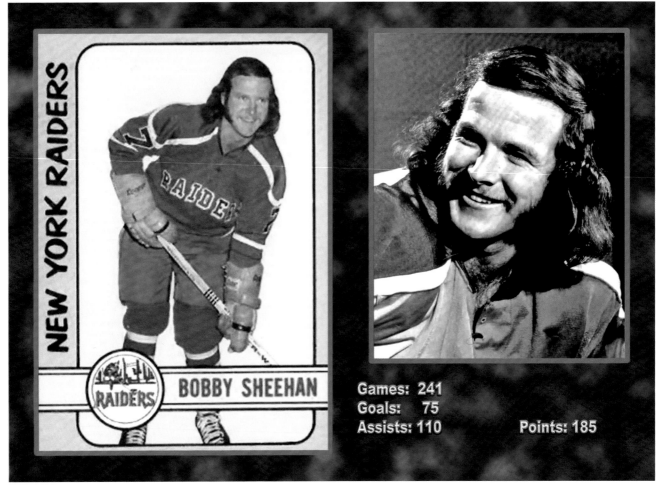

NEW YORK RAIDERS

RAIDERS | BOBBY SHEEHAN

Games: 241
Goals: 75
Assists: 110 Points: 185

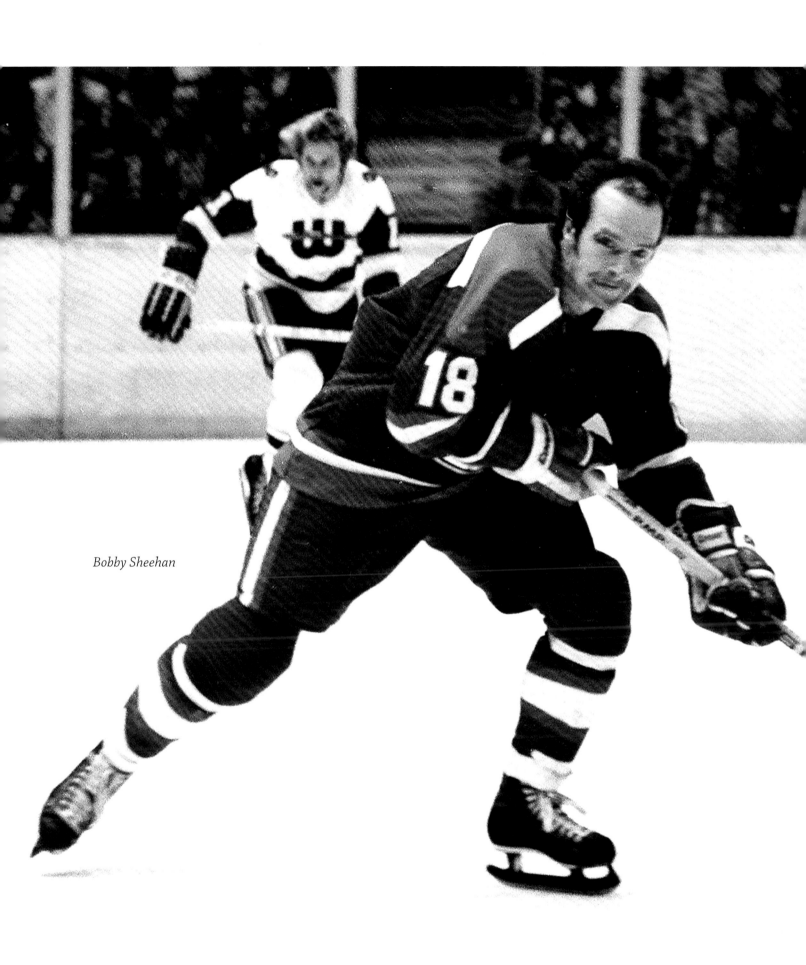

Bobby Sheehan

Bobby Sheehan

Larry Pleau

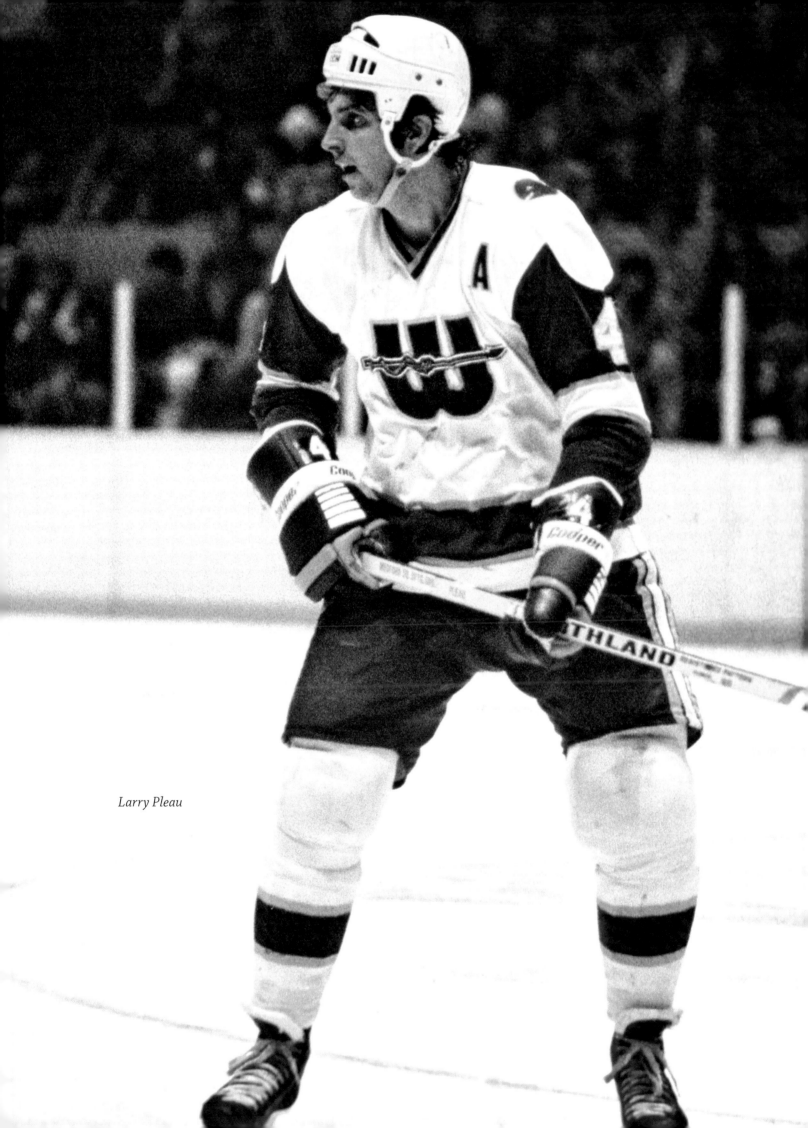

Larry Pleau

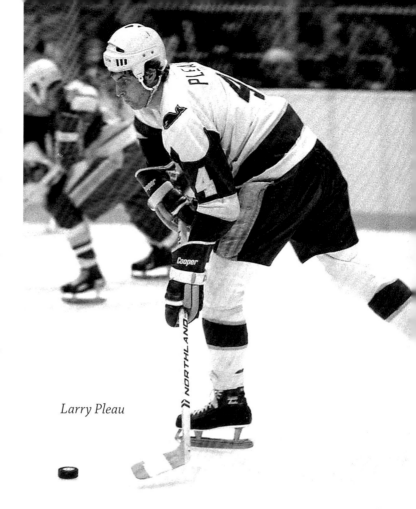

Canadiens, he found breaking into the lineup difficult. He was a member of the 1971 Stanley Cup team before being traded to the struggling California Golden Seals. It was quite a comedown, but he distinguished himself as one of the team's leading scorers with 20 goals and 26 assists.

In 1972 he jumped to the new league with the New York Raiders. In 1973, with the Raiders floundering in New York City, he found himself with the New Jersey Knights, with the Golden Blades somewhere in between.

Although his NHL rights had been traded to the Black Hawks, after a very complicated three-way deal he stayed in the WHA for two

Larry Pleau

HARPOON
THE OFFICIAL MAGAZINE OF THE NEW ENGLAND WHALERS
ONE DOLLAR INCLUDES TAX

LARRY PLEAU

Games: 468
Goals: 157
Assists: 215 Points: 372

HARPOON
THE OFFICIAL MAGAZINE OF THE NEW ENGLAND WHALERS
ONE DOLLAR

PAUL HURLEY

Games: 275
Goals: 10
Assists: 76 Points: 86

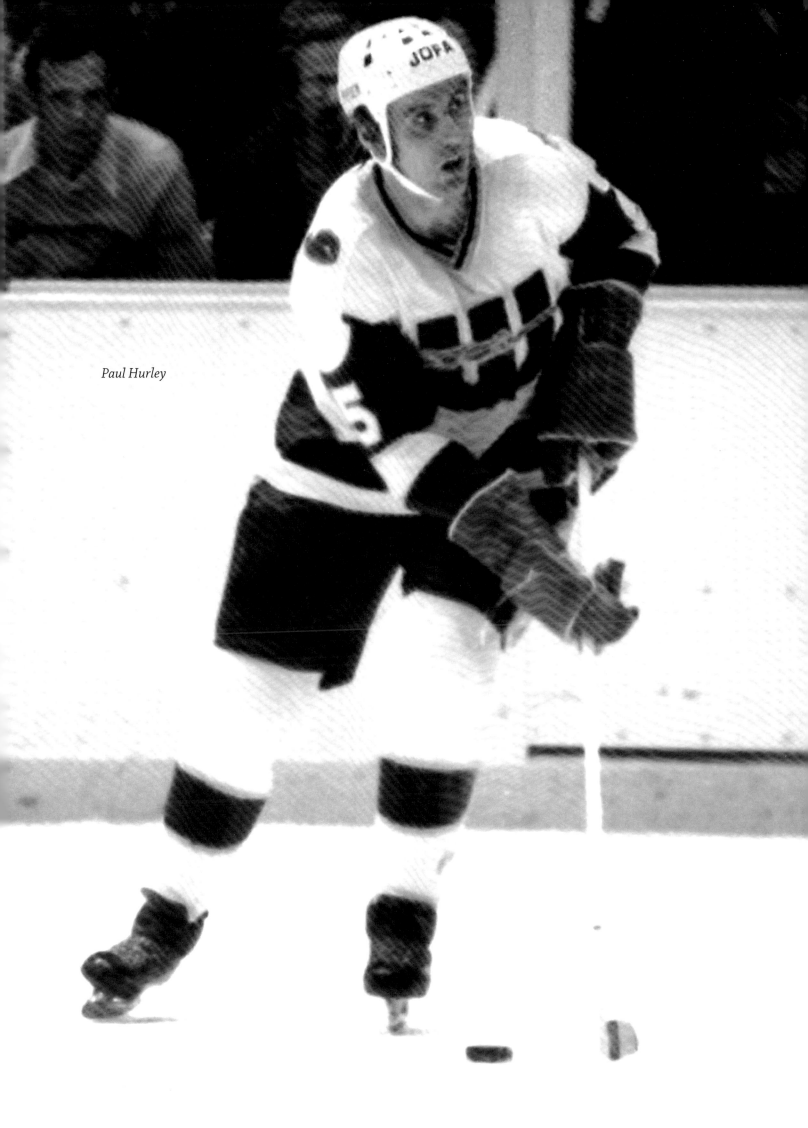

Paul Hurley

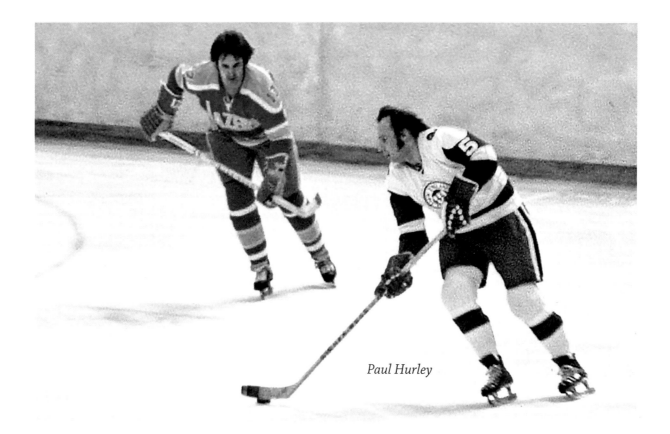

Paul Hurley

more seasons with Edmonton. Now a seasoned veteran, he returned to the NHL, putting up decent numbers in Chicago.

He had less success in Detroit, where he had signed as a free agent. Returning to the WHA, he joined the Indianapolis Racers in 1977 for their next-to-last season. He then signed with the New York Rangers but was dealt to the Colorado Rockies before he played a single game in Ranger blue. He finished his career after four games with the L.A. Kings.

Larry Pleau starred with his hometown Lynn English High School. Regarded as one of the best schoolboy hockey players of his generation, he represented the United States at the 1968 Olympics and was part of the 1969 national team.

Like Bobby Sheehan, Pleau became a part of the Montreal organization, playing for the Junior Canadiens of the Ontario Hockey League, a breeding ground for future NHL stars. And like Sheehan he found it difficult to get playing time with the Habs, then one of the strongest teams in the NHL. After three seasons with Montreal, he jumped to the new WHA, having the distinction of being the first player signed by the Whalers. For the Lynn, MA, native it was a return home.

With more playing time, his career took off. He was a key member of the inaugural Avco Cup championship with the Whalers, scoring 19 playoff points, behind only Tom Webster with 26 and Tim Sheehy with 23. In his seven years in the WHA, all with New England, he scored 157 goals and 215 assists for a total of 372 points.

Defenseman Paul "The Shot" Hurley was a star with the Melrose High Red Raiders in Melrose, MA, a suburb of Boston. It was a standout team in 1962, winning the state and New England title

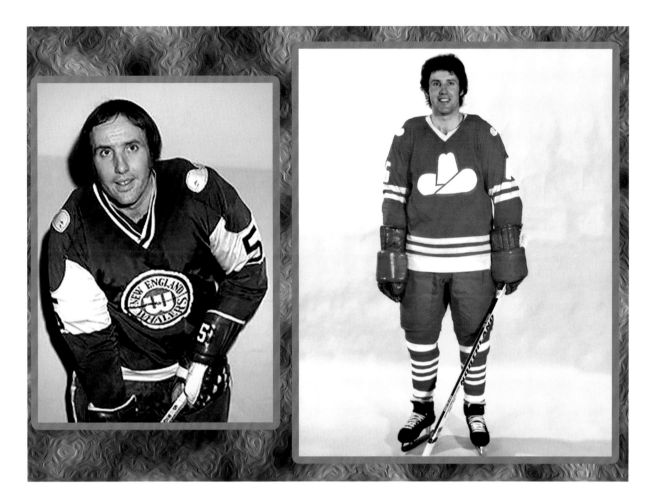

after going undefeated at 22-0-1. He also played a year at Deerfield Academy in Deerfield, MA, before attending hockey powerhouse Boston College, where he was once again a star, earning All–New England, All-East and first team All-American awards.

During this time he also had the opportunity to play for the United States with the National Team for two years, including the 1967 Ice Hockey World Championships in Vienna, Austria, and the 1968 Winter Olympics in Grenoble, France.

After graduating from college in 1969 he was signed as a free agent by the hometown Boston Bruins. It was the dream of every Massachusetts hockey player, but he would only play one game with the rising "Big Bad Bruins," spending most of his time with the minor league Oklahoma City Blazers and Boston Braves.

The new World Hockey Association gave opportunities for many players to move up to the major league ranks, and Hurley was no exception. In February 1972 he was drafted by the New England Whalers. He played a league-high 78 games that season. Joining the Whalers would allow him to play in Boston (until the team's relocation to Hartford in 1974, less than two hours away) and would guarantee more ice time. He spent four seasons in Whaler green and was a part of the 1973 Avco World Cup team.

In February 1976 he was traded to Edmonton, and the following fall he signed as a free agent with Calgary. He played one season, 1976–77, for the Cowboys, the last season of that franchise's existence, and retired after that year at age 30.

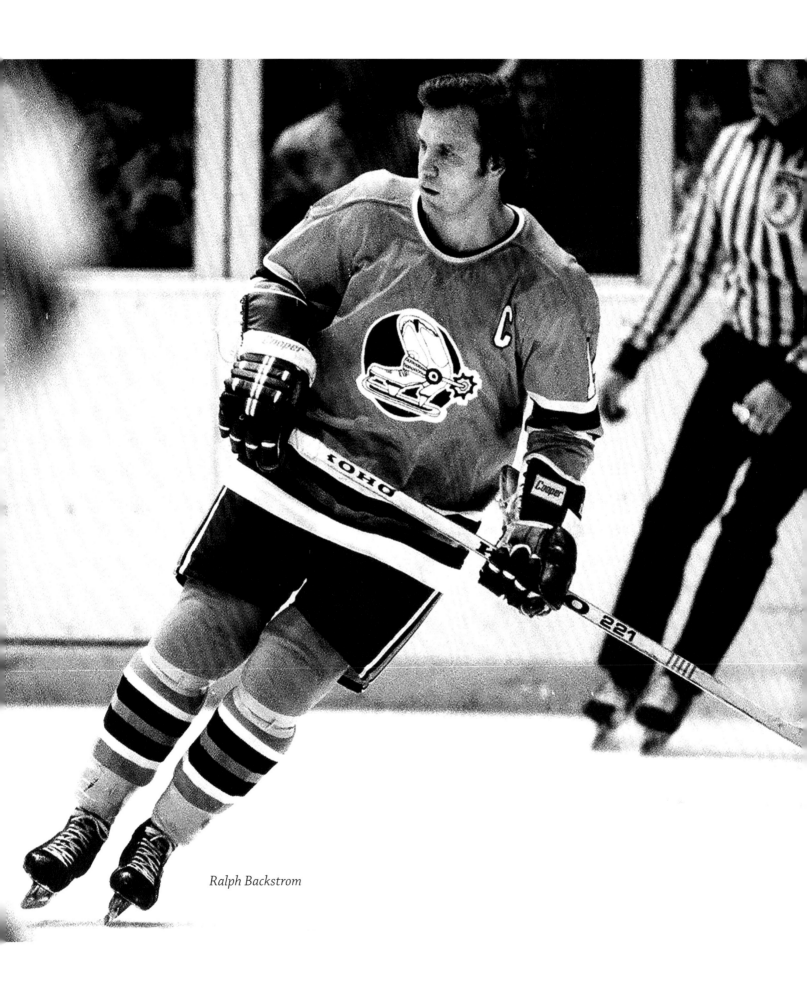

Ralph Backstrom

CHICAGO CONNECTION: BACKSTROM, MAGGS, STAPLETON

What do Ralph Backstrom, Darryl Maggs and Pat Stapleton have in common? All three played for the Chicago Black Hawks and Chicago Cougars in the course of their careers.

Winner of the 1959 Calder Trophy winner for Rookie of the Year, Ralph Backstrom played 13 full seasons with the Montreal Canadiens, picking up six Stanley Cup championships along the way. In January 1971 the aging center was traded to the Los Angeles Kings for journeymen Ray Fortin and Gord Labossiere, though neither Fortin or Labossiere would ever suit up for the Habs.

In a more even trade, in February 1973 he was sent to the Black Hawks for Dan Maloney. He finished the season with the Hawks before embarking on his new career with the World Hockey Association. After two seasons in Chicago (he even became part owner at one point), he was claimed by Denver in the 1975 expansion draft. That ill-fated franchise only lasted 41 games, so Backstrom was on the move again, this time to New England, where he would finish his playing days at age 39. While not always playing on winning teams, Backstrom was a popular player in every WHA arena. A proven winner, he was something the league needed in its formative years.

Darryl Maggs began his career with the Black Hawks in 1971. In his second season he was traded to the California Golden Seals. Going from a contender to a struggling team was a letdown,

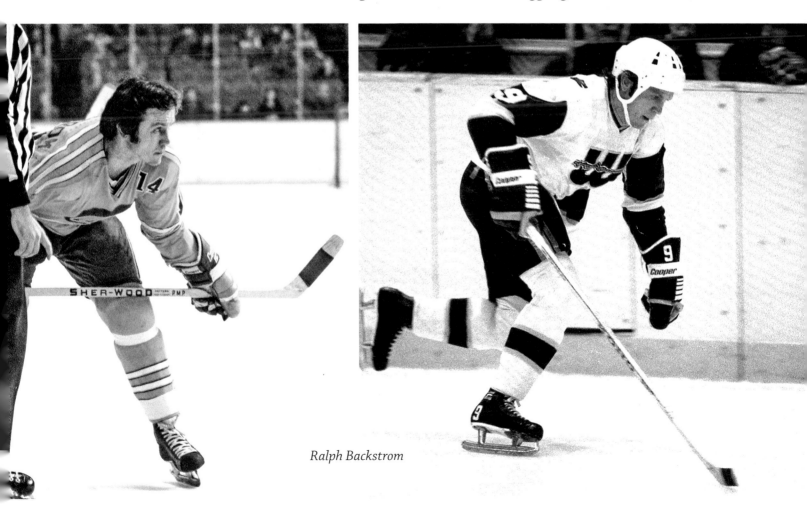

Ralph Backstrom

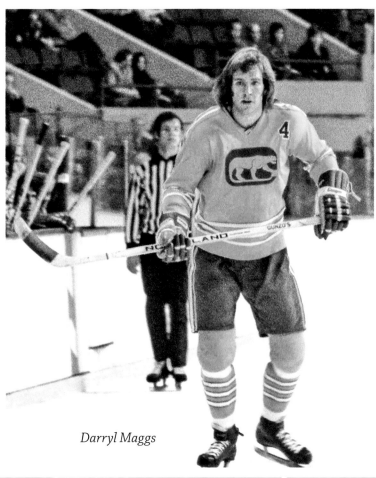

Darryl Maggs

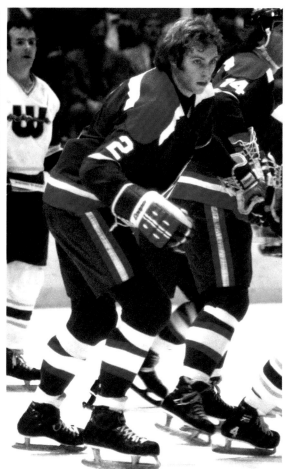

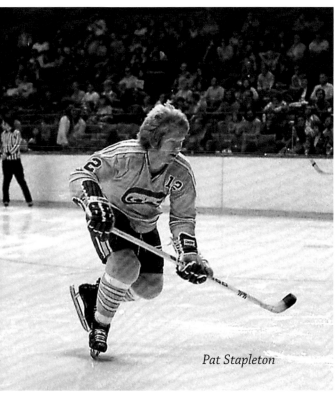

Pat Stapleton

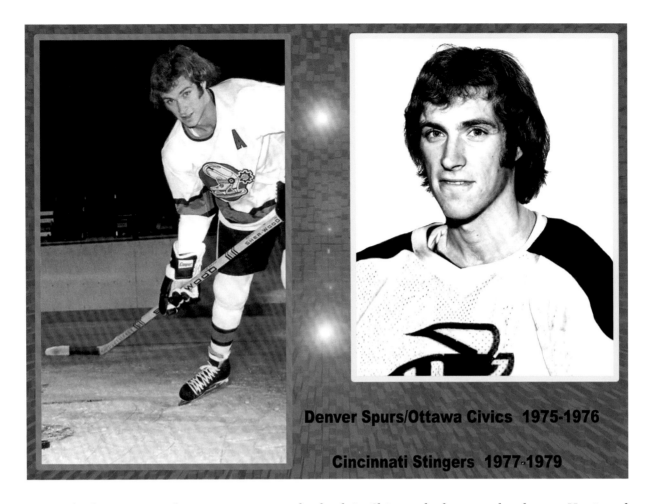

Denver Spurs/Ottawa Civics 1975-1976

Cincinnati Stingers 1977-1979

to say the least. Given the opportunity to play back in Chicago, he leapt at the chance. He signed with the Cougars and would spend two productive years (1973–75) with the team before being traded to the Denver-Ottawa franchise.

Maggs played six years in the WHA, with Chicago, Denver/Ottawa, Indianapolis and Cincinnati, before returning to the NHL with Toronto for a brief period in the 1979–80 season. The rugged 6'1" defenseman would get more playing time in the new league, finishing his WHA career with 228 points, as well as being named to the 1976–77 All-Star Team.

Pat Stapleton is a name known to any Black Hawks fan. The five-time All-Star (three times with the NHL and two with the WHA) played eight years with the Chicago Black Hawks before jumping to the Cougars in 1973. Known for his severe brush cut that would later become a 1970s shag, "Whitey" inked a five-year contract as player-coach. An immediate success, he would win the 1974 Dennis A. Murphy Trophy as Best Defenseman and score a career-high 58 points.

While WHA players were excluded from the 1972 Summit Series against the Soviet Union, Stapleton, at the time a Black Hawk, played. He again represented Canada in the 1974 series, this time as team captain.

Stapleton returned to the Cougars as player-coach for the 1974–75 season. Despite their popularity, the team struggled financially. In an unprecedented move, in December 1974, he and teammates Dave Dryden and Ralph Backstrom bought the franchise. It was a short-lived deal. The team folded after the 1975 season and Stapleton landed in Indianapolis, where he played two seasons before a contract dispute sent him to Cincinnati, his last hockey hometown.

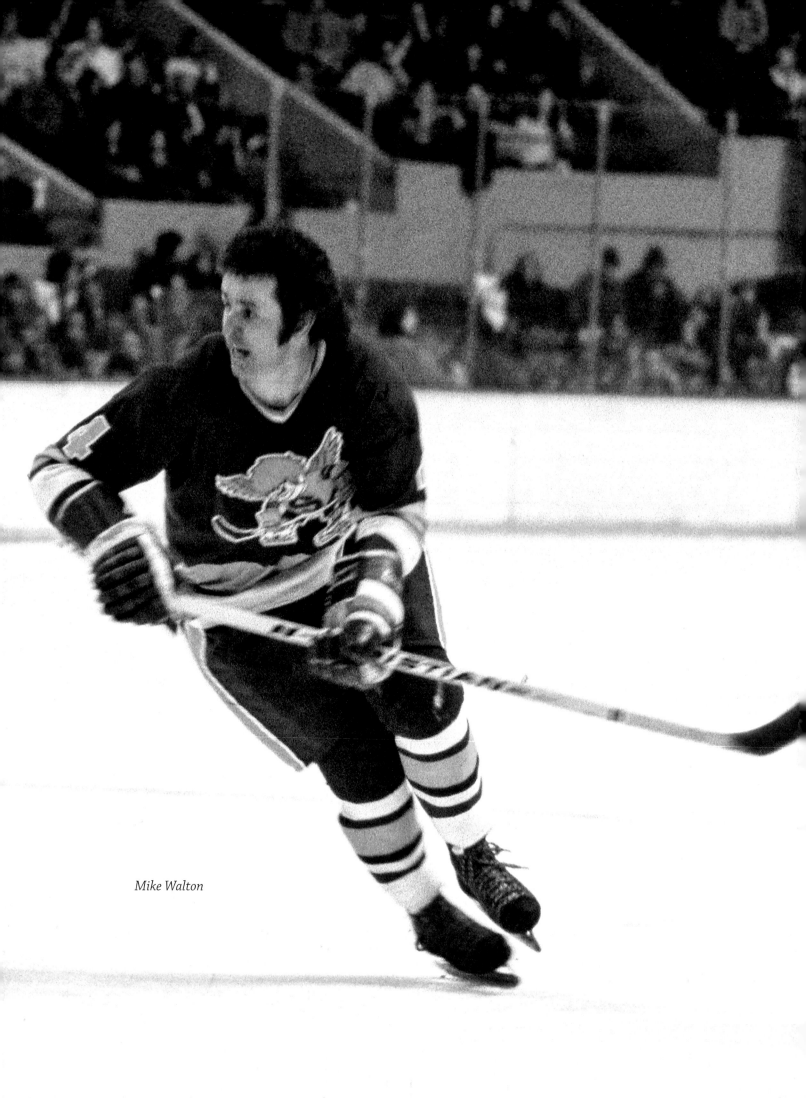

Mike Walton

THREE ACES: WALTON, LACROIX, HARRISON

Nicknamed "Shakey," Mike Walton attended Toronto's St. Michael's College, a conduit for future NHL players, especially the Maple Leafs. After the St. Mike's hockey program was shut down in 1962, the players the Leafs saw as having the potential to make the big time were transferred to Neil McNeil High School in nearby Scarborough. Many players from the school graduated to the Toronto Marlboros of the Ontario Hockey League, including NHL stars Brad Park, Rod Seiling, Gary Smith, Jim McKenny and Billy MacMillan.

Walton worked his way up the Leafs minor league system, playing for the Tulsa Oilers and the Rochester Americans. He would win a Calder Cup with the latter in 1966 and would join the Maple Leafs full time later that year—just in time to win the 1967 Stanley Cup, the last of the Original Six championships. Like many young players, especially in high-pressure hockey cities such as Toronto and Montreal, he frequently clashed with management. This was especially the case with coach Punch Imlach, whose "old school" autocratic style alienated many. Imlach was especially disdainful of younger players, and was known to be abusive.

Relief for Shakey came with a 1971 trade to Boston. The Big Bad Bruins were at their peak, winning the Stanley Cup the previous year. The change energized Walton; he would play well there and was a member of the 1972 Stanley Cup team.

In 1972 the siren song of the WHA was heard throughout the senior league. In an attempt to lure talent, a draft of NHL players was held, even though most chose to remain with their teams. In that initial draft Walton was claimed by the Los Angeles Sharks, but in June 1973 his rights were traded

 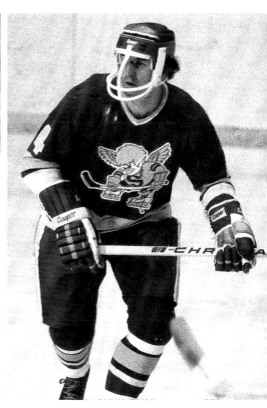

Mike Walton

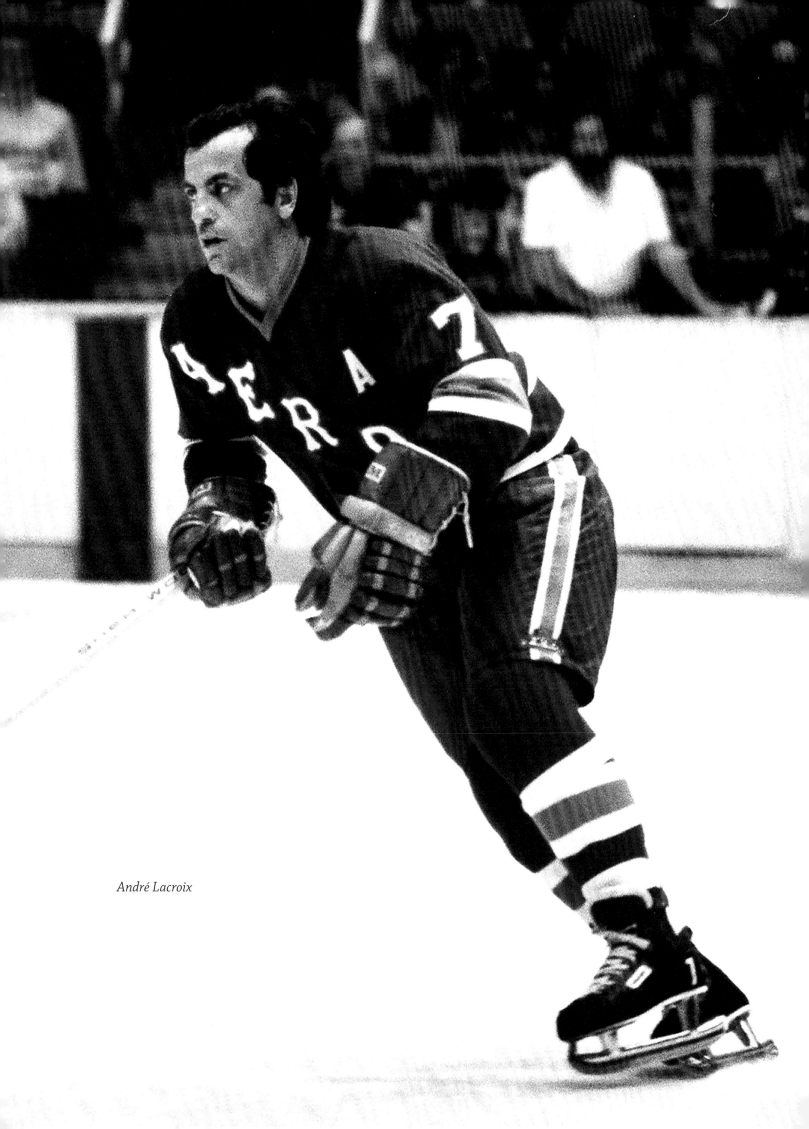

André Lacroix

André Lacroix

to Minnesota. Signing a three-year, $450,000 contract, he became a Fighting Saint.

The Saints were known as a group of rowdy, eccentric and colorful characters. Shakey fit right in, scoring a career-high 117 points, equal to his entire four years in Boston. In his three years with the team his production never slipped below 70 points, making him one of the leading scorers in the league.

In February 1976, the Saints faced financial problems and soon folded. Shakey's NHL rights were now held by Vancouver, who had acquired them in a deal with Boston. His production had dropped off, and he was traded to St. Louis in 1978. After brief stints with the Blues, Bruins and Black Hawks, as well as with Kölner Haie in Germany, he retired at the end of the 1979–80 season. He was inducted into the World Hockey Association Hall of Fame in 2010.

André Lacroix's career was split almost evenly between the NHL and WHA. Gifted in all aspects of the game, the undersized (5'8", 175-pound) center played his junior hockey with the prestigious Peterborough Petes, a team that has been home to Hall of Famers Bob Gainey, Steve Yzerman, Larry Murphy and Chris Pronger. From there he moved on to the Quebec Aces, then an affiliate of

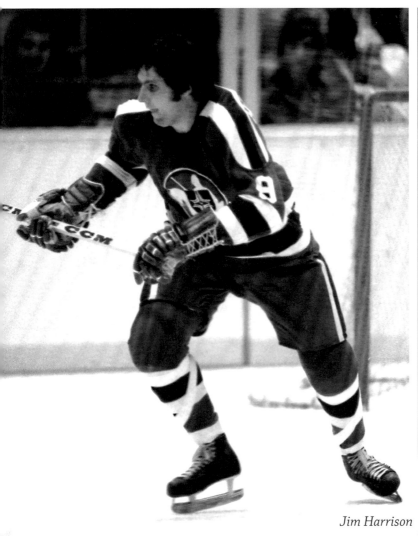
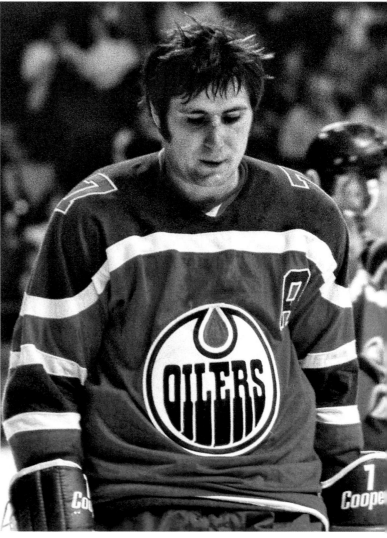

Jim Harrison

the Philadelphia Flyers. In his three full years with Philadelphia (he had a brief stint in 1967–68, scoring an impressive 14 points in 18 games), he scored a total of 156 points. His future as a Flyer seemed assured.

In October 1971, however, he was traded to Chicago. He found it difficult to fit into the Black Hawks system and, despite playing on a line with Bobby Hull, struggled to score. His production dipped to 11 points in 51 games, a total that would change drastically with his jump to the Philadelphia Blazers in 1972–73. Happily back home in Philly, that season he scored an astonishing 124 points in 78 games, including 50 goals, to lead the league.

That was the one and only season for the Blazers in Philadelphia. The following year they relocated to Vancouver, where the only competition was the expansion Canucks. The Canucks boasted few stars and every season had had a losing record, so the Blazers saw it as greener pastures. Lacroix didn't see it that way and refused to move with the team. Instead, he signed with the star-crossed New York franchise, known as the Raiders, Golden Blades and Jersey Nights in their brief existence. He once again led the team in scoring with 111 points.

When the Knights moved to San Diego to become the Mariners, Lacroix scored a career record 147 points. His 106 assists made him the only pro not named Orr, Gretzky or Lemieux to break the 100 assist mark. Enjoying his time with the Mariners, his totals never dipped below 100 points.

When the Mariners (it seemed inevitably) folded, Lacroix took his talent to Houston (1977–78). With the Aeros he led the team in scoring, with 113 points. His next stop was in New England, where he had the good fortune to play with Gordie Howe, as well as his sons Mark and Marty. Like Howe, he stayed with the club after the league merger, playing with such veterans as Dave Keon and (briefly) Bobby Hull. A born playmaker, Lacroix became the WHA's all-time leading scorer.

Jim Harrison came up through the Boston Bruins system, but like many players of his era found it difficult to crack the major league lineup. He played a handful of games over two seasons (1968–69 and 1969–70) in Boston. In December 1969 he was dealt to Toronto (and thus missed the Bruins Stanley Cup championship) for Wayne "Swoop" Carleton. Carleton himself became a WHA mainstay, playing five years for various teams. The Leafs were a far weaker team than the Big Bad Bruins, but the trade gave Harrison more ice time.

When Harrison's WHA rights were obtained by the Alberta (later Edmonton) Oilers, he went with the new league. The change of scenery seemed to agree with him. He scored a career-high 86 points to lead the team that inaugural season. He also set a league scoring record in a game against the New York Raiders, netting 10 points (3 goals and 7 assists).

He played two seasons with the Oilers before being traded to Cleveland, where he continued to put up impressive numbers. When the Crusaders relocated to Minnesota, he was sent to Calgary but never played for them. Meanwhile, his NHL rights had been traded by Toronto to Chicago, so he returned to the senior league, now a seasoned veteran at 29.

In 1979 he was dealt back to Edmonton, now in the NHL. After just three games there, he hung up his skates for good.

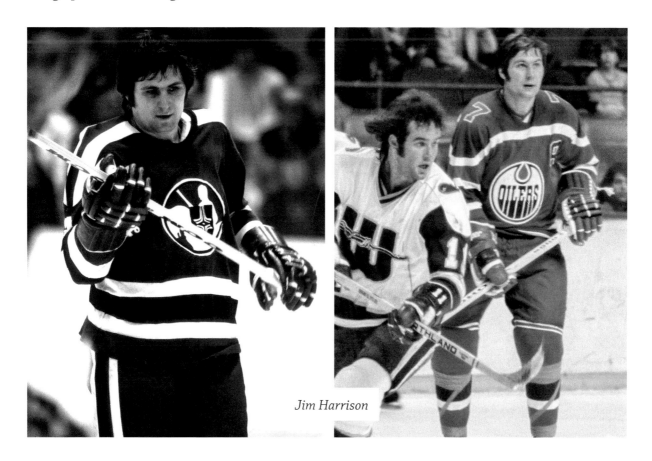

Jim Harrison

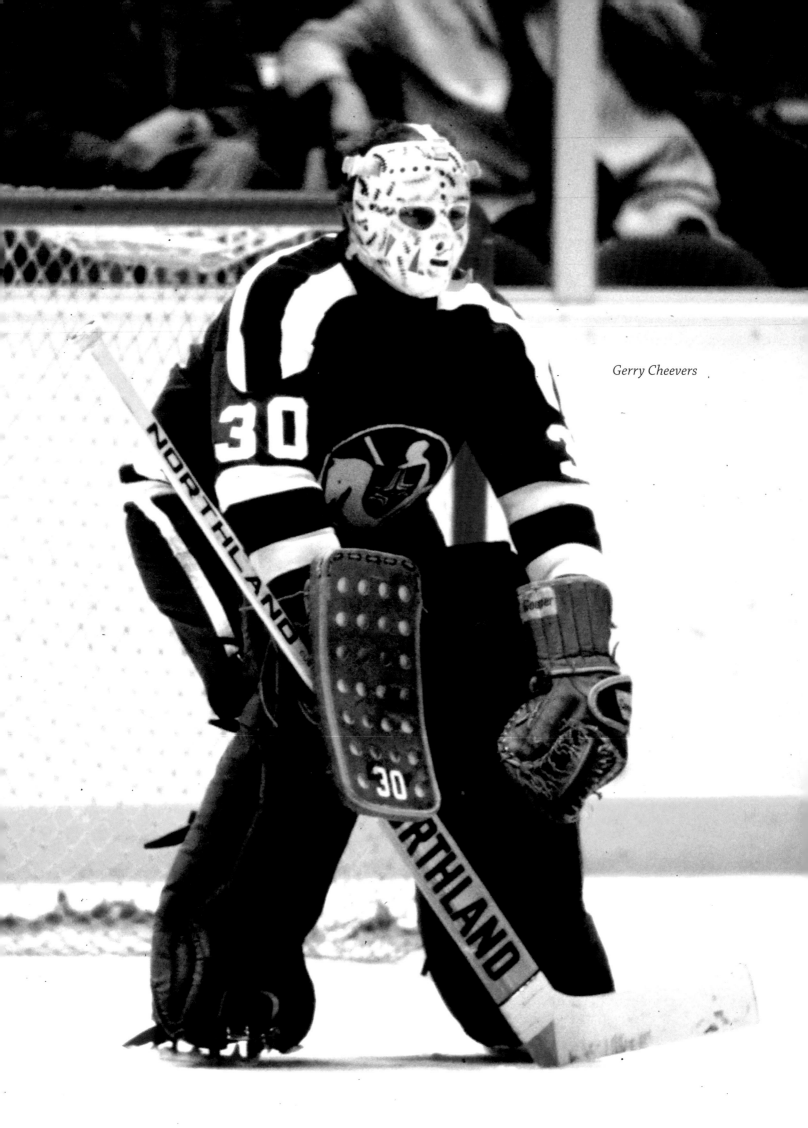

Gerry Cheevers

BOSTON CONNECTION: CHEEVERS, MCKENZIE, GREEN

The early 1970s was the era of the Big Bad Bruins, but, between expansion and the lure of big money to be had in the WHA, the team lost many of its key players.

The WHA needed marquee names to draw crowds. For the Cleveland Crusaders, that came in the person of Gerry Cheevers. Cheevers was coming off two Stanley Cup championships in Boston and was considered the best "money goalie" in the game. In 1972 he signed a then-unheard-of seven-year contract that paid $200,000 per season to jump to the new league. Instantly recognizable by his "stitch mask" (he was the first goaltender to decorate his mask), Cheevers played a big part in bringing big league credibility to the WHA.

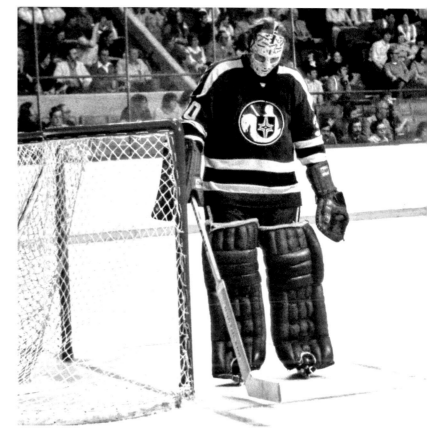

A star in Cleveland, he won All-Star honors in 1973, 1974 and 1975. But by 1976 things had begun to sour—as in most cases, over money. He returned to the Bruins, where he would finish out his Hall of Fame career.

John McKenzie, nicknamed "Pie Face" by a teammate due to his resemblance to a popular cartoon character, played for Chicago, Detroit and New York before finding his

Gerry Cheevers

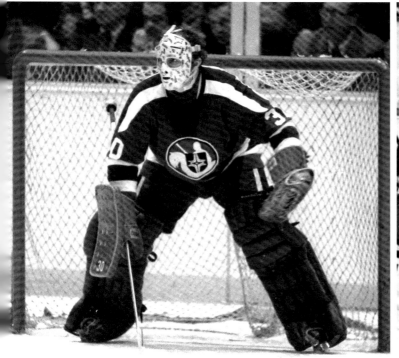

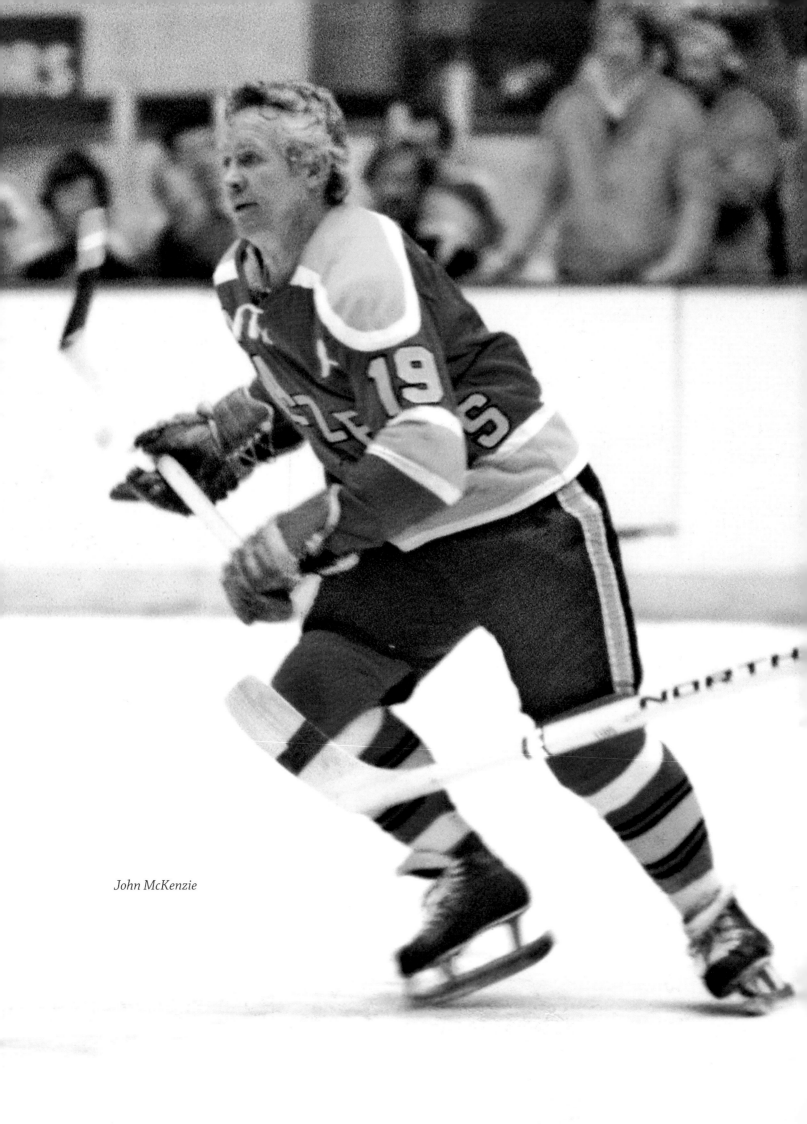

John McKenzie

place in Boston. A scrappy 5'9" forward, he was well known to take on all comers, making him a fan favorite.

He spent seven of his 12 NHL years in Boston, a time he considered the best of his life. He was, however, disappointed when he was left unprotected in the 1972 expansion draft. He signed on as player-coach of the Philadelphia Blazers, a team that also had (for a short time, anyway) stars Derek Sanderson and Bernie Parent.

His coaching was less than successful (2 and 11 in 13 games), so he stepped down to become a full-time player, something he was much better at. He continued to play for the Blazers in both Philadelphia and Vancouver before moving on to the Minnesota Fighting Saints and the Cincinnati Stingers. Eventually, he returned home to New England as a member of the New England Whalers, his final career stop.

Ted Green, who came up to the big leagues in 1961, was a defenseman in Boston through the pre–Bobby Orr lean years and was a member of the Big Bad Bruins championship teams. Tragedy struck in 1969 when Green instigated a stick fight with the Blues' Wayne Maki in a pre-season game. He suffered a fractured skull and missed the entire 1969–70 season. So respected was he by his teammates that his name was put on the Stanley Cup and he received a full share of the playoff money.

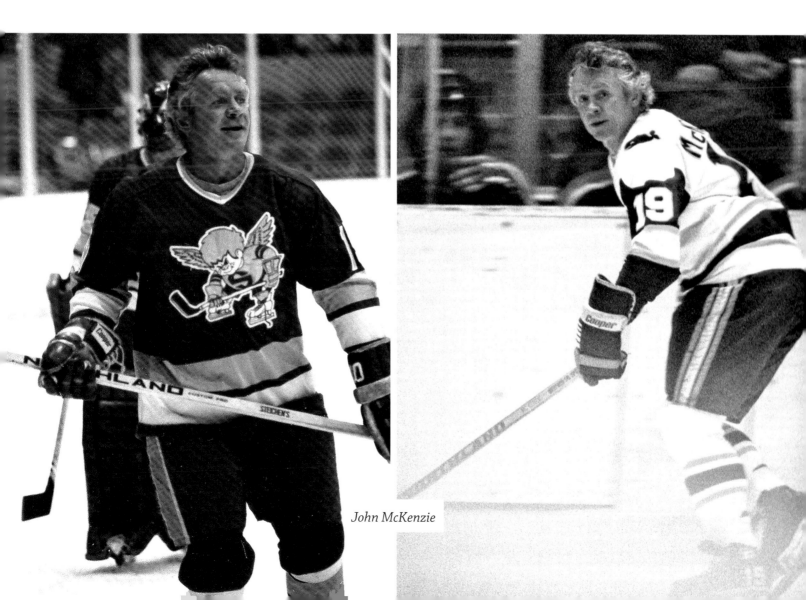

John McKenzie

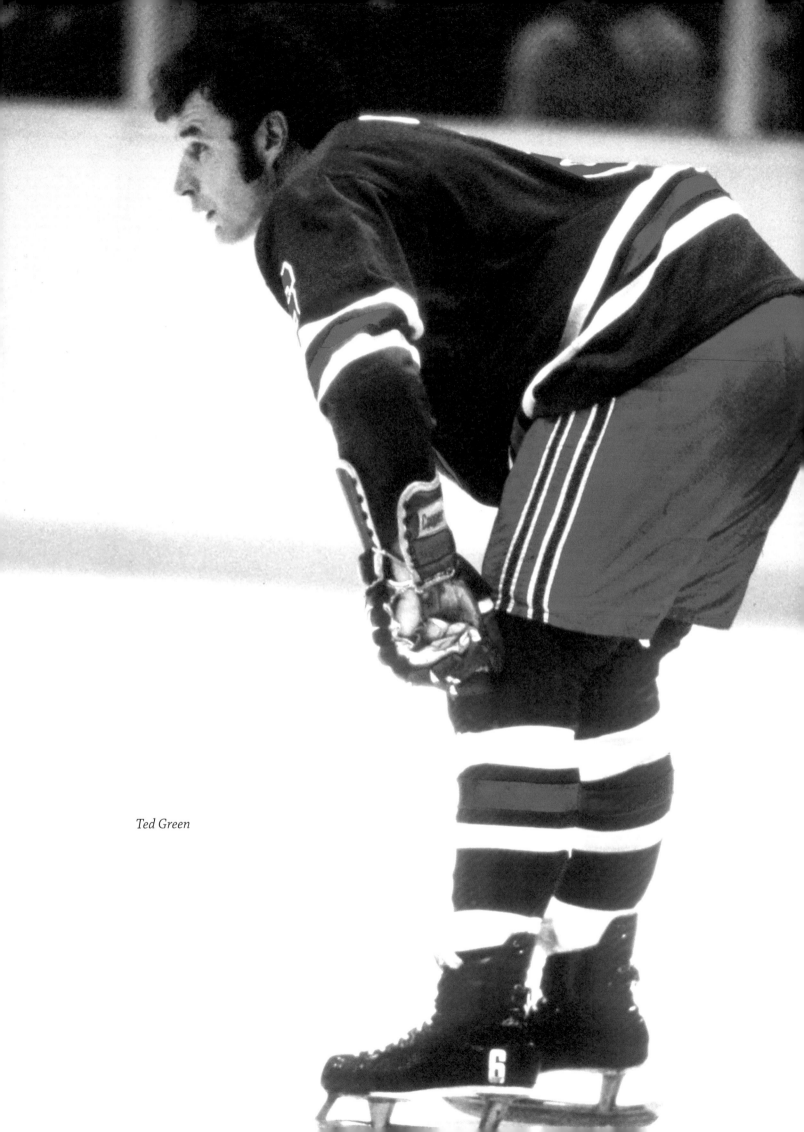

Ted Green

Ted Green

Now sporting a helmet, he returned to play for the Bruins before jumping to the New England Whalers. He would be their first captain as well as a member of the first WHA championship (and the only one for the Whalers).

In 1975 he was traded to the powerhouse Winnipeg Jets, helping them win two more championships (1976 and 1978) before retiring in 1979. He would later go on to coach with the Edmonton Oilers.

TWO DOLLARS/DEUX DOLLARS

TEAM CANADA L'EQUIPE
74

SEC. ROW SEAT

U 13 1

VANCOUVER
PACIFIC COLISEUM

$10.00

CANADA
- VS -
U.S.S.R.

MONDAY, SEPTEMBER 23,
1974.
5:00 P.M.

MANAGEMENT RESERVES RIGHT TO
REFUND AND REFUSE ADMISSION.
NOT LIABLE FOR ACCIDENTS OR
INJURIES CAUSING BODILY HARM.

PACIFIC COLISEUM, VANCOUVER, B.C.

NO REFUNDS • NO EXCHANGES

GO CANADA

CANADA-U.S.S.R. 1974

CHAPTER 5
SUMMIT SERIES— 1974 TEAM CANADA

DURING THE COLD War the Soviet hockey teams were something of a mystery. They were nominally "amateurs" (which no one believed), and the West had only really seen them in Olympic play, but this was a new situation against professionals.

Not all Canada's top players were included, however. Jean Béliveau and Gordie Howe had retired (in Howe's case for a while, anyway), and Bruins superstar Bobby Orr was down with knee woes that would require off-season surgery. Players from the newly formed WHA were notably excluded, meaning the team would be minus stars such as Bobby Hull, Gerry Cheevers, Derek Sanderson and J.C. Tremblay.

That would change in 1974.

It was called "Team Canada Two" by many, but this time Canada's roster was selected from the WHA instead of the NHL. Now players such as Bobby Hull were in the lineup along with Cheevers and Gordie Howe, who'd come out of retirement to play with his sons in Houston.

By 1974 Canada also had more experience with the Soviet style of play. Called "a nation of chess players," the Red squads played a deliberate, controlled passing game, not the rough-and-tumble rushing style of the North American game. The well-conditioned Soviet team had both speed and uncanny passing skills.

The series consisted of eight games, the first four in Canada (Quebec City, Toronto, Winnipeg and Vancouver) and the rest in Moscow. That alone seemed to favor Canada, as they could go to the USSR with several home wins if they carried the day on home ice. Unlike their counterparts of 1972, the 1974 squad would not underestimate their Soviet rivals.

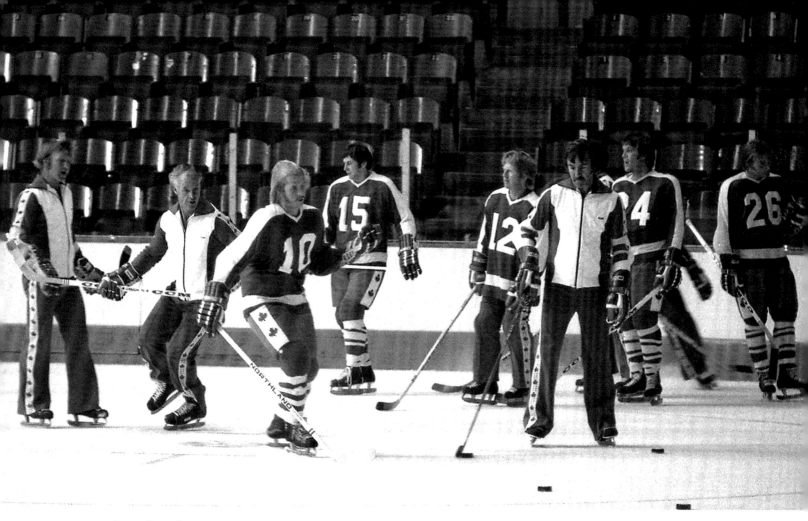

Team Canada

Playing on both the 1972 and 1974 teams for Canada were Paul Henderson, Frank Mahovlich and Pat Stapleton, who had made the move to the new league. The starting goalie was Gerry Cheevers, backed up by Gilles Gratton and Don McLeod, who had recently jumped to the new league and was a part of the 1974 Avco Cup–winning Houston team. Starting in net for the Soviet Union were Vladislav Tretiak and Alexander Sidelnikov. Tretiak played in seven games, Sidelnikov in the final game. Tretiak, now legendary for his performance in 1972, was still considered the best goaltender in the USSR; Sidelnikov was an Olympic standout.

Other Team Canada players included J.C. Tremblay, Mike "Shakey" Walton, the once and future Canadiens standout Rejean Houle, WHA legend André Lacroix, 17-year NHL veteran Ralph Backstrom, Jim Harrison, Serge Bernier (who would enjoy an eight-year career with Quebec in both the WHA and NHL), Marc Tardif and John McKenzie as well as American-born players Larry Pleau, Bobby Sheehan and Paul Hurley.

The USSR, also now more familiar with the North American game than they had been two years earlier, iced a formidable lineup that included such stars of Soviet hockey as Alexander Yakushev, Valeri Kharlamov, Boris Mikhailov, Vladimir Petrov and Alexander Maltsev. Mostly unknown in the West before the 1972 series, they were now familiar names across Canada.

Game 1 was played on September 17 before a packed house in Quebec, with Prime Minister Pierre Trudeau dropping the puck. It was an auspicious start, with Canada outshooting the

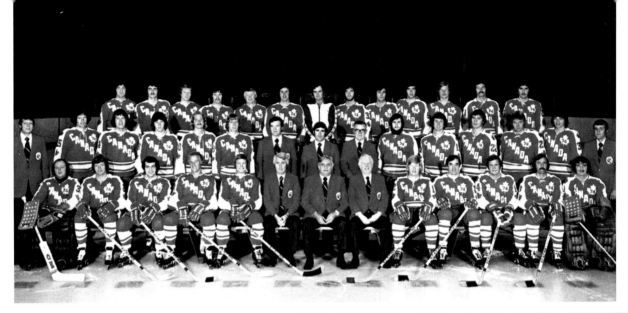

Team Canada, 1974

Soviets 34–28 as the game ended in a 3–3 tie.

Game 2 was played in Maple Leaf Gardens two days later, this time Canada besting the Soviets by a score of 4–1 and taking the series lead.

The Soviets roared back in Winnipeg on September 21, winning 8–5 in the highest-scoring game of the series. Vancouver hosted the final game on Canadian soil on September 23, yielding yet another tie, this time 5–5. It was on to Moscow.

On October 1, now on their home turf before sellout crowds, the Soviets bested the Canadians 3–2 in Game 5. Game 6 on October 3 saw the Soviets once again beat Canada 5–2. Things were beginning to look bleak for the WHA's best.

October 5 saw Game 7 end in a 4–4 tie.

Game 8, played on October 6, was the final and critical contest in the series. It ended in another 3–2 win for the Soviet team.

In retrospect Team Canada had more scoring leaders while the Soviets won more games.

SCORING LEADERS

Bobby Hull (7 goals, 2 assists, 9 points)
Alexander Yakushev (5 goals, 3 assists, 8 points)
Ralph Backstrom (4 goals, 4 assists, 8 points)
Gordie Howe (3 goals, 4 assists, 7 points)
Valeri Kharlamov (2 goals, 5 assists, 7 points)
Vladimir Petrov (1 goal, 6 assists, 7 points)
André Lacroix (1 goal, 6 assists, 7 points)
Boris Mikhailov (4 goals, 2 assists, points)
Mark Howe (2 goals, 4 assists, points)
John McKenzie (2 goals, 3 assists, 5 points)

WINS/LOSSES

September 17: Canada 3–3 USSR, played in Quebec City, QC
September 19: Canada 4–1 USSR, played in Toronto, ON
September 21: USSR 8–5 Canada, played in Winnipeg, MB
September 23: Canada 5–5 USSR, played in Vancouver, BC
October 1: USSR 3–2 Canada, played in Moscow
October 3: USSR 5–2 Canada, played in Moscow
October 5: USSR 4–4 Canada, played in Moscow
October 6: USSR 3–2 Canada, played in Moscow
USSR wins series 4-1-3

Gordie Howe

Bobby Hull

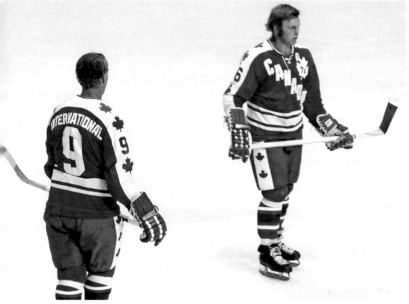

Team Canada

Gordie Howe

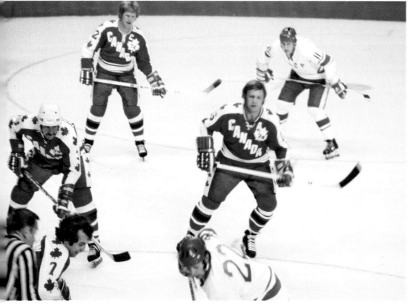

André Lacroix, Bobby Hull, J.C. Tremblay and Pat Stapleton

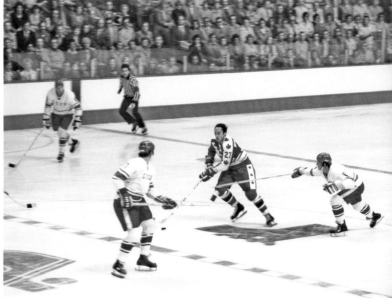

Frank Mahovlich

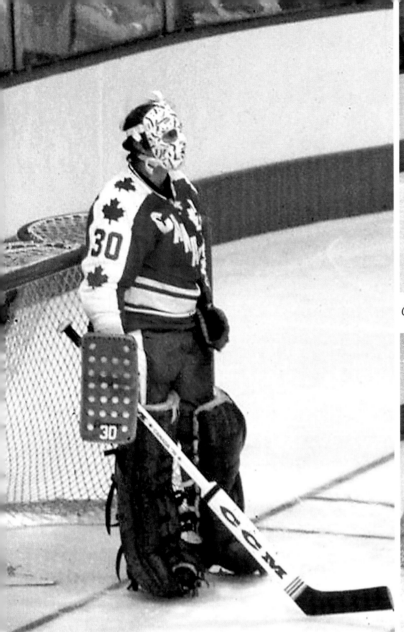

Gerry Cheevers

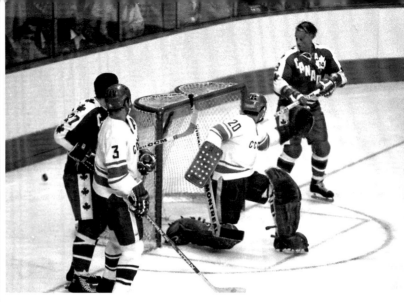

Gordie Howe and Frank Mahovlich

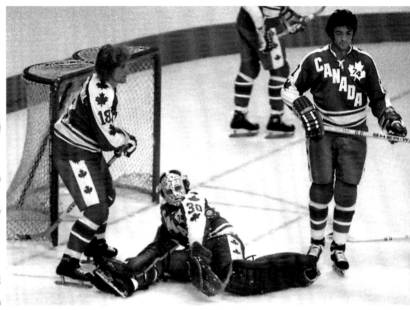

Paul Shmyr, Gerry Cheevers and Rick Smith

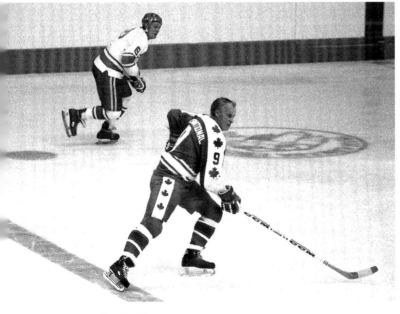

Gordie Howe

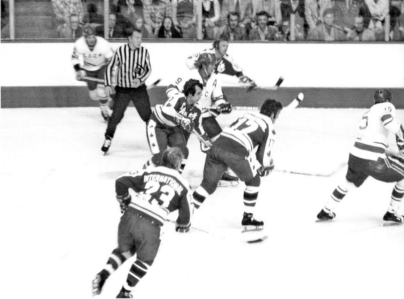

Team Canada

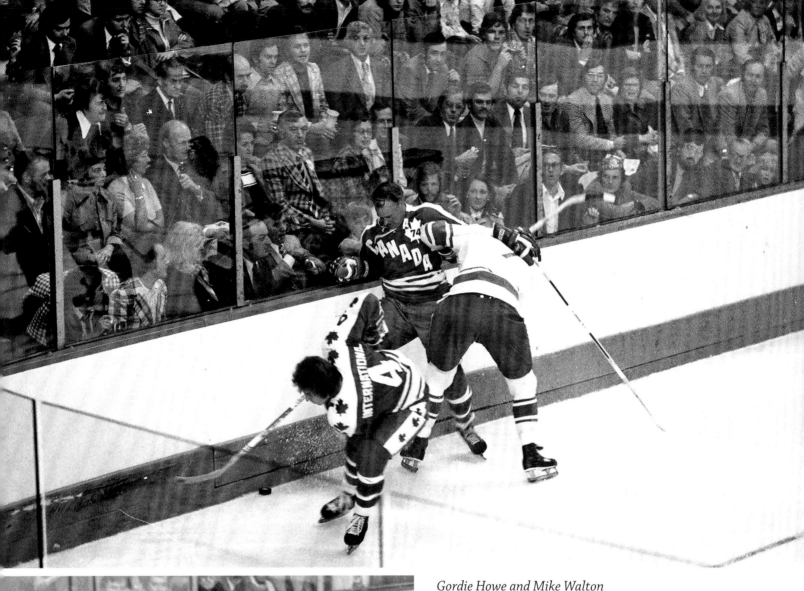

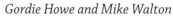

Gordie Howe and Mike Walton

Left: Serge Bernier

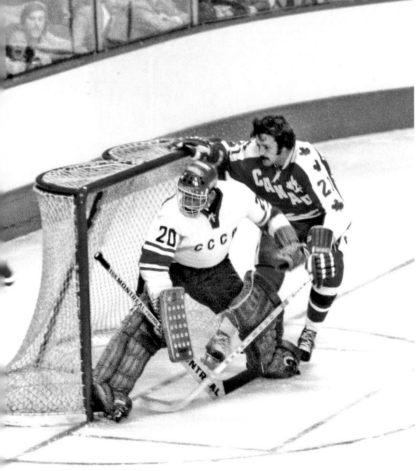

On the whole, both teams saw it as an interesting experience. Canada had gained insight not only from the Summit Series, but also from an exhibition tour against European teams before and after. Prior to the series, Team Canada played against the Swedish and Finnish national teams. Post-series, they played an exhibition game in Prague, Czechoslovakia. The WHA had led the way in signing European players; this series of games no doubt increased the profile of European talent. More importantly, it helped give the new league the legitimacy it had sought.

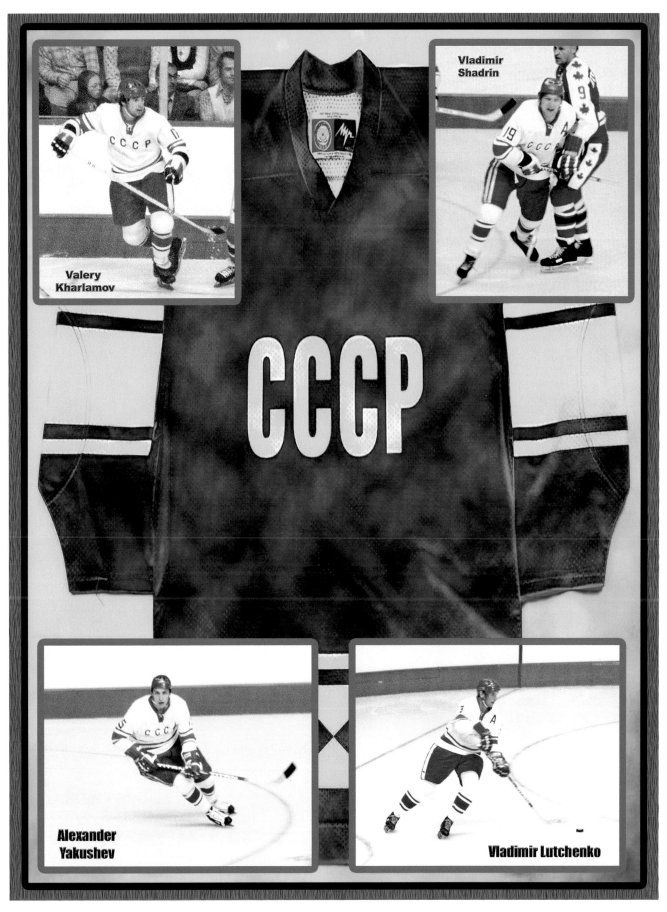

Valery
Kharlamov

Vladimir
Shadrin

CCCP

Alexander
Yakushev

Vladimir Lutchenko

Team Russia

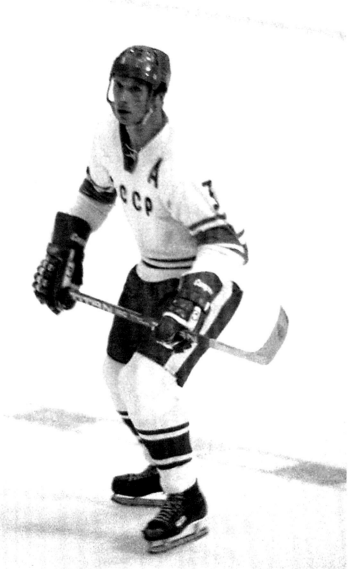

Vladimir Lutchenko

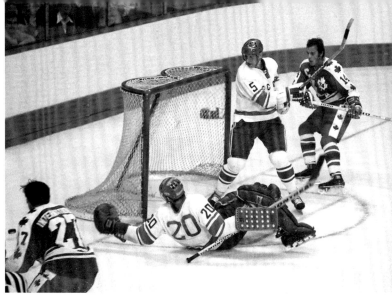

Frank Mahovlich, Ralph Backstrom, Vladislav Tretiak and Yuri Liapkin

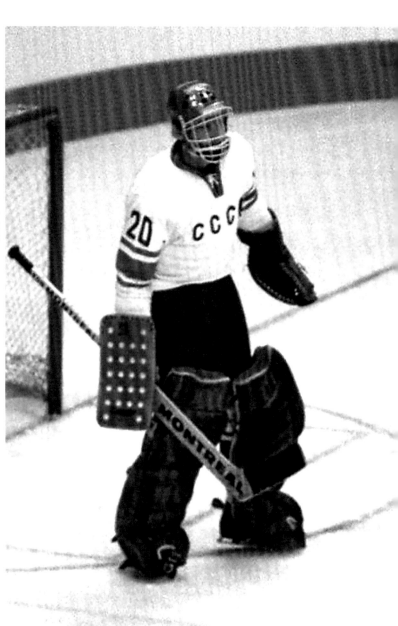

Vladislav Tretiak

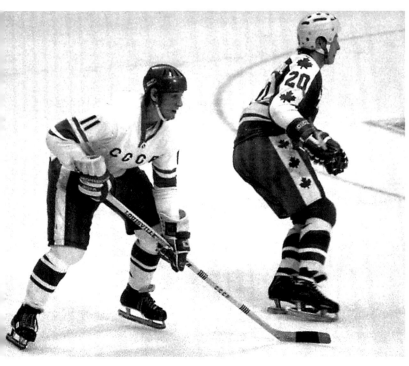

Yuri Lebedev and Bruce MacGregor

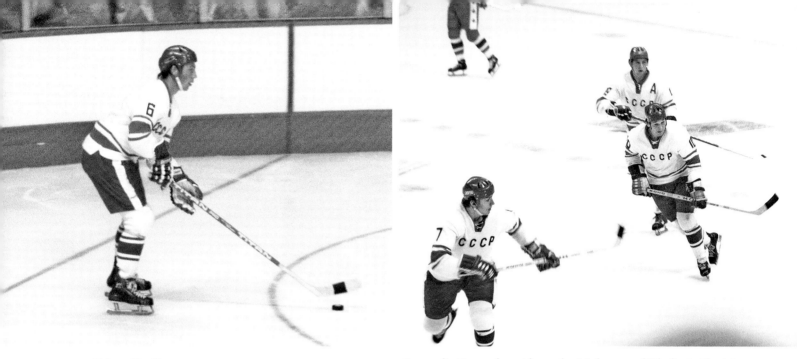

Valery Vasiliev

Gennadiy Tsygankov, Alexander Maltsev and Vladimir Shadrin

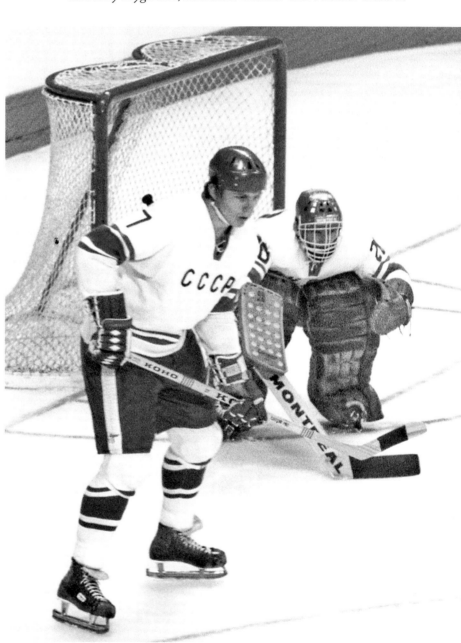

Gennadiy Tsygankov and
Vladislav Tretiak

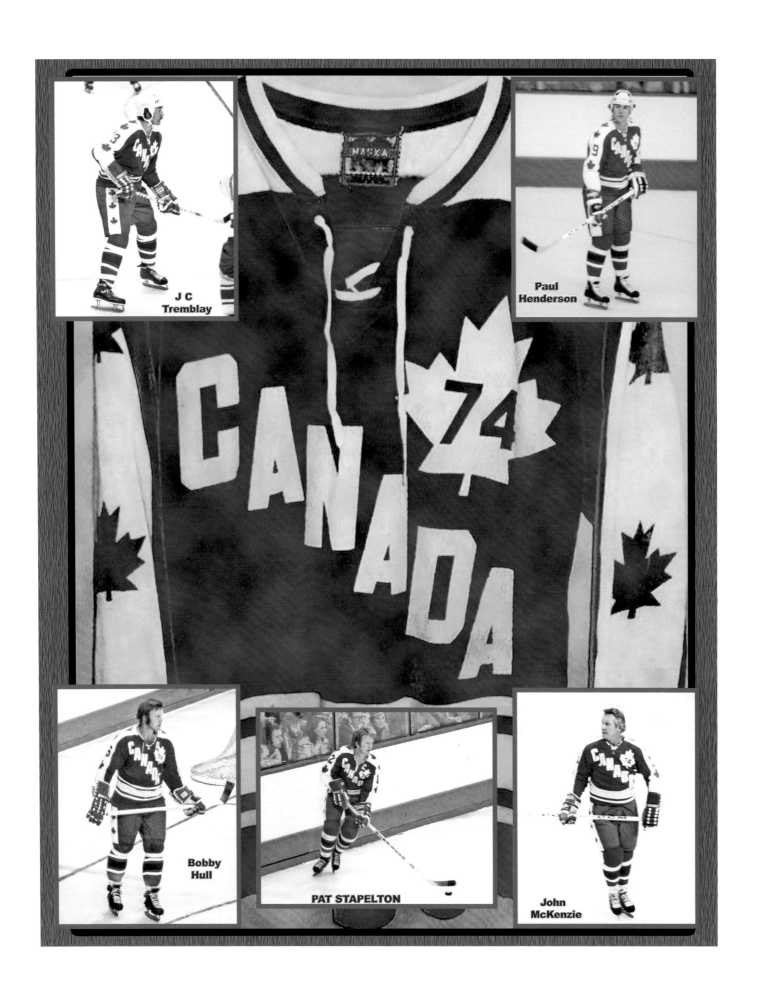

J C Tremblay

Paul Henderson

CANADA 74

Bobby Hull

PAT STAPELTON

John McKenzie

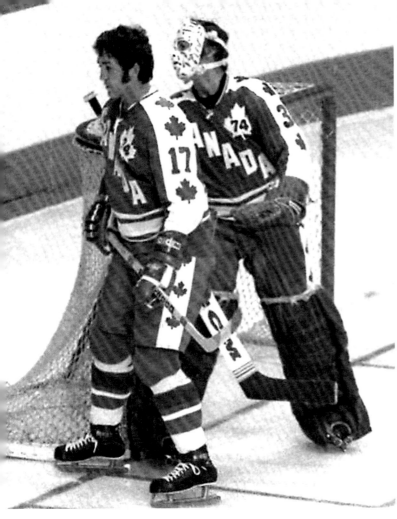

Rick Smith and Gerry Cheevers

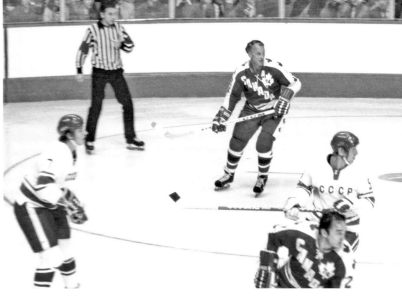

Gordie Howe

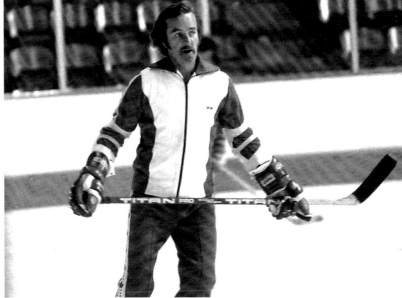

J.C. Tremblay

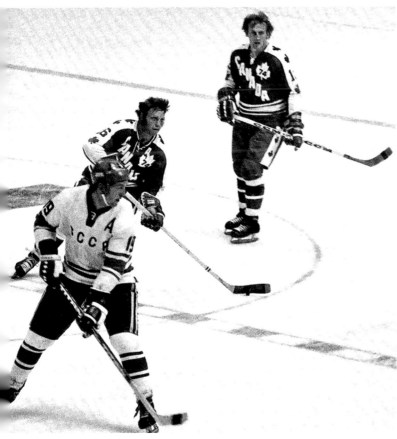

Bobby Hull and Paul Shmyr

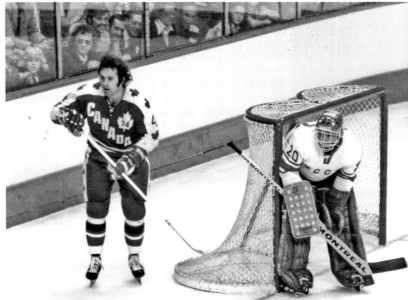

Mike Walton and Vladislav Tretiak

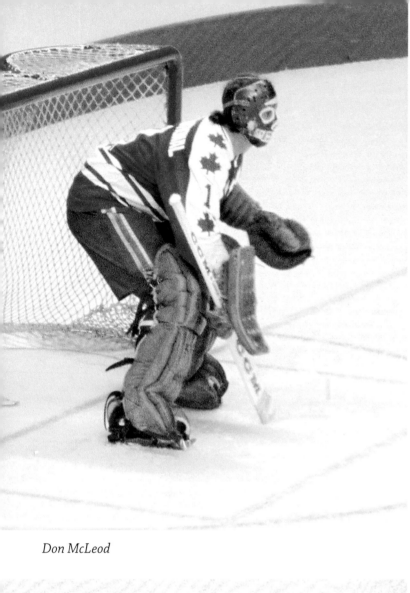

Don McLeod

Mark Howe

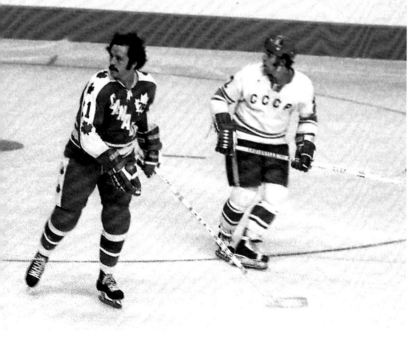

Serge Bernier

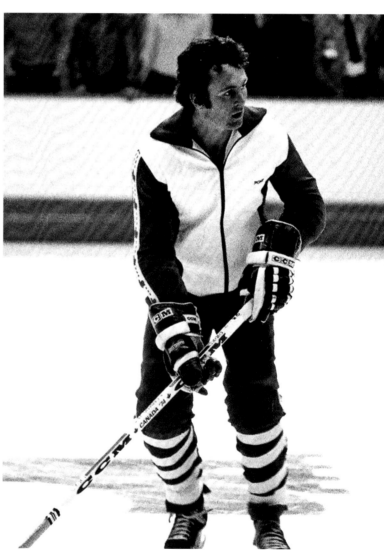

Paul Henderson

9 AND 99 IN 1979

Like generations of Canadians, Wayne Gretzky grew up idolizing Gordie Howe. But most didn't end up playing against him—or with him.

Gretzky had the opportunity to do both. In January 1979, the 17-year-old rookie phenom (he would turn 18 on January 26) was chosen to play on a line with two Howes, Gordie and his son Mark, in a tilt against the Soviets.

Needless to say, the future Great One was nervous to even be in such an exhibition, let alone playing on a line with his idol. Howe, a veteran of many such contests, took it in stride and did his best to take the skinny kid under his wing. Gretzky recalled being issued an oversized sweater (which would later become his trademark). To keep him from looking like a boy wearing his father's jersey, Howe even "tailored" it for him so it would fit the young player better.

The format that year was a three game series against Moscow Dynamo, one of the best the Soviet Union had to offer. It was to be played in Edmonton at the Northlands Coliseum. In the first game, played on January 2, the WHA stars won by a score of 4–2. The second game, played on January 4, was a scoring repeat, WHA 4, Dynamo 2. The final game on January 5 saw the WHA All-Stars sweeping the series, beating the Soviets 4–3.

It would be the last All-Star Game in WHA history.

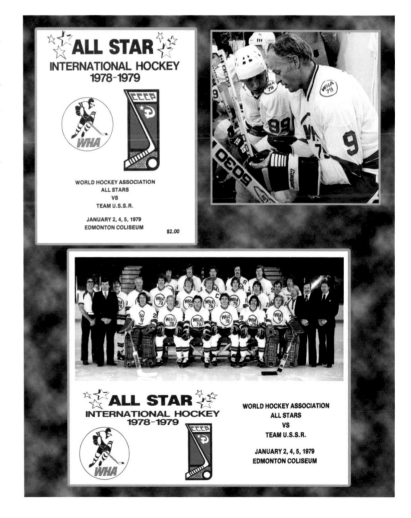

PURCHASE ORDER

TOPPS CHEWING GUM, INCORPORATED
254 - 36TH STREET, BROOKLYN, N.Y. 11232
TELEPHONE (212) 768-8900

This order no. MUST appear on all
invoices, packing slips & bills of lading

PURCHASE ORDER
DATE

H 16069

SHIP TO ☐ 254 36TH STREET, BROOKLYN, N.Y. 11232

(OR) ▶ ☐

TO:
Mr. Steve Babineau
91 Yale Street
Medford, Mass. 02155

DELIVERY DATE | TERMS CODE

VENDOR NO.

03417

TERMS

SHIP VIA
MAIL

P.A. SALES & USE TAX
☐ TAXABLE ☐ NON-TAXABLE

PRICE

TOPPS ACCOUNT NO.

F.O.B.

ITEM NO. | QUANTITY | VENDOR'S COMMODITY NO OR DESCRIPTION KEYWORD | DESCRIPTION

For suppling the following,
NHL Hockey Transparencies,
for use in 1979 Topps Hockey
Card Series.

16 Shots at
$25.00 Each

Card #
18 Wayne Gretzky
43 Gary Smith
46 Marty Howe
47 Robbie Ftorek
51 Tom Gorence
65 Pat Hughes
71 Dave Dryden
107 Alan Hangsleben
108 Marc Tardif
151 Kris Manery
166 Al Hill
175 Gordie Howe
216 Mark Howe
222 Mark Napier
239 Real Cloutier
241 Ken Linseman

DIRECT INQUIRIES TO:

MAIL ALL INVOICES TO ▶

TOPPS CHEWING GUM, INCORPORATED
254-36th STREET, BROOKLYN, N.Y. 11232

BUTCH J...

1 YOU ARE AUTHORIZED TO FURNISH THE ARTICLES LISTED HEREON IN ACCORDANCE WITH THE TERMS AND CONDITIONS ON THE FACE AND BACK OF THIS ORDER.

2 THIS CONTRACT SHALL NOT BE BINDING UPON THE BUYER UNLESS THE ATTACHED ORDER ACKNOWLEDGMENT IS SIGNED AND PROMPTLY RETURNED BY SELLER. PERFORMANCE BY THE SELLER SHALL BE DEEMED AN ACCEPTANCE OF ALL OF THE TERMS AND CONDITIONS SET FORTH IN THE CONTRACT.

FORM 264 (R-1) (7-75)

WAYNE GRETZKY • C
EDMONTON OILERS

Wayne Gretzky's card.

CHAPTER 6
"THE CARD"

FEBRUARY 16, 1979, GAME 50, 4–2, EDMONTON OILERS @ NEW ENGLAND WHALERS

"This kid, Gretzky, is coming to your neck of the woods, can you get some shots?" was the request I had gotten from both the *Hockey News* and the Topps/O-Pee-Chee card company. I had continued to shoot the WHA, following the New England Whalers after leaving Boston Garden and Boston Arena to their temporary home, the Big E Coliseum in West Springfield, MA. It would be their facility until the new Hartford Civic Center was completed in 1974. Hartford was eager for hockey, and the Whalers were looking to be out of the shadow of the Bruins. The new arena would hold 15,635 fans, with better indoor lighting to shoot games and, most importantly, it was a three-hour ride round trip from my real job. It got me home at a reasonable time for work the next day.

So, I continued to photograph the WHA as Topps now wanted to use game action shots on their cards instead of posed training camp images. I started supplying Topps with NHL photos in 1976. Soon *Hockey News*, *Hockey Digest*, *Bank of Nova Scotia Hockey College News* (Brian McFarlane's production), *Hockey Illustrated*, *Hockey World* and *Hockey Pictorial* became outlets for my work.

I had a responsibility to the Bruins as their color photographer as well as my real job, and in addition, in 1976 *Baseball Digest* (John Kuenster was the editor) gave me the opportunity to shoot the Red Sox. I had to start picking and choosing key games with the WHA. Well, a key game came along on February 16, 1979, when a request to photograph "The Kid" came in.

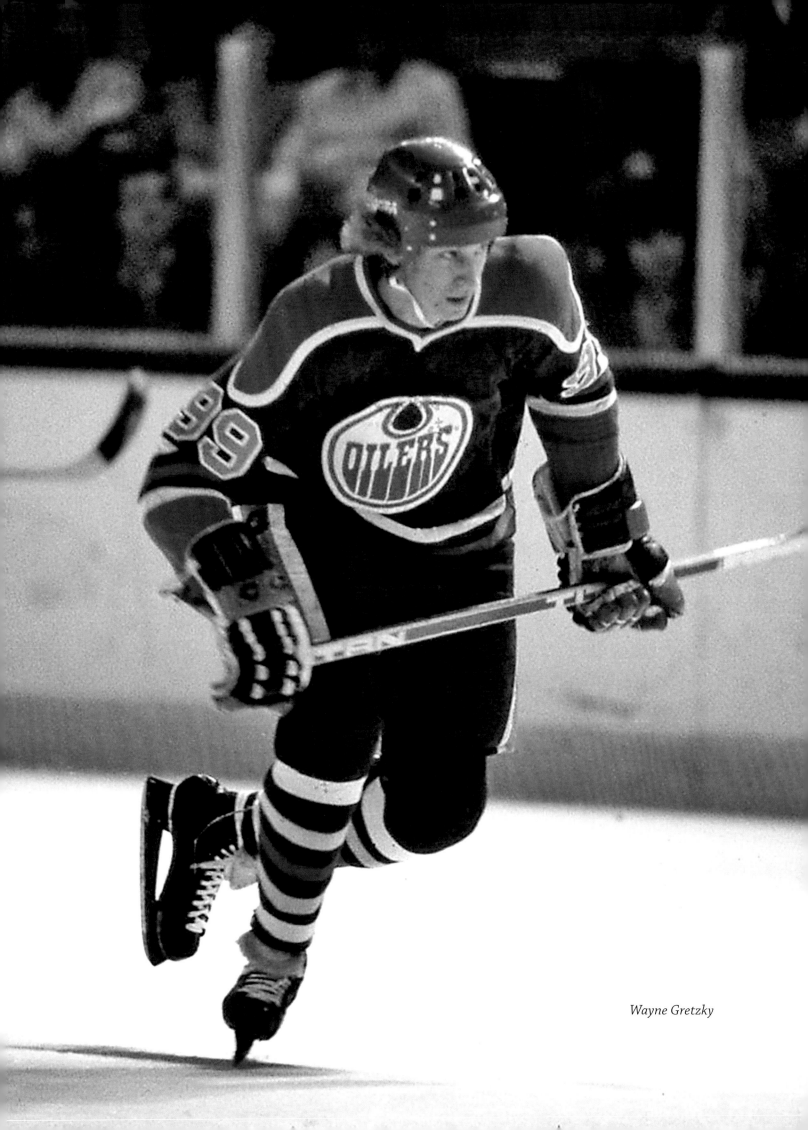

Wayne Gretzky

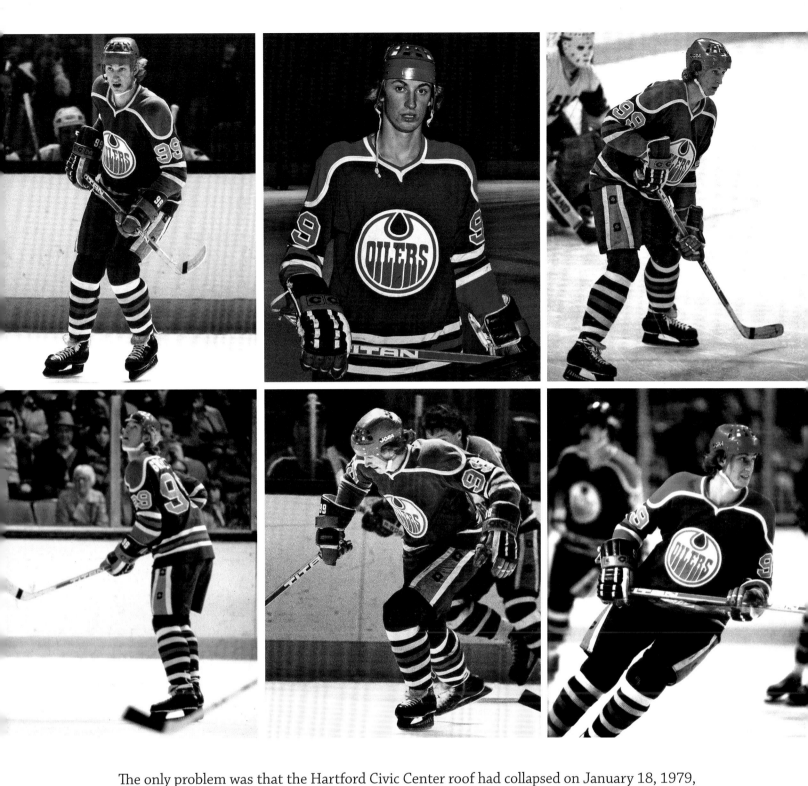

The only problem was that the Hartford Civic Center roof had collapsed on January 18, 1979, forcing the Whalers to relocate to the Springfield Civic Center. This was not a positive for me, as the lighting in the building was far different than that in Hartford, and that meant additional tweaking and expense in film processing to get proper color. Still, when I was asked to photograph Gretzky, I realized that he would be playing in a game against Gordie Howe, who was now playing for the Whalers along with his sons. I had already photographed the Howes a few times playing for Hartford before the roof issue, as well them playing for the Houston Aeros, so I was happy to shoot Gordie Howe again.

Put yourself in 1979, photographing an 18-year-old player. Do you think at that moment he is going to become "The Great One" and would go on to pass Gordie Howe for most goals

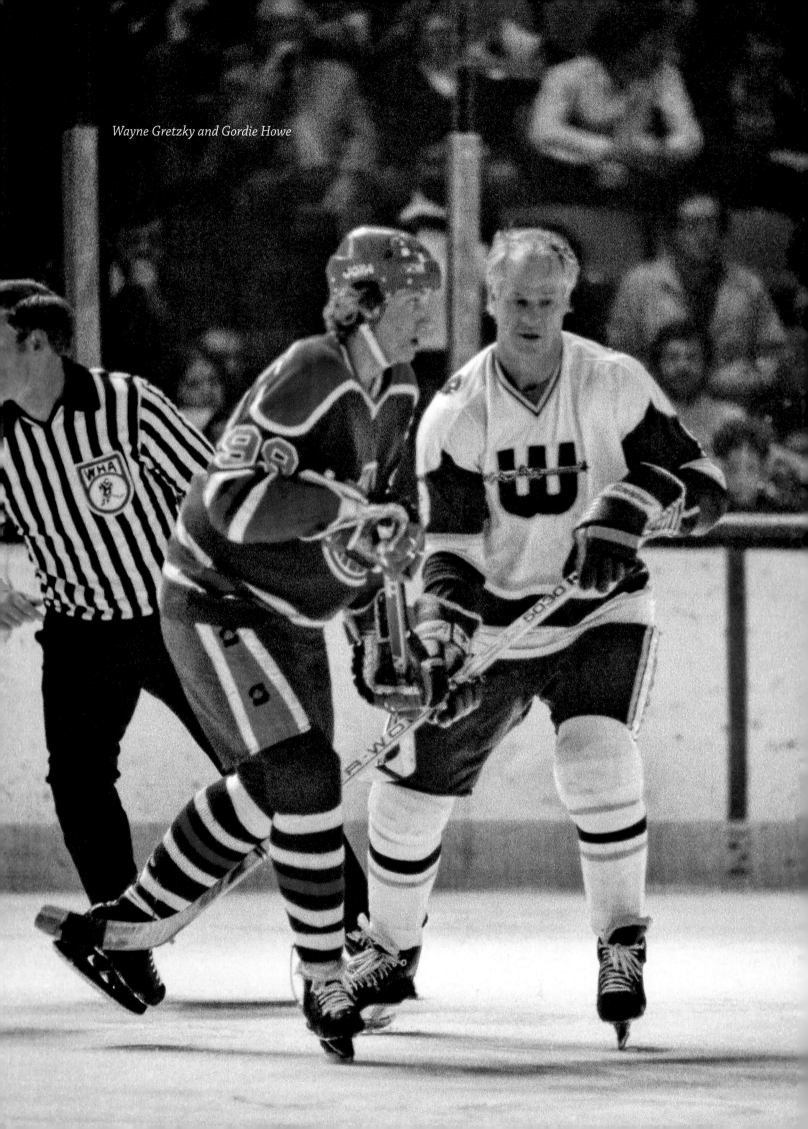
Wayne Gretzky and Gordie Howe

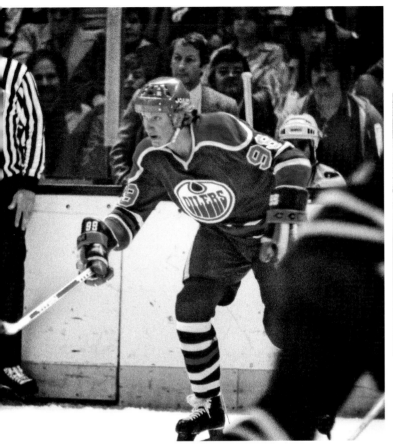

Wayne Gretzky, Stan Weir and Bill Flett

(894 to Gordie's 801)? No way. I looked at it as another player with talent: just go out and get some pics.

I got him to quickly pose for me during warm-up. I was shooting out of the penalty box and followed him over the course of the game in both black-and-white and color slide film. The key shot for me, as I look back, is Wayne and Gordie on a face-off, two of the greatest to play the game in one image.

The WHA folded at the end of the 1978–79 season, with Edmonton, Quebec, Winnipeg and Hartford becoming NHL teams the following year with minimal uniform changes. So here I was with players from those four teams in uniform, which were needed for the new hockey cards being produced by Topps/O-Pee-Chee. The hit list came from Butch Jacobs and Phil Carter at Topps, and there was Wayne Gretzky's name along with the others. I submitted a few images of Wayne from the February 16, 1979, game, playing in the WHA, as the only difference in Edmonton's uniform was the circle dimension of the logo on front being slightly larger—crucially, the jersey design and colors were the same. The rest, as they say, is history . . .

During the 2016 season I was shooting for Upper Deck in Sunrise, FL. Edmonton was playing the Florida Panthers and the Oilers were outside the Panthers locker room, waiting to go to the bench area for warm-ups. Gretzky was waiting to congratulate Jaromir Jagr for going into second place for all-time points, behind him. We made eye contact and I got the feeling that he looked at me like "Do I know this guy?" So I went over and told him I was the Boston Bruins' photographer,

and he responded, "Yes, you looked familiar. You shot between the benches in the new Garden when I played for the Rangers."

I was stunned that he would remember me with the Bruins. So I quickly said I had one for him, telling him, "I took your rookie card photo."

"Really? Where was I playing?"

"Last year of the WHA, you went from Indianapolis to Edmonton and were playing in Springfield, Massachusetts, in a game against Gordie Howe."

His eyes popped, and as he stuck out his hand and shook mine, he said, "You win!"

—STEVE BABINEAU

EPILOGUE

IN THE YEARS since its demise, the legacy of the World Hockey Association is still tangible. Without competition, the NHL had a grip on major league play in North America. The emergence of the WHA not only led to increased salaries and freedom of movement, in many cases it brought major league hockey to cities that previously had no team. The WHA gave many players a chance to compete at the major league level, and it extended the careers of several veterans (even reviving the careers of some, most notably Gordie Howe). The league also opened the way for many college players and demonstrated that European players could thrive in the North American game: because of the WHA, professional hockey is now very much an international affair.

ACKNOWLEDGMENTS

TO HAROLD "HAL" BARKLEY, legendary pioneer in photographing the game: When I saw the March 1964 *Hockey Illustrated* cover shot in color of Elmer "Moose" Vasko and Glenn Hall when I was 12 years old, that cover image became implanted in my thoughts—I thought, *how did he capture the brightness and action using his camera?* I became a collector of his work used in various publications. Later, I was able to see first-hand his work at The Hockey Hall of Fame. Shooting

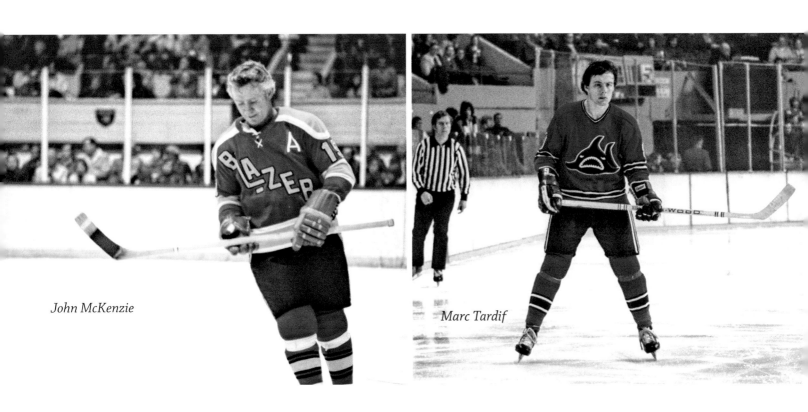

John McKenzie

Marc Tardif

SPORTS

HOCKEY
ILLUSTRATED 50c MARCH 1964

THE HAWKS
WON'T FOLD IN
THE STRETCH
By Bobby Hull

The Only Guy I'm Mad At Is MYSELF By Howie Young

GLENN HALL
AND ELMER VASKO

THE LEAFS:
Bodychecks
And Ballots

THE GREATEST... HOWE OR RICHARD?
A COMPREHENSIVE ANALYSIS BY THEIR LINEMATES
AND COACHES SID ABEL AND TOE BLAKE

RATING THE
GOALIES

photos using strobes, I followed his process installing strobes in the old Boston Garden during the 1978–79 season.

I'm so grateful to the *Hockey News* editor Charlie Halpin and publisher Ken McKenzie back in 1972 for giving me the opportunity to start this 50-year journey shooting the game of hockey. Thank you to the Topps company's Phil Carter and Butch Jacobs, New England Whalers public relations Bob Neumeier and owner Howard Baldwin. Fellow photographers back in the day, Al Ruelle, Jerry Buckley, Frank O'Brien, Denis Brodeur and television sportscaster and writer Brian McFarlane, and to Maurice "Lefty" Reid, Phil Pritchard and Craig Campbell of the Hockey Hall of Fame.

Special thanks to Doug Mclatchy, Hockey historian, who supplied from his collection PR photos of players as well as team photos, game programs and media guides to fill voids I had in compiling the franchise chapters.

—STEVE BABINEAU